THE ANTIQUE BUYER'S
DICTIONARY OF NAMES

OTHER BOOKS IN THE SERIES

Buying Antiques General Guide (revised 1968)
Buying Antiques Reference Book (published annually)

BY THE SAME AUTHOR

Blue and White Transfer Ware, 1780-1840

THE
ANTIQUE BUYER'S
DICTIONARY
OF NAMES

A. W. COYSH

DAVID & CHARLES : NEWTON ABBOT

ISBN 0 7153 4926 0

Set in 10 pt Intertype Baskerville
and printed in Great Britain
by Clarke, Doble & Brendon Limited Plymouth
for David & Charles (Publishers) Limited
South Devon House Newton Abbot Devon

CONTENTS

		Page
LIST OF ILLUSTRATIONS	7
PREFACE	9
ABBREVIATIONS AND CONVENTIONS	11
1 ART NOUVEAU	13
2 BOOK ILLUSTRATIONS AND PRINTS	23
3 BRONZES	48
4 CLOCKS AND BAROMETERS	59
5 FASHION PLATES	81
6 FIREARMS	86
7 FURNITURE	98
8 GLASS	123
9 MAPS, CHARTS, AND GLOBES	137
10 MINIATURES	148
11 MUSICAL INSTRUMENTS	170
12 NETSUKE	179
13 POTTERY AND PORCELAIN	185
14 SHEFFIELD PLATE	224
15 SILHOUETTES OR PROFILES	231
16 SILK PICTURES, PORTRAITS, AND BOOKMARKS	. .	243
17 SILVER	250

ILLUSTRATIONS

PLATES

Page

Bronze of a setter by Christophe Fratin *(Courtesy: Messrs King and Chasemore)* 17

Bronze partridges by Alfred Dubucand *(Courtesy: Messrs King and Chasemore)* 18

Bracket clock by John Stephen Rimbault *(Courtesy: Messrs King and Chasemore)* 35

Bracket clock by George Yonge *(Courtesy: Messrs King and Chasemore)* 36

Fashion plate by Anaïs Toudouze from *La Mode Illustrée* *(author's collection)* 53

Duelling Pistol by Ann Patrick *(Courtesy: Messrs Christie's)* 54

Pretzel-back chair by Daniel Trotter of Philadelphia *(Courtesy: American Museum in Britain)* 71

Art nouveau mahogany chair by Arthur Mackmurdo *(Courtesy: William Morris Gallery)* 71

Glass goblet by Giacomo Verzelini *(Courtesy: Victoria and Albert Museum)* 72

Glass jug by George Ravenscroft *(Courtesy: Victoria and Albert Museum)* 72

Miniature portraits by Richard Crosse, Horace Hone and George Engleheart *(Reproduced by permission of the Syndics of the Fitzwilliam Museum, Cambridge)* 89

Guitar by Joachim Tielke and Theorboes by Michael Rauch and J. H. Goldt *(Courtesy: Victoria and Albert Museum)* 90

Derby wine cooler with 'Duesbury' mark *(Courtesy: King and Chasemore)* 107

Transfer-printed blue dishes by John Rogers & Son and John & Richard Riley *(author's collection)* 108

7

Page

Silhouette by Stephen O'Driscoll of Cork *(Donald Gildea Collection)* — 125

Silk Picture of Joseph Marie Jacquard by François Carquillat *(author's collection)* — 126

Silver Salver by William Peaston and Coffee Pot by Thomas Whipham *(Courtesy: Woolley & Wallis)* — 143

Silver gilt cup and cover by Paul de Lamerie *(Courtesy: King and Chasemore)* — 144

IN THE TEXT

'Hyde Park—Out of Season' by Randolph Caldecott — 30

'Self Love' by George Cruikshank — 32

'Water Works' by Phil May — 41

PREFACE

BUYING antiques requires good taste, good judgment, and knowledge. Yet few people can hope to specialise in more than a single subject; for the rest they must rely on 'instant research'—the ability to look up the facts about makers or craftsmen very quickly, between viewing-day and auction sale, or before a seemingly desirable piece in a shop is sold to another customer. This normally depends on a formidable array of reference books, some of them expensive. Few can afford this equipment, nor are relevant books always readily available in public libraries. This biographical dictionary has been compiled so that buyers may make quick reference over a wide field. It lists many craftsmen, decorators, and designers who worked in America, Britain, Europe and Japan, and special care has been taken to include names that appear frequently in auction sale catalogues and dealers' advertisements. The prices paid for the work of particular craftsmen have been included where they seem to have a special interest. Each section is preceded by some brief notes on the field covered and the conventions adopted, and ends with a list of books to consult for more detailed information.

ABBREVIATIONS AND CONVENTIONS

Dates shown in brackets after a name indicate the years of birth and death—eg (1784-1855).

When only one date is definitely known, the dates of birth or death are indicated by 'b' or 'd' respectively, eg (b 1784) or (d 1855). The letter 'w' before dates indicates that they represent the working life of the artist or craftsman concerned, or the business life of a firm or partnership. It does not, as a rule, include a period of apprenticeship. Thus (w 1752-88) indicates a working life of thirty-six years ending with retirement or death.

Whenever there is doubt about a date the abbreviation 'c' for *circa* is used before that date only—thus (c1784-1855) would indicate that the birth date is doubtful but the date of death is known to be 1855.

MUSEUMS

The names of most museums are given in full but the following abbreviations are used for well known museums and galleries which are mentioned frequently.

AM	Ashmolean Museum, Oxford
BM	British Museum, London
BMFA	Boston Museum of Fine Arts
FM	Fitzwilliam Museum, Cambridge
MMANY	Metropolitan Museum of Art, New York
NPG	National Portrait Gallery, London
Tate	Tate Gallery, London
V & A	Victoria and Albert Museum, London
W Coll	Wallace Collection, London

BOOKS

Unless otherwise stated the date following the title of a book is the date of original publication. This is sometimes followed by a second

date in brackets, which is the publication year of the latest edition.

PRICES

In some cases the price for which the work of an artist has been sold at auction is given. The year of the auction is indicated in brackets after the letter 'A'. Thus £1,050 (A 1969) means 'sold at auction in 1969 for £1,050'.

1

ART NOUVEAU

In the last quarter of the nineteenth century several new artistic styles emerged, culminating in *art nouveau*, which broke away from tradition and produced designs and ornamentation with long flowing lines. The new designs were first seen in the 1880s and reached their peak between 1895 and 1905, thereafter showing a slow decline until, with the outbreak of the First World War, they virtually disappeared. The style affected architecture, metalwork, interior decoration, textiles, furniture, glass, and ceramics.

The artists depended a great deal on businessmen who took an interest in their ideas, exhibited their designs, and sold their work. In this connection three sponsors stand out—Arthur Lasenby Liberty, Samuel Bing, and Louis Comfort Tiffany. Liberty had always taken a great interest in oriental art: he was, for a time, manager of Farmer & Roger's Oriental Warehouse in London. In 1875 he started his own business at 218A Regent Street, which expanded rapidly. He gave a good deal of publicity to the artists of the aesthetic movement with textiles as his stock-in-trade. In the 1890s the firm of Liberty & Co Ltd sold *art nouveau* work on a considerable scale. All kinds of decorative furnishings and household wares were stocked and special lines were launched, such as *Cymric* silver and *Tudric* pewter. Meanwhile, in Paris, Samuel Bing had opened a shop in 1895 which he called *L'Art Nouveau* and it was this name that become generic for the style. He sold the work of leading British and French artists for about ten years and his establishment often became their meeting place. In America the main sponsor was Tiffany, who, like Liberty, was a connoisseur of oriental art. His store gave currency to the work of artists who worked in a number of fields but he is best known for Tiffany glass.

Although *art nouveau* pieces are not yet 'antiques' they do appear in antique shops. In this section the artists are grouped together, whatever field they worked in, and particular attention has been paid to those who stamped or signed their work. *Art nouveau* book illustrators are included under Book Illustrations and Prints (p 23).

ANDRÉ, ÉMILE (1861-1933), of Nancy, France, was an architect who also designed furniture with a Gothic flavour, especially chairs.

ASHBEE, CHARLES ROBERT (1863-1942), started the Guild of Handicraft in London in 1886, a practical expression of the arts and crafts movement, with the sole object of 'making useful things, of making them well and of making them beautiful'. He worked in London and at Chipping Campden in Gloucestershire, trying conscientiously to adapt his artistic ideas to a machine age. Silverware and jewellery were of particular interest to him. He wrote a good deal about art education and founded the Essex House Press in 1898, which continued until 1909 (see also under Book Illustrations and Prints, p 25).

BAILLIE-SCOTT, MACKAY HUGH (1865-1945), was an architect who also designed furniture, favouring inlays.

BARLACH, ERNST (1870-1938), was a German sculptor who produced work in bronze and terra-cotta.

BARNSLEY, ERNEST (1863-1926), was a furniture designer of the Cotswold school who used copper and wrought iron for decorating pieces which are otherwise plain and simple.

BARNSLEY, SYDNEY (1865-1926), was Ernest Barnsley's younger brother and also a furniture designer.

BEARDSLEY, AUBREY (1872-1898). See under Book Illustrations and Prints (p 27).

BLOMFIELD, REGINALD (1856-1942), was a furniture designer.

BONNARD, PIERRE (1867-1947), was a French poster artist of the Toulouse-Lautrec school whose work has a distinct left-wing bias. See Abdy, J. *The French Poster from Chéret to Capiello*. 1969.

BRACQUÉMOND, FÉLIX (1833-1914), was an engraver, ceramic designer and decorator who became greatly interested in Japanese art in 1856 as a result, so it is said, of finding some Japanese prints used as wrapping paper.

CHAPLET, ERNEST (1835-1909), of Paris, was a noted potter who developed many new glaze techniques. In the late 1880s he is known to have worked on ceramics with Paul Gauguin. His work may be seen in the Musée des Arts Décoratifs, Paris.

CHARPENTIER, ALEXANDRE (1856-1909), a leading exponent of art nouveau in France, was sculptor, architect, furniture designer, and interior decorator.

CHÉRET, JULES (1836-1933), of Paris, was an artist who, between 1869 and the early 1890s, designed over a thousand posters for the *Folies-Bergères* and other stage performances. See Abdy, J., *The French Poster from Chéret to Capiello*. 1969.

COLENBRANDER, THEODORUS A. C. (1841-1930), was a Dutch artist who used the Javanese batik style on textiles and ceramics. See Madsen, S. T. *Art Nouveau*. 1967. Plate 8.28, p 193.

COLLONA, EUGÈNE, made vases and jewellery for Samuel Bing. *Ibid*. Plate 8.5, p 150.

CRANE, WALTER (1845-1915). See under Book Illustrations and Prints (pp 31-2).

DAMPT, JEAN (1854-1946), was a Paris sculptor and designer of furniture.

DAUM, ANTONIN (1864-1930), and his brother Auguste (1853-1909) were glass-makers who worked with Émile Gallé in Nancy. They were noted for flower decoration, particularly poppies and snowdrops. They usually signed their work. A vase signed DAUM, Nancy, with the cross of Lorraine, the conical body cut and etched with a river landscape in green, mauve, and blue, $4\frac{1}{2}$ in, sold for £45 (A 1969).

De FEURE, GEORGES (1869-1928), started as a painter and then became a poster artist and furniture designer. His work shows extreme elegance and delicacy of touch. See Madsen, S. T. *Art Nouveau*. 1967. Plate 8.2, p 146.

DELAHERCHE, AUGUSTE (1857-1940), was a potter who took over the Paris atelier of Ernest Chaplet, where he developed a glaze in which colours ran to produce vertical decorative bands of fine enamel.

DIJSSELHOF, GERRIT WILLEM (1866-1924), was a Dutch artist whose furniture and interior decoration showed a number of influences—Oriental, Javanese, and English. His work may be seen in the Gemeente Museum in the Hague.

DRESSER, CHRISTOPHER (1834-1904), played an important part in the development of *art nouveau* in Britain both as a designer

and a writer. He was a keen botanist and tried to express the energy of nature in his artistic work.

GAILLARD, EUGÈNE (1862-1933), was a French furniture designer who was closely associated with Samuel Bing.

GALLÉ, ÉMILE (1846-1904), was the key figure in a group of French artists who worked at Nancy. He made furniture in which floral motifs were prominent. His pieces sometimes bear literary quotations and they are usually signed. He is best known, however, for his glass. He started production in 1874 and built up a thriving business which continued after his death until shortly before the First World War. His early glass was ornamented with enamel, then followed a period when he specialised in cased glass with floral designs. Later, with the expansion of his staff, a larger output reflected variations of more standard patterns. His personal work, however, shows the skill of a real master. These pieces are normally signed. Look for the signature within the decoration.

GRASSET, EUGÈNE (1841-1917), started his career as an architect, became interested in Japanese art, and then worked as a book illustrator. He is probaby best known for the posters he designed for opera and theatre performances—for Sarah Bernhardt's *Jeanne d'Arc*, for example. By 1890 his style was pure *art nouveau*. He has been described as 'the medievalist of the period' and also as 'France's Walter Crane'. See Abdy, J. *The French Poster from Chéret to Capiello*. 1969.

GUIMARD, HECTOR (1867-1942), of Paris, was an architect and a leading furniture designer. His pieces give the impression of being cased in muslin like a carcase of frozen beef.

JACK, GEORGE (1855-1932), was William Morris's furniture designer.

KLINGER, MAX (1857-1920), was a sculptor. A bronze statue based on a marble original by this artist, of a naked woman, her hands clasped behind her back, her right foot resting on a tree stump, with the monogram MK, 16 in, sold for £62 (A 1969).

LALIQUE, RENÉ (1860-1945), was a prominent jeweller who worked in London from 1878 to 1880 and started his own business in Paris in 1885. In 1895 he introduced the nude female figure into his designs, often associated with plants or insects. A man's gold ring, the shoulders in the form of nude women in ecstasy, their arms

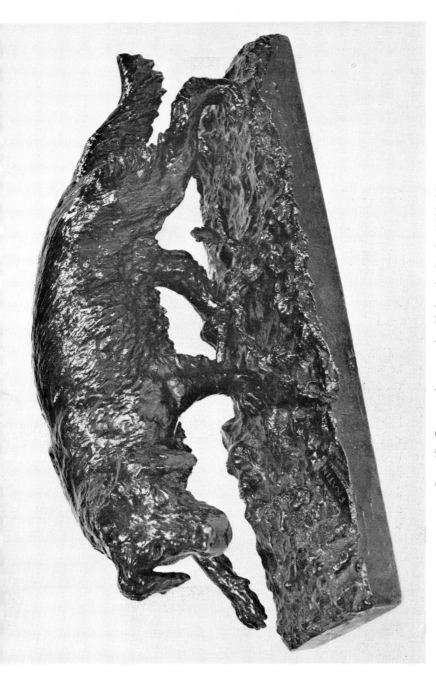

Page 17: Bronze of a setter by Christophe Fratin (1800–64)

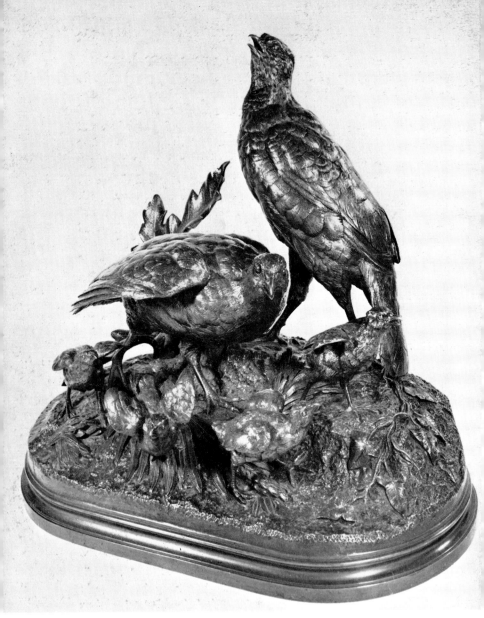

Page 18: Nineteenth-century bronze of partridges with chicks by Alfred Dubucand

supporting a star sapphire, sold for £1,800 (A 1969). Although he
made jewellery, Lalique is probably better known for his glass, but
he did not start working in this field until 1918. A vase engraved
R. Lalique, France, the cloudy, blue-tinged tapering body moulded
with four pairs of nesting budgerigars, 9½ in, sold for £50 (A 1969).
See Gros, G. 'The Case for Lalique' in *Collector's Guide,* Nov, 1968.
pp 68-71.

LARCHE, RAOUL F. (1860-1912), was a sculptor who used the
American dancer Loïe Fuller as a model. A gilt-bronze lamp signed
by this artist, cast in bronze by Siot Decauville of Paris, of Loïe
Fuller with her drapery whipping round her legs and billowing
above her head, concealing two light bulbs, 18¼ in, sold for £600
(A 1969).

LETHABY, WILLIAM A. (1857-1931), was a furniture designer
associated with Kenton & Company, which became the Cotswold
School in 1890.

MACDONALD, FRANCES (1874-1921), was married to Herbert
McNair, and worked with the Glasgow School.

MACDONALD, MARGARET (1865-1933), the elder sister of
Frances, was married to Charles Rennie Mackintosh and also worked
with the Glasgow School.

MACKINTOSH, CHARLES RENNIE (1868-1928), was the
leader of the Glasgow School of *Art Nouveau* artists, which had
a small central group known as the 'Four Macs'—himself, Herbert
McNair (another architect), and their wives, the two Macdonald
sisters. Mackintosh was an architect by profession and designed the
Glasgow School of Art when he was 28 years of age, and also a
number of tearooms for Miss Kate Cranston. These reveal his fond-
ness for white on interior surfaces and show in their decoration the
characteristic egg-shaped forms favoured by the School. His energy
and enthusiasm were remarkable, and he travelled widely in Europe,
where he inspired a number of young architects by his designs.
During World War I he moved to London and designed textiles.
After the war he took to watercolour painting and went to live in
the South of France, where he spent the last five years of his life.
See Honour, H. *Cabinet Makers and Furniture Designers.* 1969.
pp 270-77. Howard, T. *Charles Rennie Mackintosh and the Modern
Movement.* 1952. Macleod, R. *Charles Rennie Mackintosh.* 1968.

B

MACKMURDO, ARTHUR H. (1851-1942), spent a great deal of time in Italy between 1874 and 1882. When he returned, he established the Century Guild and concerned himself with designing textiles and furniture (see plate, p 71), and with book decoration. His design for *Wren's City Churches* (1883) is pure *art nouveau* and is unrelated to the contents of the book.

MAJORELLE, LOUIS (1859-1926), was brought up in Nancy where his father worked as a cabinet maker. Louis became one of the great *art-nouveau* furniture designers of the 1890s and until World War I. He produced furniture in a factory in Nancy where he used machinery but only for the sake of efficiency : he never allowed his methods to detract from a high-quality product. See Honour, H. *Cabinet Makers and Furniture Designers*, 1969. pp 259-63.

MARKS, GILBERT, was a silversmith who freely used floral designs on his work.

MARRIOTT, FREDERICK, was an artist whose significant work was done after 1900. A pair of his panels in mother-of-pearl, tempera, gilt gesso, and opals, made in 1903-5, sold for £1,900 (A 1968).

MEUNIER, CONSTANTIN (1831-1905), was a painter and poster artist who became a sculptor in the 1880s. He is known for forceful work showing the workmen of Le Borinage. A bronze statue of a kneeling miner, a pick in his right hand, one of about eight reproductions taken from a statue shown at Samuel Bing's *Exhibition of Art Nouveau* at the Grafton Galleries in 1899, $10\frac{1}{2}$ in, sold for £85 (A 1969).

MORGAN, de, WILLIAM FREND (1839-1917). See pp 198-9.

MORRIS, WILLIAM (1836-96), was born at Walthamstow. His views and work had a profound effect on English design and decoration. In 1863 he set up an establishment for making wallpapers, tiles, stained glass, and other decorative household appointments, and in 1891 founded the Kelmscott Press. Although his work is usually associated with the Arts and Crafts Movement, many of his designs especially towards the end of his life, have a close affinity with *art nouveau*, which certainly owed a great deal to him.

MUCHA, ALPHONSE (1860-1933), was a Czechoslovak. He spent many years in Paris where he worked as a poster artist in

the *art nouveau* style. Most of his work was done in the 1890s. In 1903 he went to the USA, where he lived until 1909. A signed watercolour by Mucha of a design for printed velvet showing a flaxen-haired beauty within a bower of flowers, c1900, sold for £250 (A 1969). See Abdy, J. *The French Poster from Chéret to Capiello*. 1969.

NEATBY, WILLIAM JAMES (1860-1910), is best known for ceramic tiles. An example of his work may be seen at Harrods in London.

PROUVÉ, VICTOR (1858-1943), worked closely with Émile Gallé at Nancy and managed the glassworks for some years after Gallé's death in 1904.

RICKETTS, CHARLES, RA (1866-1931), was born in Geneva. He was an illustrator and founded the Vale Press. See also pp 43-4 and p 57.

SERRURIER-BOVY, GUSTAVE (1858-1910), was a Belgian designer who was influential in making the English Arts and Crafts style known in Europe. He was a first-class *art nouveau* furniture designer.

TIFFANY, LOUIS COMFORT (1848-1933), was a painter but when he was thirty he founded a company bearing his name to develop the decorative arts, particularly glass. He started by producing stained-glass windows. Then he turned to blown glass and by 1892 the original organisation was renamed the Tiffany Glass & Decorating Company. From 1896 to 1900 his hand-blown *Favrile Glass* became famous. In 1900 the firm changed its name and function again to become Tiffany Studios. Tiffany dragonfly lamps have sold for as much as £1,600 (A 1969). See Amaya, M. *Tiffany Glass*, 1968; Koch, R. *Tiffany Coloured Glass*, 1964; Tiffany, L. *The Art Work of Louis Tiffany*. New York, 1914.

TOULOUSE-LAUTREC, HENRI de (1864-1901), is best known as a French poster artist who did his finest work in the 1890s. A poster of *Jane Avril*, the Moulin Rouge dancer who modelled for him, sold for £2,100 (A 1969). The original pencil and watercolour drawing for his *Vache Enragée* poster sold for £7,800 (A 1966). See Abdy, J. *The French Poster from Chéret to Capiello*. 1969; Fermigier, A. *Toulouse-Lautrec*. 1969; Perruchot, H. (trans by H. Hare) *Toulouse-Lautrec, a Definitive Biography*. 1960.

VELDE, HENRY van de (1863-1957), was a Belgian artist who was born in Antwerp. He turned his hand to painting, illustration, interior decoration, and designs for metalwork and furniture, establishing workshops to produce furniture and metalwork at Ixelles, near Brussels. Van de Velde was a leading figure in the *art nouveau* movement, largely, perhaps, because he was a prolific writer on the theory of art. In 1899 he left Belgium. See Honour, H. *Cabinet Makers and Furniture Designers*. 1969. pp 264-9.

VOYSEY, CHARLES F. ANNESLEY (1857-1941), was an architect who did a good deal of designing. He produced floral designs for textiles and wallpaper and in 1893 started to design furniture. His pieces show a simple elegance in oak; the more intricate designs are on the decorative metalwork they carried—eg brass hinges and other fittings.

WOLFERS, PHILIPPE (1858-1929), was a noted Belgian sculptor by profession who became a jewellery designer and entered his father's gold and silversmiths' firm. A pendant jewel signed by Wolfers, made in 1901, sold for £3,000 (A 1969). See Wolfers, M. *Philippe Wolfers*. 1965.

BOOKS TO CONSULT

Amaya, M. *Art Nouveau*. London and New York, 1966
Barelli, R. *Art Nouveau*. London, 1969
Battersby, M. *The World of Art Nouveau*. London, 1968. New York, 1969.
Grover, R. *Art Nouveau Glass*. Rutland, Vermont, 1967
Madsen, S. T. *Art Nouveau*. London and New York, 1967
Rheims, M. *The Age of Art Nouveau*. London and New York (as *The Flowering of Art Nouveau*), 1966
Schmützler, R. *Art Nouveau*. New York, 1964

2

BOOK ILLUSTRATIONS
AND PRINTS

THE fine art of book illustration may be said to have been born late in the eighteenth century when Thomas Bewick first combined the skills of artist and engraver to produce those superb little pictures of country scenes and wild life, reproduced from wood blocks, which add so much charm to the pages of *The General History of Quadrupeds* and *The History of British Birds*. These became the roots of a tree that grew and flourished, and which flowered freely in the 1860s and again in the 1890s, the two great periods of English book illustration. In America, curiously enough, it was also a naturalist who first produced an illustrated book of superb quality. John James Audubon's *The Birds of America*, which came out in four volumes between 1827 and 1838, is a monument to a man who was not only a naturalist but a fine painter and writer.

Until the advent of photography the artist had great status, but he was very much in the hands of the engraver who prepared his work for the presses. Sometimes he combined both functions, and sometimes he drew directly on a wood block, but usually the engraver took his drawing and, after finishing the engraving, destroyed the original work—particularly if he had done a poor job.

By the 1890s things had changed. Reproduction techniques had improved and there was, in general, a closer liaison between author or editor, and artist and engraver : the production of an illustrated book was often the result of long and serious conference. These books, some illustrated with line drawings and others with coloured plates by such artists as Rackham and Dulac, are now keenly sought by collectors.

Some book illustrations by noted artists were published separately as prints, usually enlarged in special and limited editions, often signed. The following list contains the names of artists whose work has an individual quality and deserves to be preserved. A date shown in brackets after the title of a book is the publication date of the edition illustrated by the artist under consideration.

23

ABBEY, EDWIN AUSTIN (1852-1911), was born in Philadelphia and worked in England, mainly for *Harper's* and other American magazines. His delicate drawings were used to illustrate a number of books including *Herrick's Poems* (1882). He collaborated with Alfred Parsons in the illustration of *The Quiet Life* (1890). Abbey was a master of pen drawing and could suggest light and shade with the subtlety of a watercolour artist.

AGAR, JOHN SAMUEL (w 1790-1830), a well-known engraver who worked mainly in stipple, was, for a time, President of the Society of Engravers.

ALDIN, CECIL CHARLES WINDSOR (1870-1935), made drawings mainly of dogs, horses, country inns, and hunting scenes. He illustrated *Kipling's Jungle Book* (1894-5), *A Dog Day* (1902), *Old Inns* (1921), etc. He was also an author: he wrote and illustrated *Ratcatcher to Scarlet* (1926), *Dogs of Character* (1927), and *The Romance of the Road* (1928).

ALKEN, HENRY (1784-1851), was born in London. His father, whose name was Seffrien, had been employed by the Danish Court in Copenhagen but had been forced to leave Denmark (c 1772) with his brother Samuel because they had become involved in a political plot. They moved to London, changing the family name to Alken, after a small Danish village in North Jutland. His son, Henry, was born in 1784. Henry's uncle was an aquatint engraver of country scenes and it seems certain that the boy was stimulated to follow in his uncle's footsteps. He developed a keen interest in horses, hounds, and the hunt, and soon began to produce engravings which were keenly sought after by print-sellers and publishers. They were lively and realistic, mainly in colour. He illustrated many books with coloured plates, among them his own *The Beauties and Defects in the Figure of the Horse* (1816). Others include *National Sports of Great Britain* (1821), *Sporting Scrapbook* (1824), *Shakespeare's Seven Ages* (1824), *Don Quixote* (1831) and *Jaunts and Jollities* (1837). He also wrote a book on *The Art and Practice of Etching* (1849).

It should be noted that Henry Alken had three sons; one of them, Henry Gordon Alken (1810-92) painted in his father's manner and copied his pictures, using the name of Henry Alken or the initials H.A. He lacked his father's touch and his colours do not match those of the originals. It is, however, necessary to make a close

study of Alken prints in order to be able to distinguish between the originals by Henry Alken Snr and the copies made by his son. See Sparrow, H. S. *British Sporting Artists.* 1922 (1965). Chapter 9.

ALKEN, SAMUEL (c1750-c1825), Henry Alken's uncle, was an aquatint engraver of topographical scenes, especially of the Lake District and North Wales.

ALLEN, DAVID (1744-96), was a Scottish artist who designed and engraved plates for an illustrated edition of Allan Ramsay's *The Gentle Shepherd*, published in 1788, and other books relating to Scotland.

ANDERSON, ALEXANDER (1775-1870), was the first American wood engraver. He based his style on that of Thomas Bewick.

ANGUS, WILLIAM (1752-1821), was designer and engraver of topographical scenes, particularly of historic houses.

ARCHER, JOHN WYKEHAM (1808-64), was born in Newcastle. At an early age he moved to Edinburgh. Finally he settled in London and worked in the studio of W. and E. Finden, engraving steel plates. He is known particularly for his drawings of old buildings in Northumberland, Edinburgh, and London, and published a book called *Vestiges of Old London*.

ARMOUR, GEORGE DENHOLM (1864-1949), contributed to many magazines—*Punch, The Graphic, Sporting and Dramatic News, The Unicorn, Windsor Magazine*, etc. He later illustrated books with fine chalk and watercolour drawings of hunting scenes, eg Lord Willoughby de Broke's *The Sport of our Ancestors* (1921) and Isaac Bell's *Foxiana* (1929), and he wrote and illustrated several humorous books, including *Humour in the Hunting Field* (1928).

ASHBEE, CHARLES ROBERT (1863-1942), architect, designer, and illustrator, was greatly influenced by the ideas of William Morris and John Ruskin, and founded the Essex House Press, which flourished between 1898 and 1910. Some *art nouveau* influence is seen in its productions; one was *The Psalter* (1901), and over a dozen books by Ashbee himself, including *An Endeavour towards the Teaching of John Ruskin* (1901), *Echoes from the City of the Sun* (1905), and *The Private Press: a Study in Idealism* (1909). See Franklin, C. *The Private Presses.* 1969. pp 64-80.

AUDUBON, JOHN JAMES (1785-1851), was an American ornithologist who made watercolour drawings of American birds in

their natural surroundings. These were mainly engraved by Robert Havell, Jr in London, to illustrate *The Birds of America*, which was published in 80 instalments, from 1827 to 1838. In all there are 435 hand-coloured aquatints in four bound volumes, generally known as 'Audubon prints'. A fine copy of *The Birds of America* sold for £90,000 (A 1969). A lithograph folio of *The Birds of America* by J. Bien was produced in 1860.

BARNARD, FRED (1846-1896), was an illustrator of magazines over a long period. He first contributed to *Punch* in 1863 and he did line drawings for the serial in the *Illustrated London News*. In the 1870s he sketched for *Fun* and *Judy* and in the 1890s for *Chums*. He illustrated the *Household Edition of Dickens* (1871-9).

BARTLETT, WILLIAM HENRY (1809-54), was a landscape painter who provided the illustrations for books on English cathedrals and cities. He travelled widely in Europe and the Near East and made four visits to America between 1836 and 1852. Many publications resulted from his journeys and are keenly sought after today, particularly the books on Canadian and American scenery.

BARTOLOZZI, FRANCESCO (1725-1815), was born in Florence. He was a prolific etcher and engraver, who settled in London in 1764, and became a founder member of the Royal Academy. He used both line and stipple (after 1770) and his work was printed in black, brown, and red. In 1805 he went to take charge of a school of engravers in Lisbon where he lived until he died. See Tuer. *Bartolozzi and his Works*. 1882. 2 vols.

BAXTER, GEORGE (1804-67), born at Lewes, the son of a printer John Baxter, was himself printer, publisher, artist, and inventor. He worked mainly in London and is best known for the invention of colour printing and for some 300 coloured prints he issued between 1835 and 1860 from 11 and 12 Northampton Square. He patented a process which involved making a wood or metal block for each colour impression in addition to a steel plate engraving. As many as 14 blocks were used for a colour print of Rubens' *Descent from the Cross* which he printed in 1857. His prints were published on stamped mounts, or on mounts with lettering or red seals. Occasionally they were without mounts at all and some were printed for book illustration. A number of other printers obtained licences to use the Baxter process while his patent was in force : they included Abraham Le Blond, Vincent Brooks, Brad-

shaw and Blacklock, William Dicker, Kronheim & Co, George Cargill Leighton, Joseph Mansell, and Myers & Co. Le Blond and Brooks used Baxter's plates but Le Blond replaced Baxter's name by his own and his prints are now known as 'Le Blond prints'. Baxter's career ended in bankruptcy. His prints may be seen in the Print Room of the V & A. See Clarke, H. G. *Baxter Colour Prints: Their History and Production.* 1919; *The Centenary Baxter Book.* 1936; Lewis, Courtney T. *George Baxter: His Life and Work,* 1908; *The Picture Printer of the Nineteenth Century—George Baxter.* 1924.

BEARDSLEY, AUBREY (1872-1898), started drawing at a very early age and became the most brilliant illustrator of the 1890s. He specialised in grotesque black and white drawings and developed a highly individual style in which much use was made of curving lines and the spaces enclosed by them. He was influenced by the pre-Raphaelites and also by Japanese art. His first commission was to illustrate Malory's *Morte d'Arthur,* published by J. M. Dent in 1892. The following year he illustrated *Salome.* From 1894 to 1895 he was Art Editor of *The Yellow Book* (four issues) and in 1896 did the drawings for *The Rape of the Lock.* See Burdet, D. *The Beardsley Period.* 1925; Walker, R. A. (intro). *The Best of Beardsley.* 1948 (1967).

BEERBOHM, MAX (1872-1956), was an author and caricaturist who did pen drawings of well-known people for a number of magazines in the 1890s. Some of these were published in book form as *Caricatures of Twenty Five Gentlemen* (1896); *The Poets Corner* (1904); *Rossetti and his Circle* (1922); and *Observations* (1925).

BENNETT, W. J. (1787-1844), was born in England and emigrated to America in 1816. He was an artist and engraver noted particularly for his aquatints, *Views of American Cities* (1836-38).

BEWICK, THOMAS (1753-1828), was born at Cherryburn Farm in Eltringham on the banks of the Tyne. He started to draw at an early age and when he was fourteen he was sent as an apprentice to Ralph Beilby, a copperplate engraver of St Nicholas Churchyard, Newcastle. He soon became what we should call a commercial artist, designing and engraving trade cards and billheads. In 1768 he started wood-engraving. Bewick's apprenticeship ended in 1774 and in 1776 he went to London but only for a few months. When he returned, he became Ralph Beilby's partner. He had always been

a keen observer and lover of nature and he began to sketch and engrave the illustrations for books—*Gay's Fables* (1779), *Select Fables* (1784), and his *History of Quadrupeds* (1790). This fully established his reputation and he went on to produce his *History of British Birds* (1797-1804) in two volumes. His work is accurate and powerful, yet it somehow reveals an understanding and love of nature that few other artists have displayed. *The Fables of Aesop the Slave* (1818) was his last major achievement. In this he was assisted by other engravers, including his son, Robert Ellcott Bewick (1788-1849), who had become his partner in 1812. A *History of Fishes* was unfinished when Bewick died. He left an autobiography— a *Memoir of Thomas Bewick, Written by Himself* but this was not published until 1862. See also Cirker, A (Ed). *1800 Woodcuts by Thomas Bewick and his School*. 1969; Dobson, A. *Thomas Bewick and his Pupils*. 1889; Stone, R. *Wood Engravings of Thomas Bewick*. 1953; Weekley, M. *Thomas Bewick* (1953).

BIRCH, THOMAS (1779-1851), was an artist who worked for some years with his father, William Birch (q.v.) in Philadelphia. He was later responsible for a number of naval pictures of the war of 1812.

BIRCH, WILLIAM (1755-1834), was an engraver who left England with his son, Thomas, in 1794 and settled in Philadelphia. Together they produced *Views of Philadelphia* in 1800 and eight years later issued a series of views of country houses.

BLAKE, WILLIAM (1757-1827), earned his living as an engraver but found time to write and to illustrate his own books. He regarded these as an entity : his visionary writing and vigorous flowing designs were interwoven. His work is highly imaginative and his techniques of expression greatly influenced the Pre-Raphaelites and later the *Art Nouveau* movement. Blake's engravings in his books were coloured by hand. He published *Songs of Innocence* (1789), *Songs of Experience* (1794), and a number of *Prophetic Books—The Book of Thel* (1789), *The Marriage of Heaven and Hell* (1791), *The French Revolution* (1791), *The Song of Los* (1795), and many others. His work may be seen in the BM, Tate, V & A, and the art galleries of Aberdeen and Manchester. See Blunt, Sir Anthony. *The Art of William Blake*. 1959; Bronowski, J. *William Blake*. 1943; Lister, R. *William Blake*. 1968; Wilson, M. *The Life of William Blake*. 1927.

BODNER, KARL, was a Swiss artist who illustrated Maximillian of Weid's *Travels in the Interior of North America* (1840). The engravings were printed by Ackermann of London.

BRANGWYN, SIR FRANK, RA (1867-1956), was born in Bruges, of Welsh extraction. He is perhaps best known for his large mural decorations, but was also a prolific contributor of etchings, lithographs, and woodcuts for magazines, eg *The Graphic, The Idler, Pall Mall*, etc, and he also illustrated books—Robert Leighton's *The Wreck of the Golden Fleece* (1893), Michael Scott's *The Cruise of the Midge* (1894), and S. R. Crockett's *Tales of our Coast* (1896). He was particularly at home sketching ships and sailors. Much of his work is to been seen in Bruges Museum.

BROCK, CHARLES EDMUND (1870-1938), was an illustrator who worked for *The Graphic, The Quiver*, and *Good Words*, and illustrated many books, including *Gulliver's Travels* (1894), *Westward-Ho!* (1891), *Robinson Crusoe* (1898), *The Vicar of Wakefield* (1898), *The Pilgrim's Progress* (1900), *Penelope's English Experiences* (1900) and *Essays of Elia* (1903).

BROCK, HENRY MATHEW (1875-1960), brother of C. E. Brock, and probably the better artist, contributed to the same magazines and also illustrated books—*Cranford* (1897), *Waverley* (1898), and novels by Captain Marryat and J. Fenimore Cooper.

BROWNE, GORDON FREDERICK (1858-1932), the son of Hablot Browne, was a prolific worker. He illustrated many books, including *The Red Grange* (1892), *Island Nights Entertainments* (1893), and *Grimm's Fairy Tales*. He also illustrated a number of children's books by Juliana Horatio Ewing.

BROWNE, HABLOT KNIGHT (1815-1882), was born in London. He was apprenticed to a line-engraver but concentrated on etching and watercolour drawings. In 1833 he was awarded a medal by the Society of Arts for an etching of John Gilpin, and in 1836 did some illustrations for *Pickwick Papers*. His pseudonym was 'Phiz' and he built up a remarkable reputation with his designs for other works by Dickens—*Nicholas Nickelby* (1838-9), *The Old Curiosity Shop* (1840-41), *Martin Chuzzlewit* (1843), *Dombey and Son* (1848), *David Copperfield* (1849-50), *Bleak House* (1852-3), *Little Dorrit* (1856-7), and *A Tale of Two Cities* (1859). He also did some illustrations for Harrison Ainsworth's novels. In 1867 he fell

ill with paralysis. See Kitton, E. G. *Phiz, a Memoir.* 1882; Thomson, D. C. *The Life and Labours of H. K. Browne.* 1884.

BURNE-JONES, SIR EDWARD (1833-98), was born of Welsh ancestry in Birmingham. As a designer, Burne-Jones was greatly influenced by William Blake (qv). He became very friendly with William Morris when both were at Exeter College, Oxford. He is known mainly as a painter but illustrated some books, including the title-page for the *Works of Geoffrey Chaucer* for the Kelmscott Press in 1896. See Bell, M. *Sir Edward Burne-Jones.* 1902; Burne-Jones G. *Memorials of Edward Burne-Jones.* 1904.

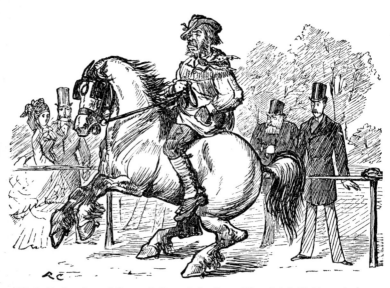

'Hyde Park—Out of Season.' One of the first of Randolph Caldecott's drawings for *London Society* in 1870. It shows his feeling for animals and a fine sense of humour, in this instance directed at the fashionable aristocracy.

CALDECOTT, RANDOLPH (1846-86), was born in Chester and educated at King's College, where he became head boy. He then worked as a bank clerk in Whitchurch, Shropshire, and later in Manchester until he was 26 years of age. Meanwhile, he did some work for illustrated papers such as *London Society*. He loved the countryside and spent much time among farmers and their animals, always sketching with a fine sense of humour. In 1872 he moved to London and was soon contributing to *Punch*. In that

year he also illustrated a book by Henry Blackburn, *The Harz Mountains: a Tour in the Toy Country.* Then followed work for the *Daily Graphic* and the *Pictorial World.* Some of these drawings were later published in book form in *Last Graphic Pictures* (1888) and *Gleanings from the Graphic* (1889). Book illustration took up much of his time. He illustrated Washington Irving's *Old Christmas* (1876) and *Bracebridge Hall* (1877), F. Locker Lampson's poems, and a series of sixteen children's *Picture Books* in colour (1878-85). Caldecott's health deteriorated in the 1880s and he spent much time abroad. He eventually died in Florida in 1886. See Blackburn, H. *Randolph Caldecott.* 1886.

CATESBY, MARK (1679-1749), was an English naturalist who drew and engraved the earliest of all American bird prints for the two volumes of *Natural History of the Carolinas, Florida and the Bahama Islands.* (London, 1723-43).

CATHERWOOD, FREDERICK (1799-1854), did the drawings for John Stephens' *Incidents of Travel in Central America, Chiapas and Yucatan* (1841).

CATLIN, GEORGE (1796-1872), travelled widely in the western parts of America, studying the Indians and their life. He was the artist for the lithographs in *North American Indian Portfolio* (London, 1844) and *Osceola,* a life portrait of an Indian.

CATTERMOLE, GEORGE (1800-68), was an illustrator who provided drawings for some of Dickens' books, including *Master Humphrey's Clock.* Many of his sketches depict Victorian Gothic furniture.

COBDEN-SANDERSON, T. J. (1840-1922), was a disciple of William Morris and founder of the Doves Press (1900-16). See Franklin, C. *The Private Presses.* 1969.

CRANE, WALTER (1845-1915), was born in Liverpool, the son of a portrait painter, Thomas Crane (1808-59). He was trained as an artist and designer, and was apprenticed to W. J. Lintot, a wood engraver. He was a great admirer of the pre-Raphaelites and by the time he was 25 years of age his own style was emerging. In the 1870s he designed nursery wallpapers with floral patterns involving long curving lines, the beginning of *art nouveau.* He is probably best known for his book designs and illustrations. He was particularly interested in children's books and designed and illustrated

several books himself—*Toy-books* (1869-75), *The Baby's Opera* (1877), *The Siren's Three* (1885), and *Renascence* (1891). Other books which are collected for his illustrations are *Mother Hubbard, Flora's Feast,* and *Grimm's Fairy Tales.* Crane was art director to the City of Manchester (1893-96), to Reading College (1898), and Principal of the Royal College of Art, South Kensington (1898-99). He wrote about art as a critic and expressed his views in the book *Line and Form* (1900). See Konody, G. *The Art of Walter Crane*; Masse, G. *Bibliography of Walter Crane* (1923).

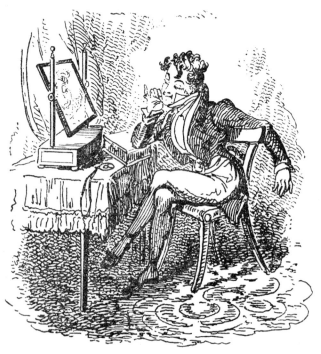

'Self Love.' George Cruikshank, as a keen observer of people, understood the emotions and motives behind their behaviour.

CRUIKSHANK, GEORGE (1792-1878), whose parents were Scots, was born in London. His father was a caricaturist and his two sons no doubt learned something of the art from him. When the father died in 1811, George and his brother Isaac continued the business, which consisted mainly of 'hack' work, sketching for cheap

books, song sheets, lottery tickets, etc. George loved adventure, was
a skilful boxer and a keen observer of the London scene in fairs,
taverns, markets, and the street. He had a tremendous output and
illustrated many books as well as contributing amusing etchings to
the *Humorist* (1819-21) and *Points of Humour* (1823-4). He illus-
trated Dickens' *Oliver Twist* (1837-9) and Ainsworth's *Jack Sheppard*
(1839), *Tower of London* (1840), *Guy Fawkes* (1842), and *Windsor
Castle* (1843). In 1840 he espoused the temperance cause and pro-
duced eight plates depicting the tragedy of a family as the result
of addiction to drink; they were published under the title *The Bottle*
(1847). Cruikshank was a keen watercolourist and in his later years
spent much time painting in oils. He exhibited at the Royal
Academy. His work may be seen in the BM, National Gallery, and
the V & A. There are collections of his sketches, such as *Four Hun-
dred Humorous Illustrations*, and a number of biographies. See
McLean, R. *George Cruikshank*. 1948.

CURRIER, NATHANIEL, founded a New York lithographic
firm in 1833. James M. Ives joined the firm in 1857 which became
Currier and Ives. They published circus posters and prints of sport-
ing subjects. Collectors are particularly interested in Barnum's
Gallery of Wonders.

DALZIEL, THE BROTHERS, GEORGE (1815-1903) and
EDWARD (1817-1905). It is justifiable in this case to deal with
two men under one heading for they worked together for fifty
years. With a third brother, Thomas, they established a thriving
business as wood engravers under the name of 'Brothers Dalziel'.
In mid-Victorian times they produced many books at the Camden
Press, which they owned. In 1870 they bought the magazine *Fun*
and they also produced *Tom Hood's Comic Annual* (Tom Hood
was the editor of *Fun* when the Dalziels took it over). From 1872 to
1888 they published *Judy*. See Dalziel, G. and E. *Brothers Dalziel:
A Record of Work. 1840-90*. 1901.

DORÉ, GUSTAV (1833-83), was born in Strasbourg. He was a
painter and book illustrator and between 1855 and 1870 built up
a connection which earned him about a quarter of a million pounds.
He is known today for his illustrations for *Dante's Inferno* (1861),
Don Quixote (1863), *Fairy Realm* (1865), *The Bible* (1865-6), *Para-
dise Lost* (1866), *Idylls of the King* (1867-8), *La Fontaine's Fables*
(1867), and *The Rime of the Ancient Mariner* (1877). He also

painted a number of religious pictures in oils. See Tromp, E. *Gustav Doré.* 1932.

DOYLE, JOHN (1797-1868), was a well-known caricaturist who signed himself 'H.B.'

DOYLE, RICHARD (1824-83), John Doyle's son, was born in London and learnt his craft as a caricaturist from his father. In 1843 he started to work for *Punch,* for which he designed the cover. One of his main contributions was a series of sketches called *Ye Manners and Customs of Ye Englishe*, which were later published as a collection. He was a Catholic and in 1850 left *Punch* because of criticism of the Catholic Church. He then took to book illustration. Among the books he illustrated were *The Newcomes, Scouring of the White Horse, Jar of Honey, King of the Golden River.* He was particularly skilful at drawing fairies and did some delightful illustrations for children's books, including William Allingham's *In Fairyland* (1870). An original drawing of a Doyle fairy picture sold for £525 (A 1969).

DULAC, EDMUND (1882-1953), produced many fine colour illustrations with an oriental flavour. *Stories from the Arabian Nights* (retold by Laurence Housman) is a good example. Other books illustrated by Dulac include *Dreamer of Dreams, Stealers of Light, Sinbad the Sailor, Kingdom of the Pearl, Treasure Island, Rubáiyát of Omar Khayyám*, and *Sleeping Beauty.* He also did black and white illustrations for Helen Beauclerk's *The Green Lacquer Pavilion* (1925).

DU MAURIER, GEORGE LOUIS PALMELLA BUSSON (1834-96), was the grandson of a Paris glass-maker who fled to England in 1789 to escape from the police. He took the name of Du Maurier, thinking he might be taken for a refugee aristocrat. His son married an Englishwoman in Paris, and their son George studied painting there. Young George finally settled in England where he soon gained a reputation as an illustrator. He contributed to *Once a Week* and the *Cornhill Magazine* and made sketches for new editions of Thackeray's *Esmond* and Foxe's *Book of Martyrs.* The loss of an eye in 1859 forced him to restrict himself to drawing in black and white. He suffered much poverty until, in 1864, he succeeded John Leech on the staff of *Punch.* His work mainly reflects the foibles of the aristocracy and well-to-do and he created several popular characters—Sir Gorgius Midas, Mrs Ponsonby de Tomkyns,

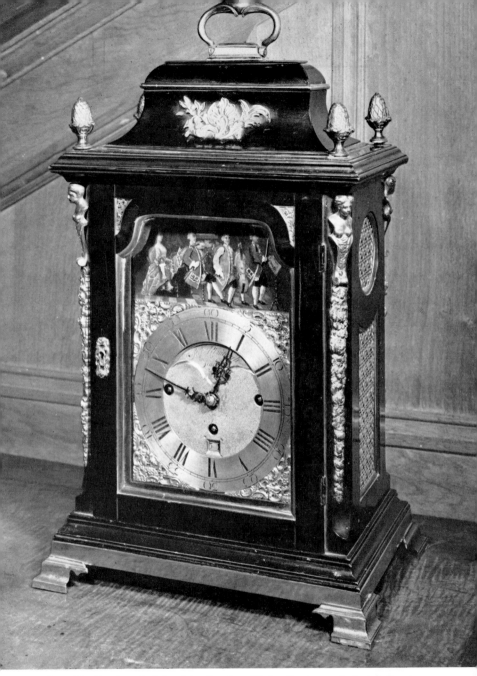

Page 35: Bracket clock by John Stephen Rimbault who worked at 7 Great
St Andrew's Street, London, from 1760 to 1781. The dial is surmounted by
a painted panel of figures in contemporary dress playing musical instruments.
The ebonised pearwood case is surmounted by brass finials

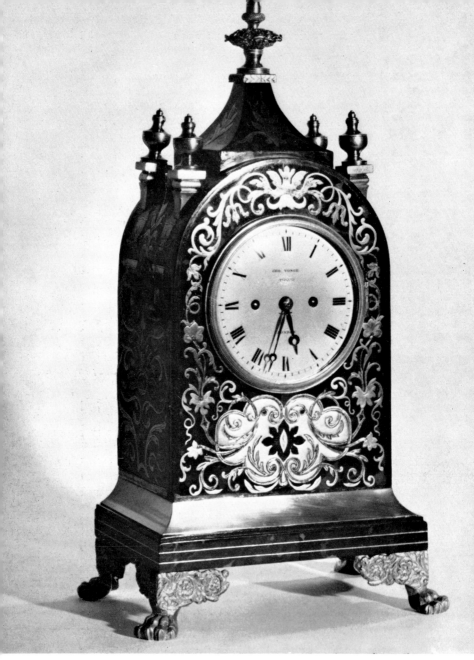

Page 36 : A late eighteenth-century tortoiseshell and brass bracket clock by
George Yonge of 31 Strand, London

and the Cimabue Browns. In later years the quality of his work declined, partly perhaps because he became more interested in the pen, for he wrote and illustrated three popular books—*Peter Ibbetson* (1891), *Trilby* (1894), and *The Martian* (1896). See Whiteley, *George Du Maurier*. 1948; Ormond, L. *George Du Maurier*. 1969.

FINDEN, WILLIAM (1787-1852), was an engraver who worked with his younger brother, Edward Francis Finden (1792-1857), with many assistants to illustrate works by Lord Byron, George Crabbe, and Thomas Moore. His *Landscape Illustrations to the Life and Works of Lord Byron* (1831-4) is noteworthy and the plate of Lord Byron at the age of nineteen (after G. Saunders), done by William Finden himself, is a fine example of his work.

FOSTER, BIRKETT (1825-99), was born in North Shields but was taken to London in 1831. He started to draw at an early age and before he was 21 had made many sketches of rural scenes for wood engravings, mainly for the *Illustrated London News*. He illustrated many books of poems with countryside scenes. His *Pictures of English Landscape* (1862) is typical of his work. He became a member of the Water Colour Society in 1861. See Cundall, H. M. *Birkett Foster*. 1906.

FURNISS, HARRY (1854-1925), was born at Wexford in 1854. He moved to London in 1873 and from 1880 to 1894 worked for *Punch* as a caricaturist, producing sketches that were hard-hitting but had a great sense of fun. He published *Confessions of a Caricaturist* in 1900.

GILBERT, SIR JOHN, RA (1817-97), was born at Blackheath, London. He was a painter in oil and watercolours who became one of the pioneers of illustrated journalism in the 1860s when he was noted for his contributions to the *Illustrated London News*. He illustrated editions of *Don Quixote*, *The Works of Shakespeare*, in 3 volumes (1856), and books by Sir Walter Scott.

GILLRAY, JAMES (1757-1815), was born in Chelsea and became a prolific caricaturist. His work is vigorous, satirical, and sometimes almost vulgar. He aimed his wit at George III, the politicians of the day, the French and particularly Napoleon. Four years before his death he became insane. See Grego, J. *The Works of James Gillray*. 1873; Thomber, H. *James Gillray*. 1891.

GREENAWAY, KATHERINE (1846-1901), better known as Kate Greenaway, was the daughter of a wood engraver. She started

c

to make drawings for Christmas cards while still at school in Clerk-enwell, London, her father engraved them and they were sold to publishers. She held her first exhibition in 1868 and later devoted much of her time to book illustration. She specialised in depicting children in the costume of an earlier period, with bonnets, frilled dresses, and ribbons : these coloured sketches are full of charm and humanity. From 1879 to 1890 she contributed the colour frontis-piece to *The Girls' Own Paper* and she illustrated such books as *Mother Goose* (1881) and *The Language of Flowers* (1884). She illustrated fourteen annual Almanacks between 1883 and 1897 and did many designs for Christmas cards, most of which she signed 'K.G.' A list is given in George Buday's *The History of the Christ-mas Card*. 1954 (1965), pp 227-9. See also Spielmann, M. H. and Layard, G. S. *Kate Greenaway*. 1905.

GRIEFFENHAGEN, MAURICE. (w c1890-c1900), was a pro-lific contributor to such magazines as *Pall Mall*, *The Windsor*, and *Judy*. He was equally at home with pen or wash drawings. He con-tributed drawings to illustrate such books as Rider Haggard's *Allan's Wife*.

HAMMOND, CHRIS (w c1880-c1900), was one of the most prolific story illustrators of the 1880s and 1890s. She contributed pen drawings to many magazines—the *Illustrated London News*, *Pall Mall Budget*, *Good Words*, *Cassell's Family Magazine*, and many others. She also illustrated books by Maria Edgeworth in Mac-millan's Illustrated Standard Novels, and for George Allen she made drawings for *Goldsmith's Comedies* (1896), and Jane Austen's *Emma* (1898) and *Sense and Sensibility*, among others.

HAMMOND, GERTRUDE DEMAIN (d 1952), Chris Ham-mond's sister, was also a story illustrator, using wash, pen, and pencil drawings, and contributing to *The Lady's Pictorial*, *The Queen*, *Madame*, *The Quiver*, and *The Minster*. Her book illustrations were mainly in wash but she did some colour drawings for Blackie & Son's school books.

HASSALL, JOHN (1868-1948), was a regular contributor to illustrated magazines in the 1890s and provided colour plates for a number of books such as H. A. Spurr's *A Cockney in Arcadia*.

HATHERELL, WILLIAM (1855-1928), specialised in wash drawings and illustrated a few books in colour, including J. M.

Barrie's *Sentimental Tommy* (1897) and R. L. Stevenson's *Island Nights' Entertainments* (1893).

HAVELL, ROBERT, JR (1793-1878), a painter and engraver, was responsible for most of the aquatints in Audubon's *Birds of America* (1827-38) and for the illustrations for *New York from North River* (1840) and *New York from East River* (1844).

HOUGHTON, ARTHUR BOYD (1836-75), illustrated books with drawings that made use of plain surfaces of white at a time when most illustrators were filling every inch of the page. Laurence Housman edited a book of his work which was published in 1896.

HOUSMAN, LAURENCE (1865-1959), is best known for his literary work but was a very fine illustrator. He made sketches for several of his own books—*A Farm in Fairyland* (1894) and *Imitation of Christ* (1898), and also illustrated Christina Rossetti's *Goblin Market* (1893) and Jane Barlow's *The End of Elfin Town* (1894). See Taylor, J. R. *The Art Nouveau Book in Britain*. 1966, pp 104-12.

KEENE, CHARLES (1823-91), born at Hornsey in London, considered both architecture and law as possible careers. He trained, however, with a wood engraver and from 1851 until 1890 worked for *Punch*. His cartoons reflect middle-class life, especially tradespeople. He was one of the finest draughtsmen *Punch* ever employed. Joseph Crawhall, the painter, was a friend and gave him ideas for many of his best cartoons.

KING, JESSIE M. (1876-1948), born in Glasgow, studied at the Glasgow School of Art and won a scholarship which took her to France and Italy. When she returned, she started work as an illustrator in the *art nouveau* style; she also painted murals in schools. In 1902 she won a Gold Medal at the Turin International Exhibition of Modern Decorative Art. Jessie King was completely responsible for the design and illustrations of William Morris's *The Defence of Guinevere* (1904) and Oscar Wilde's *A House of Pomegranates* (1915). She wrote and illustrated her own children's book *Little White Town of Never Weary* (1917). See Taylor, J. R. *The Art Nouveau Book in Britain*. 1966.

LEAR, EDWARD (1812-88), was born in London, the twentieth child of a middle-class family. He was primarily a painter though he is better known for his illustrated books, particularly his children's *Book of Nonsense* (1846). He did the illustrations for a book

on parrots (1830) and for the poems of Alfred Lord Tennyson. His own illustrated books include *Sketches of Rome* (1842), *Illustrated Excursions in Italy* (1846), *Journal in Greece and Albania* (1851), *Journal in Calabria* (1852). See Davidson, A. *Edward Lear: Landscape Painter and Nonsense Poet.* 1968.

LE BLOND, ABRAHAM (w 1850-68), used the process invented by George Baxter for colour printing in oils under licence. The prints bear the inscription Le Blond and Co, Licensee, London, usually on the base of the cardboard framing mount. Le Blond prints of Queen Victoria and Prince Albert were issued as souvenirs of the Great Exhibition of 1851. They were printed from ten blocks, nine carrying colour on wood. His finest prints were the thirty-two 'ovals' which show real originality and technical skill. See Lewis, C. T. *The Le Blond Book.* 1920.

LEECH, JOHN (1817-64), was born in London, son of a coffee-house owner. He was educated at Charterhouse with Thackeray and started to train as a doctor, but his fondness for sketching led him to contribute to illustrated papers and he became a well known artist and engraver. He worked for *Punch* from 1841 and separate books of his cartoons were published in the 1850s and 1860s by Bradbury & Evans under the title *Pictures of Life and Character.* He did many fine woodcuts for such papers as *Once a Week* (1859-62), *The Illustrated London News* (1856), and *Hood's Comic Annual* (1842). See Brown J. *John Leech.* 1882; Frith, W. P. *John Leech.* 2 vols. 1891; Kitton, F. G. *Biographical Sketch.* 1883.

LUCAS, DAVID, was a mezzotint engraver of Constable's paintings. See *The Published Mezzotints of David Lucas after John Constable.* 1930.

MACLISE, DANIEL, RA (1811-70), the son of a Scot, was born in Cork. In 1828 he went to the school of the Royal Academy, London, and trained as a painter. Although best known for his oils, he did a number of striking line drawings of famous people, which first appeared in *Fraser's Magazine* (1830-38). There is a remarkable example, engraved by C. H. Jeens, of Dickens at 58 Lincoln's Inn Fields on 2 December 1844, in the company of Forster, Carlyle, Dyce, Harness, Maclise himself, and others.

MACKMURDO, ARTHUR HEYGATE (1851-1942), was educated at Oxford and became friendly with many notable painters and critics—Whistler, Wilde, and others. In 1882 he founded the

Century Guild to encourage art in every sphere of design. He was a furniture designer and also an illustrator in the *art nouveau* style. He designed the title page for *Wren's City Churches* (1883), which is striking but curiously out of keeping with the contents of the book.

MAY, PHILIP WILLIAM (1864-1903), who was usually known simply as Phil May, was born on the outskirts of Leeds, the seventh

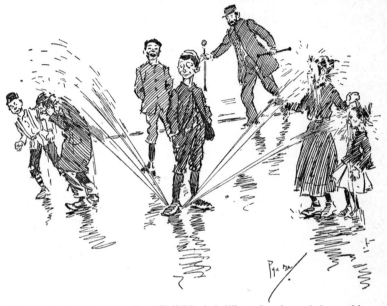

'Water Works.' An example of Phil May's brilliant drawings of the working-class Cockney child, from *Guttersnipes*.

child of a family of eight. He took to drawing and painting at an early age. For some time he was engaged to paint scenery at the Grand Theatre in Leeds but later moved to London and made a meagre living contributing drawings to illustrated papers. Offered a job in Australia, he lived there from 1885 to 1888, when he was given an opportunity to 'study the masters' in Rome, then moved to Paris and back to London. His book *The Parson and the Painter* (1891), which depicts the adventures of the Rev Joseph Slapkin and his nephew Charlie Summers, established his reputation. He worked for the *Sketch* and other periodicals, reflecting social life in the nineties with accuracy and humour. He had a real feeling for the

working-class Cockney. Unfortunately, drink played too great a part in his unconventional life and led to his death in 1903 from consumption and cirrhosis of the liver.

MORROW, GEORGE (1870-1955), was a contributor to *The Idler* and *The Windsor* magazines and he collaborated closely with the author E. V. Lucas. He illustrated an edition of Mary Russell Mitford's *Country Houses* for Seeley & Co in 1896.

NANTEUIL, ROBERT (c1623-1678), was born at Rheims, and in 1648 went to Paris and started to work as an engraver. Within a few years he was commissioned to engrave portraits of leading citizens, including Louis XIV. His finest prints were produced between 1655 and 1665. The portraits appear in a simple oval engraved frame and many of them were produced as book illustrations. See Messell, J. 'Robert Nanteuil, A Great Portrait Engraver' in *Collector's Guide*, November, 1966. pp 74-6.

NEW, EDMUND HORT (1871-1931), contributed pen drawings to a number of magazines in the 1890s and illustrated many books, including an edition of Isaak Walton's *The Compleat Angler* (1897), J. Wells's *Oxford and its Colleges* (1897), and A. H. Thompson's *Cambridge and its Colleges* (1898).

OSPORAT, HENRY (1878-1909), was a Russian who came to England about 1897. He was a fine caricaturist and illustrated a number of books, including *Shakespeare's Sonnets* (1899) and *The Poems of Matthew Arnold* (1900).

PARTRIDGE, SIR BERNARD (1861-1945), joined the staff of *Punch* in 1891 and became the principal cartoonist. He illustrated a number of books of which one of the most interesting is Austin Dobson's *Proverbs in Porcelain* (1893).

PEGRAM, FREDERICK (1870-1937), illustrated many books from the late 1890s onwards including Captain Marryat's *Midshipman Easy* (1896) and *Masterman Ready* (1897), and Jerome K. Jerome's *Tea Table Talk* (1903).

PELLEGRINI, CARLO (1839-89), was born in Capua and came to London in 1864. For the last twenty years of his life he worked for *Vanity Fair* as a cartoonist under the pseudonym of *Ape*.

PENNELL, JOSEPH, was born in America. His wife, Elizabeth Robins Pennell, was a writer and together they produced a number of illustrated topographical books such as *Over the Alps on a Bicycle*

(1898). He also sketched for a number of books in the *Highways and Byways* series, sometimes sharing the task with Hugh Thomson who provided the 'human interest' illustrations.

PICKERING, WILLIAM (1796-1854), was one of the earliest publishers to concern himself with the overall artistic merit of a book, including type, decoration, and binding. Some of his books were printed by the Chiswick Press, which has always maintained a high standard in its productions.

PINWELL, GEORGE JOHN (1842-75), was a Londoner. He started as a designer of carpets and tapestry but took to book illustration and later (after 1865) to painting in watercolours. He made many sketches for *Fun* and *Once a Week*. Books he illustrated include *English Rustic Pictures* (1865) and *The Arabian Nights*.

PYLE, HOWARD (1853-1911) was an American illustrator who first worked with line engraving on wood as in *The Merry Adventures of Robin Hood* (1883) and in his own book *The Wonder Clock* (1888). He also painted illustrations for reproduction in colour as in *The Autocrat of the Breakfast Table* (1883). He was a fine teacher and had a profound influence on American illustrators.

RACKHAM, ARTHUR (1867-1937), is noted for his remarkable coloured illustrations in books such as *Fairy Tales by the Brothers Grimm* (1900) in which he was able to give free rein to his gift for fantasy. Among other books illustrated by Rackham in various editions are *The Christmas Carol, Irish Fairy Tales, The Pied Piper of Hamelin, Peter Pan in Kensington Gardens, Mother Goose, Legend of Sleepy Hollow*, and *Where the Blue Begins*. See Hudson, D. *Arthur Rackham, his Life and Work.* 1960.

RICKETTS, CHARLES (1866-1931), was an important figure in the *art nouveau* period as a book designer. He had a long partnership with Charles Haslewood Shannon. His first book design was for Ward Lock—*The Picture of Dorian Gray* (1891), but the first book he designed and published himself was *Daphnis and Chloe* (1893). In 1889, with Shannon, he produced the first of five issues of *The Dial*, an artistic magazine, and in 1896 he started the Vale Press, which continued until 1903. After that date he again worked for commercial publishers and devoted more time to painting. J. R. Taylor, who discusses Ricketts at some length in the *Art Nouveau Book in Britain* (1966), points out that his secret as a designer was

his ability to vary the expressions of his style to match with almost uncanny precision the form and nature of the text upon which he was working.

ROBINSON, CHARLES (1870-1937), was one of three brothers who were all illustrators. He sketched in the *art nouveau* style with flowing lines for such books as *A Child's Garden of Verses* (1896), *Lullaby Land* (1897), and *The True Annals of Fairyland* (1900).

ROBINSON, WILLIAM HEATH (1872-1944), illustrated such books as *The Poems of Edgar Allan Poe* (1900), but he later became a noted cartoonist who made drawings of fantastic machines tied together with string. See Day, L. *The Life and Art of Heath Robinson.* 1947.

ROSSETTI, DANTE GABRIEL (1828-82), though primarily a painter, also illustrated books and designed bindings for them. He was a great admirer of William Blake.

ROWLANDSON, THOMAS (1756-1827), born in London, studied art in Paris, whose pleasures he greatly enjoyed. When he returned to England he worked hard but managed to combine this with a careless enjoyment of life and travel. His work has a vigorous irreverent character which enlivens the books he illustrated with his aquatints. These include the three *Tours of Dr Syntax, The Dance of Death, Sentimental Journey, Peter Pindar,* etc. A Rowlandson drawing of the Dutch Packet, signed and dated 1791, sold for £1,995 (A 1969). See Falk, B. *Thomas Rowlandson: His Life and Art,* 1949; Wolf, E. C. J. *Rowlandson and his Illustrations of Eighteenth Century English Literature.* 1945.

SAMBOURNE, EDWARD LINLEY (1844-1910), was born in London and started to train in the marine engine works at Greenwich. In 1867, however, he started to work for *Punch* and late in life succeeded Tenniel. He illustrated a number of books, including editions of *Hans Andersen's Fairy Tales* and Charles Kingsley's *Water Babies.*

SANDYS, FREDERICK (1832-1904), was one of the most popular illustrators of mid-Victorian times, particularly in the 1860s. Technically he was a superb draughtsman, though in later years his sketches became rather crowded and fussy.

SCOTT, JOHN (1774-1828), was born in Newscastle. He moved to London and was taught his craft of engraving by Robert Pollard.

Then, for some years, he worked for Wheble's *Sporting Magazine.* He illustrated such sporting books as *British Rural Sports* (1801), *The Sportsman's Cabinet* (1804), *The History and Delineation of Horses* (1809), and *The Sportsman's Repository* (1820); many of his engravings were after such artists as Reinagle, Stubbs and Gilpin. See Bunt, C., A. 'Find of Old Engravings' in the *Collectors' Guide.* March, 1966, pp 59-60.

SHAW, JOSHUA (1776-1860, was an artist who emigrated from England to America in 1817. He produced the drawings for *Picturesque Views of America* which were engraved in aquatint and published in Philadelphia in 1819-20.

SULLIVAN, EDMUND J. (1869-1933), was one of the great illustrators of the 1890s, both in line and wash. He did the drawings for editions of *The School for Scandal* (1896) and *The Rivals* (1896), *Lavengro* (1896), *The Pirate and the Three Cutters* (1897), and *Sartor Resartus* (1898), which probably contains his best work. He wrote two books on *The Art of Illustration and Line* (1921 and 1922).

SULLIVAN, JAMES FRANCIS (1853-1936), often known as *Jassef* was given his first opportunity as an illustrator by the Brothers Dalziel. He worked for *Fun*, to which he contributed articles, verse, and drawings. His work also appeared in the *Strand Magazine*. He wrote and illustrated books of short stories—*Here They Are* and *Here They Are Again*. In later life he spent much of his time studying antiques : he was particularly interested in arms and armour.

TENNIEL, SIR JOHN (1820-1914), was born in London. He had no special training but nevertheless became a noted illustrator and a leading cartoonist for *Punch*. He illustrated editions of *Aesop's Fables, Lalla Rookh, The Ingoldsby Legends* and the two Lewis Carroll books—*Alice in Wonderland* and *Alice Through the Looking Glass.* He was knighted in 1893. See Sarzano, S. *Sir John Tenniel.* 1948.

THOMSON, HUGH (1860-1920), was a prolific book illustrator, mainly in black and white pen drawings though he did some colour illustrations for Barrie's *Quality Street*, and for *As you Like It* and *The Merry Wives of Windsor.* He did pen drawings for editions of Mary Russell Mitford's *Our Village* (1893), Austin Dobson's *The Story of Rosina* (1895), Fanny Burney's *Evelina* (1903), and such authors as Jane Austen, George Eliot, and Oliver Goldsmith. He

was also noted for topographical work, collaborating with Herbert Railton to illustrate W. Outram Tristram's *Coaching Days and Coaching Ways* and with Joseph Pennell to illustrate some of the *Highways and Byways* series. His work reveals a primary interest in people but his scenery is well drawn and his settings are invariably authentic. See Spielmann, M. H. and Jerrold, W. *Hugh Thomson*, 1931.

WAIN, LOUIS (1860-1939), was noted in the 1890s and into the twentieth century for drawings of dogs and especially of cats and kittens. They are sentimental and highly anthropomorphic but have enjoyed great popularity. He started to contribute to the *Sporting and Dramatic News* at the age of nineteen and also sketched for the *Pall Mall Budget*, *The Gentlewoman*, *The Sketch*, and other illustrated papers. He also designed Christmas cards for Raphael Tuck.

WALKER, FREDERICK, ARA (1840-75), was born in Marylebone, London. He became a wood engraver and did black-and-white illustrations for the *Cornhill*, *Good Words*, and *Once a Week*. He was also an accomplished watercolour artist.

WALL, WILLIAM GUY (1792-c1862), was an Irish artist who worked in America between 1818 and 1836. He was responsible for the watercolours engraved for the *Hudson River Portfolio*, published by Megarey of New York c1823. His views of *New York from Weehawk* and *New York from Brooklyn Heights* are particularly notable. He did many drawings for use in decorating blue and white transfer-printed earthenware with American scenes. Andrew Stevenson of Cobridge, Staffordshire is said to have given him a commission for such work.

WARD, LESLIE (1857-1922) was a caricaturist who worked for *Vanity Fair* from 1878 to 1909 under the pseudonym of *Spy*. He wrote *Forty Years of 'Spy'* (1915).

WHISTLER, JAMES ABBOT McNEILL (1834-1903), was born at Lowell, Massachusetts. In 1857 he studied art in Paris and although he painted and exhibited, his skill as an etcher was soon recognised. He took a great interest in book designing and evolved a characteristic layout and style of binding. His work is instantly recognisable from the butterfly signature he used as a decorative motif.

WYETH, N. C. (b 1882) was a prolific American illustrator, providing many colour pictures for children's books.

BOOKS TO CONSULT

Bland, D. A. *A History of Book Illustration*. London, 1958. Revised 2nd Ed. London and Berkeley, California, 1969

Hamilton, S. *Early American Book Illustrators and Wood Engravers, 1670-1870*. 2 vols. Princeton, 1968

James, P. *English Book Illustration, 1800-1900*, London 1947

Linton, W. J. *The History of Wood Engraving in America*. Boston, 1882

Mahoney, B. E., Latimer, L. P., and Folmsbee, B. *Illustrators of Children's Books, 1744-1945*. Boston, 1947

Pitz, H. A. *Treasury of American Book Illustration*. New York, 1947

Reid, F. *Illustrators of the Sixties*. London, 1928

Shadwell, W. *American Printmaking, the First 150 Years*. New York, 1969

Smith, J. A. *Illustrated Children's Books*. London, 1948

Thorpe, J. *English Book Illustration: The Nineties*. London, 1935

Tooley, R. V. *English Books with Coloured Plates, 1790-1860*. Boston, 1935. London, 1954

Vigeurs, R. H., Dalphen, M., and Millen, M. B. *Illustrations of Children's Books, 1946-56*. Boston, 1958

3

BRONZES

Bronze has been used for sculpture and ornament for over 3,000 years. It is usually described as an alloy of copper and tin but other metals, such as zinc, lead, or nickel, are often added, though in smaller proportions. Cast bronze which has been fire-gilded is known as ormolu: it was used, particularly between 1720 and 1760, to make candlesticks and clock-cases, and for decorative mounts on furniture.

Bronze is particularly suitable for casting sculpture, and small antique bronzes are much sought today by collectors and interior decorators. For this reason the work of the group of animal sculptors, usually referred to as *Les Animaliers*, who worked in France during the nineteenth century, is much in vogue. Working closely with the foundries, they produced an amazing variety of animal bronzes, many of them showing nature 'red in tooth and claw'.

The work was done in four main stages:

1. The sculpture was first cased in plaster. This was then cut and removed in pieces so that it could be put together again.

2 This mould was then used to cast a model in wax. At this stage the artist could touch-up the model before the third stage.

3. The wax was then enclosed in a clay mould and the temperature was raised until the wax ran away through a hole. Hence the term given to the whole process is *cire perdue* or 'lost wax'.

4 The molten bronze was then poured into this mould. When cool it had taken the shape of the original model and the mould could be cut away to reveal the cast, which could then be worked on again to remove blemishes.

Most of the early sculptors liked to be involved in the whole process and to do the touching-up themselves, ending with what is known as an 'autograph bronze'. Indeed, some established their own bronze foundries. But it is a costly business in terms of time and money and when a number of copies were required the 'touching-up' was often done by the foundry company. Bronzes made in this way are 'edited bronzes'.

AUGUSTE : see Cain, Auguste-Nicolas (p 50).

BARBÉDIENNE, F. (1810-92), was a bronze-founder who established a factory in Paris in 1839 in association with Achille Collas. He cast many bronzes and took a special pride in following faithfully the intentions of the sculptors for whom he worked. Collas invented the technique which made it possible to reproduce bronzes in considerable numbers. He worked for Barye and when Barye died in 1875 Barbédienne bought some of his models. These were reissued and some of them bear the 'F. Barbédienne' signature; others merely 'F.B.'.

BARYE, ANTOINE-LOUIS (1796-1875), learned the art of modelling small animals while apprenticed to a goldsmith and this led to an interest in animal sculpture to which he devoted himself with singlemindedness. He studied at the École des Beaux Arts in Paris and took care to learn the elements of anatomy. When he began working in bronze he established his own foundry in 1838 though he was not able to keep it going between 1848 and 1857. He was pre-eminent among nineteenth-century animal sculptors and may be regarded as the founder of *Les Animaliers*. His bronzes include studies of individual animals but he is noted for groups showing animals in combat—a jaguar struggling with an alligator, a lion with a peccary, or an elk attacked by a lynx. Carnivores, therefore, figure largely in his repertoire. His work may be seen in the Louvre and the Musée du Luxembourg in Paris, the Museum of Lyons, the Museum of Marseilles, the National Gallery, London, the V & A, FM, and AM, and the Walters Museum, Baltimore, USA. See Ballu, R. *L'Ouvre de Barye*. Paris, 1950.

BOLOGNA, GIOVANNI DA (1528-1608), was born as Jean Boulogne in Douai and learnt his craft in Flanders. He moved to Italy in his mid-twenties to work in Rome and later in Florence. Many of his bronzes such as *Mercury* (1564) are well known and small replicas by pupils who trained in his workshop occasionally appear on the market. Later replicas are very common indeed.

BONHEUR, ISIDORE-JULES (1827-1901), was the son of a French painter and sculptor, Raymond Bonheur. He specialised in animal figures. A pair of wild bulls in menacing attitude, upon oval plinths, sold for £1,000 (A 1969).

BONHEUR, MARIE ROSALIE (1822-99), more usually known as Rosa Bonheur, was the sister of Isidore Bonheur. She produced

a number of bronzes that were edited by Hippolyte Peyrol, her brother-in-law. Her work does not often appear on the market but examples may be seen in the W Coll and in France in museums at Bordeaux, Boulogne, Grenoble, Langres, and Rouen.

BOULTON, MATTHEW (1728-1809), made ormolu at his Soho manufactory near Birmingham where, with the help of workmen from France, he produced door furniture, mounts for Derbyshire spar, and other ormolu pieces for decoration.

BUGATTI, REMBRANDT (1885-1916), was born in Milan, son of a silversmith and furniture designer, and brother of Ettore Bugatti, the motor-car designer. He learnt much from his father and studied in Milan. Later he lived and worked in Antwerp and Paris. He was fascinated by animals and Adrien Hébrard, the bronze founder, cast many bronzes from his sculptures. These are impressionistic in style and can be clearly distinguished from nineteenth-century animal bronzes. His groupings are often unusual—a baby elephant with a camel, cock with frog, etc. Bugatti committed suicide in 1916. His work may be seen in the Tate, the Musée du Luxembourg in Paris, and in the Musées des Beaux Arts in Antwerp and Brussels.

BULIO, JEAN (1827-1911), was a minor French sculptor who studied in Paris and exhibited bronzes in the Salon until 1903.

CAFFIÉRI, JACQUES (1678-1755), the son of a sculptor, became a noted French bronze founder who made many decorative pieces, such as wall lights, in the rococo style, and especially furniture mounts which are sometimes signed with his surname. Much of his finer work is signed and examples may be seen in the W Coll; the V & A; and the Louvre in Paris. See Lady Dilke. *French Furniture and Decoration of the Eighteenth Century.* 1901.

CAIN, AUGUSTE-NICOLAS (1821-94), is often known simply as Auguste. He specialised in animal and bird sculptures—a linnet protecting her nest against a rat, an eagle defending its prey, a hawk hunting rabbits, and a pheasant surprised by a marten, are among his subjects. By 1851 he had a secure reputation. In 1852 he married P. J. Mêne's daughter and was able to use his father-in-law's foundry, which he continued after Mêne's death. He won many awards for his work.

CARRIER-BELLEUZE, ALBERT-ERNEST (1824-87), was a skilful sculptor of figures and a very efficient businessman. He ex-

hibited at the Paris Salon from 1851 and between 1850 and 1855 worked as a modeller for Minton's, the Staffordshire potters. Later he had a large studio in the Rue de la Tour d'Auvergne in Paris and his workmen and apprentices, among them Rodin (from 1864), copied his models in detail and these all carried the Carrier-Belleuze signature. Four bronze figures of *The Seasons* attributed to this sculptor, 31 in high, sold for £460 (A 1968).

CATTANEO, DANESE (1509-73), was a pupil of Jacopo Tatti in Venice. He made many small bronzes, such as a model of *Fortune*.

CHOPIN, F., was a French bronze-caster who worked in St Petersburg in the second half of the nineteenth century. He exhibited at the Paris Exhibition of 1878.

COMOLÉRA, PAUL (1818-97), was a pupil of Rude and he favoured animals and birds as subjects—two dead birds, fighting cockerels, a dead finch, birds fighting, a bull, etc. His son Paul was also an *animalier*. Comolera trained Jules Moigniez to become a sculptor in bronze.

DALOU, JULES (1838-1902), was trained at the Petite École in Paris. In 1871 he was forced to flee to London after the fall of the Paris Commune and he became a professor at South Kensington Museum. His stay had a profound effect on English sculpture, which was still bound by marble and the neo-classical tradition. In 1879 he returned to France under an amnesty and produced bronzes of peasants, based on figures in the paintings of Millet. A bronze of a bather drying her foot, 13¾ in high, sold for £950 (A 1969). See Caillaux, H. *Dalou*. 1935.

DAUBRÉ, ALFRED (d 1885), was a noted bronze-founder who started in 1855 and edited a number of Christophe Fratin's bronzes.

DEGAS, HILAIRE-GERMAIN EDGARD (1834-1917), was born in Paris. Although primarily a painter, he did some work as a sculptor late in life, his subjects including horses and ballet dancers. His work was done in clay or wax and no bronzes of his sculptures were cast in his lifetime. After his death about 150 models were discovered in his studio but about half of them were badly damaged. However, some seventy-two models were cast in 'editions' of twenty-two of which twenty reached the public market. Each model has a serial number : individual bronzes in each edition were marked serially with a letter—A to T. One additional model, cast later, has no identification mark. A Degas bronze of a horse sold for £18,000 (A 1969).

DELABRIERRE, PAUL-EDOUARD (1829-1912), was one of *Les Animaliers* who exhibited at the Salon from 1849 to 1904. He is known for some large sculptures but his most interesting work was done on a small scale; he produced bronzes based on single animals or birds—horse, pointer, pheasant, and also groups—greyhound and tortoise, lion and crocodile, fox and wild duck, etc.

DUBUCAND, ALFRED (b 1828), was one of the lesser known of *Les Animaliers*. He exhibited from 1867 to 1883 and his subjects included a stallion, and partridges with chicks (plate, page 18).

DUPLESSIS, J. C. (d 1774), was a bronze-founder attached to the Sèvres porcelain factory in 1747 to design and model mounts for vases and other ceramic pieces.

FALGUIÉRE, JEAN ALEXANDRE JOSEPH (1831-1900), produced some small bronze busts including *Diane*. His work was signed and was cast by Therbaut Frères of Paris.

FIOT, M., was an *animalier*. A group of three greyhounds by this sculptor, 33 in wide, sold for £250 (1968).

FORD, E. ONSLOW (1852-1901), was an English sculptor who produced a number of bronzes, such as *Folly*, of which small replicas were cast.

FRATIN, CHRISTOPHE (1800-64), was born in Metz, the son of a taxidermist, and grew up with an interest in animals (especially dogs) and birds. He is best known for his bronzes, though he worked in other materials, and these were regularly exhibited at the salons from 1831. At the Great Exhibition of 1851 in London he was awarded a medal as 'the most celebrated sculptor of animals of the present day'. At first his sculptures were cast by Susse Frères, then by E. Quesnel, and in later years by Alfred Daubré and L. Richard Eck et Durand. He is a popular artist, perhaps because he tended to concentrate on single animals or birds, though he did produce some groups, such as a mare and foal, and bears wrestling. A bronze of a setter, signed Fratin, sold for £160 (A 1969) (see page 17). Examples of Fratin's works may be seen in the W Coll, in his home town of Metz, and in the Peabody Institute, Baltimore, USA.

FRÉMIET, EMMANUEL (1824-1910), was a pupil of Rude. Most of his work was on a large scale and his sculptures may be seen in public places. He was responsible, for example, for the fine equestrian statue of Joan of Arc (1874) in the Place des Pyramids,

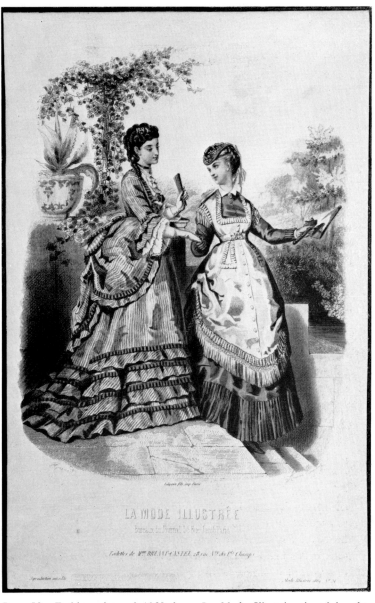

Page 53: Fashion plate of 1869 from *La Mode Illustrée*, signed by the artist Anaïs Toudouze (1822–99)

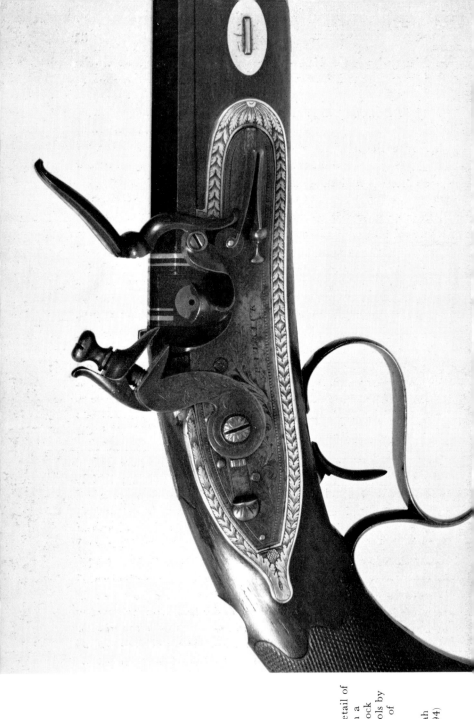

Page 54: Detail of a pistol from a pair of flintlock duelling pistols by Ann Patrick of Liverpool, c 1820–30 (See Jeremiah Patrick, p. 94)

Paris. But he also worked on a small scale. His early bronzes are of animals, particularly single cats, dogs and horses, though he also worked on groups of racehorses and jockeys. From 1843 he exhibited at the Salon and the quality of his work was recognised in many ways: he was for a time Professor of Drawing at the Jardin des Plantes, President of the Academy of Fine Arts, and Grand Officer of the Legion of Honour. His work may be seen in the Louvre, Paris, and in museums at Bayonne, Nantes and Rennes; in Hamburg Museum; and in Baltimore Museum, USA.

FRENCH, DANIEL CHESTER (1850-1931) was an American sculptor who learnt his art from William Rimmer (q.v.).

GARDET, GEORGES (1863-1939), was the son of a sculptor and studied under Frémiet at the École des Beaux Arts in Paris. He worked in marble as well as bronze and exhibited at the Salon from 1883. His bronzes of a tiger and a bison are to be seen at the entrance to the Musée de Laval, Paris. His groups include lion and lioness, fighting panthers, and a bison attacked by a jaguar. It is interesting to note that a number of his sculptures have been reproduced in Sèvres porcelain.

GRIMALDI, COUNT STANISLAV, produced fine bronzes, mainly lively equestrian groups, in the 1880s.

HÉBRARD, A.A., was the owner of one of the Paris bronze foundries and cast the work of Dalou, Degas, and Bugatti.

HINGRE, LOUIS-THEOPHILE, was working later than most of *Les Animaliers*. He started to exhibit at the Salon in Paris in 1881 and was working well into the twentieth century.

JACQUEMART, HENRI-ALFRED-MARIE (1824-96), was born in Paris and studied at the École des Beaux Arts. He exhibited at the Salon from 1847. Most of his work was monumental.

JAYET, CLEMENT (1731-1804), was a minor French sculptor who made decorative bronzes for domestic use.

LANCEROY, EUGENE (1848-86), was a Russian sculptor who produced equestrian bronzes of horses.

LECOURTIER, PROSPER (1855-1924), was a pupil of Frémiet who worked well into the twentieth century. He favoured domestic animals—a mastiff or a donkey, for example.

LEIGHTON, FREDERICK, LORD, PRA (1830-96), was one of the first sculptors in England to be influenced by the French

D

school. In 1877 he showed a bronze—*Athlete struggling with a python*—which was widely noticed and regarded as a pioneer 'new sculpture'.

LENORDEZ, PIERRE, a nineteenth-century French sculptor who specialised in bronzes of horses.

LEONARD, LAMBERT ALEXANDRE (b 1831), exhibited animal sculptures at the Salon in Paris from 1851.

MABRASSI, L., was a nineteenth-century Paris sculptor. A nude group in bronze by him sold for £140 (A 1968).

MARISTON, E. A pair of male figures by this sculptor, stamped and dated 1884, on rough marble bases, 37 in high, sold for £360 (A 1968).

MÊNE, PIERRE JULES (1810-79), was the son of a metal turner and largely self-taught. He was a prolific and versatile artist and worked in Paris, where he established his own foundry in 1838, with Auguste-Nicolas Cain who became his son-in-law in 1852. Mêne's bronzes have always been sought after, especially those of horses and gun dogs, which are remarkably elegant and realistic. His groups are usually 'family groups'—goat and kid, mare and stallion, mare and foal—though he does provide contrast in, for example, greyhound and King Charles spaniels. His 'Arab Mare and Stallion' signed P. J. Mêne, 21 in long, 13 in high, sold for £880 (A 1969).

Mêne exhibited at the Salon from 1838 until his death. He exhibited not only in Paris but also in London at the Great Exhibition of 1851 and in 1862. His work was later edited and cast by Cain, Barbédienne, Susse Frères, and the Coalbrookdale Iron Company (in bronze and cast iron). Examples may be seen in the AM, in the Louvre in Paris, and in the museums of Marseilles, Levrettes, and Rouen.

MOIGNIEZ, JULES (1835-94), had the advantage of having a father in the metal trade who started a bronze foundry in 1857 to cast his son's work and that of other French sculptors. Much of the output was for export and this may account for th efact that Moigniez's work turns up fairly frequently in England. He particularly favoured birds, especially water fowl, though his bronzes, which show great vitality, covered the whole field of domestic animals, especially dogs. He exhibited regularly at the Salon for over thirty years from 1859. His work shows a dark brown patination and is usually signed.

PAUTROT, FERDINAND, was born at Poitiers. He exhibited at the Salon from 1861 to 1870. Most of his bronzes are of birds and animals, especially gun dogs with game. Two bronzes, one of a retriever with a snipe, the other of a pointer with a hare, sold for £1,800 (A 1969).

PETEL, GEORG, was a seventeenth-century Flemish sculptor. A gilt-bronze relief of the Three Graces by this artist, 12 in high, sold for £12,000 (A 1969).

PETER, VICTOR (1840-1918), was a French sculptor who exhibited at the Salon in Paris from 1868 to 1900. Some of his bronzes were cast by A. A. Hébrard.

POMPON, FRANÇOIS (1855-1933), studied at the École des Beaux Arts in Dijon and then worked for some time as a painter in Paris. He spent much of his working life, however, in Rodin's studios and eventually developed a style of his own. He only established a name for himself late in life and his work is scarce and expensive. He is noted for the smooth simplicity of his bronzes, as in the famous example of the Polar Bear. Much of his work is to be seen in the Dijon Museum. See Courrières, E. de F. *Pompon*, Paris 1926.

QUESNEL, E. (w 1811-47), was a Paris foundry-owner who cast bronzes for Christophe Fratin and other sculptors.

RICKETTS, CHARLES, RA (1866-1931), did a little sculptural work. A bronze, *Figure of Silence*, by this artist of a young man wearing a heavy cloak, with his right hand to his lips, 14½ in, sold for £250 (A 1969).

RIMMER, WILLIAM (1816-79), was a self-taught sculptor and painter who was also a keen student of anatomy and, as a teacher, has considerable influence on younger sculptors.

ROCHE, W., produced bronzes from the 1880s, mainly of mounted horses.

RODIN, AUGUSTE (1840-1917), was born in Paris and became the greatest sculptor of his time. His bronzes have an individual style and are full of character, beautifully modelled with great attention to detail. Notable examples are Honoré de Balzac and Victor Hugo. See Champigneulle, B. (in translation) *Rodin*. 1967.

RUDE, FRANÇOIS (1784-1855), was born at Dijon, the son of a coppersmith. His *Mercury tying his Sandals* may be seen in the

Louvre, Paris. Rude had a great influence on the younger genera-tion of sculptors, who found him to be an excellent instructor.

SAINT-GAUDENS, AUGUSTUS (1848-1907) was an Irishman who emigrated to America and became a noted sculptor.

SOLDANI, MASSIMILIANO (1658-1740), was an Italian sculp-tor who based some of his work on bronzes by earlier sculptors. His *Faun* is an example. This was also adapted for use in the eighteenth-century porcelain factories. Soldani's work may be seen at Glynde Place, near Lewes, Sussex.

STEVENS, ALFRED (1817-75), was born in Blandford, Dorset. After some years in Italy working as a hack artist, he returned to England in 1842. In 1856 he was responsible for the sculptures mounted on either side of the arch over the tomb in the Wellington Monument in St Paul's Cathedral. A pair of bronze groups modelled on these sculptures in which Victory is shown triumphing over a slave-like figure of a man cowering beneath her, 26 in, sold for £300 (A 1969).

SUSSE, JEAN VICTOR (1806-60) and SUSSE, J. B. AMÉDÉE (1808-80), together ran the business of Susse Frères in Paris. They were bronze founders and editors from about 1840 and made very many small bronzes for export.

SWAN, JOHN MACALLAN (1847-1910) was a pupil of Frémiet and may be regarded as the only *animalier* of England.

TROUBETZKOY, PRINCE PAUL PETROVITCH (1866-1938), worked in several parts of Europe at various times—France, Italy, and Russia. An admirer of Rodin and of Impressionism, he exhibited his work in Europe and America in the first decade of the twentieth century.

VALTON, CHARLES (1851-1918), learnt his craft from Barye as an *animalier* in Paris and started to exhibit at the Salon in 1868. His subjects included chained dogs.

BOOKS TO CONSULT

Gunnis, R. *Dictionary of British Sculptors, 1660-1851*. London, 1951
Pope-Henessy, J. *Italian Renaissance Sculpture*. London, 1958
Redcliffe, A. *European Bronze Statuettes*. London, 1966
Savage, G. *A Concise History of Bronzes*. London, 1968
Wilson, P. (Ed.) *Antiques International*. London, 1966

4

CLOCKS AND BAROMETERS

IN 1632 Charles I granted the Clockmakers of London their Charter, and from that date until the end of the eighteenth century they maintained very high standards of craftsmanship. This was largely due to two factors. Firstly, they were able to exercise a firm control over their craftsmen, who were not admitted as members of the Clockmakers' Company until they had served a long apprenticeship and attained a high degree of skill. Secondly, there existed a wealthy aristocratic clientele able to afford to pay for pieces which demanded fine materials and long hours of work by skilled craftsmen. Clocks of this period with the mechanism in its original state, or with few repairs, therefore, are highly desirable and fetch high prices, particularly if they have fine cases.

Makers of eighteenth-century clocks can usually be identified, since an Act of Parliament of 1698 forced them to inscribe their names and addresses on their clocks. Difficulties often arise, however, from the fact that the craft tended to run in families and some of these families had common names. An auction sale catalogue, for example, may describe a lot as 'An eighteenth-century wall timepiece by John Hall in a carved and gilded wooden case'. The reference books list at least ten clockmakers of the period with the name John Hall, three of them working in London.

Most eighteenth-century American clocks are of the long-case type and examples by early makers such as David Rittenhouse of Pennsylvania have a high value.

In this section, the dates given after the name of a clockmaker are the most accurate available but should nevertheless be treated with caution. Where possible the actual dates of birth and death are given. Sometimes it has only been possible to state the working period and this has been assumed to start at the end of the years of apprenticeship. The end of the working life is often more difficult to pinpoint and must inevitably be regarded as approximate unless a maker is known to have been working until the year of his death.

AICKEN, GEORGE (w 1763-c1813) of James Street, Cork, made musical clocks. The Dublin Museum has a bracket clock with a pointer that will select six different tunes.

AIRY, GEORGE BIDDELL (1802-92), of London was Astronomer Royal 1853-81. He worked hard to make timekeepers more accurate and designed a very accurate clock for Greenwich Observatory.

ALEXANDER, WILLIAM (w 1830-40), of 10 Parliament Street, London, made long-case clocks using a mercury pendulum.

ALLAM & CAITHNESS (w c1795-c1820), of London, made bracket clocks in the Regency style.

ANDERSON, T., of Gravesend made five-dial scroll barometers, c1800.

ARNOLD, JOHN (1736-99), was born at Bodmin in Cornwall, where his father made watches. In 1760, after some time as a journeyman, he took premises at Devereau Court, Fleet Street, London. In 1764 he completed a miniature half-quarter repeating watch which weighed only 5 dwt $7\frac{3}{4}$ gr. It was set in a ring and presented to George III. Arnold spent some years working on marine chronometers, one of which was used by Captain Cook in 1772 on the *Resolution*. In 1782 he patented his improved detent escapement. In 1785 he moved to 112 Cornhill, where he worked with his son John Roger, and in 1787 they formed a partnership which lasted until John Arnold's death.

BAGNALL, BENJAMIN (1689-1740), was born in England and emigrated to Boston c1710. He was probably Boston's first clockmaker for he made eight-day clocks from about 1722, mainly in pine and walnut. His son Samuel carried on the business until 1760.

BAGNALL, JOHN (w 1762-91), of Dudley, was a maker of long-case clocks : an example with a brass dial sold for £50 (A 1969).

BAILLON, JEAN BAPTISTE, was a noted Paris watchmaker in the second half of the eighteenth century.

BALCH, DANIEL (1735-c1790), of Newbury, Massachusetts, made clocks with engraved brass faces and chased spandrels from c1760-90. His sons continued the business until c1835.

BANGER, EDWARD (w 1695-c1720), was apprenticed to his uncle, Thomas Tompion, in 1687, and worked with Thomas Tompion Jr, 1701-8.

BARRETT, T., of Lewes, Sussex, is known to have taken apprentices 1713-36. A 32-hour long-case oak clock is in Guildford Museum.

BIOLE, B. was a late eighteenth-century maker of banjo barometers in Cambridge.

BLANCHARD, CHARLES (1688-1768), worked in London from about 1750 making verge escapement six-bell quarter bracket clocks.

BÖHM, MARCUS, of Augsburg, was a maker of 'Telleruhr' clocks c1700. These were wall clocks with a metal pendulum in the form a disk (telleruhr) swinging in front of the dial.

BREGUET, ABRAHAM LOUIS (1747-1823), was the founder of a noted firm of Paris clock and watch makers. Most of his pieces were signed and numbered. A silver *pendule de voyage* with calendar and equation work, half and quarter repeating, and with alarm, sold for £12,000 (A 1963). The firm continued after his death as Breguet et Fils and has always maintained a reputation for high quality. See Solomons, D. L. *Breguet, 1747-1823*, 1923; Breguet, C. A. L. *Breguet—Horologer*. 1964.

BREWSTER, ELISHA C. (1791-1880), of Bristol, Connecticut, was a clockmaker from 1833 to 1862 with a branch warehouse in London. He made the first American spring clocks based on his own invention.

BROCKBANKS & ATKINS (w 1815-35), of 6 Cowper's Court, London, had George Atkins as a partner until 1821 and thereafter Samuel Atkins. They made marine chronometers.

BROWN, DAVID, of Providence, Rhode Island, was an American clockmaker in the early nineteenth century. He made some small and unusual wall clocks.

BROWN, GAWEN (1719-1801), was an English clockmaker who settled in Boston, Massachusetts and made long-case clocks and watches.

BUCKINGHAM, JOHN (w c1700-40), of the Minories, London, was a maker of long-case clocks. An example in an oyster veneer case inlaid with birds and flowers and stained ivory sold for £1,250 (A 1969).

BURNAP, DANIEL (1760-1838), of East Windsor, Connecticut, started a workshop c1780 and made fine long-case clocks with brass works. These normally have an engraved silver face and they often

show phases of the moon and have chimes. In 1786 he took Eli Terry as an apprentice. He moved to Andover c1800 and remained there for the rest of his life. His clocks are rare and prized.

CABRIER, CHARLES (w 1726-72), was a noted London watchmaker. Both his father and his son were named Charles and they also made watches.

CAMDEN, WILLIAM (w 1708-51), of Plumtree Court, Shoe Lane, London, was a noted maker of long-case clocks.

CAMP, HIRAM (1811-93), was a Connecticut clockmaker who played a major part in starting the New Haven Clock Company in 1853. He was a nephew of Chauncey Jerome.

CARON, PETER AUGUSTE (1732-99), of Paris, was clockmaker to the King in 1755 and made a very small watch for Mme de Pompadour.

CHALLONER, WILLIAM, of Skinner Street, London, was a late seventeenth-century maker of bracket clocks. A clock with a movement by Challoner sold for £130 (A 1966).

CHANDLER, BENJAMIN (d 1747), arrived in Philadelphia from England c1702 and made long-case clocks for many years.

CHATER, JAMES & SON (w 1753-84), were London makers of month regulator long-case clocks.

CHENEY, BENJAMIN, worked with his brother Timothy (1730-95) in the East Hartford/Manchester district of Connecticut in the second half of the eighteenth century. They made clocks with wooden movements at a time when brass was scarce : the brass available was kept for the dials. Eli Terry worked for the Cheneys c1790 and they taught woodworking to at least one member of the Willard family.

CLAGGETT, THOMAS (w c1720-49), of Newport, Rhode Island, was born in 1696 and became a Freeman of Newport in 1726. He was a noted maker of long-case clocks. An example may be seen in the Museum of Fine Arts, Boston.

CLAGGETT, WILLIAM (1696-1749), twin brother of Thomas Claggett, was born in Wales, moved to Boston and set up as a clockmaker c1720 in Newport, Rhode Island. His clocks have finely engraved dials.

CLEMENT, WILLIAM (1638-1704), a London maker from 1677

to 1699, was probably the first to use the anchor escapement invented by Dr Hooke.

CLOWES, JOHN (w 1672-1713), of London, made bracket and long-case clocks.

COLE, JAMES FERGUSON (1799-1880), of London, was a fine inventive clock and watch maker who worked to perfect the lever escapement. He has been called 'The English Breguet'.

COLLEY, THOMAS (w c1754-70), of Fleet Street, London, was apprenticed to George Graham. He made watches and fine bracket clocks.

COLSTON, RICHARD (w 1682-1709), was a London maker of watches and long-case clocks.

COSTER, SALOMON, of The Hague, Holland, made experimental pendulum clocks in the middle for the seventeenth century for Christian Huygens, the Dutch physicist.

COTTEY, ABEL, emigrated from England to America with William Penn in 1682 and started a business in Philadelphia, making long-case clocks.

COWAN, JAMES (w 1751-81), of Edinburgh, was one of the most famous Scottish makers of bracket and long-case clocks.

COX, JAMES (w c1740-88), of 103 Shoe Lane, London, spent much of his life devising musical and chiming clocks, clocks with singing birds, and what he called a 'perpetual motion clock' (self-winding). Most of these were for the Chinese market. An exotic musical architectural clock mounted above two agate panelled caskets decorated with rocaille work and standing one above the other, both on feet shaped as morose elephants, sold for £3,200 (A 1969).

COXETER, NICHOLAS (w 1646-77), was a noted London maker of lantern and long-case clocks.

CRANE, AARON D., an American clockmaker, developed the torsion pendulum as a commercial proposition in the middle of the nineteenth century.

CROCE, J., of York, made barometers in the late eighteenth century.

CULPEPER, EDMUND (w 1666-c1700), was a London maker of clocks and barometers. A stick barometer c1700 sold for £230 (A 1966).

CUMMING, ALEXANDER (c1732-1814), was probably born in Edinburgh. In 1754 he was a watchmaker in Inverary and in 1756 in Edinburgh. By 1763 he was working in London at the Dial and Three Crowns, New Bond Street, and later at 12 Clifford Street (until 1794) and then in Fleet Street. He was an inventive clock-maker, the first to experiment with curved teeth for the cylinder escape wheel. In 1766 he published *The Elements of Clock and Watch Work*. He made a clock for George III which registered the daily barometric pressure. See 'Clockmaker Extraordinary', *Country Life*, 12 June 1969, pp 1528-35.

CURTIS, LEMUEL (1790-1857), was born in Boston and be-came an apprentice of Simon Willard. He set up in business in Con-cord, Massachusetts, and in 1818 moved to Burlington, Vermont. He was noted for wall and shelf clocks and particularly for small banjo clocks which were round at the base to allow for the swing of the pendulum. The convex glass was often painted with classical scenes.

CUSTER, JACOB D. (1805-1872), of Norristown, Pennsylvania, was a maker of long-case clocks.

DAKEN, JAMES, of Boston, was an American maker of long-case and shelf clocks towards the end of the eighteenth century.

DECHARMES, SIMON (w 1691-1730), was a French clock-maker who worked in London. A long-case clock in lacquered cabinet sold for £110 (A 1969).

DELANDER, DANIEL (w 1699-1733), of Fleet Street, London, was the inventor of a spring to secure the cases of watches and he made repeating jewel watches and bracket clocks. He also made fine barometers.

DENNISON, AARON L. (w c1840-1888), of Boston, formed a friendship with Eli Whitney, the gunsmith, and, after studying watchmaking methods in Europe, set up a factory at Roxbury with Whitney's help. They were soon turning out over forty watches a week. This works later moved to Waltham and eventually became the Waltham Watch Company. Meanwhile, Dennison had moved to England and started the Dennison Watch Case Company.

DENT, EDWARD JOHN (1790-1853), of London, after working with Richard Rippon, worked on his own except for the ten years 1830-40 when he was in partnership with John Roger Arnold. He

made some fine chronometers for which he gained a prize, made the clock for the Royal Exchange, and also clocks and watches for domestic use.

DOWNS, EPHRAIM (w 1811-43), was a clockmaker of Bristol, Connecticut.

DREW, EDWARD (w 1692-1720), was a London maker of long-case clocks.

DUBOIS. A French family that produced over twenty clock-makers between 1730 and 1850. German Dubois (w 1757-89) made an ormolu-mounted clock in 1786 with blue porcelain panels, which sold for £578 (A 1969).

DUTTON, WILLIAM (w 1746-94), of London, was appren-ticed to George Graham in 1738 and was in partnership with Thomas Mudge at 148 Fleet Street from 1755 until 1771, when Mudge went to Plymouth. He was a maker of long-case clocks.

EARNSHAW, THOMAS (1749-1829), was born in Cheshire and lived there until he had completed his training as a clockmaker. He then moved to London, where he worked for John Brockbank. In 1795 he established his own workshop at 119 High Holborn and made many fine clocks and marine chronometers.

EAST, EDWARD (c1612-c1697), lived in Pall Mall and later in Fleet Street. He was the most famous watch and clock maker of the seventeenth century. He was watchmaker to Charles I, who kept one of East's silver alarm clocks at his bedside. He was an assistant of the Clockmaker's Company when it was formed in 1631 and was twice elected Master, in 1664 and 1682. His work may be seen in the BM and the AM. A walnut long-case clock sold for £8,775 (A 1968).

ELLIOTT, HENRY (w from 1688), was a London long-case clockmaker, as was his son Henry (w from 1720). An oak-cased long-case clock by 'Henry Elliott' sold for £190 (A 1969).

ELLICOTT, JOHN, of All Hallows, was the first of a famous family of clockmakers. He started in business in 1696 and built up a considerable reputation before he died.

ELLICOTT, JOHN, FRS (1706-1772), son of John Ellicott (above) was an eminent and inventive maker who started in business at Sweeting's Alley in 1728. In 1738 he was elected a fellow of the Royal Society. He was the inventor of the compensation pendulum and did much useful work on the cylinder escapement. On his

sudden death he was succeeded by his son Edward Ellicott, who had worked with him for three years. Edward took relatively little interest in the firm.

EMERY, JOSIAH (w 1750-97), a Swiss watchmaker who settled in London, also made clocks, including long-case. He was succeeded by Recordon and Dupont before his death in 1797.

ETHERINGTON, GEORGE (w 1684-1728), was a London maker of bracket and long-case clocks. There is a bracket clock in the AM.

FAGIOLI, D., of Clerkenwell, made barometers c1850-60.

FARRAR, C. and D. (w 1760-80), of Lampeter, Pennsylvania, made long-case clocks with carved hoods and broken pediments.

FENNELL, RICHARD (w 1679-1705), was a London maker of bracket and long-case clocks. A bracket clock by Fennell sold for £350 (A 1969).

FRODSHAM, WILLIAM (w 1781-1807), of London (Red Lion Square) was a pupil of Earnshaw and a maker of watches and striking mantel clocks.

FROMANTEEL, AHASUERUS (w 1663-1700), was the third Ahasuerus in a famous family of clockmakers. He is said to have been the first maker in England of pendulum clocks, as a result of information received by a member of the family about the Huygens' clock in Holland. One of his long-case clocks sold for £13,000 (A 1968). There were many Fromanteels making clocks between about 1630 and 1710 so that it is not always easy to decide on the particular individual responsible for a 'Fromanteel clock'.

GARON, PETER (w 1694-1730), London watchmaker whose son was also called Peter and became a watchmaker.

GAUDRON, PIERRE (w 1690-1740), was a noted Paris watch and clock maker who made bracket clocks in the Boulle style. His work may be seen at Waddesdon Manor, near Aylesbury, Buckinghamshire.

GEMMEL, MATTHEW (w 1805-c1820), was a New York watch and clock maker. One of his long-case clocks sold for £310 at Lewes in Sussex (A 1969).

GILMAN, B. C., of Exeter, New Hampshire, was an American clockmaker, especially of shelf clocks, towards the end of the eighteenth century.

GORDON, ALEXANDER (w 1756-87), was a Dublin watch and clock maker. A long-case clock by Gordon is in the Dublin Museum.

GOULD, CHRISTOPHER (w 1682-1718), was a noted London maker of bracket and long-case clocks.

GRAHAM, GEORGE (1673-1751), was born in Kirklinton in Cumberland and is said to have walked all the way to London in 1688. He was certainly apprenticed in London in that year. In 1795 he started to work for Thomas Tompion and they became close friends; Tompion left his business to Graham when he died in 1713 and Graham carried on in the same premises until 1720, the year in which he became a Fellow of the Royal Society. One of the greatest clockmakers of his time, he invented the dead-beat escapement (c1715) and the mercury compensation pendulum (c1725). In later years his interest in astronomical instruments to some extent diverted his attention from the making of clocks and watches for everyday use. He devised a regulator, an accurate type of clock for scientific use, which became more or less standard for such clocks throughout the nineteenth century; one of the earliest of Graham's regulators sold for £10,600 (A 1969). A repeating bracket timepiece in ebony veneered case with decorated silver flower spandrels (c1715), sold for £11,000 (A 1969), a plain oak long-case clock for £550 (A 1969), and a quarter repeating cylinder watch with a brass scape wheel for £1,100 (A 1969). When Graham died in 1751 he was buried in the same grave as Thomas Tompion in Westminster Abbey.

GRAY, BENJAMIN (1676-1764), was a London maker who worked c1724-1764 and became Clockmaker to George II from 1744. He made miniature and chiming bracket clocks and also watches.

GRETTON, CHARLES (w 1672-1733), of Fleet Street, London, was known for his elaborate bracket clocks, some with basket tops. He also made long-case clocks : an example, 6 ft 6 in high, sold for £180 (A 1966).

GUDIN, JACQUES JÈRÔME (w 1762-89), was a Paris maker of bracket and mantel clocks and of watches. A porcelain bracket clock sold for £330 (A 1969).

HALEY, CHARLES (w 1781-1825), of Wigmore Street, London, made many fine marine and pocket chronometers.

HALIFAX, JOHN (1694-1750), was a maker of barometers. His work may be seen in the V & A.

HARLAND, THOMAS (1735-1807), was a London clock and watch maker who emigrated to America, landing in Boston in 1773. He established a workshop in Norwich, Connecticut, making long-case clocks with brass works. The demand for these was soon so great that he had to take on apprentices, among them Daniel Burnap and Eli Terry. He was a dominating figure in the Connecticut school of clockmakers.

HARRISON, JOHN (1693-1776), the son of a carpenter, worked as a clockmaker with his brother James in the Lincolnshire village of Barrow until 1735 when he moved to London. G. H. Baillie describes him as 'the most remarkable man in the history of horology'. He was entirely self-educated. In 1725 he was using a grid-iron pendulum and three years later had invented the grasshopper escapement. Although the British Government had offered a prize of £20,000 in 1714 for an instrument which would determine accurately the longitude of a ship at sea, he did not hear of this until 1720. He then decided to try his hand. By 1726, with the help of his brother, he produced a remarkably accurate long-case clock. In 1735 he made a huge watch, which was proved on a voyage to Barbados. He made four more, the fifth showing only a two-minute error after a voyage that took five months, and winning him the £20,000. It was a fine instrument, not only efficient but beautiful.

HERBERT, THOMAS (w 1676-1708), worked in Whitehall, London, and was Clockmaker to the King.

HIGGS & EVANS (w 1775-1825), of Royal Exchange, London, made chiming bracket clocks and had an export trade to Spain.

HILL, MATTHEW (w 1744-c1790), of Devonshire Street, London, and later (after 1777) of Upper Charlotte Street, made eight-day bracket clocks with verge striking movements and calendar apertures. They were sometimes in pearwood cases with ormolu mounts.

HOLMES, JOHN (w 1762-1815), was a well-known maker of the Strand, London, and responsible for the installation of the Greenwich Hospital clock.

HOOKE, Dr ROBERT, FRS (1655-1703), was an eminent scientist who became interested in horology and is said to have invented

the anchor escapement (c1676). He had many friends among clock-makers.

HOWARD, EDWARD (b 1813), of Higham, Massachusetts, learnt clockmaking from the Willard family. He then tried to mass-produce watches, with some success.

HOWSE, CHARLES (w 1761-1804), was a maker of bracket clocks.

IVES, CHAUNCEY & LAWSON (w 1831-36), of Bristol, Connecticut, were makers of eight-day brass clocks.

IVES, JOSEPH (w 1810-55), was an American clockmaker of Bristol, Connecticut, who made wooden clocks, eight-day brass clocks and long-case clocks with iron plates and brass wheels. He devised the wagon-spring clock c1830.

JAPY, FRÉDÉRIC (1749-1813), started the firm of Japy Frères at Beaucourt in France. He was a designer of clockmaking tools and was the first to make certain watch parts by machine in 1776. The firm now makes scientific instruments.

JEROME, CHAUNCEY (1793-1860), of Bristol, Connecticut, established his workshop in 1821 and decided to make both clock movements and cases. By 1838 he had made a machine that could mass-produce wheels, and the bracket or shelf clocks he made sold well in the USA and later in Britain. They were made in vast quantities by Jerome & Co of New Haven, Connecticut, who described themselves as 'Manufacturers of Eight and One Day Brass Clocks, Time Pieces and Marine Clocks'. In 1855 Chauncey Jerome's firm became the New Haven Clock Company. Jerome published a *History of the American Clock Business* in 1860.

JEROME, NOBLE, was in partnership with his brother Chauncey Jerome c1824-40. He is said to have invented the thirty-hour weight movement which soon forced all wooden clocks out of production.

JONES, HENRY (1632-95), of the Temple, London, was a well-known maker of bracket clocks and of watches.

KNIBB, JOHN (w c1670-c1710), was a prominent Oxford clock-maker who became Mayor of the city. He made bracket, wall, and long-case clocks. A veneered ebony bracket clock sold for £8,000 (A 1968), and an alarm clock in ebony veneer case for £4,600 (A 1969).

KNIBB, JOSEPH (1640-1711), the brother of John Knibb, worked for Oxford University 1670-77 and then in London. He made bracket, lantern, and long-case clocks of high quality. A bracket clock sold for £6,825 (A 1968); a burr-walnut grande-sonnerie bracket clock for £10,000 (A 1968); and a long-case clock in figured walnut case, the face decorated with cherub and flower spandrels engraved with tulips, for £9,000 (A 1969). See Bentley, W. J. 'That Famous Pendulum Maker, Knibb', *Collectors' Guide*, June 1969, pp 90-93; Lee, R. A. *The Knibb Family—Clockmakers.* 1964.

LE ROY, PIERRE (1717-85), was the most famous clockmaker of his day in Paris. He won the prize of the Academy of Science for his study of time measurement at sea. An example of his work may be seen at Luton Hoo, Bedfordshire. The establishment continued after his death and became Leroy et Fils in 1820.

LISTER, THOMAS (1745-1814), of Halifax, Yorkshire, made clocks and orreries : there is an example of the latter in the University Museum, Glasgow.

LITHERLAND, PETER (w 1790-1800), was a Liverpool watchmaker who patented the rack-lever escapement in 1792.

LOWNDES, JONATHAN (w 1680-1710), sometimes spelt Loundes, was a noted London maker of bracket, lantern, and long-case clocks who worked in Pall Mall.

MANN, PERCIVAL (w 1754-90), was a watch and clock maker of Lincoln's Inn Fields, London, who succeeded in making a small eight-day watch. A quarter-chiming bracket clock sold for £680 (A 1969).

MARKHAM, MARKWICK (w c1725-80), was the trade name of the London clockmaker, Robert Markham, of the Royal Exchange. He specialised in the export of clocks and watches to Turkey. Various partners joined the firm, the best known being F. Perigal.

MARTIN, BENJAMIN (1704-82), of Fleet Street, London, made globes, clocks, and stick barometers. He published several books and his *Lectures* (1743) is much sought after.

McCABE, JAMES (w 1781-c1811), was a noted London maker of bracket clocks; an example sold for £260 (A 1968). His sons continued the business after his death.

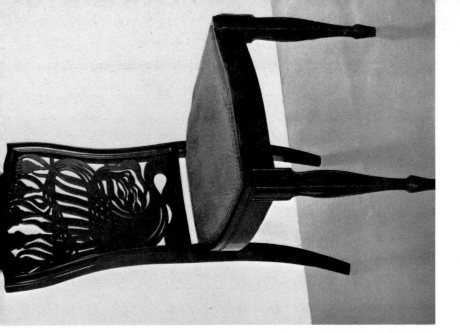

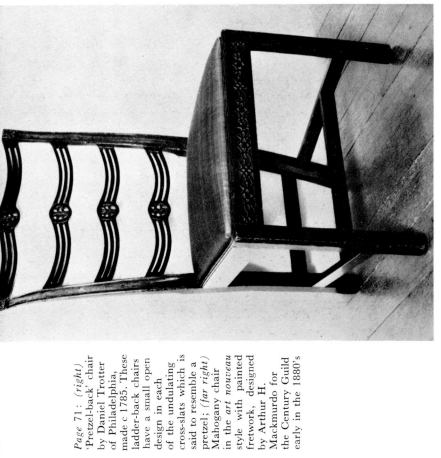

Page 71: (right)
'Pretzel-back' chair
by Daniel Trotter
of Philadelphia,
made c 1785. These
ladder-back chairs
have a small open
design in each
of the undulating
cross-slats which is
said to resemble a
pretzel; *(far right)*
Mahogany chair
in the *art nouveau*
style with painted
fretwork, designed
by Arthur H.
Mackmurdo for
the Century Guild
early in the 1880's

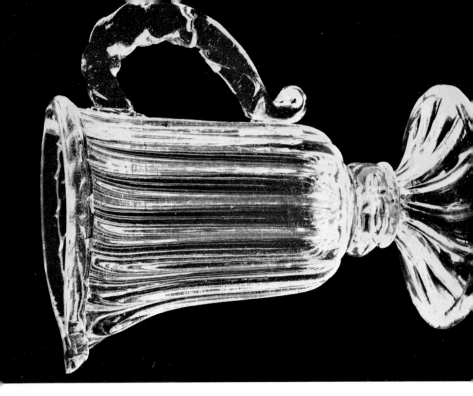

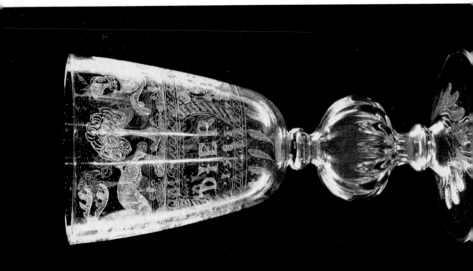

Page 72: (*left*)
Brownish crystal
engraved-glass goblet
made in the London
glasshouse of
Giacomo Verzelini,
dated 1581; (*right*)
clear, colourless glass
jug with mould-
blown ribbing,
probably made in
the Savoy glasshouse
of George Ravenscroft,
c 1676

MOLYNEAUX, ROBERT (w c1800-40), of Southampton Row, London, made bracket clocks with precision lever escapements.

MUDGE, THOMAS (1717-94), was born in Bideford in Devon, the son of a local schoolmaster. He was apprenticed to George Graham and continued to work with him until Graham died in 1751. Mudge then carried on the business at 'The Deal and Three Crowns' in Fleet Street. In 1755 he entered into a partnership with William Dutton which lasted until 1790. Mudge's main claim to fame was the invention of the 'forked' or 'lever' escapement (c1757). This made it possible to reduce the size of clock movements, and could also be used in watches. He used this escapement in a watch he made for Queen Charlotte, but it was not widely used until well into the nineteenth century. In 1771 Mudge moved to Plymouth, where he worked for three years on marine chronometers. In 1774 his first 'Marine Timekeeper' (now in the British Museum) was tested on a voyage to Newfoundland and the Board of Longitude encouraged him to continue his experiments. Two more timekeepers were tested but failed to win the £10,000 that had been offered by the Government for the best work in this field. The Board appeared to prefer the timepieces made by John Arnold (qv). However, after protests and an appeal to Parliament, Mudge was paid £2,500.

MUNROE, DANIEL AND NATHANIEL, of Boston, Massachusetts, were brothers who worked together from 1800 to 1808 and with Samuel Whiting from 1808 to 1817. In addition to their clockmaking business they operated a brass foundry.

NEWSAM, BARTHOLOMEW (d 1593), was Clockmaker to Queen Elizabeth I. A spring-driven chamber clock (c1590) by this maker is in the BM.

NORTON, EARDLEY (w 1750-94), was a noted London maker of St John Street, who made watches and elaborate clocks with grande sonnerie and automaton work, often cased in tortoiseshell.

OGDEN, THOMAS (1692-1769), was a clockmaker who worked in Halifax, Yorkshire. The long-case clocks he made included a rotating globe showing the phases of the moon and were known as 'Halifax Clocks'.

PANCHARD, ABEL (c1760-84), was a London clock and watch maker. A long-case clock with arched silver dial in mahogany case with fluted corners sold for £110 (A 1969).

E

PEARSON, ISAAC, was one of the earliset American clock-makers. He established a workshop in Burlington, New Jersey, c1730.

PECKOVER, RICHARD (w c1707-54), a London maker of Change Alley (1735) and Royal Exchange (1751), was known for watches and small bracket clocks. He apparently took over from Quare & Horseman's in 1733 : his watches are numbered.

PINCHBECK, CHRISTOPHER (1670-1732), of Fleet Street, London, made musical clocks and watches. He invented the zinc-copper alloy resembling gold which bears his name 'Pinchbeck'.

POOLE, JAMES (w c1767-c1780), was a London maker of bracket clocks.

PRIOR, GEORGE (w 1765-1810), was a London watchmaker of Prescot Street.

PYKE, JOHN (w 1747-c1780), was a London maker of Grays Inn who produced bracket clocks and watches.

QUARE, DANIEL (1649-1724), was a Quaker and one of the most famous makers of clocks, watches, and barometers of his time. He was in business at St Martin's le Grand, London, and later at the King's Arms, Exchange Alley. He invented a repeating watch and produced many of these from 1680 onwards, successfully meet-ing a challenge from the Rev Edward Barlow, who sought a patent for a similar device. He became Master of the Clockmakers Com-pany in 1708. His work may be seen at Hampton Court (walnut-veneered long-case clock) and The Vyne, Hampshire (barometer). A late seventeenth-century bracket clock in ebony case with gilded mounts and carrying handle, the silver and gilt dial having an eight-day striking and repeating movement on five bells, engraved *Daniel Quare, London, No 218*, sold for £2,450 (A 1969). A late seven-teenth-century long-case olivewood clock by Daniel Quare with cherub spandrels and ebonised pilasters, 7 ft high, sold for £7,500 (A 1969).

RAMSEY, DAVID (w 1590-1655), who studied in France, was Clockmaker to James I and Charles I. He made spring-driven clocks; the only one known to have survived is in the V & A.

RAYMENT, THOMAS (w 1760-84), of Stamford, Lincolnshire, made long-case clocks. An example with Japan-lacquered case may be seen in Breamore House, Hampshire.

REITH, JAMES (w 1705-36), of the Strand, London, made

watches and long-case clocks. An example may be seen in Little-cote House, Berkshire.

REVEL, JOSEPH (w 1775-1818), was Master of the Paris clock-makers in 1789.

RIMBAULT, JOHN STEPHEN (w 1760-81), was a London maker of bracket clocks with workshops at 7 Great St Andrew's Street. An example with a dial surmounted by a painted panel of figures in contemporary dress playing musical instruments, in an ebonised pearwood case surmounted by brass pineapple finials sold for £1,220 (A 1969) (see p 35).

RITTENHOUSE, DAVID (1732-96), of Norristown, near Phila-delphia, was a noted early maker of long-case clocks. He later turned to making astronomical clocks. Rittenhouse was the first Master of the American Mint, became secretary of the American Philosophical Society, and was for a time Professor of Astronomy in Pennsylvania University.

ROBB, WILLIAM (w 1776-c1797), of Montrose, Scotland, made long-case clocks and musical bracket clocks.

ROUSSEAU, JEAN (1606-84), was a Geneva maker of watches noted for their quality.

SARGENT, WILLIAM (w 1794-1820), of Golden Square, Lon-don, was watchmaker to the Princess of Wales.

SCHOFIELD, JAMES (w c1745-c1760), was a clockmaker of the Strand, London.

SCHREINER, MARTIN (w c1760-80), of Lancaster, Pennsyl-vania, made long-case clocks with broken pediments.

SHEARMAN, W., of Andover, Massachusetts, was an American maker of long-case clocks in the early part of the nineteenth century.

SHEPLEY, EDWARD (w c1780-c1800), was a Manchester maker of long-case clocks.

SOUTH, JAMES, of Charlestown, Massachusetts, was an Ameri-can clockmaker at the end of the eighteenth century, noted for shelf clocks.

SPIEGELHALTER FAMILY. This German family produced wooden clocks in the Black Forest in the first half of the nineteenth century. They established themselves as Spiegelhalter & Co, at 6 Mount Place, Whitechapel Road, London, c1840 and about ten years later became George Spiegelhalter & Co.

STAMPER, FRANCIS (w 1682-1700), of London, made watches and long-case clocks.

STOKES, SAMUEL, was a maker of long-case clocks in the last decade of the seventeenth century, with a workshop at Little Britain, London.

STRETCH, PETER, was one of the earliest clockmakers in Philadelphia, where he settled in 1702.

SULLY, HENRY (1680-1728), was apprenticed to Charles Gretton and worked in London 1705-8. He then went to Europe, eventually settling in Paris in 1715, and directed factories at Versailles and St Germain. He did a great deal of work on marine timepieces.

TABER, ELNATHAN (1784-1854), was born of Quaker parents in New Bedford, Massachusetts. He was apprenticed to Simon Willard at Roxbury and then set up on his own as a maker of shelf clocks. In 1839 Taber took over the goodwill of the Willard business. Examples of his work may be seen in the BMFA.

TERRY, ELI (1772-1852), was apprenticed to Daniel Burnap of East Windsor, Connecticut in 1786. In 1793 he started making brass-wheeled clocks. Shortly afterwards he moved to Northbury. He was soon attempting to standardise his clocks so that the parts would be interchangeable and he could produce his clocks in batches. His opportunity came when two brothers of Waterbury encouraged him with an order for four thousand long-case clock movements, to be made of wood. He set up a special workshop and took on Silas Hoadley to work as his carpenter and Seth Thomas to assemble the parts. The firm became Terry, Thomas & Hoadley.

In 1811 Eli sold out his interest and moved to Plymouth, New Hampshire. There he set about making a clock which would be smaller and more efficient though the parts were still to be of wood. He finally produced the thirty-hour shelf clock with a painted dial and a pendulum. This type of clock became so popular that it very soon replaced the long-case clock. From about 1817 many of his shelf clocks had pillared sides and a scrolled top with a broken pediment; known as 'pillar and scroll' clocks, they were soon being produced by other makers, often with a landscape or pattern painted on the lower panel of the door. In 1833 Eli Terry retired and the business was continued by his eldest son Eli Terry, Jr.

THOMAS, SETH (1774-1859), worked for some years as a maker of cases for long-case clocks. Then, after a brief period with Eli Terry, he started to make wooden and later brass clocks at Plymouth, Connecticut, where he built up a prosperous business, the Seth Thomas Clock Company.

TOMLIN, EDWARD (w 1768-98), was a London maker of Bartholomew Lane and Royal Exchange who produced ormolu striking musical clocks for the Turkish market.

TOMPION, THOMAS (1639-1713), born at Northhill in Bedfordshire, has often been called 'the father of English clockmaking'. He started making clocks at 'The Dial and Three Crowns, at the corner of Water Lane, in Fleet, London' in 1671, and became Chief Watchmaker at the Court of Charles II. He consorted with mathematicians and, drawing on the knowledge and inventions of his friends Dr Robert Hooke and the Rev Edward Barlow, he made great advances in the art of clockmaking, which were fully appreciated by contemporary craftsmen. He was primarily a clockmaker but in 1675 he made a watch with balance springs for Charles II that greatly enhanced his reputation in England and in France. By 1682 he had a large staff of fine craftsmen. In 1701 he took Edward Banger into partnership and in 1704 became Master of the Clockmakers Company. Tompion's clocks made after 1685 are numbered. He also made barometers : there is an example at Hampton Court Palace made for William III.

A grande sonnerie veneered bracket clock signed by Thomas Tompion sold for £12,000 (A 1969), and a walnut long-case clock, with superb panel inlay, the dial signed by *Thomas Tompion*, sold for £4,800 (A 1968). See Symonds, R. W. *The Life and Work of Thomas Tompion*. 1951.

TUPMAN, GEORGE (w 1794-1820), was a watchmaker of Charles Street, Hanover Square, London.

VALLIN, NICHOLAS (w c1598-1640), a Flemish protestant clockmaker, escaped from religious persecution and came to work in London making enamelled watches and small clocks.

VULLIAMY. Family of clockmakers which consisted of three generations—Justin Vulliamy (w 1730-90), Benjamin Vulliamy (w 1775-1820) and Benjamin Lewis Vulliamy (w 1809-54). Justin came from Switzerland. Benjamin, his son, became Clockmaker to

George III (c1800) and Benjamin Lewis upheld the tradition by becoming Clockmaker to George IV.

WAGSTAFF, THOMAS (w 1756-93), or Wagstaffe, of Carey Street and Gracechurch Street, London, made chiming bracket clocks, long-case clocks, and watches. He was a Quaker and visiting Quakers from America often stayed at his home and bought clocks to take back with them.

WAINWRIGHT, SAMUEL (w c1760-95), was a Northampton watchmaker who made examples having enamelled faces decorated with roses and grapevines.

WALKER, JOHN (w 1787-95), of Newcastle-on-Tyne, made long-case clocks and gold enamelled watches.

WALKER, THOMAS (w c1760-80), of Fredericksburg, Virginia, USA, was a noted maker of long-case clocks. An example may be seen in the BMFA.

WARNER, GEORGE, & HINDS, ISAAC (w 1796-1824), of Dublin, made long-case clocks. There is an example at Hampton Court Palace in a mahogany case 6ft 8in. with 12 in circular brass-mounted white-painted dial.

WATSON, SAMUEL (w 1675-c1715), worked both in Coventry and at Long Acre in London, making bracket and long-case clocks. His work may be seen in the Herbert Art Gallery & Museum, Coventry.

WEBSTER, WILLIAM (w 1697-1733), was apprenticed to Thomas Tompion and had his own business later in Exchange Alley, London. He made watches and also bracket and long-case clocks.

WHEELER, THOMAS (w 1655-c1694), was a London maker of lantern and long-case clocks. One of his lantern clocks may be seen at Littlecote House, Berkshire. He is sometimes confused with another Thomas Wheeler who was working a little later.

WHITEHURST, JOHN, FRS (1713-88), was a famous maker, of Derby and London. In 1750 he invented a watchman's clock with a plunger that could be pressed to activate a peg that marked the time on the outer dial. In this way an employer could check his watchman's movements.

WILDER, JOSHUA, of Hingham, Massachusetts, was an American maker of long-case clocks in the early part of the nineteenth century.

WILLARD, AARON (1757-1844), brother of Simon Willard, had a workshop in Washington Street, Roxbury. Early in the 1790s he started a factory in Boston which had a considerable output of long-case and mantel or shelf clocks. From c1802 to c1820 he made banjo clocks which included fine-quality glass paintings. He retired in 1823. His son, Aaron, who originated the 'lyre-clock', continued the business until c1863.

WILLARD, BENJAMIN (1740-1803), was one of a famous family of American clockmakers. He had a workshop in Grafton, Massachusetts from about 1764, in 1768 moved to Lexington, and in 1771 to Roxbury, Massachusetts. The brass dials of his long-case clocks were made locally. He died in Baltimore.

WILLARD, SIMON (1753-1840s), was born in Grafton, Massachusetts, and worked as an apprentice under his elder brother Benjamin (c1770-72). In 1788 he was established in Roxbury and had gained a high reputation. He made long-case clocks (mainly between 1780 and 1802) and in 1801 patented a banjo-shaped clock or 'improved timepiece', though the patent was often infringed. He also patented a 'lighthouse clock' which stood on a cylindrical wooden base to represent the tower of the lighthouse. The clock was enclosed within a bell-shaped glass cover. See Willard, J. W. *Simon Willard and His Clocks*. New York, 1968.

WILLARD, EPHRAIM, of Boston, Massachusetts, made a few very fine long-case clocks but nothing like the number produced by his brothers Aaron, Benjamin and Simon.

WILLIAMSON, JOSEPH (c1693-1724), of Clements Lane, London, invented the equation mechanism. One of his eight-day equation long-case clocks is in the AM.

WILLIAMSON, RICE (c1740), was a London maker of stick barometers.

WILLIAMSON, ROBERT (w 1666-c1714), was a London maker of watches and long-case clocks.

WINDMILLS, JOSEPH (w 1671-1723), a noted London maker of Tower Street, formed a partnership with his son (c1700). He made watches, and bracket and long-case clocks. An ebony silver-mounted bracket clock with movement by Joseph Windmills, 1 ft 2½ in high, sold for £3,600 (A 1969).

WISE, JOHN (w 1646-c1690), was a London maker whose name
is often spelt Wyse. (There were several makers with this name
working in London late in the seventeenth century.) A walnut long-
case clock decorated with floral marquetry, with a 10in dial, spirally
turned columns, cherub and flower spandrels, the hood having a
pierced fret frieze beneath a flat dome, 6ft 8in high, sold for £1,300
(A 1969), and a small repeating clock for £3,200 (A 1969).

WISE, PETER (w 1693-1741), of Cheapside, London, was Master
of the Clockmakers Company 1725-41. He made bracket and long-
case clocks, and watches.

WOOD, B., of Liverpool made marine barometers c1800.

WOOD, DANIEL (w c1714-45), of the Haymarket, London,
made both clocks and watches.

WOOD, DAVID, of Newburyport, Massachusetts, was a noted
American clockmaker working in the closing years of the eighteenth
century. He made a considerable number of bracket or shelf clocks.

YONGE, GEORGE (w 1776-c1815) of 31 Strand, London, was
a maker of bracket clocks. An example sold for £225 (A 1969). See
plate page 36.

BOOKS TO CONSULT

Baillie, G. H. *Watchmakers and Clockmakers of The World*. Lon-
don, 1947 (1966). This book contains over 35,000 names with
historical notes

Bell, G. H. and E. F. *Old English Barometers*. Winchester, 1951
(1970)

Britten, F. J. *Old Clocks and Watches and Their Makers*. London,
1899 (revised edition London and New York, 1956)

Bruton, E. *Clocks and Watches, 1400-1900*. New York, 1967. Lon-
don, 1968

Clutton, C. and Daniels, D. *Watches of Europe and America*.
London, 1965. New York (as *Watches*), 1965

Drepperd, C. W. *American Clocks and Clockmakers*. Boston, 1958

Edey, W. *French Clocks*. London and New York, 1968

Lloyd, H. A. *The Collector's Dictionary of Clocks*. London, 1964.
Cranbury, N. J., 1966

Palmer, B. *The Book of American Clocks*. New York, 1950

Smith, J. *Old Scottish Clockmakers*. London, 1921

5

FASHION PLATES

IT is often assumed that magazines for women are a relatively recent development. In fact they have been on the market for nearly 200 years, and although they have covered a wide range of interests they have always devoted much attention to fashion. From the end of the eighteenth century these magazines carried fashion plates, engraved and usually hand-painted.

They all have great intrinsic interest, because they provide a historical record of costume changes over the years, and many of them are small works of art. Collectors particularly value those signed by the artist and engraver. Relatively few of the magazines have survived intact so it is a field where interesting discoveries can sometimes be made. It would, of course, be wrong to tear apart a fine copy of one of these magazines for the plates, but usually they are badly worn : even the edges of the plates may be frayed. The salvage job should be approached with care, as the text which accompanies the plates often gives detailed descriptions of the dresses and costumes and should be preserved with them. If the plates are to be framed, the descriptions can be pasted on the back.

One of the earliest magazines with costume plates appeared in France in 1778—*Gallerie des Modes et des Costumes Français*. The first to appear in England, in serial form, was Heidelhoff's *Gallery of Fashion* (1794). In the nineteenth century English magazines followed the French publications and fashion plates were often imported from France. America's first magazine, Graham's *American Monthly Magazine of Literature, Art and Fashion*, started in 1824, was very like the French *La Belle Assemblée*.

This section gives two lists. The first shows some of the publications which contained fashion plates, with the period they covered. The second gives the names of fashion-plate artists and engravers. Very little is known about many of these men and woman : collectors will find a hobby that leads inevitably to research. Some museums keep fashion plates in their print rooms.

MAGAZINES WITH FASHION PLATES

1. PUBLISHED IN AMERICA

 Godey's Ladies' Book published in Philadelphia (1830-98)
 Graham's American Monthly Magazine of Literature, Art and Fashion (1824-58)

2. PUBLISHED IN ENGLAND

 The Gallery of Fashion (1794-1803)
 The Ladies' Magazine (1770-1828)
 La Belle Assemblée (1806-69). This was published by John Bell of Southampton Street, Strand, London, and only the title was in French. It was issued with colour plates but also, at a lower price, with the same plates in black and white
 Repository of the Arts (1809-29). Published by Rudolph Ackermann
 The Ladies' Monthly Museum (in the 1820s)
 The Court Magazine (in the 1820s)
 Townsend's Selection of Parisian Costumes (1823-88)
 The World of Fashion (1824-c1837)
 The Ladies' Cabinet (1832-70)
 The Ladies' Gazette of Fashion (1842-94)
 The Englishwoman's Domestic Magazine (1852-77)
 The Queen (1861-)
 Myra's Journal of Dress and Fashion (1875-93)

3. PUBLISHED IN FRANCE

 Gallerie des Modes et des Costumes Français (1778-87)
 Magasin des Modes Nouvelles, Français et Anglaises (first published in 1786)
 La Beau Monde (1806-7)
 Le Petit Courrier des Dames (1822-68) which merged in 1868 with *Le Journal des Demoiselles* (1833-68) and continued into the 1900s
 Le Follet Courrier des Salons (1829-99) which was exported to England
 La Mode (1829-32)
 Le Musée des Familles (in the 1830s)
 Le Bon Ton (in the 1830s)

Journal des Dames (first published in 1834)
Journal des Tailleurs (first published in 1841)
Les Modes Parisiennes (1843-75)
Le Moniteur de la Mode (1843-92)
Le Magasin des Demoiselles (1844-93)
La Mode Illustrée (first published in 1869)
La Mode Artistique
La Revue de la Monde (1872-88)

4. PUBLISHED IN VIENNA
 Die Wiener Moden-Zeitung (1816-44)
 Wiener Mode (first published in 1887)

FASHION-PLATE ARTISTS

ALARS, W., designed plates for *The World of Fashion* from 1824.

CLOSMÉUIL, FLORENSA DE, designed plates for *Le Petit Courrier des Dames.*

COMPT-CALEX (1813-75), whose real name was Dr François Claudius, was a book illustrator who designed fashion plates in the 1840s for *Les Modes Parisiennes.*

DAVID, JULES (1808-92), was a book illustrator but became one of the best known of French fashion-plate artists. He appears to have been most prolific between 1863 and 1870 though he continued to work until his death. He started designing for *Le Moniteur de la Mode* in 1843 and some of his signed plates were used in the *English Woman's Domestic Magazine* in the 1860s and in other magazines published in England, France, Germany, and Spain.

DEGRAINE was a French fashion-plate artist.

DESRAIS designed plates for *Gallerie des Modes et des Costumes Français* (1778-87).

GARVANI, whose real name was Sulpici Guillaume Chevalier, was a caricaturist who designed and engraved plates for *La Mode* in 1830, perhaps the finest plates of their kind ever produced. He also contributed designs for other magazines.

HEIDELHOFF, NIKLAUS WILHELM von (1761-c1839), was born in Stuttgart. In 1784 he moved to Paris and became a miniaturist, but he fled to England during the French Revolution and

worked for Ackermann's. He was responsible for the plates in *The Gallery of Fashion* published in parts 1794-1802. These were hand-coloured and embellished in gold and silver. In 1808 he engraved a number of aquatint plates after Baron Eden, which were published by Ackermann's in *Costume of the Swedish Army*. In 1815 Heidel-hoff became a director of the Mauritshuis at The Hague where he died. See Sitwell, Sacheverell. *Gallery of Fashion 1790-1822.* 1949. (This reproduces a number of Heidelhoff's plates and includes notes on the plates by Doris Langley Moore.)

KIMFEL was an artist for *The Gallery of Fashion* (1795-6).

LELOIR, HÉLOÏSE, worked as an artist in Paris between c1840 and c1870.

NOËL, LAURE, was an artist for *Le Petit Courrier des Dames*.

PAUQUET, A., also worked as an artist for *Le Petit Courrier des Dames*.

PIERPONT, MISS, of Edward Street, Portman Square, London, was a dress-designer whose name appears on plates of her 'creations' in *The Ladies' Magazine* and the *Ladies' Monthly Museum* in the 1820s.

PRÉVAL, E., was a well-known French fashion-plate artist whose work was exported for use in England.

TAVERNE, A. de, designed plates for *Le Petit Courrier des Dames*.

TOUDOUZE, ANAÏS (1822-99), was one of the finest fashion-plate artists in the second half of the nineteenth century. She designed plates for *Le Follet Courrier des Salons* in the 1850s but worked mainly for *Le Magasin des Demoiselles* and *La Mode Illustrée* (see p 53). She was a sister of Laure Noël and Héloïse Leloir.

TOUDOUZE, ISABELLA, daughter of Anaïs Toudouze, designed plates for *The Queen*.

FASHION-PLATE ENGRAVERS

The quality of fashion plates depended greatly on the skill of the engravers who worked from the artists' drawings. Among the engravers whose names appear on well-designed plates are W. ARNDT who worked for *The Gallery of Fashion* (1795-6);

BARREAU and HOUARD, who engraved for Anaïs Toudouze;
A. BODIN, BONNARD, and CODIER, whose names appear on
plates by David Préval; C. M. D'OLERON, who worked from
drawings by Compte-Calix; and VOYSAND, who engraved for
Desrais.

BOOKS TO CONSULT

Holland, V. *Hand Coloured Fashion Plates, 1770-1899.* 1955
Laver, J. *Fashion and Fashion Plates, 1800-1900.* 1943
Sitwell, S. and Moore, D. L. *Gallery of Fashion, 1790-1822.* 1949

6

FIREARMS

No list of gunsmiths can be complete and accurate. So much information has been lost and so many errors by early writers have been perpetuated. The list given here is based mainly on the more interesting firearms that passed through salerooms in 1969. This naturally includes many famous names—the top makers of flintlock pistols, for example, such as Egg, the Mantons, Mortimer, and Wogden, each with an individual style which enables the expert to spot the maker without seeing the signature. It also includes a number of American makers, though the traffic across the Atlantic was largely one-way until after the Declaration of Independence. Before that, weapons were taken in by European immigrants or imported from Britain or France. The first armouries in America were at Springfield in Massachusetts and at Harper's Ferry in Virginia, and the significant period for the manufacture of what are now antique firearms was in the first half of the nineteenth century.

The fact that a maker's name is to be found on a pistol or gun is no guarantee that the whole weapon was made in his workshop. Weapons consist of many assembled parts, and accessories or even major parts may have been acquired from another maker. When guns bear silver mounts, do not assume that the silver hallmark will date the gun. Silversmiths made such mounts in quantity and supplied them on demand : the gun may have been made some years after the mount. It is even possible that an old mount has been placed on a much later gun to deceive the unsuspecting buyer. The proof marks on a gun are a much more reliable indication of date. Until 1813 the only official Proof House in England was the Tower of London, after that date British guns could also be officially marked in Birmingham. The Gun Proof Act of 1855 made it compulsory for every gun sold or used to be proved.

Sometimes a name appears on a firearm which cannot be traced in any of the reference books : it *may* be the name of a retailer. Firearms dealers sometimes arranged for their names to be placed on the weapons they sold.

ADAMS, ROBERT (w c1856-c1866), was a London maker of revolvers. There was much argument in the late 1850s as to the relative merits of the American Colt single-action revolver and the Adams double-action weapon. A 36-bore percussion Dragon revolver in blue-lined and fitted case with powder flask and cap tins sold for £65 and a percussion revolver with powder flask complete in box with trade label for £41 (A 1969).

ALLEN, ETHAN (1808-71), who was born in Bellingham, Mass, set up as a gunsmith in Grafton, Mass, in partnership with Thurber, making pepperbox pistols. From 1842 to 1847 the firm was in Norwich, Connecticut, but then returned to Worcester in Massachusetts. After 1856 when Thurber died a new partnership was formed with Wheelock. In 1864 Wheelock died and the firm became Ethan Allen & Company. The output was entirely civilian. Allen was noted for patenting a double-action lock which put him ahead of Colt in producing quick-firing guns.

BAKER, EZEKIEL (w c1775-1832), a London gunsmith of Whitechapel Road, specialised in duelling pistols.

BARNES, HARMAN (w 1635-c1670), was a London maker of flintlock pistols.

BECKWITH, H. (w 1851-68), was a maker who started in Birmingham and moved to London in 1853.

BENNETT & LACY (w 1805-c1820), were gunsmiths of 67 Royal Exchange, London; makers to HRH The Prince Regent. A pair of signed flintlock presentation pistols sold for £3,000 (1968).

BOND, EDWARD & WILLIAM (w 1840-61), were London makers.

BOSS, THOMAS (w 1812-c1860), of 73 St James Street, London, probably learnt his trade from his father, who worked for Joseph Manton. When Boss died the firm continued as Boss & Co. There is an example of his work in the Castle Museum, Norwich.

BOUTET, NICOLAS (1761-1833), of Paris and Versailles, inherited the title of *Arquebusier du Roi* from his father. He became artistic director of the State arms workshop in the Grand Common of the Palace of Versailles in 1792; this workshop was founded by the French Revolutionary Government when the production of weapons fell too low. The guns and pistols were lavishly decorated. A pair of flintlock target pistols by Boutet (c1800) with walnut full

stocks set in furniture finely cast and chased with anchors, ships, and marine trophies sold for £2,310 (A 1964) and again for £7,140 (A 1968). A single flintlock target pistol inlaid with gold and silver sold for £1,890 (A 1969).

BRANDEN, W. (1637-40), was a London maker of flintlock pistols.

CADELL, THOMAS. There were two Scottish makers of this name; the first worked 1646-78 and the second 1757-67. A pair of flintlock pistols by the second maker covered with engraving and silver strapwork sold for £3,300 (A 1968).

COLLIER, ELISHA H. (w c1810-20), was a London gunsmith who patented an improved system in 1818 for lining up a revolver charge with the barrel. He produced many flintlock revolvers but few have survived in good condition.

COLLIS, J., was an Oxford gunsmith who worked in the early nineteenth century. A full-stocked silver-mounted holster pistol sold for £100 (A 1969) and a pair of 23 bore flintlock pistols for £400 (A 1969).

COLT, SAMUEL (1814-62), was born in Hartford, Connecticut, USA. He ran away to sea at the age of 13 and when 18 was travelling about the country lecturing on chemistry. In 1836 he took out his first American patent for a practical and reliable single-barrel revolver with revolving cylinder (which was later to be adopted by the US Army) and after some time at Paterson, New Jersey, he built up an enormous armoury in Hartford, Connecticut, in 1848 to produce firearms. Some of the firearms were sent to London to be subjected to the London Proof House before being cased and sold in the European Market. A rare and good quality example of his Hartford-English Colt Dragoon revolver sold for £2,205 (A 1969). Many Colt revolvers were sold for use in the Mexican war of 1846-8. The resulting prosperity of his firm made it possible to build a London factory on the banks of the Thames at Pimlico in 1853 which produced some 50,000 revolvers in four years of existence. Many reproductions of Colt revolvers have been made in recent years which can easily deceive the amateur. Genuine early specimens, however, fetch high prices. A Colt Whitneyville Walker Dragoon revolver dated 1847 and stamped with the name of *Samuel Colt of New York City* sold for £4,200 (A 1968).

Miniature portrait of Mrs Johnstone
by Richard Crosse

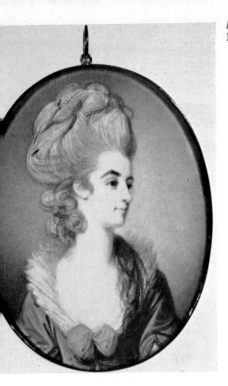

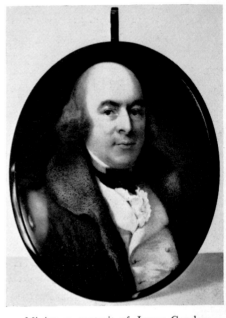

Miniature portrait of James Gandon
by Horace Hone

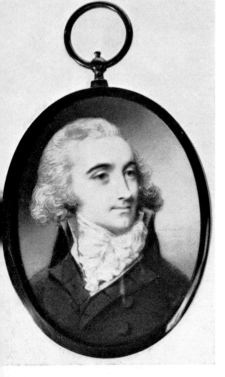

Miniature of an unknown man by
George Engleheart

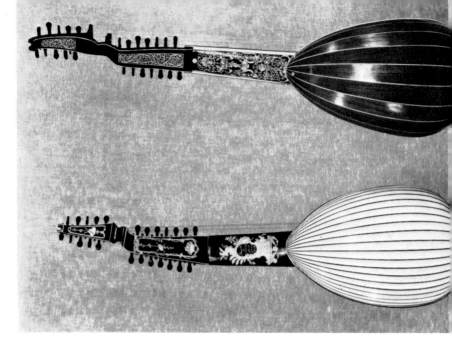

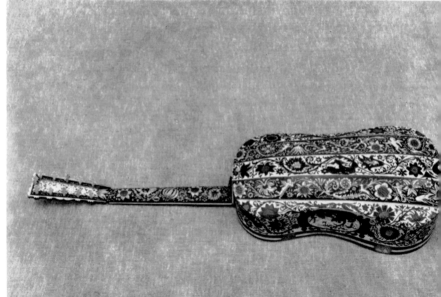

Page 90: *(left)* Guitar made by Joachim Tielke of Hamburg, 1693, decorated in engraved marquetry of tortoiseshell, ivory, and pewter with floral patterns and figures; *(centre)* Theorboe made by Michael Rauch of London, 1762; *(right)* Theorboe made by J. H. Goldt of

COMMINAZZO, LAZARINO (1563-1646), an Italian maker of flintlock pistols, had a workshop at Brescia.

COOPER, B. & J., were New York gunsmiths who made flintlock duelling pistols. A single pistol sold for £504 (A 1969).

DAFTE, JOHN (w 1640-90), was a London maker of flintlock pistols.

DERINGER, HENRY (1786-1868), was born in Easton, Pennsylvania, was apprenticed in Richmond, and from 1806 worked in Philadelphia as a gunsmith, making pistols and rifles for the US Government. He also made flintlock hunting rifles for the Indians of the West. During the Californian gold rush he sold many percussion pocket pistols, which soon became known as 'Deringers'. They were single-shot weapons with a large bore. See Parsons, J. E. *Henry Deringer's Pocket Pistol.* New York, 1952.

DICKSON, JOHN, & SON (w 1820-40), were Edinburgh makers. A pair of percussion back-action 16 bore shotguns in fitted cases sold for £1,112 (A 1968).

EGG, DURS (1750-1834), was a gunsmith at Coventry Street, Haymarket, London, from 1772 to 1834. For a time between 1803 and 1815 he was in partnership with Henry Tatham. Durs Egg was noted for flintlock duelling pistols. A pair of double-barrelled holster pistols, converted to percussion, sold for £500 (A 1968), and a pair of flintlock duelling pistols for £620 (A 1970).

EGG, JOSEPH (w 1775-1837), brother to Durs Egg, worked at No 1 Piccadilly and specialised in duelling pistols. A double-barrelled over-and-under flintlock pistol by this maker with a detachable carbine stock (c1820), sold for £1,418 (A 1969).

FERNANDEZ, JUAN (w 1717-39), was a gunsmith of Madrid, Spain.

FORSYTH, ALEXANDER JOHN, LL D (1768-1843), became a minister at Belhelvie in Aberdeenshire in 1791. In 1807 he patented his application of the detonating principle in firearms. This involved firing a chemical mixture to detonate the gun. It was followed by the adoption of the percussion cap. By 1812 the firm of Forsyth & Co was established at 10 Piccadilly, with James Purdey as the manager, and some of the finest English guns were made there. These are now greatly prized by collectors. See Neal, W. K. and Back, D. H. L. *Forsyth and Co. Patent Gunmakers.* 1969.

F

FOWLER, THOMAS (w c1820-c1840), was a Dublin gunsmith. A pair of brass-barrelled flintlock blunderbusses sold for £300 (1968).

FRENCH, THOMAS (1778-1862), was an American gunsmith of Canton, Massachusetts.

FREY, JOHANN JACOB, was apprenticed to a gunsmith in Vienna in 1691 and made firearms early in the eighteenth century. A wheelock breech-loading sporting rifle with barrel signed by Frey, and dated, sold for £1,750 (A 1969).

GRIFFIN, B. (w 1739-73), was a London maker of flintlock pistols.

HALL, JOHN HANCOCK (1778-1841), was born in Portland, Maine and became interested in firearms during a period of service in the militia; in 1811 he patented a pistol with a rising receiver action. The workshops at Portland turned out large numbers of rifles for the army, and in 1818 he was asked by the Government to undertake a special assignment, working at the national armory at Harper's Ferry until 1840. He was the first maker to succeed in producing interchangeable parts for a rifle.

HARDING, JAMES (w 1815-40), was a London maker of blunderbusses for the mail coaches. Most of them carry the words *For His Majesty's Coaches*.

HARMAN, JOHN (w c1720-50), was a London maker of flintlock pistols.

HENRY, BENJAMIN TYLER (1821-1898), was born in Claremont, New Hampshire. For some years he worked for various gunsmiths and at the Springfield Armory. In 1842 he joined a firm which became Robbins, Kendall & Lawrence, and here he started to perfect the repeating system used in rifles. Later Henry joined the New Haven Arms Company under Henry Winchester, and his improvements were incorporated in the Henry rifle, using a patent granted in 1860. Further improvements led to the Winchester rifle, produced in 1866 by the Winchester Repeating Arms Company of New Haven, though by this time Henry had ceased to be connected with the manufacture. The name derived from Oliver F. Winchester.

HUNTER, JAMES (w c1775-81), was a maker of flintlock pistols at Falmouth, County Virginia, USA.

JOHNSON, R. (w 1822-54), was an American gunsmith of Middleton, Connecticut.

KALTHOFF, CASPAR (w 1654-64), was a London maker of flintlock pistols.

KETLAND is a name which may refer to one of seven firms. Ketland & Co was a London firm (c1750) and there were six Birmingham firms using this name between about 1750 and 1825.

KUCHENREUTER, JOHANN ANDREAS, was a maker of flintlock pistols in the early nineteenth century. His family had been gunsmiths since 1626.

LAROCHE (w c1740-74) was *Arquebusier du Roi* during the reign of Louis XV. After 1743 he had official lodgings in the Louvre. A pair of small Laroche flintlock pistols (1750) sold for £1,700 (A 1969).

LE MAURE was a maker of flintlock pistols in the early eighteenth century.

LE PAGE, JEAN (1779-1822), a Paris maker who worked with Boutet, was one of Napoleon's gunsmiths.

MANTON, JOHN (1752-1834), was born in Grantham in Lincolnshire and served his apprenticeship as a gunsmith in Leicester. By 1775 he was working in London, where he became foreman in John Twigg's workshop. He started his own business in 1781 at 6 Dover Street. In 1814 his son George Henry Manton joined him as a partner and the business became John Manton & Son, making over-and-under percussion pistols. After the death of John Manton, his son continued as a gunsmith, working with Gildon Manton. A flintlock SB sporting gun by John Manton, No 4342 (c1805), sold for £400 (A 1968).

MANTON, JOSEPH (1766-1835), was the younger brother of John Manton and was also born at Grantham. After his apprenticeship he worked for a time with his brother and in 1792 took a shop in Davies Street, Berkeley Square, London. He was an inventive maker and perfected a patent breech for muzzle-loading and made improvements in the sighting of double-barrelled guns for which he was noted. In 1819 he moved to Hanover Square and shortly afterwards was joined by his sons Charles and Frederick, when the firm became Joseph Manton & Sons; in 1826 it went bankrupt. Attempts to restart the business met with little success

and three years after Joseph Manton's death it was sold. Joseph Manton was regarded in his day as the finest gunmaker in the country. A pair of Manton flintlock duelling pistols (c1815) sold for £1,680 (A 1969). See Neal, W. K. and Back, D. H. L. *The Mantons: Gunmakers*. 1967.

McDERMOT (w c1790-1820), was a Dublin gunsmith. A cased pair of his officers' pistols, half-stocked and filled with set triggers and spur trigger guards, with engraved steel mounts, all contained in a velvet-lined brass-mounted case complete with bullet mould, leather-covered combination powder flask, and oil bottle, sold for £400 (A 1969).

MORTIMER, H. W. (w c1780-1835), of Fleet Street, London, became gunmaker to George III. He specialised in flintlock pistols, and made them for duelling and for the mail coaches. One of his double-barrelled flintlock pistols sold for £55 and a stocked flint-lock overcoat pistol for £65 (A 1969).

MORTIMER, THOMAS J. (w c1810-32), was a London maker of percussion duelling pistols. A cased pair sold for £63 (A 1969).

NOCK, HENRY (1741-1804), was a London gunsmith of 12 Ludgate Street—now Ludgate Hill. In 1787 he invented a patent breech and became Master of the Gunmakers Company in 1802. A pair of his percussion pistols sold for £205 (A 1968).

NOCK, SAMUEL, was the son of Henry Nock, from whom he learnt his trade. He was in business at 180 Fleet Street in 1812 and at 43 Regent Street from 1826. In 1836 he became Master of the Gunmakers Company.

NORTH, SIMEON (1765-1825), was a noted American gun-maker of Connecticut, who made fine duelling pistols. A pair (1820) is to be seen in the Smithsonian Institution, Washington, and there are others in the West Point Museum Collection.

PATRICK, JEREMIAH (w c1806-c1820), was a Liverpool gun-smith whose relative Ann (she may have been widow, daughter or niece) continued the business at 45 Strand Street after his death. A pair of flintlock duelling pistols (c1830) sold for £1,000 (A 1969). See plate, p 54.

PURDEY, JAMES (1784-1863), was the son of a London gun-maker. He was apprenticed to T. K. Hutchinson in 1797, worked for Joseph Manton from 1803 to 1806, and then went to Forsyth's,

where for eight years he had experience of the new percussion guns. In 1814 he started his own business at Princes Street, off Leicester Square, and in 1826 took over Joseph Manton's. Although he made flintlock guns, he concentrated more and more on the percussion-cap muzzle loader, particularly after a move to Oxford Street in 1826. The reputation he built up fortunately persisted and the firm of James Purdey & Sons Ltd exists today.

PURDEY, JAMES, JR (1828-1909), was apprenticed to his father in 1843, and took over control of the firm in 1863 when new developments were in the air. In 1879 his son, Athol Stuart Purdey (1858-1939), in turn joined the company, which became James Purdey & Sons.

RAPER, BENJAMIN (w 1830s), was a Leeds gunsmith. A pair of his fully-stocked officer's percussion pistols sold for £185 (A 1969).

REMINGTON, ELIPHALET, JR. (1793-1861), set up workshops for making guns at Ilion on the Erie Canal before 1830 and produced guns under Government contract. In 1859 he produced a new revolver, but the full benefit to the business was reaped by his three sons after his death. Nevertheless, Remington workshops were noted primarily for quality firearms rather than for innovations. See Hatch, A. *Remington Arms in American History*. New York and Toronto, 1956. Karr, C. L. and C. R. *Remington Handguns*. Harrisburg, 1956.

RICHARDS, WESTLEY (w c1812-50), was a Birmingham and London maker, particularly noted for percussion sporting rifles.

SHARPS, CHRISTIAN, founded the Sharps Rifle Manufactory Company at Hartford, Connecticut, in 1851, but left after two years. He had, however, arranged to be paid a royalty on his patents of dropping breechblock percussion firearms which he had developed in 1848. These were produced from 1853 under various managements and various names until 1881 when the company ceased to exist. See Smith, W. O. *The Sharps Rifle*. New York, 1943.

SMITH, HORACE (1808-93), established a workshop at Norwich, Connecticut. In partnership with Daniel B. Wesson he started to market a repeating pistol in 1854. In the following year the firm became the Volcanic Repeating Firearms Company. Horace Smith then left the company and set up workshops in Springfield, Massachusetts, where he was joined by Wesson in 1857. They started to make a revolver for a metallic-rim cartridge and were the only pro-

ducers of this 'Smith & Wesson' type of firearm until the patent expired in 1869. See Parsons, J. E. *Smith and Wesson Revolvers.* New York, 1957.

SPANG & WALLACE were nineteenth-century gunmakers of Philadelphia, USA. A pair of percussion-cap duelling pistols sold for £850 (A 1969).

SPENCER, CHRISTOPHER M. (1833-1922), was a designer and inventor who patented the Spencer repeating shoulder arms in 1860. Thousands of Spencer rifles were made and used during the Civil War. Spencer founded the Spencer Repeating Rifle Company of Boston.

TATHAM, HENRY. See Egg, Durs.

THOMAS, JOHN, of Edinburgh, was a maker of flintlock duelling pistols in the early nineteenth century.

TURVEY, WILLIAM (w c1720-54), was a London gunsmith noted for flintlock pistols. A pair sold for £420 (A 1968).

TWIGG, JOHN (w 1760-90), of Piccadilly, London, was the foremost maker of firearms of his time, producing superbly finished pistols and guns.

WHITWORTH & CO LTD (w 1866-89), were in business at 28 Pall Mall, London, and were noted for percussion rifles. In 1871 the firm became Sir Joseph Whitworth & Co.

WOGDEN, ROBERT (w c1776-90), of the Haymarket, London, made flintlock duelling pistols. A pair of 36 bore flintlock pistols (1776) sold for £950 (A 1969).

WOGDEN & BARTON (w 1790-1800), were London makers of duelling pistols.

WYNN, DAVID (w c1700-25), was a London maker of flintlock breech-loading carbines.

BOOKS TO CONSULT

Akehurst, R. *Game Guns and Rifles from Percussion to Hammerless Ejector in Britain* (London, 1969) contains a valuable last chapter on 'Gunmakers of the Period' with biographical notes on important makers, some notes on London gunmakers and a list of provincial gunmakers.

Blair, C. *European and American Arms.* London and New York, 1962

Boston, N. *Old Guns and Pistols* (London and Fairlawn, 1958) gives a list of nearly 2,000 British gunsmiths to the year 1871 with dates which are 'all accurate to within a decade'.

Carey, A. M. *English, Irish and Scottish Firearms Makers.* London and New York, 1967

Kauffman, H. J. *The Pennsylvania-Kentucky Rifle.* Harrisburg, Pa., 1960 (1968)

Peterson, H. L. (Ed.) *Encyclopaedia of Firearms.* London and New York, 1964 (1967); *The Treasury of the Gun.* New York, 1962; *The Book of the Gun.* London, 1963 (1967)

Taylerson, A. W. E. *The Revolver, 1865-1888.* London, 1966; *The Revolver, 1818-1865.* New York, 1968

Winant, L. *Early Percussion Firearms.* New York, 1959; London, 1967; *Firearms Curiosa.* New York, 1955; *Pepperbox Firearms.* New York, 1952

7

FURNITURE

THE names listed in this section are mainly of furniture makers and designers who flourished in the eighteenth and nineteenth centuries. Until the middle of the seventeenth century furniture was made by joiners—carpenters who were skilled in assembling timber to make tables, benches, stools, and cupboards. It was the advent of veneering, demanding new skills, which led to the establishment of cabinet-makers (in France they were called *ébénistes*), the name given to makers of fine furniture from about 1650 until 1830, when hand craftsmanship was largely replaced by machine.

Designers were very important to cabinet-makers in the eighteenth century because they required a detailed plan to work from. It is for this reason that the men who produced books of designs gained such prominence, whether they made furniture themselves or not.

The names of Kent, Chippendale, Adam, Hepplewhite, and Sheraton are all attached to particular styles, though Adam was an architect and Sheraton may never have made furniture at all. When we speak of a Chippendale bookcase or a Hepplewhite chair we do not mean that these men were the makers. Authenticated pieces are rare. The names are used broadly to describe furniture designed by these men and made by *contemporary* craftsmen. Later pieces can only be accurately described as 'in the Chippendale style' or 'in the Hepplewhite style'.

In America the designer was historically less important. Cabinet-makers and chairmakers were scattered widely along the eastern seaboard, producing 'country-made' furniture, and in the towns the output was greatly influenced by English and French styles. But the late eighteenth-century 'Chippendale', 'Hepplewhite' and 'Sheraton' furniture of America bears its own stamp, reflecting the originality, vigour and independence of a new nation. The blocked front and curved shell furniture is typically American.

French furniture is in a class of its own and the individual *ébénistes* have a particular interest since much of their work is stamped with a name.

ADAMS, NEHEMIAH (1769-1840), of Salem, Massachusetts was a cabinetmaker who sent much furniture to the southern states.

AFFLECK, THOMAS (d 1795), was a Scot from Aberdeen who after gaining experience in London emigrated to America and settled as a cabinetmaker in Philadelphia in 1763.

ALLISON, MICHAEL (w c1800-45), of New York City was a cabinetmaker who favoured the Sheraton and Directoire styles. He was a neighbour of Duncan Phyfe and his work may be seen in the MMANY.

ALLWINE, LAWRENCE (w c1786-c1800), of Philadelphia Pa, was a maker of Windsor chairs that were often painted with his own colours, which were covered by a US patent.

ALWAYS, JAMES, an American maker of Windsor chairs, worked at 40 James Street, New York, in the first decade of the nineteenth century.

APPLETON, WILLIAM (1765-1822), was a cabinetmaker of Salem, Massachusetts.

ASH, GILBERT (1717-85), was a noted maker of Windsor chairs in New York. He was succeeded by his son Thomas Ash (w c1770-c1815), in turn followed by his son, also Thomas Ash.

BACKUS, G. H., of 44 Fulton Street, New York City, made papier-mâché furniture and smaller objects such as buttons and trays in the 1840s.

BARNETT, JOHN (w c1840-50), of New York, made rosewood and mahogany desks in the Louis XV style.

BELL, PHILIP, worked with his mother Elizabeth Bell, c1740-50 : a signed burr-walnut bureau of this period has been noted. Thereafter he worked on his own : a signed mahogany secretaire tallboy of the 1760s has been recorded.

BELTER, JOHN HENRY (1804-63), was of German origin : his name at birth was Johann Heinrich Belter. He was trained as a woodworker in the Black Forest. By 1844 he was working as a cabinetmaker in Chatham Square, New York, and by 1858 had established a large workshop in Broadway employing many apprentices.

His furniture had an individual style. He favoured rosewood and devised a way of producing a laminated wood which could be bent and elaborately carved. His rococo pieces are designed with cabriole

legs, and serpentine curves, and his tables are marble-topped. They appealed to those Americans who wanted furniture that would reflect the richness and solidity of their social position. His work may be seen in the MMANY.

BENEMAN, JEAN GUILLAUME, was a German cabinetmaker who moved to Paris c1784. In the following year he became *maître-ébéniste*. He made and repaired furniture for the Court at the time when Riesener was proving too expensive. He is noted for commodes which are stamped G. Beneman but, in general, his work does not show the delicacy of many of the French craftsmen.

BENNETT, SAMUEL (d 1741), probably started work as a cabinetmaker in the 1690s. He sometimes signed his work : there is a burr-walnut bureau inlaid with marquetry by Bennett in the V & A.

BEVAN, CHARLES (w 1865-69), was a designer of furniture in the Victorian Gothic style and of exhibition furniture. A cabinet of ebonised and gilt wood with stoneware plaques by George Tinworth (see under Pottery p 218) was made for the London International Exhibition of 1872 and may be seen in the V & A. See Jervis, S. *Victorian Furniture*. 1968. Plate 65.

BOULLE, ANDRÉ-CHARLES (1642-1732), born in Paris, the son of a carpenter, learned many skills. He was a painter, architect, bronze worker and, above all, a superb cabinetmaker who became *ébéniste du roi* in 1672. For the previous eight years he had worked as a freelance, making furniture with his own style of marquetry which consisted of inlays of tortoiseshell, ivory and brass.

Boulle made a good deal of furniture for Versailles—examples may be seen in the W Coll, London, and in the Louvre, Paris. Attributions are not always certain for Boulle did not sign his work.

The atelier was continued after his death by his sons André-Charles (d 1745) and Charles-Joseph (d 1754). See Honour, H. *Cabinet Makers and Furniture Designers*. 1969. pp 50-55.

BOULTON, MATTHEW (1728-1809). See pp 225 and 253.

BRETTINGHAM, MATTHEW (1699-1769), was a furniture designer who had been a pupil of William Kent.

BRINNER, JOHN (w c1762-1790), was a London cabinet and chair maker who started a business in Broadway, New York. He brought skilled workmen with him, including carvers.

BRUSTOLON, ANDREA (1662-1732), was an Italian who trained as a sculptor in Belluno and then in Venice. He carved furniture in boxwood with figures, putti, mermaids and mythological animals. In 1699 he returned to Belluno and remained there carving furniture and religious subjects.

BURGES, WILLIAM (1827-81), was an architect who designed some furniture privately for his friends. He wrote a book on *Art Applied to Industry* (1865) and was an advocate of the massive Gothic style decorated in colour and gilt, such as the washstand to be seen in the V & A. See Jervis, S. *Victorian Furniture*. 1968. Plate 51.

BURLING, THOMAS (w c1772-1800), was a cabinetmaker who established a business in Chapel Street, New York, later to become Thomas Burling & Son at 25 Beekman Street.

CAFFIÉRI, JACQUES (1678-1755), made bronze mounts for furniture. See under Bronzes, p 50.

CARLIN, MARTIN (d 1785), was a German cabinetmaker who became a *maître-ébéniste* in 1766. He made furniture in lacquer, often decorated with plaques of Sèvres porcelain. Much of his work was marketed through the dealer Darnault. Examples may be seen at Waddesdon Manor, near Aylesbury.

CARLISLE, JOHN (1762-1832), was born in Boston and started as a cabinetmaker in Providence, working in the style of Hepplewhite and Sheraton.

CHAMBERS, SIR WILLIAM (1726-96), was Architect (with Robert Adam) to George III and, like Robert Adam, concerned himself with the way his buildings were furnished. Between 1740 and 1749, before starting his professional career, he visited China, where he took a keen interest in Chinese arts and crafts. In 1757 he published *Designs of Chinese Buildings, Furniture, Dresses, Machines and Utensils*. The Pagoda at Kew was planned by Chambers and he designed a good deal of furniture.

CHANNON, JOHN (w 1737-c1760), was a casemaker of St Martin's Lane, London, whose furniture was mounted in ormolu and inlaid with brass and tortoiseshell. Some signed pieces, such as bookcases, are known to exist.

CHAPIN, AARON (c1751-1838), was born in Chicopee, Massachusetts. In 1783 he set up as a cabinetmaker in Hartford, Connecticut. He was noted for fine highboys.

CHAPIN, ELIPHALET (1741-1807), was one of the finest cabinetmakers of East Windsor, Connecticut, and later Hartford, Connecticut. In the 1780s he made Chippendale highboys of the finest quality with spiral rosettes on broken pediments.

CHIPPENDALE, THOMAS (1718-79), was born in Yorkshire and probably moved to London around 1745. In 1753 he established himself as a cabinetmaker at 60 St Martin's Lane. The following year he published *The Gentleman and Cabinet Maker's Director*. This went into several editions—the second in 1755, the third in 1762 (with more plates). It was reissued in London and New York in 1957. The designs in this pattern book included many by Henry Copland and Matthias Lock. *The Director* was the book which brought Chippendale fame : previously he was regarded as a good though not outstanding maker. In 1771, Thomas Haig formed a partnership with him. When Chippendale died in 1779, his eldest son took his place. See Brackett, O. *Thomas Chippendale*. 1924; Coleridge, A. *Chippendale Furniture, The Work of Thomas Chippendale and his Contemporaries in the Rococo Taste*, 1745-1765. 1968.

CHIPPENDALE, THOMAS THE YOUNGER (1749-1822), was a partner in the firm of Chippendale, Haig & Co from 1779. Haig left in 1796 and Chippendale carried on but went bankrupt in 1804. However, he re-established himself in 1814, this time in the Haymarket, and in 1821 moved to Jermyn Street. He did a great deal of work at Stourhead in Wiltshire, which can be seen in the library. Thomas Chippendale the Younger was also a painter who exhibited at the Royal Academy.

CIPRIANI, GIAMBATTISTA (1727-85), a Florentine painter and decorator, came to England in 1755 with Sir William Chambers and acquired a considerable reputation with his designs for the decorative additions to furniture.

CLARK, DANIEL (1768-1830), of Salem, Massachusetts, was trained as a cabinetmaker in Boston. He made household furniture in Salem from 1796.

CLAY, HENRY, of Newhall Street, Birmingham, patented a process for making 'paper-ware' in 1772. This was made from many layers of paper glued together in a mould and heated. The product could be worked like wood and was used for making furniture.

Clay established a thriving business in Bedford Street, London, with showrooms in Covent Garden. He was made 'Japanner in Ordinary to George III and the Prince of Wales'. Paper ware was widely used for table tops, which were decorated by well known artists.

COBB, JOHN (d 1778), was one of the finest cabinetmakers of the mid-eighteenth century. He was in partnership with William Vile and together they were makers and upholsterers to George III, having premises at St Martin's Lane from 1755. Vile retired in 1765 but Cobb carried on the business until his death.

COLCUTT, T. E. (1840-1924), architect and furniture designer, was one of the first to use ebonised wood with painted ornament, and to include bevelled glass panels in his pieces. A cabinet by Colcutt can be seen in the V & A.

CONNELLY, HENRY (1770-1826), was a Philadelphia cabinetmaker who worked in the Sheraton and Empire styles.

COPLAND, HENRY. See Lock, Matthias.

COWPERTHWAITE, JOHN K. (w c1800-35), was a chairmaker of 4 Chatham Square, New York.

CRESSENT, CHARLES (1685-1768), was born at Amiens in France, the son of a sculptor, François Cressent. He started to work as a sculptor but was soon working for Joseph Poiton, a noted *ébéniste*. When Poiton died, Cressent married his widow and became *ébéniste* to the Duke d'Orleans, Regent of France. As an *ébéniste* he was not allowed to make bronze mounts for his furniture although he had been trained as a fondeur : several times Cressent was in trouble for breaking this rule. He was a fine cabinetmaker and designer. His furniture has veneered surfaces and finely sculptured bronze mounts. His work was not signed. Examples may be seen in the W Coll and at Waddesdon Manor, near Aylesbury.

CRUDEN, JOHN (1740-c1828), was particularly interested in 'Chinese' fret patterns and produced a book which was widely used by craftsmen in the furniture trade—*The Joyner and Cabinet-maker's Darling*.

DARBY, MATHIAS (d c1780), was an engraver who prepared most of the plates for the pattern books of Chippendale and of Ince and Mayhew. He also published books of his own—*A New Book on Chinese, Gothic and Modern Chairs* (1750-51) and *Chinese Designs* (1754).

DE WITT, JOHN, & CO (w c1786-1801), were New York makers of Windsor chairs.

DENNIS, THOMAS (c1638-1706), worked in Ipswich, Massachusetts, from c1670 to 1694. He was a joiner who made chairs, chests, boxes and cupboards. He used white oak and his pieces were richly carved, especially the panel decoration. He is particularly noted for his 'Pilgrim' wainscot chairs. His work may be seen in the MMANY and BMFA.

DISBROWE, NICHOLAS (1612-83), was born at Walden in Essex, England and emigrated to America before 1639 where he became a joiner in Hartford, Connecticut, making mainly oak chests. Most of these have stiles and rails profusely carved. Examples in MMANY and in Yale University Art Gallery.

DUBOIS, JACQUES (c1693-1763), became *maître-ébéniste* in Paris in 1742, working in the Louis XV style and decorating his lacquer furniture with gilt bronze mounts. A chinoiserie black-lacquer bombé commode, signed Dubois, with a moulded serpentine marble top, the front with two drawers decorated with groups of figures in green, red and blue, sold for £15,000 (A 1969). When Dubois died, his widow and sons carried on the business. Réné Dubois (d 1799) continued to use his father's stamp and made furniture for the Court.

DUNLAP, SAMUEL, Jr. (1751-1830) was the best known member of a family of cabinetmakers working in Concord, New Hampshire. He used large shell motifs, similar to those favoured by John Townsend, on highboys, chests of drawers and high-back chairs. His highboys have distinctive fretwork tops.

EDGE, WALTER (w c1765-1810), of Gilmantown, New Hampshire was a notable country craftsman who used local woods, such as maple, rather than imported mahogany, for his furniture. He continued to use the Chippendale style despite the fact that urban tastes favoured American Directoire at this time.

EGERTON FAMILY. Matthew Egerton worked as a cabinetmaker in New Brunswick, NJ, from c1742 until his death in 1787, making Hepplewhite and Sheraton case pieces. His son, Matthew, Jr, continued the business until c1830.

ELFE, THOMAS (1719-75), was a cabinetmaker of Charleston, South Carolina, who favoured fretted pieces of furniture. His work

may be seen in the Charleston Museum which has issued a booklet about him. His son, Thomas Elfe (1759-1825), took over the business, moved to Savannah for a short period from 1784, but had re-established himself in Charleston by about 1800.

ELLIOT, CHARLES (w c1784-c1846), was one of a family of cabinetmakers that dated back to the 1680s. He worked at Nos 97 and 98 New Bond Street, London, until 1808 and was Upholsterer to George III. From 1808 the business was at 104 New Bond Street under the name of Elliott & Francis, but whether he was personally involved until 1846 when the firm ceased to operate is not known.

ELLIOT, JOHN (1713-91), was born at Bolton, England and emigrated to America in 1753. A Quaker, he established a business as a cabinetmaker in Philadelphia, and was noted for looking-glasses. He retired in 1776.

ESSEX, CHARLES, of 19 Pantheon, Oxford Street, London, a cabinetmaker, was working in the 1820s. Signed pieces occasionally turn up in auction sales.

FROTHINGHAM, BENJAMIN (1734-1809), was born in Boston, the son of Benjamin Frothingham (d 1765) a cabinetmaker. He started in the same trade in Charlestown, Massachusetts, in 1756 but his career was interrupted by a period in the army where he rose to the rank of major and became a friend of George Washington. In 1782, however, he returned to work as a cabinetmaker, his mahogany block-fronted furniture being mainly in the Chippendale and Hepplewhite styles. His son Benjamin (d 1832) was also a cabinetmaker.

GAINES, JOHN II (1677-1750), of Portsmouth, New Hampshire, was a maker of traditional Queen Anne furniture of Colonial design, especially chairs.

GAINES, JOHN III (1704-1743), worked with his father and then started his own business in Portsmouth, New Hampshire in 1724. He made fine maple chairs with rush seats. Examples in MMANY and the Winterthur Museum, Delaware.

GATES, WILLIAM (w c1777-83), of Long Acre, London, was Cabinetmaker to George III.

GAUDREAU, ANTOINE-ROBERT (c1680-1751), was a Paris cabinetmaker who produced furniture in the Louis XV style for the Crown and for Madame de Pompadour. Some furniture he made

for Versailles (c1738) with bronze ornamentation by J. Caffiéri may be seen in the W Coll.

GAUTIER, ANDREW (1720-84), was born in New York of Huguenot stock. He was one of the first craftsmen to make Windsor chairs.

GIBBONS, GRINLING (1648-1721), was born in Rotterdam and came to England when he was nineteen years of age. Many people regard him as the most famous of all woodcarvers. In 1671 he was discovered by John Evelyn carving a crucifix; he was appointed by Charles II to a place in the Board of Works, working in the Chapel at Windsor. Sir Christopher Wren employed him at St Paul's Cathedral and Hampton Court. Some regard his work at Petworth House in Sussex as among his finest. He usually carved in lime or pearwood and particularly favoured birds, fruit and flowers in his carvings. He became Monumental Carver and Master Carpenter to George I in 1714. Gibbons' work has been much copied.

GILLINGHAM, JAMES (1736-1791), of Philadelphia, was a noted maker of chairs of Chippendale style with carved crest rails. A few pieces are marked with his name. His nephew, also James Gillingham, is said to have worked with him. Examples may be seen in the MMANY, BMFA and in the Winterthur Museum, Delaware.

GILLOW, ROBERT (1703-73), was a cabinetmaker of Lancaster who developed a business founded by the family in 1695. He was so successful that he supplied increasing quantities of fine furniture to the London market and for export. A London branch was opened in 1761. The firm was continued by Richard Gillow when his father died (he had already been working with him since 1757) and it remained a family concern until 1811. The business still continues as Waring & Gillow Ltd. Stamped pieces of Gillow's furniture are not uncommon. The trade name was included on most pieces from about 1790 to 1800 and again after 1820. Fine examples of Gillow's furniture may be seen at Leighton Hall, near Carnforth in Lancashire, which belonged to the family. (It is open to the public on certain days in summer.)

GODDARD, JOHN (1723-85), was the son of a shipwright. He was apprenticed to the cabinetmaker Job Townsend and later started his own business in Newport, Rhode Island, where in the 1760s he

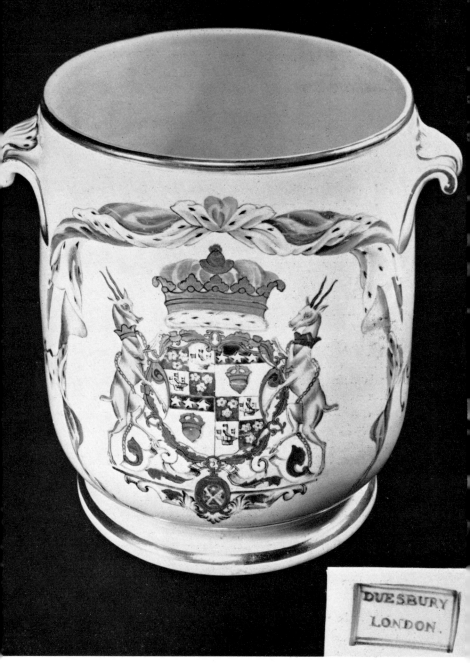

Page 107: A Derby porcelain wine cooler made for the Duke of Hamilton in 1790 bearing his arms and the exceptionally rare mark of 'Duesbury London' in puce

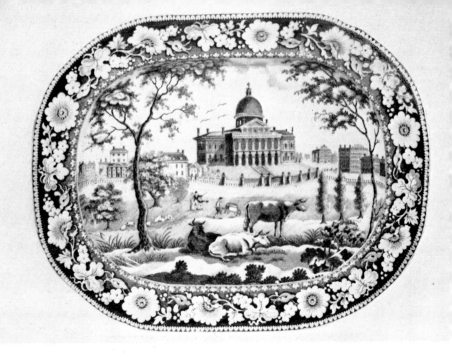

Page 108: *(above)* Transfer-printed blue dish of Boston State House by John Rogers & Son of Longport, Burslem, for the American market, c 1820; *(below)* Transfer-printed blue dish of Denton Park, Yorkshire, by John and Richard Riley of Burslem, c 1820

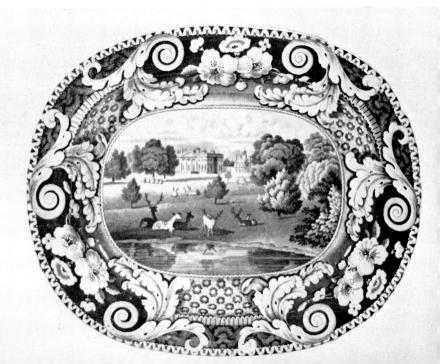

became the leading cabinetmaker, making block-front furniture in the Chippendale and Hepplewhite styles, mainly of mahogany. His pieces were no mere copies but showed great originality He favoured carved shell ornamentation on the aprons of furniture and on long-case clocks. His tables are noted for legs with an open claw and ball foot. His desks are beautifully fitted with many 'secret' drawers. Examples of his work may be seen in the BMFA. When he died his son Thomas Goddard (1765-1858) carried on the business.

GODWIN, EDWARD WILLIAM (1833-86), was a Bristol architect who worked in the Gothic style. He moved to London in 1862 and became interested in Japanese craftsmanship. This influenced his furniture designs, which break away from the heavier Victorian tradition, and show a more delicate and graceful type of construction for which he often used ebonised wood. Some of his designs for furniture made about 1867 by William Watt, may be seen in the V & A. See Honour, H. *Cabinet Makers and Furniture Designers.* 1969. pp 252-7.

GOODISON, BENJAMIN (d 1767), was a noted cabinetmaker in the reign of George II. He made a small fortune supplying furniture for some of the larger country mansions. His son, Benjamin, and his nephew, Benjamin Parran, carried on the business until 1783.

GOSTELOWE, JONATHAN (1744-1806), of Philadelphia, was one of the greatest American cabinetmakers of his time. He favoured the Chippendale style but added his own characteristic touches : broad-shaped serpentine feet to support chests and bureaux, for example. In 1788 he became chairman of the Gentleman Cabinet & Chair Makers in Philadelphia. He retired in 1793. Examples in Philadelphia Museum of Art.

GOUTHIÈRE, PIERRE (1732-1813), worked in Paris from 1758 as a noted *maître-doreur*, making decorative bronzes for fine furniture including some made by Adam Weisweiler.

GRENDEY, GILES (1693-1780), was a Clerkenwell joiner and chairmaker, one of the few who marked his furniture with a trade label. In 1766 he became Master of the Worshipful Company of Joiners of the City of London.

GUMLEY, JOHN (w 1694-1729), was a cabinetmaker who had a workshop in the Strand and a looking-glass manufactory at Lambeth, and was cabinetmaker to George I. From 1714 he was in partnership with James Moore.

G

HAIG, THOMAS (d 1703), was partner to Thomas Chippendale 1771-9 and to Thomas Chippendale the Younger from 1779 to 1796.

HALLETT, WILLIAM (1707-81), set up in business in 1732 and became one of the most notable and sought-after cabinetmakers of the period. He numbered many wealthy aristocrats among his clientele, and made enough money to retire in 1769.

HASELAR, EDWIN (w 1832-1845), was a decorator of papier mâché for Jennens & Bettridge; he favoured floral designs.

HENNESSEY, EDWARD (w c1840-60), was a cabinetmaker of Brattle Street, Boston, Massachusetts. He made American Empire furniture and also pieces of cottage furniture.

HEPPLEWHITE, GEORGE (d 1786), was apprenticed to Robert Gillow in Lancaster and later moved to London and opened a shop in Cripplegate. Little is known about him apart from the fact that he designed furniture : although he no doubt actually made furniture, especially chairs, which were his main interest, nothing can certainly be attributed to him. Hepplewhite's name came before the public only after his death when his widow published his designs in *The Cabinet Maker and Upholsterers' Guide* (1788). This had run into three editions by 1794.

HITCHCOCK, LAMBERT (1795-1852), established a chair factory at Barkhamsted, Connecticut, in 1818. He first made parts to be assembled elsewhere and later whole chairs which were sold all over the country. In 1826 he enlarged his premises and his many workers formed the settlement of Hitchcockville (now Riverton). His mass-produced chairs have curved tops and a carved back slat; the uprights continue to form the legs. Decoration consists of stencilled designs on a black base. These chairs were widely copied and the Hitchcock name is now given to all chairs of the same type and period. Competition forced Hitchcock into bankruptcy in 1829. In 1830 he formed a partnership with Arba Alford under the name of Hitchcock, Alford & Co. Then, in 1843 he started again on his own with the Unionville Chair Company which was not successful. See Brazen, E. S. 'Random Notes on Hitchcock and his Competitors' in *The Antiques Book*. New York, 1950. pp. 35-42.

HOLBIRD, ISAAC, had a cabinet manufactory at 13 Catherine Street, London, in the early nineteenth century.

HOPE, THOMAS (1769-1831), was born into a prosperous banking family of Scottish origin in Amsterdam. He was a student of architecture and travelled widely in the years from 1786 to 1795, then settled in London. He took a house in Duchess Street in 1799 and in 1807 acquired Deepdene, a country house in Surrey. He was a great collector and patronised a number of artists, Flaxman and Benjamin West among them. His great interest was in Greek and Egyptian antiquities. These formed the basis of his furniture designs and were widely used after the publication of his *Household Furniture and Interior Decoration* (1807). See Watkin, D. *Thomas Hope and the Neo-Classical Idea.* 1968.

HOPPENHAUPT, JOHANN MICHAEL (1709-c55), was born at Merseburg and learnt his craft as a cabinetmaker in Dresden and Vienna. He worked in a number of places until 1746 when he moved to Berlin and became a designer for Frederick the Great. In 1750 he returned to his birthplace and started to design domestic furniture in a rococo style. See Honour, H. *Cabinet Makers and Furniture Designers.* 1969. pp 115-19.

INCE, WILLIAM (w 1759-1803), was a cabinetmaker and upholsterer in partnership with Thomas Mayhew. Together they produced *The Universal System of Household Furniture* (1759-62).

JACOB, GEORGE (1739-1814), was a German cabinetmaker in the eighteenth century who was noted for his chairs, settees and beds. He worked in Paris to the designs of Jacques-Louis David and became *maître-ébéniste* in 1765. He signed his work G. IACOB. Jacob retired in 1796 and his two sons George II and François-Honoré continued the business, but in 1803 George II died and he started to work again. The firm was then known as Jacob-Desmalter et Cie. He retired a second time in 1813 but the firm continued to make Empire-style furniture.

JENNENS & BETTRIDGE were Birmingham makers of papier-mâché who took over Henry Clay's factory in 1816 and became pre-eminent in this field. Although the material was normally used to make small articles, such as tea-caddies, glove boxes, letter racks, etc, it could also be used for tables and chairs. It was often painted with coloured scenes or decorated with pearl-shell inlay. The main output was between 1820 and 1850. Pieces were usually signed. Examples may be seen at the V & A.

JENSEN, GESSEIT (w 1680-1715), came from the Low Countries and settled in London in the 1670s. He made furniture for Charles II and for William and Mary, often with metal marquetry. In 1693 he established himself in St Martin's Lane and built up a successful business. The spelling of his name varies a great deal : he has often been called 'Johnson'.

JOHNSON, EDMUND (w c1780-1811), of Salem, Massachusetts, made furniture, especially desks and secretaires, in the Hepplewhite style to which he added his own individual touches and decoration.

JOHNSON, THOMAS (d c1778), was a carver and gilder who worked in London from 1755 to 1763 and favoured the rococo style. He is known chiefly for his design books—*Twelve Girandoles* (1755), *The Book of the Carver* (1758), and *One Hundred and Fifty New Designs* (1756-8). He had a considerable influence particularly on Ince and Mayhew. See Hayward, H. *Thomas Johnson and the English Rococo.* 1964.

JONES, WILLIAM (d 1757), was an architect and furniture designer who published *The Gentleman's and Builder's Companion* (1739). His furniture bears some similarity to that of William Kent.

KELSO, JOHN, was a noted American maker of Windsor chairs, first in Philadelphia and later, from 1774, in New York.

KENT, WILLIAM (c1686-1748), was born at Bridlington in Yorkshire. He was both architect and furniture designer and combined these functions when working on large houses such as Houghton Hall in Norfolk. His style was influenced by baroque and the furniture is heavily decorated with acanthus leaves, masks, and shells, and is carved and gilded. See Jourdain, M. *The Work of William Kent.* 1948.

LACROIX, ROGER, sometimes known as Roger Vandercruse, was the son of a Flemish cabinetmaker. He became a *maître-ébéniste* in Paris in 1755 and produced furniture of delicacy and fine proportions sometimes with inset plaques of Sèvres china. His sister married Jean-François Oeben. Examples of Lacroix furniture may be seen at Waddesdon Manor, near Aylesbury.

LANGLOIS, PETER (b 1738), was born in Paris. He established a workshop in Tottenham Court Road, London, where he made furniture in the Boulle style with metal and tortoiseshell inlay.

LANNUIER, CHARLES-HONORÉ (w 1779-1819), was born at Chantilly in France. He moved to New York as a small boy and from 1805 worked as a cabinetmaker in the Louis XVI and French Empire styles. He was Duncan Phyfe's chief competitor. The business was continued for five years after Lannuier's death by J. Gruez, his foreman.

LE GAIGNER (w 1814-1830), a Paris cabinetmaker, established a workshop at 19 Queen Street, Edward Road, London, in 1814, to produce Boulle-type furniture with hand-cut brass inlay. He became Cabinetmaker to the Prince Regent.

LELEU, JEAN FRANÇOIS (1729-1807), was born in Paris. He was trained by J. F. Oeben and became *maître-ébéniste* in 1764, working for the Court. In 1780 he formed a partnership with his son-in-law, C. A. Stadler. Leleu's work shows his versatility : he produced pieces in differing styles, most of them stamped J. F. Leleu.

LINNELL, JOHN (d 1796), was a cabinetmaker and designer of Berkeley Square, London, from 1763.

LOCK, MATTHIAS, woodcarver and designer, played a major part in introducing the rococo style to England. Between 1740 and 1746 he published many designs, mainly for carvers—*A New Drawing Book of Ornaments, Shields, Compartments, Masks* (c1740), *Six Sconces* (1744), and *Six Tables* (1746). He then formed a partnership with Henry Copland and they produced together *A New Book of Ornaments* (1752) and worked for Thomas Chippendale on plates for his *Director*. Lock then produced two more books— *A New Book of Pier Frames* (1769) and *A New Book of Foliage* (1769). A pair of brilliantly carved, painted and giltwood candlesticks, designed and made by Lock about 1744, sold for £23,000 (A 1968).

McINTIRE, SAMUEL (1757-1811), of Salem, Massachusetts, was one of the finest carvers of his time. His work was delicate and in the neo-classical style, the decoration often including a basket of fruit. He made chairs which he carved himself, but he also carved furniture for other makers such as Benjamin Frothingham. Examples of his work may be seen in the BMFA.

MAGGIOLINI, GIUSEPPE (1738-1814), was born at Parabiago, near Milan, and after training in a monastery workshop, set up his own establishment as a maker of furniture, despite opposition from the professionals in the nearby city. He built up a successful

business and had many customers among the noble families of North Italy. He is noted for commodes and tables which are severely rectangular in shape and beautifully decorated with marquetry. He avoided carving and decorative mounts. See Honour, H. *Cabinet Makers and Furniture Designers.* 1969. pp 164-7.

MANWARING, ROBERT, cabinetmaker and chairmaker, published several design books, among them *The Cabinet and Chair-maker's Real Friend and Companion* (1765) and *The Chairmaker's Guide* (1766).

MAROT, DANIEL (1661-1720), was born in Paris but in 1685 fled to Holland where he designed furniture, ceramics and even gardens for William and Mary. From 1694 he spent four years working in Hampton Court Palace. He favoured the baroque style with generous carving and designed beds from which fine drapery could be hung.

MAYHEW, JOHN (d 1811). See Ince, William.

MEISSONNIER, JUSTE-AURÈLE (1675-1750), a native of Turin, was a designer of bronzes and furniture; he published his patterns (1723-35) and had a decisive influence in the development of the rococo style.

MILLS & DEMING (w c1793-c1805) of New York, produced very fine Hepplewhite-style furniture, especially sideboards and secretaires.

MOORE, JAMES (d 1726), was a cabinetmaker who worked c1708-26 and became Cabinetmaker to the Crown. He was involved in furnishing Blenheim, making pieces decorated in gilt gesso. From 1714 he was in partnership with John Gumley.

MORGAN & SANDERS (w 1801-22) were cabinetmakers and upholsterers, in business 'three doors from the Strand' in Catherine Street, London. This was a large firm with over 100 workers and specialised in making beds and dining-room furniture, and also 'knock-down' furniture for travellers and for export. 'Trafalgar' was used as a brand name for some of its lines, presumably because Lord Nelson was a customer; a cellarette made for Nelson is in the National Maritime Museum. The firm also made library steps that would fold into a chair, called 'The Metamorphic Chair'.

NICHOLSON, MICHAEL ANGELO (c1796-1842), was a draughtsman who collaborated with his brother, Peter Nicholson, a

cabinetmaker, to produce *The Practical Cabinet Maker, Uphol-sterer and Complete Decorator* (1826), a book of practical instruction.

NICHOLSON, PETER (1765-1844), was apprenticed to a cabinetmaker in Edinburgh and then went to London. He published *The Carpenter's New Guide* (1792). From 1800 to 1808 he worked as an architect in Glasgow and then was for two years County Surveyor of Cumberland. He then returned to London and produced various books on architecture.

OEBEN, JEAN-FRANÇOIS (c1720-63), was born at Ebern in Germany and moved to Paris when in his twenties. In 1749 he married the sister of Roger Lacroix. From 1751 he worked for Charles-Joseph Boulle making furniture for Madame de Pompadour. In 1754, when Boulle died, he became *ébéniste du Roi*. Many of his pieces showed great mechanical ingenuity and he favoured floral marquetry. His work may be seen at Luton Hoo, Bedfordshire.

PHYFE, DUNCAN (1768-1854), came from Scotland and became a distinguished New York cabinetmaker, greatly interested in furniture with classical motifs. His early work was influenced by Hepplewhite but he later established a style known as American Directoire, which had much in common with the Sheraton style. He used the lyre shape for chair backs and table ends, and sabre legs are common in his chairs. His work is noted for its carved drapery. Phyfe later turned to a heavier Empire style with pedestal tables having three or four supports and claw feet. Leaves and fruit were often carved on the legs and arms of his furniture. He retired in 1847. See McClelland, N. *Duncan Phyfe and the English Regency, 1795-1830*. New York, 1939.

PIFFETE, PIETRO (c1700-77), was an Italian cabinetmaker who started to work in Rome and in 1730 moved to Turin as *ebanista nostro*, making furniture for the King. Most of his pieces are very ornate, inlaid with ivory, mother-of-pearl and rare woods with ormolu decoration. See Honour, H. *Cabinet Makers and Furniture Designers*. 1969. pp 97-101.

PINEAU, NICOLAS, was a French designer who spent some years at the Court of Tsar Peter the Great in Russia. He worked in Paris in the rococo style during the 1730s and 1740s and examples of his furniture may be seen in the Musée des Arts Decoratifs.

PIRANESI, GIOVANNI BATTISTA (1720-78), was an Italian architect and designer who settled in Rome. When in his forties he turned to designing furniture—ornate, sculptural pieces profusely decorated with 'antique' motifs. See Honour, H. *Cabinet Makers and Furniture Designers*. 1969. pp 142-7.

PUGIN, AUGUSTUS WILBY NORTHMORE (1812-52), was one of the main designers responsible for the Gothic Revival. He designed the decorations and furniture of the new Houses of Parliament. See Ferrey, B. *Recollections of A. W. N. Pugin and his Father Augustus Pugin.* 1861; Trappers-Lomax. *Pugin, A Mediaeval Victorian,* 1932.

QUERVILLE, ANTHONY (w c1830-49) produced Directoire and Empire-style furniture in Philadelphia at the 'United States Fashionable Cabinet Warehouse'. He is said to have made the White House furniture for Andrew Jackson.

RANDOLPH, BENJAMIN (d 1792), of Chestnut Street, Philadelphia, made chairs and other furniture in the Chippendale style from c1762. His work, often referred to as 'Philadelphia Chippendale', shows fine elaborate carving in the rococo style. Examples in MMANY, Philadelphia Museum of Art and Winterthur Museum, Delaware. See Woodhouse, S. W. 'Benjamin Randolph of Philadelphia' in *The Antiques Book*. New York, 1950. pp 96-103.

RIESENER, JEAN HENRI (1734-1806), was born in Gladbach in the Rhineland and moved to Paris before he reached the age of twenty, becoming the most famous *ébéniste* in Paris in the second half of the eighteenth century. He started work with Jean-François Oeben and when Oeben died in 1763 continued to work with his widow, whom he married five years later. In the same year he became *maître-ébéniste*, and in 1774 became *ébéniste du Roi*.

He produced many ingenious secretaires, commodes and tables for the Court but his work was expensive and after 1784 his popularity declined. Nevertheless he continued to make furniture for Queen Marie Antoinette for her rooms at Fontainebleau. Later he survived the Revolution but found no work to his taste and in 1801 he retired. Reisener's work which was usually stamped R. H. Riesener, shows superb craftsmanship. His marquetry has never been surpassed and his bronze ornamentation—which he was able, if he wished, to make in his own workshop—shows fine sculpture. Examples may be seen at Waddesdon Manor, near Aylesbury.

ROBINSON, GERRARD (d 1890), was a woodcarver of Newcastle, apprentice and later foreman of Thomas Tweedy. He has been described as the 'Grinling Gibbons of the North' and his most notable work was the Chevy Chase sideboard, commissioned by the Duke of Northumberland, now to be seen in the Grosvenor Hotel, Shaftesbury, Dorset. The carving tells the story of the border Battle of Chevy Chase between the Percy ancestor of the Duke of Northumberland and the Scottish Douglas.

ROENTGEN, ABRAHAM (1711-1793), was born at Mühlheim in Germany. He worked for some time in Holland, at Amsterdam, The Hague, and Rotterdam, and then moved to London in 1731 to do marquetry work. In 1738 he returned to Germany and in 1740 set off for America as a Moravian missionary. However, his ship was wrecked off Ireland and he returned and started in business near Coblenz, inviting English craftsmen from London to join him. Here he made furniture in the rococo style often with intricate mechanical devices. In 1772 he retired, but by this time his son, David, had taken charge of the workshops.

ROENTGEN, DAVID (1743-1807), was born near Frankfurt in Germany, the son of Abraham Roentgen, a cabinetmaker of the rococo period. David, however, became interested in the classical styles of Paris. He spent short periods in Paris, first in 1774 and again in 1779; between 1772 and 1780 he sold furniture in Berlin, Paris and Vienna. Then he became a *maître-ébéniste* in Paris where he supplied furniture to the Crown. He established premises in the city which he maintained until the Revolution. His bureaux and tables with mechanical devices fitted to the drawers are particularly notable. After 1780 he stamped some of his pieces DAVID. Roentgen was a successful businessman and was able successfully to meet the needs of his wealthy customers for over thirty years.

SANDERSON, ELIJAH (1751-1825), of Salem, Massachusetts, formed a partnership with his brother Jacob and Josiah Austin to produce furniture which was sold in the southern states.

SAVERY, WILLIAM (1721-87), of Philadelphia, was a Quaker of Huguenot descent. He made walnut furniture in the Queen Anne style and later in the Chippendale style but avoided carving and decoration. Examples in the Philadelphia Museum of Art and the Henry Ford Museum, Dearborn.

SCHÜBLER, JOHANN JAKOB (1689-1741), was a furniture designer who published a number of pattern books. He was particularly interested in mechanical contraptions. His publications, issued from Nuremberg, included *Nützliche Vorstellung* (1730) and *Ars Inveniendi* (1734).

SEDDON, GEORGE (1727-1801), founded a large business (c1750) in which his sons George and Thomas and his son-in-law Thomas Shackleton became partners. Over 400 men were employed in the 1780s and large stocks of furniture were kept to supply the home market and the export trade. George Seddon was Master of the Joiners Company in 1795. The firm continued into the nineteenth century.

SEIGNOURET, FRANÇOIS (w 1822-53) was a French-born cabinetmaker who settled in New Orleans. He was known for fine Louis XV chairs.

SEYMOUR, JOHN, & SON (w c1790-1828), of Boston, Massachusetts, designed and made furniture in the Hepplewhite and Sheraton styles. The firm was noted for tambour desks and elegant sideboards. The son, Thomas, probably continued the business after his father's death. See Swan, M. M. 'John Seymour and Son, Cabinetmakers' in *The Antiques Book*. New York, 1950. pp 113-122.

SHAW, RICHARD NORMAN (1831-1912), designed Victorian Gothic furniture : examples may be seen in the V & A.

SHEARER, THOMAS, was a cabinetmaker and designer who engraved plates for the *Cabinet-Makers' London Book of Prices* (1788). In the same year, under his own name, he produced *Designs for Household Furniture*.

SHERATON, THOMAS (1751-1806), was born at Stockton-on-Tees. He was for some time a journeyman for a cabinetmaker. About 1790 he moved to London and established himself at 106 Wardour Street, Soho. Although he had a thorough knowledge of cabinetmaking it is doubtful whether he actually made furniture. He describes himself as a designer and a teacher of drawing. At a later date he moved to 8 Broad Street, Golden Square. He was a scholarly man and published a number of design books—*The Cabinet Makers' and Upholsterers' Drawing Book* (in parts, between 1791 and 1794), *The Cabinet Dictionary* (1803), *The Cabinet Maker, Upholsterer and General Artists' Encyclopaedia* (unfinished when

he died, though some of it appeared before he died). After his death a book including plates from his earlier publications appeared under the title *Designs for Household Furniture by the late T. Sheraton, Cabinet Maker.*

Sheraton's furniture is lighter than most previous styles. He favoured chairs with rectangular backs and delicately shaped splats, and with legs that are often turned and always taper. Reeding and fluting are common types of decoration. See Ledstone, M. 'The Charm of Sheraton', *Collectors' Guide*, May 1968, pp 60-63.

SHORT, JOSEPH (1771-1819), of Newburyport, Massachusetts, USA, made fine furniture in the style of Chippendale.

SMITH, GEORGE (w c1800-36), was a cabinetmaker and designer who was influenced by the work of Thomas Hope, though, as an essentially practical man, he thought in terms of simplification and comfort. He was patronised by the Prince Regent and the 'Regency style' owes a good deal to him. He started in business in Cavendish Square, London, and later moved to 41 Brewer Street, Golden Square. His published designs are to be found in *A Collection of Designs for Household Furniture and Decoration* (1808, but previously issued in two parts), *A Collection of Ornamental Designs after the Manner of the Antique* (1812), and *The Cabinet Makers' and Upholsterers' Guide, Drawing Book and Repository of New and Original Designs for Household Furniture* (1826).

TALBERT, BRUCE JAMES (1838-81), started his career as a woodcarver in Dundee and later trained as an architect in Glasgow. He then became a professional designer, and, after short periods in Coventry and Manchester, moved to London in 1865. He favoured the Gothic style and published *Gothic Forms applied to Furniture and Decorations for Domestic Purposes* (1867). His designs are for large pieces of furniture, which often carry inlaid geometrical patterns. He sometimes used metal for decoration and for bold Gothic strap hinges. Later he published a second book—*Examples of Ancient and Modern Furniture* (1867). Examples of his work may be seen in the V & A.

THONET, MICHAEL (1796-1871), was a cabinetmaker who lived at Boppard on the Rhine. He tried bending wood under steam heat in the 1830s and succeeded in making whole chairs from wood bent in moulds. He patented his techniques in 1841, and

from 1843 to 1846 worked with Carl Leistler in Vienna on furniture for the Liechtenstein Palace. In 1849 he started on his own and made furniture for London's Great Exhibition of 1851. In 1853 his five sons joined him to form Gebrüder Thonet. He was granted sole rights in 1856 to make 'chairs and tables from beechwood bent in steam or boiling liquids'. After his death in 1871 his sons continued the business, using mass-production methods. New factories were opened and bentwood furniture was exported all over Europe and also to America.

TOWNSEND FAMILY. Job Townsend (1699-1765) and Christopher Townsend (1701-1773) were master cabinetmakers of Newport, Rhode Island. They started making block front and shell furniture in the Queen Anne and, later, in the Chippendale style. Christopher's son, John Townsend (1733-1809) made block-front furniture and favoured the Hepplewhite style. Job Townsend was the father-in-law of John Goddard. See Downs, J. 'The Furniture of Goddard and Townsend' in *The Antiques Book*. New York, 1950. pp 86-95.

TROTTER, DANIEL (1747-1800), was a Philadelphia cabinetmaker who produced a design for a Chippendale-style ladderback side chair, the double-arched slats with a carved motif in the centre resembling a pretzel. These are sometimes known as 'Pretzelback chairs' (see plate, p 71). Trotter's later work was influenced by the Classical Revival.

TUFFT, THOMAS, was a Philadelphia cabinetmaker with a workshop in Second Street, working between 1765 and 1793 in the Chippendale style.

VANDERCRUSE, ROGER. See Lacroix.

VILE, WILLIAM (d 1767), was one of the finest cabinetmakers of the eighteenth century and early in the reign of George III was Cabinetmaker to the Crown. From about 1750 he was in partnership with John Cobb, who carried on the business after his retirement in 1765.

WEBB, PHILIP (1831-1915), was born in Oxford and became a furniture designer in London in the 1850s. He was closely associated with William Morris and Edward Burne-Jones. His designs are plain in outline and solid without veneer, though the wood is sometimes stained or painted and there may be some decoration of

leather or gesso. The link with Morris ceased in 1875. He continued to design furniture, however, until 1901.

WEISWEILER, ADAM (c1750-1809), was born near Frankfurt in Germany and came to Paris at the beginning of the reign of Louis XVI. In 1778 he became *maître-ébéniste* and started to produce furniture of a very individual style mainly of plain woods, particularly ebony and mahogany, often combining them with panels of Japanese lacquer or plaques of Sèvres porcelain. He continued in business through the Revolution and until 1810. His work is usually signed A. Weisweiler. A Louis XVI side table in ebony and Japanese lacquer by Weisweiler, though unsigned, fetched £17,725 (A 1968).

WRIGHT & MANSFIELD were cabinetmakers who made superb copies of eighteenth-century furniture in the 1860s. These are so well made that they have often been mistaken for originals. Their premises were at 104 New Bond Street and 6 Ridinghouse Street.

BOOKS TO CONSULT

Andrews, E. D. and F. *Shaker Furniture*. New York, 1950

Aslin, E. *Nineteenth Century English Furniture*. London, 1962. New York, 1966

Bjerkoe, E. H. *The Cabinetmakers of America*. Garden City, NY, 1957

Brackett, O. *Thomas Chippendale*. London, 1924

Burton, E. M. *Charleston Furniture, 1700-1825*. Charleston, 1955

Cescinsky, H. *English Furniture of the Eighteenth Century*. 3 vols. London, 1911-12. Magnolia, Mass, 1968

Coleridge, A. *Chippendale Furniture, The Work of Thomas Chippendale and his Contemporaries in the Rococo Taste: c1745-1765*. New York, 1968. London, 1969

Comstock, H. *American Furniture, Seventeenth, Eighteenth and Nineteenth Century Styles*. New York, 1962

Downs, J. *American Furniture of the Queen Anne and Chippendale Periods*. New York, 1952

Edwards, R. *Sheraton Furniture Designs*. London and New York, 1949; *Hepplewhite Furniture Design*. London and New York, 1955

Edwards, R. and Jourdain, M. *Georgian Cabinet Makers*. Revised, London and New York, 1963

Fastnedge, F. *English Furniture Styles from 1500-1830*. London, 1955 (1962), Baltimore, Md, 1962; *Sheraton Furniture*. London, 1962. New York, 1966

Gloag, J. *A Short Dictionary of Furniture*. London, 1952 (1969)

Harris, J. *Regency Furniture Designs, 1803-25*. London and Chicago, 1961

Heal, A. *The London Furniture Makers, 1600-1840*. London, 1953. New York, 1954

Hinkley, F. L. *A Directory of Antique Furniture*. New York, 1953

Honour, H. *Cabinet Makers and Furniture Designers*. London and New York, 1969

Iverson, M. D. *The American Chair 1630-1890*. New York, 1937

Macquoid, P. and Edwards, R. *The Dictionary of English Furniture*. 3 vols. London, Revised, 1954

Miller, E. G. *American Antique Furniture*. 2 vols. New York, 1966

Montgomery, Charles F. *American Furniture: Federal Period (1788-1825)*. New York, 1966

Musgrave, C. *Regency Furniture, 1800-30*. London, 1961. New York, 1966

Nagel, C. *American Furniture, 1650-1850*. New York, 1949

Ormsbee, T. H. *The Windsor Chair*. New York, 1962

Otto, C. J. *American Furniture of the Nineteenth Century*. New York, 1965

Sack, A. *Fine Points of Furniture: Early American*. New York, 1950 (1962)

Souchal, G. *French Eighteenth Century Furniture*. London and New York, 1961

Symonds, R. W. *English Furniture from Charles II to George II*. London and New York, 1929

Verlet, P. *French Furniture and Interior Decoration of the Eighteenth Century*. London, 1969

Ward-Jackson, P. J. *English Furniture Designs of the Eighteenth Century*. London, 1958

8

GLASS

In the sixteenth and early seventeenth centuries Venetian glass was supreme in Europe and was imported into Britain in considerable quantities. It was only towards the end of the seventeenth century, when the Glass Sellers' Company was well established in England, that real competition was possible. The key factor was the agreement signed by George Ravenscroft in 1674 to supply a new type of glass to the company. By the end of the century this 'white' glass, containing lead, was being widely used.

Georgian times saw the flowering of craftsmanship in the glass industry and the production of decorated pieces, engraved, cut, enamelled or gilded. However, it is not as easy to sign a name on glass as it is to paint it on porcelain or stamp it on furniture or silver; relatively little is therefore known about eighteenth-century glass craftsmen.

In the nineteenth century there were new developments. Much more decorative coloured glass was produced and new techniques were evolved by men like Apsley Pellatt and John Northwood in England, and by John Amelung, Henry Stiegel and Caspar Wistar in America. After 1840 machine-made pressed glass appeared in increasing quantities.

Collectors of early glass have a difficult task. There is so little to be seen in a piece of glass to enable one to date it, and glass is easily copied. It is often as important, therefore, to know where and when a piece was made as to know who made it. Many people, for example, who can recognize 'Sandwich' glass would know little or nothing about the work of Deming Jarves, who was responsible for devising the techniques of manufacture.

The names given in the following list are mainly of men who made their mark in the glass industry by the discovery and application of new techniques. The decorators mentioned are men and women whose work is normally identifiable, either because it is signed in some way, or because it bears the unmistakable stamp of a particular craftsman.

ABSOLON, WILLIAM (1751-1815), was a decorator of porcelain, pottery, and glass from about 1790. He painted in enamel colours, sometimes on clear glass but mainly on coloured and opaque glass, and also did some gilding. He sometimes signed his work with his initials. Examples may be seen in the V & A and in Norwich Castle Museum.

ADAM, ROBERT (1728-92), and his brother James, were responsible for the design of much glassware intended for interior decoration such as candelabra, candlesticks, epergnes and vases.

AKERMAN, JOHN (w c1719-c1755), was a London glass-seller who established (c1719) a business which was the first to advertise cut glass. In 1755 it became a partnership of Akerman & Scrivenor, and in 1775 Akerman, Scrivenor & Shaw. How long John Akerman was actually associated with it is not known. He was succeeded by his son, Isaac.

AMELUNG, JOHN FREDERICK (1739-98), was born in Bremen, Germany, and emigrated to America in 1784. A glass-maker, he brought skilled workers with him and started the New Bremen Glass Manufactory, in Frederick County, Maryland. He was a fine craftsman and engraved many pieces of glass which are usually signed and dated. He was associated in the 1790s with other glasshouses.

ATTERBURY COMPANY, Pittsburg, Pa, USA, were noted makers of milk glass in the 1870s and 1880s. See Belknap, E. M. *Milk Glass*. New York, 1949.

AYCKBOWER, J. D., started making glass in Dublin in 1799 and marked most of the pieces he produced.

BAKEWELL, BENJAMIN, founded The Pittsburgh Flint Glass Works in 1808, the first firm to make a commercial success of cut glass in North America. It soon became Bakewell, Pears & Co, operating under that name until 1882. In 1825, John Palmer Bakewell, Benjamin's son, patented a machine for pressing glass. The factory had a very large output which included incrustations or sulphides used to produce portrait medallions.

BARBER, RALPH (w 1905-12), was a craftsman at the Milville Glass Works, New Jersey, USA. He was particularly noted for his paperweights, each containing a rose in white, yellow, pink or red.

BECK, WASHINGTON (b 1839), was born in Pittsburgh and became a designer and maker of moulds for glassmakers.

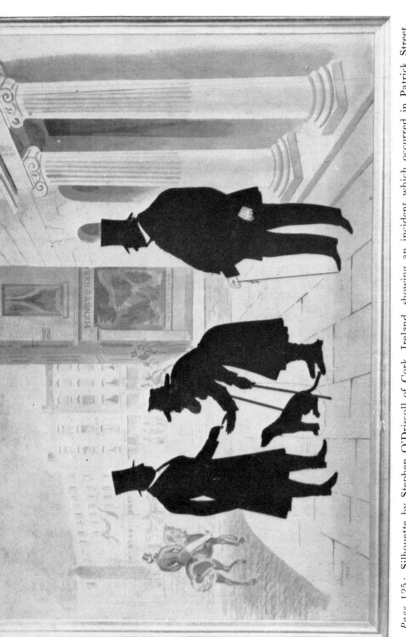

Page 125: Silhouette by Stephen O'Driscoll of Cork, Ireland, showing an incident which occurred in Patrick Street, Cork, in 1843. Dan Callaghan, MP, on leaving an hotel after luncheon, accidentally dropped a gold coin which rolled on the pavement. Father Mathew, who was passing, picked up the money and gave it to a mendicant known as the 'King of the Beggars'

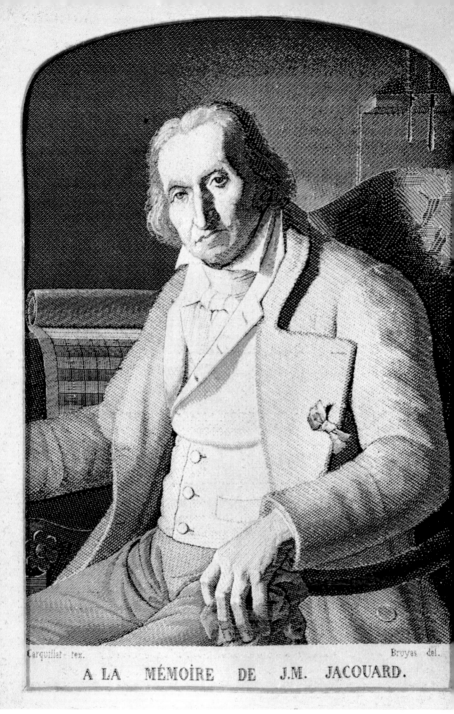

Carquillat - tex. Bruyas del.

A LA MÉMOÏRE DE J.M. JACOUARD.

Page 126: Silk picture of Joseph Marie Jacquard (1752–1834), woven by
François Carquillat (1803–84) of Lyons in 1839

BEILBY, MARY (1749-97), was the daughter of William Beilby Sr (1706-65). She was born in Durham and moved with the family to Newcastle-on-Tyne about 1760. She learned at an early age to enamel on glass, though it is not possible to identify her work among the Beilby output. She probably decorated less than other members of the family, since she became an invalid in her twenties.

BEILBY, RALPH (1743-1817), was a wood engraver and it is thought that his knowledge of heraldry may have had some influence on the early work of his elder brother William.

BEILBY, WILLIAM (1740-1819), Mary Beilby's brother, started to enamel glass about 1762, using armorial devices. About twelve years later his scope widened to include landscapes, birds, the flowering vine, and hops, both in colour and in white. Some of his work was signed and carries a butterfly trademark. When his mother died in 1778 he moved with his sister Mary to Scotland and apparently ceased his enamelling work. A glass bowl decorated in opaque white with rural scenes sold for £400 (1968).

BETTS, THOMAS (d 1767), a London glass-cutter and glass seller, was in business from about 1738 until 1761. He dealt mainly with table glass—wineglasses, decanters, carafes, and cruets.

BIGAGLIA, PIERRE, a Venetian glassmaker, is credited with having been the first to introduce millefiori glass in 1845.

BISHOPP, HAWLEY, was in charge of George Ravenscroft's experimental glasshouse at Henley-on-Thames from 1676. This had been provided by the Glass Sellers' Company and when Ravenscroft ended his agreement with them in 1678, Bishopp carried on the work. When Ravenscroft died in 1681, Bishopp also took over the Savoy glasshouse.

BUCKINGHAM, GEORGE VILLIERS, 2nd Duke of (1628-87), was a wealthy aristocrat who gave financial backing to the glass industry (although he knew little about the technical side) and set up glassworks at Greenwich and Vauxhall. His patronage covered the period from about 1660 to 1674. The Greenwich works specialised in glass of Venetian style and employed Italian workers; the Vauxhall works produced plate glass for looking-glasses.

CARRÉ, JEAN (d 1572), who had worked in the glasshouses of Arras and Antwerp, came to England in the middle of the sixteenth

H

century with several Protestant glassmakers from Lorraine and started to work in the Weald with encouragement from Queen Elizabeth. Eventually he moved away from that area and set up a glassworks at Crutched Friars in London. When he died the resentment of the English Wealden glassmakers showed itself in open hostility, and the Lorraine families scattered to other parts of the country where they could practise their craft without hindrance. They settled in such centres as Newcastle-on-Tyne and Stourbridge, where glass has been made ever since.

CHALLINOR, TAYLOR & CO, of Tarentum, Pennsylvania, were noted manufacturers of milk glass and slag glass in the 1870s and 1880s. See Belknap, E. M. *Milk Glass*. New York, 1949.

COLLINS, TIMOTHY, was a craftsman at the New England Glass Works, Sandwich, USA.

DAGNIA. An Italian family of glassmakers who started to make glass in Bristol, and moved to Newcastle-on-Tyne in 1648, where they appear to have introduced lead glass. They built up a flourishing glass industry.

DAUM, ANTONIN. See p 15.

DAVIDSON, GEORGE, & CO. A Gateshead-on-Tyne firm who made pressed glass in the second half of the eighteenth century. Their pieces are often marked with a turret and lion.

DONOVAN, JAMES (w 1770-1829), of Dublin, owned a glasshouse near the city, and is said by some to have enamelled glassware towards the end of the eighteenth century; but there is no clear evidence to support this view.

DORFLEIN, PHILIP (1816-1896), worked in Philadelphia from 1842 as a maker of metal moulds for glassmaking. Some of his bottle designs included portraits of well known public figures.

EDKINS, MICHAEL (1734-1811), is noted for his enamelling of glass at Bristol from about 1762 to 1811. He worked mainly on milk-white opaque glass and on blue glass, though he had started by working on delft tiles at a pottery in Redcliffe Backs. The painted decoration usually shows birds or figures, and is beautifully executed. Occasional pieces show a signature : those that do not can only be tentatively attributed to Edkins, even if the work is superbly done. A number of other decorators did similar but inferior work.

EDWARDS, BENJAMIN, was a Bristol glassmaker who established a glasshouse at Drumrae in Ireland in 1771 and moved to Belfast in 1776. 'B. Edwards' in moulded lettering is to be found on the Belfast pieces.

GALLÉ, ÉMILE, See p 16.

GATCHELL, JONATHAN (d 1825), was a Quaker who worked at Waterford as a clerk to George and William Penrose. In 1789 he took the place of John Hill (qv) and in 1811 became the owner of the Waterford factory, which he ran until he died in 1825. His son George was still very young and for some years various partnerships continued the business until he took over in 1845. The works closed in 1851.

GILLILAND, JOHN L., was a glassmaker who worked at the New England Glass Company, Cambridge and in 1823 started the South Ferry Glass Works, Brooklyn, which he operated until 1868. He was able to produce a fine metal for making wineglasses and decanters which compared favourably with imported glass. In 1829 he received an award from the American Institution for his pressed glass, and in 1851 the prize for the best flint glass metal at the Great Exhibition in London.

GREEN, JOHN (w 1667-80), of the Glass Sellers' Company, designed glasses for the English market to be made in Murano, Italy, and these designs were later used by glassmakers in England. Many of Green's designs are preserved among the Sloane manuscripts in the BM.

GREENER, HENRY, & CO, was a Sunderland firm noted for the manufacture of pressed glass in the late nineteenth century. It sometimes carries the trade mark of a lion crest.

GREENWOOD, FRANS (1680-1761), a Rotterdam engraver, is said to have discovered diamond-stippling, which he adopted (c1720). His work may be seen in the V & A.

GREGORY, MARY, was an artist at the Boston & Sandwich Glassworks in Massachusetts, USA, in the mid-nineteenth century. She painted clear and coloured glass with figures of children in white enamel. This set a style and much late nineteenth-century glass was decorated in this way, especially in Bohemia. Many pieces are wrongly attributed to Mary Gregory: the name should now be regarded as generic for a type of decoration.

GUMLEY, JOHN (d 1729), was a looking-glass manufacturer whose factory was started in Lambeth in 1705. He was already in business as a cabinetmaker.

HAEDY, CHRISTOPHER, was probably the first German glass-cutter to come to London, to work for John Akerman from 1719, when he first advertised cut glass. Members of his family were glass-cutters until 1810 at 287 The Strand.

HILL, JOHN, a Stourbridge glassmaker, went to Waterford in Ireland about 1784 with a number of Worcestershire craftsmen to help George and William Penrose establish the industry there. He left Waterford in 1789.

JACOBS, ISAAC (w 1771-1806), worked in his father's glass-house in Temple Street, Bristol. He was a Glassmaker to George III. The firm produced a large range of coloured glass but specialised in the well-known dark 'Bristol blue'. Some finger bowls and decanters are signed *I. Jacobs*, though they seldom appear on the market. When they do they can fetch as much as £400.

JACOBS, LAZARUS (d 1796), glass merchant of Temple Street, Bristol, worked closely with his son Isaac. Michael Edkins (qv) was for some time a gilder for the firm.

JARVES, DEMING (1791-1869), the son of a Huguenot immigrant, was a prominent figure in the American glass industry in the early nineteenth century. He invented mechanical methods for moulding and pressing glass and from 1818 to 1825 was connected with the New England Glass Company at Cambridge. In 1825 he established the Boston & Sandwich Glass Works. Skilled workers were brought from England, Ireland, and Belgium. One of the specialities was a pressed glass known as Lacy Sandwich, which reflects the light as though the glass were cut. It was very popular in the 1830s. In 1858 Jarves withdrew from the organisation, which by then had become very large indeed and started the Cape Cod Glass Company, also at Sandwich, which failed. The original Boston and Sandwich Glass Works continued until 1887.

JOHNSON, JEROME (w 1739-61), was one of the first en-gravers and cutters of English glass, especially candlesticks, lustres, and salts. Much of his work was exported.

KAY, F. E., was a wheel-engraver at Thomas Webb's Dennis glasshouse at Stourbridge between c1870 and c1890.

KRAMER, CHRISTIAN (1773-1858), was born in Germany and emigrated to America to make glass at New Geneva, Pennsylvania in 1797. Later he was connected with a factory at Greensboro which produced flint and bottle glass of good quality, much of it coloured.

LALIQUE, RENÉ. See pp 16 and 19.

LECHEVREL, ALPHONSE E., was a Frenchman who engraved on cameo glass for Benjamin Richardson. Examples of his work may be seen in the Brierley Hill Branch Museum and Art Gallery, Dudley, Worcestershire.

LEHMANN, CASPAR (1570-1622), one of the first artists to practise wheel-engraving, worked in Prague and was made Glasscutter to the Court.

LOCKE, JOSEPH, was responsible for making Amberina glass at the works of the New England Glass Company, Cambridge, Massachusetts, between c1880 and 1910; this was a glass shading from an amber-yellow to ruby.

LUTZ, NICHOLAS, was a craftsman at the Boston & Sandwich Glass Works, Sandwich, Massachusetts, in the second half of the nineteenth century. He was noted for making paperweights in the form of flint-glass globes with encased flowers, fruit or millefiori.

MANSELL, SIR ROBERT (1573-1656), was an Admiral of the Fleet who became interested in glassmaking from about 1608. At this time there was some concern about the amount of timber used for the glass furnaces, and in 1615 a Royal Proclamation made it necessary to change to coal as a fuel. A patent had been granted to Sir Edward Zouche which gave him the right to make and also to import glass into England and Wales. Sir Robert Mansell, then forty-two years of age, joined his organisation. He was an extremely shrewd and efficient businessman. By 1623 the right to make glass became his and he planned production carefully, organising the import of soda and the distribution of coal. He was, however, a soldier by temperament and treated his craftsmen in such a way that morale was low and it was difficult to keep the best men in the industry. Although glassmaking was placed on a sound commercial basis in the first half of the seventeenth century it was not a period of great invention or particularly fine artistry.

MILDNER, JOHANN (1764-1808), was a glassmaker of lower Austria who specialised in double-layered glasses with decorations in red lacquer and gold leaf placed between the layers. A signed armorial tumbler by Mildner sold for £410 (A 1970).

MULVANEY, CHARLES, was a Dublin glassmaker from 1785, who marked his pieces 'C.M. Co.'

NORTHWOOD, HARRY, of West Virginia, USA, found a cheap method of producing pressed iridescent glass in the late nineteenth century. It was made in many colours and used for prizes at fairgrounds; for this reason it is sometimes called 'carnival' glass.

NORTHWOOD, JOHN, Sr (1836-1902), was apprenticed to Benjamin Richardson of Stourbridge who offered a reward of £1,000 for a reproduction of the famous Portland Vase. Northwood devoted many years of experiment and painstaking work to this task. He worked with cameo glass; this involved fusing a layer of white glass on to a dark glass ground and carving the white glass so that the carving stood out in white relief. In 1876 he completed the replica of the Portland Vase, which had taken three years to carve, and had inspired a number of other craftsmen, including his son, John, to do similar work. In the 1860s Northwood had invented a 'geometrical' etching machine, which was widely used in late Victorian times to produce table glass with key-pattern decoration. See Northwood, John, Jr. *John Northwood*. 1958.

O'FALLAN, J. M., was an engraver of cameo glass.

PARKER, WILLIAM, was a noted maker of cut-glass candelabra in the eighteenth century, and had premises at 69 Fleet Street.

PELLATT, APSLEY (1791-1863), was the son of the owner of a London glass warehouse. In 1821 he started a glasshouse in Falcon Street, Southwark. He had previously taken out a patent in 1819 for making glass incrustations. This involved coating medallions or pottery ornaments in a thick layer of clear, brilliant glass. He produced vases, plaques, decanters, scent bottles, and paperweights, by this method and these were extremely popular when they first appeared : today these cameo incrustations are collectors' items. Pellatt wrote two books on glassmaking—*Glass Manufactures* (1821) and *Curiosities of Glass-making* (1849).

PENROSE, GEORGE & WILLIAM, were brothers who started the Waterford glassworks in Ireland in 1784, using master craftsmen

from Bristol or Stourbridge. Some pieces are marked *Penrose, Waterford*. In 1799 the firm was acquired by Ramsey, Gatchell & Borcroft, who built new premises. By 1811 Jonathan Gatchell (qv) had become the sole owner.

PIERRE, FRANÇOIS, was an employee of the New England Glass Company, Sandwich, New Jersey, who made blown-glass 'pear and apple' paperweights. He had previously worked at the Baccarat factory in France.

RAVENSCROFT, GEORGE (1618-81), was a shipowner who had an interest in chemistry and carried out many experiments with glass. He was encouraged by the Glass Sellers' Company to try to produce a metal that was less likely to shatter than Venetian glass. In 1673 he established a glasshouse in the Savoy in London and there produced 'glass-of-lead' or 'flintglass' as it was called, which included an oxide of lead; it was heavier and softer to engrave than the Venetian imported glass and reflected the light brilliantly. He obtained a patent for this invention in 1673 and a year later made an agreement with the Glass Sellers' Company to provide them with glass, the company setting up a glasshouse for him at Henley-on-Thames. Unfortunately, the glass suffered from a defect known as crisselling—developing a network of fine cracks. By 1675 Ravenscroft had remedied this defect (see plate, p 72) and by 1677 had begun to use the 'Raven's head seal' on his products. Ravenscroft died in 1681 and the Savoy glasshouse was taken over by Hawley Bishopp (qv).

RICHARDSON, BENJAMIN, was a flint glassmaker of Stourbridge in the middle of the nineteenth century.

ROBINSON, JOHN, established the Stourbridge Flint Glassworks (1823-45) near Pittsburgh, USA.

ROCHE, PHILIP, took over an existing glassworks in Dublin in 1691.

SANG, JACOB (w c1752-62), a noted Dutch wheel-engraver of Amsterdam, used glass from Newcastle for his work. Many of his pieces are signed and examples may be seen in the V & A.

SCHWANHARDT, GEORG (1601-67), was an assistant to Caspar Lehmann (qv) in Prague and continued his master's work after his death in 1622. He polished his engravings to improve their appearance. His sons Georg and Heinrich (d 1693) followed the same craft

with wheel and diamond point. Heinrich is said to have etched glass with hydrofluoric acid. Georg Schwanhardt Sr signed much of his work.

SCHWINGER, HERMANN (1610-83), was a glass engraver at Nuremberg.

SOWERBY, J. C., & CO, were late nineteenth-century glass-makers who operated the Ellison Glass Works at Gateshead-on-Tyne. They produced a large range of glassware, especially pressed glass, plain and coloured, between 1860 and the 1880s. In 1876 they registered their trademark, a peacock's head, which is found on many pieces.

STIEGEL, HENRY WILLIAM (1729-85), emigrated from Germany to America in 1750, where he married the daughter of a wealthy iron master. In 1756 he took charge of some iron furnaces and by 1765 had established a glassworks at Mannheim, Pennsylvania. He employed skilled craftsmen from Europe, including engravers and enamellers. He established a second glassworks in 1769 where processes involved blowing and decorating with pattern moulds. Unfortunately he overreached himself and in 1774 was declared bankrupt. The style of his glass had a considerable influence on the output of other American glasshouses. Stiegel glass is now rare. See Hunter, W. H. *Stiegel Glass*. New York, 1950.

TASSIE, JAMES (1735-99), was born at Pollokshaws, near Glasgow, and studied sculpture at Foulis Academy, Glasgow. In 1763 he went to Dublin and worked with Dr Henry Quin. They produced a glass paste from which they could make casts of engraved gems. In 1767 Tassie moved to London, where he took premises first in Great Newport Street and from 1772 in Compton Street, Soho. By 1791 he had made reproductions of some 15,000 gems, some ancient, others by contemporary artists, and he issued a *Descriptive Catalogue of a General Collection of Ancient and Modern Engraved Gems, Cameos and Intaglios*, in two volumes. He received commissions from the Adam Brothers and from Josiah Wedgwood. The medallions with portrait relief were extremely popular. See Gray, J. M. *James and William Tassie, a Biographical and Critical Sketch.* London, 1894.

TASSIE, WILLIAM (1777-1860), carried on the business of his

uncle, James Tassie, after his death in 1799. In 1840 he handed over to John Wilson.

TIFFANY, LOUIS COMFORT. See p 21.

VERZELINI, GIACOMO (1522-1606), was a Venetian glass-maker who had been working in Antwerp until he came to England in 1570. It is said that he worked briefly with Jean Carré at Crutched Friars in London. Carré died in 1572 and in 1575 the Crutched Friars glasshouse was destroyed by fire. Verzelini was successful in that year in obtaining a twenty-one year monopoly to make 'Venice' glass in England and all imports were to be prohibited. He also agreed to teach the craft to English workers. The glasshouse which he established in Broad Street was a great success and when he retired in 1592 he was a wealthy man. Many of Verzelini's glasses are said to have been engraved with a diamond point by Anthony de Lysle, a Frenchman who also worked on pewter. Relatively few have survived, though some museums have examples. There is a goblet dated 1581 (the Dier Glass) in the V & A (see plate, p 72); a goblet dated 1578 in the FM; and a goblet dated 1577 in the Steuben Collection, New York.

VISSCHER, ANNA ROEMERS (1583-1651), was the first known woman engraver on glass. She worked in Amsterdam, using a diamond point for linear work and stippling. Some of her work is signed.

WISTAR, CASPAR (c1695-1752), was a Dutch emigrant to America in 1717 who, after a successful period in business, turned to the manufacture of glass. In 1739 he established a glasshouse near Salem, New Jersey, operated entirely by Dutchmen under an exclusive contract. Apart from bottles and window glass, the output included high-class domestic glassware, both clear and coloured. His son Richard helped Wistar to build up a highly successful enterprise, which he continued until 1775.

WOLFE, DAVID (c1732-1808), was a Dutch engraver who specialised in diamond-stippling. His work may be seen in the V & A, the Rijks Museum, Amsterdam, and the MMANY.

WOODALL, JOHN (1850-1925), was a craftsman of the Northwood School who produced some fine work on cameo glass. Examples may be seen in the Brierley Hill Branch Museum and Art Gallery, Dudley, Worcestershire.

BOOKS TO CONSULT

Belknap, E. McC. *Milk Glass*. New York, 1949

Bergstrom, E. *Old Glass Paperweights*. London and New York, 1947

Chipman, F. W. *The Romance of old Sandwich Glass*. New York, 1932

Davis, D. C. and Middlemas, K. *Coloured Glass*. London, 1968

Elville, E. M. *Paperweights and Other Glass Curiosities*. London, 1954

Godden, G. A. *Antique China and Glass under £5*. London, 1966. Contains useful chapters on English and Victorian glass and glass 'fairy' lights

Kampfer, F. and Beyer, K. G. *Glass: A World History*, London and Greenwich, Conn, 1967

Lee, R. W. *Early American Pressed Glass*. New York, 1931 (1946)

McKearin, George S. and Helen. *American Glass*. New York, 1941

McKearin, H. and G. S. *Two Hundred Years of American Blown Glass*. New York, 1950. Revised edition, New York, 1966

McKearin, H. *American Historical Flasks*, Corning, 1953

Revi, A. C. *American Pressed Glass and Figure Bottles*. Camden, NJ, 1964

Rogers, F. and Beard, A. *Five Hundred Years of Glass*, New York, 1958

Schwartz, M. *Collectors' Guide to Antique American Glass*. New York, 1969

Thorpe, W. A. *A History of English and Irish Glass*. 2 vols. London, 1929 (1968). West Orange, NJ, 1969

Wakefield, H. *Nineteenth Century British Glass*. London, 1961. New York, 1962

Watkins, L. W. *American Glass and Glass-making*. New York, 1950

Wilkinson, O. N. *Old Glass: Manufacture, Styles, Uses*. London and New York, 1968

Wilkinson, R. *The Hallmarks of Antique Glass*. London, 1969

9

MAPS, CHARTS, AND GLOBES

THE art of mapmaking was first established in the Netherlands in the sixteenth century and spread from there to other parts of Europe, though the map publishers of Amsterdam—Blaeu, Hondius and Jansson—dominated map production for much of the seventeenth century. It was a task for co-operation : surveyors, engravers, editors, printers, and map-sellers worked closely together, some individuals combining several of these functions. Collections of maps were assembled and in the sixteenth and seventeenth centuries were given the name *Theatre*, the early description of what we now refer to as an atlas. Once the plates had been engraved for a map they were often used over long periods; sometimes prints were made long after the original mapmaker had died. Later mapmakers relied a great deal on the work done by their predecessors and many early maps were copied, particularly those made by early settlers in North America, such as John Smith's *Virginia*.

Copies are sometimes passed off as originals, and it is not always easy to distinguish between a genuine early map and a later copy. Collectors usually buy from a reputable established dealer, who will guarantee the origin of the map he sells. There are, however, a number of points which the inexperienced should look for.

1. The paper on which early maps were printed was handmade. It is soft and thick and often shows a watermark.

2. Colours were hand-painted on the printed map since no colour-printing processes had been invented. Contemporary colours differed from modern water-colour paint, though these can be imitated by the copier. Old paint usually shows through the paper on the back of the map.

3. A seam may often be seen down the middle of a map where it was bound in the *Theatre* or atlas.

4. Lists of early maps are available. Collectors should check the imprint of a map and its character with the relevant catalogue.

Museums do not always exhibit maps but may keep them in a Print Room. It is always worth asking if any are available for study.

ABBOT, H. L. (w 1855-64), an American cartographer, produced maps of the Mississippi and Virginia.

ABERT, Col J. J. (w 1824-47), produced maps of Maryland, Texas, Mississippi, Arkansas.

ADAMS, JOHN (w 1672-93), undertook a survey of England and published a large map of England and Wales (1677) and *Index Villaris*, an early gazetteer, in 1680, 1690 and 1710.

AINSLIE, JOHN (w 1772-1813), was a Scottish cartographer who produced maps of many of the Scottish counties and also of Edinburgh (1780) and of Scotland (1789).

ANDREWS, ISRAEL D., produced maps of railroads in the USA (1853) and *The Straits of Florida* (1852).

ANDREWS, JOHN (d 1809), was a London cartographer of 211 Piccadilly, who produced an atlas of the *British Colonies in North America* (1777), a *Historical Atlas of England* (1797) and *Mineral Waters and Bath Places in England* (1797).

ARMSTRONG, ANDREW, produced a number of county maps and worked with Bowen and Kitchen on the large *English Atlas* (1767-87).

ARMSTRONG, MOSTYN JOHN (w 1770-91), was the son of Andrew Armstrong. He made a number of Scottish maps but is perhaps best known for a map of the *London-Edinburgh Coach Road* (1776).

ARROWSMITH, AARON (1750-1833), produced many large maps between 1790 and 1822 including the *World* (1790), *North America* (between 1795 and 1814), and a *New General Atlas* (1817).

BELLIN, JACQUES NICOLAS (1703-72), was a French hydrographer who produced a number of maps and charts of eastern Canada, eg *Nouvelle France* (1744).

BIEN, JULIUS (1829-1909), was an engraver and map-maker who worked for the US Government and produced a *Statistical Atlas of the U.S.* (1874).

BOUCHETTE, JOSEPH, was a Surveyor-General of Lower Canada who produced maps of Quebec and parts of the St Lawrence valley between 1815 and 1831.

BICKHAM, GEORGE (1684-1758), a map-engraver, worked with a younger brother George Bickham (d 1758) from 1735 to

1757 to produce *The British Monarchy* (1754), a series of county maps of England which gave a bird's-eye view of the areas covered.

BLAEU, WILLEM JANSZOON (1571-1638), of Amsterdam, was the principal cartographer of his time and was also a binder, publisher, map-seller and globe-maker. Most of his maps and publications bear his name but seldom in its true form : he used, among others, Guliemuis Blaeu and Guilielmus Janssonius, the latter being sometimes confused with Jan Jansson. His son, John Blaeu (1596-1673), continued his work and formed a partnership with his brother Cornelius in 1640. They published the *Atlas Novus* in 1648 and the folio-size *Atlas Major* or *Geographia Blaviana* in 1660. This is a collection of fine maps in eleven volumes. Editions were printed in Dutch, German, French, Latin, and Spanish between 1662 and 1665, all in Amsterdam. The Blaeu workshops had a serious fire in 1672 which destroyed many valuable plates. After John Blaeu died in 1673 two of his sons continued the business until 1700. Blaeu's maps carry Roman lettering.

A first edition of the *Atlas Major* with the maps coloured by a contemporary hand sold for £5,500 (A 1968) and his *Le Grande Atlas*, published in twelve volumes in 1667, for £7,400 (A 1969).

BLOME, RICHARD (w 1660-1705), published rather poor reproductions of John Speed's maps in *Britannia* (1673) and *Speed's Maps Epitomized* (1681). His *Cosmography* appeared in 1682.

BOWEN, EMANUEL (w 1720-1767), was Engraver of Maps to George II and Louis XV. Many of his maps carry extensive notes on topography and antiquities. He collaborated with Thomas Kitchen (d 1784) to produce the *Large English Atlas* (c1755). When Emanuel Bowen died his son Thomas Bowen (d 1790) continued the business.

BOWLES, JOHN (w 1720-79), son of Thomas Bowles, had a map business in Cornhill and from 1753 to 1764 worked in partnership with his son Carington (1724-93), as John Bowles & Son.

BOWLES, THOMAS (w 1702-67), had a thriving map-printing and selling business in St Paul's Churchyard. In 1767, when he died, the firm was taken over by his grandson Carington Bowles (1724-93) and, when he died, became Bowles & Carver (w 1794-1832).

BRAUN, GEORG (w 1572-1618), was the editor of a city atlas, *Civitates Orbis Terrarum*, published in Cologne over a period of forty-six years and engraved by Frans Hogenburg.

BUELL, ABEL (1742-1822), engraved many maps of America, including a large wall map. He was also a silversmith.

CAMDEN, WILLIAM (1551-1623), was born in London, the son of a painter. He was a distinguished antiquary and historian, and became headmaster of Westminster School in 1593. He is known for his historical survey of the British Isles published in Latin in 1585 under the title *Britannia*. This contains a number of relatively small maps based on those of Saxton and Norden. It was translated into English in 1610 and other editions have followed both in Latin and in English.

CAREY, H. C. (1793-1879), worked with Isaac Lea on an *American Atlas* published in Philadelphia in 1822.

CAREY, MATHEW (1760-1839), published the first *American Atlas* in Philadelphia in 1795 and also an *American Pocket Atlas* (1796).

CARY, JOHN (d 1835), was a map-engraver and 'Surveyor of the Roads to the General Post Office' who also sold maps from 181 Strand, London. He published a *New and Correct English Atlas* (1787), which was a series of county maps with little decoration; and the *Traveller's Companion or Delineation of the Turnpike Roads of England and Wales* (1791), which contained county road maps and details of the coaching routes, coaching inns, etc. He also offered for sale New Twelve-Inch Globes, celestial and terrestrial. His family carried on his work until about 1850 and became noted makers of globes.

COLLINS, CAPTAIN GREENVILE (w 1679-93), as 'Hydrographer to the King', surveyed the coasts of Britain for Charles II and produced a series of charts in *Great Britain's Coasting Pilot* (1693), which was published by Richard Mount (qv).

DRAYTON, MICHAEL (1563-1631), was born near Atherstone in Warwickshire and is known primarily as a poet. His *Polyalbion* (c1613), a chorographical description of all the tracts, rivers, mountains, forests, and other parts of Great Britain, is full of antiquarian and historical information. The maps which illustrate this work are sought more for their decorative appeal than for their accuracy. They are adorned with nymphs, shepherds, goddesses, and characters from well-known fables.

DUDLEY, SIR ROBERT (1573-1649), worked with an Italian engraver in Florence to produce a sea-atlas, *Dell' Arcano del Mare*

(1645-7) with charts on Mercator's projection. A flamboyant script is used for the lettering.

FADEN, WILLIAM (1750-1836), map publisher of St Martin's Lane, London, produced a *North American Atlas* (1776) and *Battles of the American Revolution* (1793). He retired in 1823.

FOSTER, JOHN (1648-1681), was born in Dorchester, Massachusetts. He became the first printer in Boston and engraved the first American map which appeared in William Hubbard's *A Narrative of the Troubles with the Indians in New England* (1677).

GREUTER, MATTHEW (d 1638), was a globe-maker.

HOGENBURG, FRANS (1535-90), an engraver of maps, worked in Cologne for Braun, Ortelius, Saxton, and others. He set a clear but decorative style which was adopted by later engravers, and printed information was often enclosed in a cartouche.

HONDIUS, JODOCUS (1563-1612), was a skilled Flemish engraver who spent ten years in London as an exile. During this period he engraved *Theatrum Artis Scribendi*, an early copybook. He then settled in Amsterdam and built up a reputation not only as an engraver but also as publisher and map-seller. He published his own atlas and engraved maps for other cartographers, notably for Speed's *Theatrum of the Empire of Great Britain* (1611-12). He with a great admirer of Mercator and succeeded in 1600 to his business, which continued to print many of his maps.

JANSSON, JAN (1588-1664), engraver and map-seller of Amsterdam, succeeded Jodocus Hondius in 1637 in the business started by Mercator. He published a number of atlases, some pirated, and when he died his sons-in-law continued the business under the name of Janssonius-Waesbergh.

JEFFERYS, THOMAS (d 1771), was a London map-seller who was appointed Geographer to the King. He produced a *Small English Atlas* (1749) in collaboration with Thomas Kitchen (qv).

KITCHEN, THOMAS (1718-84), collaborated with Emanuel Bowen to produce the *Large English Atlas* and with Thomas Jefferys to produce the *Small English Atlas*. Between 1738 and 1776 he also issued small maps of the counties of Britain.

LAURIE, ROBERT (1750-1836), was a London map publisher who, with his partner James Whittle, issued an edition of *The North*

American Pilot in 1794. The business flourished between c1792 and 1812 when Richard Holmes Laurie (d 1858), his son, took over.

LEA, PHILIP (w 1683-99), was a map-seller and globe-maker. His globes were mainly of 26 in diameter.

MERCATOR, GERHARD (1512-94), was a Flemish mathematician of German extraction. He made large globes in his early days as instrument maker (c1541-51) and was the first mapmaker to use the word 'atlas' for a collection of maps. His *Atlas Sive Cosmographical Meditationes* (1588-95) had the names inscribed in italic script. His reputation was high and other cartographers followed his methods and style. In 1600, his business passed from his family to Jodocus Hondius, who published a number of revised editions of the *Atlas*. In 1657, Jan Jansson (whose sister had married Mercator's son, Henricus) took over the business.

MOLL, HERMAN (d 1732), was a Dutchman who came to London in the 1670s and sold books and maps in Blackfriars. In 1719 he produced a *New Complete Atlas* and in 1724 a series of county maps which are packed with information, especially about antiquities.

MORDEN, ROBERT (d 1703), made and sold maps and globes. He prepared the maps for an English translation of Camden's *Britannia*.

MOULE, THOMAS, was a nineteenth-century bookseller who issued many maps, embellished with engravings of houses and country scenes, with the routes followed by the early railways.

MOUNT, RICHARD (w 1684-1722), was a map-seller who established a business which was carried on by his son William (d 1769). He took into partnership Thomas Page (d 1762) and the firm was eventually run by their sons in turn.

MUNSTER, SEBASTIAN (1489-1552), a Basle mapmaker, printed from woodcuts in the sixteenth century. His collection of maps was called *Cosmographia* (1545). A larger edition was published in 1550.

NORDEN, JOHN (1548-1626), developed the use of symbols on maps and was the first English mapmaker to show the routes of roads. He made a number of county surveys, which had little commercial success but influenced the work of later cartographers, such as John Speed.

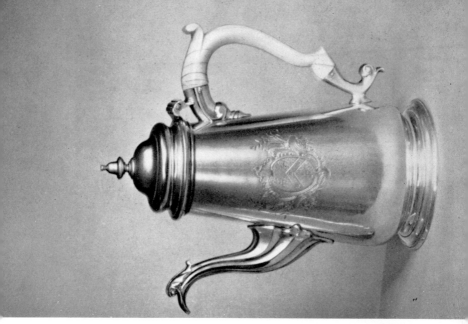

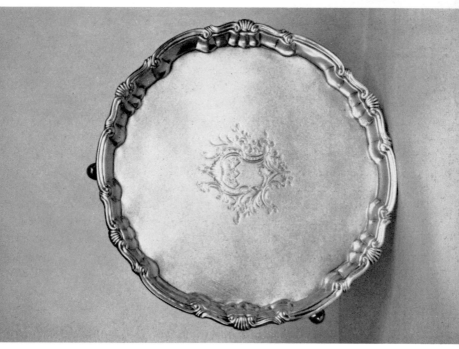

Page 143: (right)
Silver salver with
contemporary coat
of arms within
scroll and shell
border on three
hoof feet, made by
William Peaston,
London, 1748.

(far right) Silver
coffee-pot of
tapering cylindrical
shape with tuck-in
base, faceted leaf-
cut spout, domed
cover with finial
and ivory handle,
made by Thomas
Whipham, London,
1747

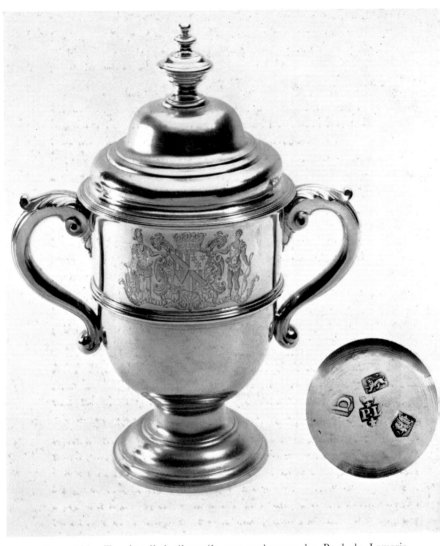

Page 144: Two-handled silver-gilt cup and cover by Paul de Lamerie,
London, 1737

OGILBY, JOHN (1600-76), was born in Edinburgh. He had a varied career as theatre-owner, dancing-master, translator, bookseller, and printer, and suffered many misfortunes in the Irish Rebellion of 1641 and in the Great Fire of London. He made his name in the 1670s as a mapmaker, producing the first systematic survey of coach roads, published in 1675 as *Britannia*. The portions of road were shown in parallel strips, which made it possible for him to use a large scale. On each page the route starts in the bottom left-hand corner and the route taken by the road is read upwards. Nearby hills were shown as were streams, arable and pasture land, inns, and bridges, all entered with meticulous care. Mileages and compass bearings were given. The first edition was folio size, but later editions were smaller, to suit the needs of travellers. Before this major work had been completed he had published maps of *Africa* (1670), *America* (1671), and *Asia* (1673).

A facsimile reproduction of *Britannia* was published by Alexander Duckham & Co Ltd in 1939.

ORTELIUS, ABRAHAM (1527-98), was born of German parents in Antwerp : Ortelius is the Latinised name of Ortel. He was a friend of Mercator and produced the first great atlas, *Theatrum Orbis Terrarum*, in 1570, for which Frans Hogenburg engraved most of the maps. He used the work of very many cartographers and gracefully acknowledged his sources. His atlas maintained its popularity throughout the remaining years of the seventeenth century. An edition of the *Theatrum* printed in Antwerp in 1595 sold for £1,300 (A 1968).

PETTY, SIR WILLIAM (1623-87), economist, physician, and mapmaker, was born at Romsey in Hampshire and studied in France and Holland. In 1652 he was appointed physician to the army in Ireland and started a number of industries on the estates he acquired in the south-west of the country. Charles II made him Surveyor-General of Ireland and he started a survey in 1654. This was completed after many setbacks and the results were published in 1685 as *Hibernatio Delineatio*. As an economist Petty was particularly interested in the use of land, and used a large scale for his maps, which resulted in a high standard of accuracy.

SAXTON, CHRISTOPHER (w 1569-1606), was born in Yorkshire. He surveyed the counties of England and Wales for Queen Elizabeth and his coloured maps, thirty-five in all, appeared between

I

1574 and 1579 as an *Atlas of the Counties of England and Wales*. They were reprinted again and again : a list of the many editions is given in R. A. Skelton's *Decorative Printed Maps*, 1952. Editions of his *Traveller's Guide* were still being printed early in the eighteenth century.

SAYER, ROBERT (d 1794), was a map publisher of 53 Fleet Street who issued the first edition of the *North American Pilot* (1775) based on the charts of James Cook and Michael Lane. He was at that time in partnership with John Bennett (d 1787). Shortly before Sayer's death the business was taken over by Robert Laurie and James Whittle.

SELLER, JOHN (w 1669-91), was a map-seller who had a shop in London and a workshop at Wapping where charts were printed. He published *The English Pilot* in 1671, using worn copper plates imported from Holland. Later reprints extended over a period of about 150 years. See R. V. Tooley. *Maps and Mapmakers*. 1949. pp 60-61.

SENEX, JOHN (w 1690-1740), was a map-seller and engraver. He produced a new edition of John Ogilby's *Brittania* and issued a *New General Atlas of the World* (1721).

SMITH, CAPTAIN JOHN, was one of the party that sailed from England to establish the first English settlement in North America in 1607. In 1612 he produced a map of *Virginia* which was revised many times and used by other map-makers.

SPEED, JOHN (1552-1629), was born in Cheshire. He started work as a tailor in London, with an amateur's interest in map-making which later became his full-time occupation. He had a great interest in history and worked on maps of the counties, claiming no great originality but using the work of earlier cartographers. *Fifty-four Maps of England and Wales* was published between 1608 and 1610. These maps were later incorporated in his *Theatre of the Empire of Great Britain* (1611-12), for which many plates were engraved in Amsterdam by Jodocus Hondius. The maps show the heraldic arms of county families, plans of some of the larger cities, and views of great houses and churches. The plates were used for later editions over a very long period, though alterations were sometimes made on them. The text was sometimes reset. Dating one of Speed's maps is a task for the expert, who will need, also, to examine

the paper and the watermark. Speed also produced general maps in *Prospect of the most Famous Parts of the World* (1627).

A copy of Speed's *Theatre* with ninety-five double-page engraved maps, published by Bassett & Chiswell as late as 1676, sold for £2,000 (A 1968), and a copy of the *Prospect* for £2,200 (A 1969).

VISSCHER, C. J. (1587-1637), worked for Hondius and later set up an engraving and map-printing establishment that was taken over by his son (1618-79) of the same name, when he died in 1637. A third C. J. Visscher (1649-1709) continued the business. Their maps were based on the work of earlier cartographers. The Latin name of Piscator is sometimes found on the maps of the younger Visschers.

BOOKS TO CONSULT

Serious collectors of early maps should note the excellent publications of the Map Collectors' Circle which are edited by R. V. Tooley, Durrant House, Chiswell Street, London, EC1. These are available to all members. (The annual subscription is at present £6 10s ($17.00).)

Bagrow, L. *History of Cartography*. London and Cambridge, Mass, 1964, contains a list of cartographers to 1750.

Fite, D. E. and Freeman, E. *The Book of Old Maps*. New York, 1965

Lister, R. *How to Identify Old Maps and Globes*. London and Hamden, Conn, 1965. Gives a list of cartographers, engravers, publishers, and printers, concerned with printed maps and globes from c1500 to c1800

Skelton, R. A. *Decorative Printed Maps of the Fifteenth to Eighteenth Centuries*. Latest edition, London, 1967

Tooley, R. V. *Maps and Mapmakers*. London and New York, 1949

Wagner, H. R. *Cartography of the North West Coast of America*. New York, 1937

Wheat, C. I. *Mapping of the Transmississippi West*. Menlo Park, Calif, 1957

10

MINIATURES

MINIATURE portraits can be defined as portraits that are small enough to hold in the hand. They first became popular in the late sixteenth century as personal adornment, being known is limnings, and the painter as a limner. Usually they were likenesses of members of a family and were painted on vellum or card in oils. Nicholas Hilliard, the Exeter limner, who painted miniature portraits of Queen Elizabeth and Sir Walter Raleigh, normally worked on card.

In the seventeenth century painting was often on wood, metal, or bone. Ivory was also tried, and by about 1740 became the usual material on which to paint miniatures. Stippling was introduced late in the seventeenth century.

The art of limning was at its height in the eighteenth century, which produced many fine artists. Richard Cosway had a great following and so did Andrew Plimer, one of his pupils, and his brother Nathaniel. In America a number of miniaturists were protégés of Benjamin West, the first American painter to gain a reputation in Europe. When he settled in London, where he became president of the Royal Academy, he received many young painters as students, including Charles Willson Peale and John Trumbell.

Signed miniatures are more valuable than unsigned examples and those with a named sitter have greater interest. The signature often consists merely of the initials of the artist. It is wise to search carefully with a magnifying glass: they may sometimes be found in the hair or on part of the clothing. But many miniaturists, including some of the greatest, did not sign their work. The search for a signature often encourages the amateur to try to take a miniature from its locket to see if it has been signed on the back. Beware of trying this: it is only too easy to crack or chip a miniature in this way. Leave it to the experts.

The work of some miniaturists, such as Cosway and Engleheart, has been copied. The only way to decide whether an individual specimen is genuine is to become familiar with the style of an artist by studying his work in museums or other collections.

ARLAUD, BENJAMIN (w 1701-c1730), was a Swiss miniaturist who came to England, probably after a period in Holland. Few of his paintings are of named sitters. Signature, if present, on back. A miniature of a gentleman by this artist sold for £70 (A 1969). V & A; W Coll.

ARLAUD, JACQUES ANTOINE (1668-1746), a Swiss miniaturist, was probably the elder brother of Benjamin. He worked in Dijon on small ornamental portraits and later in Paris, where he gained a considerable reputation, and was a favourite of the Duc d'Orléans. He eventually returned to Switzerland, spending the last years of his life in Geneva. His work is usually signed. V & A; W Coll; Windsor.

ARLAUD, LOUIS AMI (1751-1829), a Swiss miniaturist, who was grand-nephew of Benjamin and Jacques. After a period in Paris and a tour of Italy he settled in Geneva from 1778 to 1792, where he prospered. In 1792 he moved to London and received many commissions from the nobility, exhibiting his work at the Royal Academy. In 1802 he returned to Geneva and lived there until his death.

AUGUSTIN, JEAN BAPTISTE JACQUES (1759-1832), a painter on enamel whose work is much sought after for its rich colour and vigorous style. AM.

AUTISSIER, LOUIS MARIE (1772-1830), worked in Belgium, France, and Holland, painting miniatures of aristocrats and celebrities.

BARRY, JOHN (w 1784-1827), was a London miniaturist who exhibited at the Royal Academy throughout his working life. He is noted for an unusual treatment of the hair and eyebrows of his subjects. V & A.

BEALE, CHARLES (c1660-94), was the son of Mary Beale. He was a pupil of Thomas Flatman. Beale was forced at one point in his career to give up painting miniatures because of poor eyesight.

BEALE, MARY (1633-99), a London miniaturist, was a pupil of Sir Peter Lely. She was primarily a portrait painter on a larger scale : her output of miniatures appears to have been small.

BEAUMONT, JOHN THOMAS BARKER, FSA, FGS (1774-1841), was known until 1820 as J. T. Barker. Born in Marylebone, London, he studied at the Royal Academy School and gained many

awards. His interests were wide—he was an antiquarian, organiser of a rifle corps, businessman in insurance, and writer. His painting of miniatures was done mainly between 1794 and 1806, when he received commissions from the Royal Family.

BOGLE, JOHN (c1746-1803), a Scottish miniaturist, studied at the Drawing School in Glasgow and later worked first in Edinburgh and then in London (from 1770) where he exhibited between 1772 and 1774 at the Royal Academy. He returned to Edinburgh for the last three years of his life. His portraits of lady sitters were particularly successful. He signed his work either with full surname or simply 'J.B.' V & A; National Gallery, Dublin; National Gallery of Scotland, Edinburgh.

BOIT, CHARLES (c1662-1727), was a Swede, the son of French parents. He worked with a goldsmith in Stockholm until he was twenty years of age and moved to England in 1687. In 1696 he became Court Enameller to William III, but he was never happy in one place for very long; in 1699 he went back to Holland, then to Germany, before returning to England in 1703. He was commissioned to do work for Queen Anne but never completed it, and when she died in 1714 he went to France and worked there until his death. He is noted for his use of pink and yellow. NPG; AM; Woburn Abbey.

BONE, HENRY, RA (1755-1834), was born in Truro and worked as a decorator of porcelain at Plymouth and Bristol until he was nearly thirty years of age (see pp 192-3). He studied the painting of miniatures in London and executed many *Portraits of Illustrious Englishmen* in enamel, mainly copies of larger paintings (usually signed on the back), and a number of originals on ivory that are normally signed on the front. He became an ARA in 1801 and an RA in 1811. NPG; AM.

BONE, HENRY PIERCE (1779-1855), son of Henry Bone, learnt enamelling from his father. Many of his miniatures are copies of portraits by artists such as Reynolds and Van Dyck, but he painted a number of originals which he signed on the back. In 1833 he became Enamel Painter to Queen Victoria. AM.

BOZE, JOSEPH (1746-1826), was a French painter of miniature portraits which included those of Louis XVI and Marie Antoinette. At the time of the French Revolution he came to England.

BUCK, ADAM (1759-1833), was born in Cork, the son of a silversmith. He started as a miniaturist in Cork but moved to London in 1795, where he exhibited at the Royal Academy. His work was usually signed.

BUCK, FREDERICK (c1770-c1840), younger brother of Adam Buck, started painting in Cork, where he was born. He specialised in miniatures of military men.

CARWARDINE, PENELOPE (1730-1801), was the daughter of a spendthrift country gentleman, John Carwardine, who lived in Withington, Herefordshire, where she was born. She was forced to earn a living and did well as a miniature painter until she married in 1772.

CHINNERY, GEORGE (1774-1852), was an artist of Irish descent who was born in London into a family with artistic interests. He exhibited at the Royal Academy in 1791, where his work was highly praised. A few years later he went to Dublin and in 1799 married, but the marriage broke up in 1802 and he returned to London. (It was in Ireland that he had become particularly interested in the painting of miniatures.) He went almost immediately to India, living in Madras and in Bengal. Then in 1825 he went to China, though it is doubtful whether he continued to paint miniatures there. However, it is not surprising that Chinnery's work is liable to turn up in unexpected places.

COLLINS, RICHARD (1755-1831), was born in Hampshire. In 1787 he became Chief Miniature Painter to George III.

COLLINS, SAMUEL (d c1768), was born in Bristol and worked as a miniaturist in Bath, where he incurred so many debts that in 1762 he had to go to Dublin. When he was born or how long he lived is not known but since known examples of his work date only from the 1760s he may have died young. V & A.

COMERFORD, JOHN (1773-1832), was born in Kilkenny, Ireland, and moved to Dublin to study at the Dublin Society's Academy. It was some years before he produced many portrait miniatures; his early work was mainly on a larger scale and included portraits in oils. This influenced his later work, which was of very high quality.

COOPER, ALEXANDER (d c1660), elder brother of Samuel Cooper, learnt his craft from his uncle, John Hoskins. Relatively

little is known about him, perhaps because he spent many years abroad, mainly in Holland and Sweden. He signed his work with his initials. V & A; AM.

COOPER, SAMUEL (1609-1672), was born in London and, like his brother Alexander, was a pupil of his uncle, John Hoskins, with whom he worked until 1634. Mrs Daphne Foskett describes him as 'the greatest English-born painter in miniature and some would say the finest miniaturist in Europe during the seventeenth century'. He was a cultured man and a superb craftsman who caught the character of his sitters unerringly. He painted on vellum laid over card and was probably the first to use a white paint covering before using colours. He is particularly noted for the fine way in which he painted the hair of his sitters. Most of his work seems to have been done in the last thirty years of his life between 1642 and 1672. His work may be seen in the NPG (Oliver Cromwell); V & A; W Coll; AM; FM; and at Waddesdon Manor, near Aylesbury.

COPLEY, JOHN SINGLETON, RA (1738-1815), taught himself to paint in his home town of Boston in the 1760s, and worked for many years as a portrait painter in America. In 1774 he settled in England. Many of his portraits and drawings were destroyed in the Great Fire of Boston in 1872. Some of his miniatures may be seen in the BMFA. See Prown, J. D., *John Singleton Copley*. 2 vols. Cambridge, Mass., 1966.

COSWAY, RICHARD, RA (c1742-1821), was born and brought up at Tiverton in Devon, where his father was headmaster of Blundell's School. He started painting miniatures when he was eleven years of age and was in London soon afterwards as a pupil of William Shipley. He showed great concentration and enthusiasm and won many prizes for his work. By 1771 his reputation was secure and he became a Royal Academician solely because of his eminence as a miniaturist. Cosway appears to have been a great social success, at least in certain circles. He loved clothes and dressed as a dandy, although he was by no means handsome. His wife was an artist friend of Angelica Kauffman, and after the marriage they lived in Berkeley Square and later at Schonberg House, not far from Carlton House, where he became a great collector, particularly of drawings and prints. In 1786 he was made Miniaturist to the Prince of Wales.

Cosway was unrivalled as a painter of miniatures on ivory and he exploited the full possibilities of this base. Early examples are usually small but as time went on he painted on three-inch ivories and was noted for the blue clouds painted in his backgrounds. He worked rapidly and prided himself on his ability to do so. Yet the results exhibit a flair lacking in many a more painstaking artist. Examples of his work may be seen at the NPG (self-portrait); W Coll; AM; and Woburn Abbey. See Williamson, G. C. *Richard Cosway, RA 1897*. 1905.

COTES, SAMUEL (1734-1818), was born in London. He exhibited at the Royal Academy from 1769 to 1789. It is often difficult to distinguish between his miniatures and those of Samuel Collins since they used the same initials when signing their work.

COURTOIS, MARIE (1655-1703), was a French miniaturist who married the portrait painter Marc Nattier.

CROSS, LAWRENCE (c1653-1724), sometimes spelt Crosse, painted on parchment or vellum on card, often using fine stippling on the face and many of his sitters wore rather pretentious wigs for their portraits. A portrait of Anne Countess of Winchelsea sold for £820 (A 1969). NPG; V & A; W Coll; AM; and the Liverpool Museum.

CROSS, PETER (c1630-c1716). Little is known about this miniaturist except that he may have been related to Miguel de la Cruz, a Spanish painter. But his signed portraits have been studied and show a greenish stippling which is characteristic.

CROSSE, RICHARD (1742-1810), was born near Cullompton in Devon. He was a deaf mute but found an outlet in his concentration on painting. He went to London to train and work, living in Henrietta Street, Covent Garden. He found satisfaction in exhibiting, first at the Incorporated Society of Artists and the Free Society of Artists, and later at the Royal Academy from 1770 to 1796, when he began to suffer from a serious decline in health that eventually led to a return to Devon before his death. His work is not signed and his characteristic style must be studied before attribution is possible. Examples in FM. See plate p 89. A set of miniatures by Richard Crosse of the three children Joseph, Peter, and Amelia de Lautour, sold for £4,000 (A 1969).

DAFFINGER, MORIZ MICHAEL (1790-1849), was an Austrian miniaturist who painted many court nobles in Vienna.

DANIEL, ABRAHAM (d 1806), was a Somerset miniaturist who moved to Plymouth, probably in the 1770s, but appears to have visited Bath from time to time 'for the season'.

DANIEL, JOSEPH (1760-1803), was Abraham Daniel's brother. For some time he worked in Bristol but from about 1785 he appears to have been in his home town of Bath. It is extremely difficult to attribute miniatures which are merely described as by 'Daniel of Bath' definitely to Abraham or to Joseph.

DAY, THOMAS (1732-1807), was a Devon man who studied under Ozias Humphrey when he was already in his mid-thirties. His work is usually signed, most frequently with the initials 'T.D.'. A miniature of a gentleman by Day sold for £80 (A 1969).

DELACAZETTE, SOPHIE CLÉMENCE (1774-1854), was born at Lyons. She became a pupil of Augustin and exhibited regularly between 1806 and 1838.

DERBY, WILLIAM (1786-1847), was born in Birmingham and moved to London. He made copies of larger portraits, such as that of Viscount Duncan after Hoppner (National Gallery of Scotland).

DES GRANGES, DAVID (c1611-75), was the son of a Guernseyman and became a painter, engraver, and limner, working in London. He had the patronage of Charles I and Charles II. His work was signed 'D.G.' or sometimes 'D.D.G.' There is an example at The Vyne, near Basingstoke.

DIXON, ANNIE (w 1844-1901), was born in Lincolnshire and started painting miniatures at Horncastle before she began to move around—first to Hull, then to the Isle of Wight, and finally to London. She exhibited at the Royal Academy from 1844 to 1893. Examples in the V & A and at Windsor Castle.

DIXON, NICHOLAS (w 1667-1708), succeeded Samuel Cooper as Limner to Charles II in 1673. It is not certain where he learnt to paint: some say from Sir Peter Lely, others from John Hoskins. He is noted for painting the flesh a brownish-red colour so that his subjects always look in good health. AM.

DONALDSON, JOHN (1737-1801), was born in Edinburgh and showed talent as an artist at an early age. He worked for some time in his native city and then moved to London in 1760, where he was closely associated with the Society of Artists. He worked in black-lead, watercolour, and enamel, and also painted porcelain as an

outside decorator (see p 199). In the 1790s he became blind and suffered from extreme poverty.

DOWNMAN, JOHN, ARA (1750-1824), was brought up in Wales but was in London by 1768 as a pupil at the Royal Academy School. He came from a Quaker family and this led to a close association with Benjamin West, the American painter, from whom he learnt a great deal. He preferred to move around rather than establish a long-term permanent base and he accepted commissions from all over the country, not only for miniature portraits but also to paint larger portraits in watercolour and oil.

DUNN, ANDREW (w 1809-20), studied in Dublin and then worked at Waterford and Kilkenny and later in London. He exhibited at the Royal Academy from 1809 to 1811. His work is usually signed *A. Dunn.*

EASTON, REGINALD (1807-93), was a London miniaturist noted for his child portraits. He exhibited at the Royal Academy from 1835 to 1887. For a short period in 1850 he worked in Leamington. Examples in Royal Collection, Windsor.

EDRIDGE, HENRY, ARA (1769-1821), was born in London. He studied at the Royal Academy Schools and from 1786 until the year of his death exhibited at the Academy. He used various techniques, painting on ivory or on paper, sometimes working in black on white, often using watercolours on a faint outline drawing. He usually signed his work, sometimes with initials on the portrait, often with full details on the back. NPG.

EINSLE, ANTON (1801-71), was born in Vienna where he worked as a miniaturist.

EMM, PETER (1799-1873), a German painter of miniatures.

ENGLEHEART, GEORGE (1750-1829), was the youngest member of an artistic family. His father was a skilled modeller in plaster. George studied at the Royal Academy Schools and became a highly skilled, prolific, and meticulous worker. He became one of the great miniaturists of the eighteenth century and during his working life he painted well over 100 miniatures a year: in 1788 he painted over 200. A complete record exists from 1775 to 1813 when he ceased to accept commissions. His sitters, men and women, though he preferred the latter, wore attractive and colourful clothes for their portraits—bright coats, picture hats, frilled and beribboned

dresses, and he showed consummate skill in painting these materials.

Experts divide his work into three periods. First, the small portraits on ivories less than 2 in high, with applied lead white for the highlights and grey or grey-brown backgrounds shaded with near vertical strokes of the brush. Then came the second and more confident period after 1780, when he used stronger colours on larger ivories and took great care with the elaborate hair styles of his subjects, and other detail. In the third period, from about 1800, his miniatures became larger still and often rectangular.

Engleheart exhibited at the Royal Academy from 1773 to 1812. He became Miniature Painter to George III and painted him twenty-five times. Most of his sitters were respectable solid citizens—businessmen and members of the armed services (Richard Cosway served the gayer elements in society).

Miniatures of unknown sitters by George Engleheart have sold for £200, £300, and £400 (A 1969). Examples of his work may be seen in the NPG (self-portrait); AM (see plate p 89); and Woburn Abbey, Bedfordshire.

ENGLEHEART, JOHN COX DILLMAN (1784-1862), was a nephew and pupil of George Engleheart and nephew of Thomas Richmond. He started work on his own in 1807 and is known to have lived for a while in Birmingham, where he married in 1811. He exhibited at the Royal Academy from 1801 to 1828 but in that year he gave up work because of ill health, travelled abroad, and eventually settled in Tunbridge Wells, where he lived to the age of 78. His miniatures are usually signed in full on the back. There is a self-portrait in the NPG, and examples in the FM.

A portrait of a boy sold for £160 (A 1966) and a similar portrait for £520 (A 1969).

FAED, JOHN (1819-1902), was born at Gatehouse-of-Fleet, Kirkcudbrightshire, and showed promise as a painter at an early age. By 1841 he had settled at 5, York Place, Edinburgh, where he had considerable success as a miniaturist, exhibiting at the Royal Scottish Academy. In 1862 he moved to London, where he lived and worked until 1880, exhibiting at the Royal Academy. He then returned to his native country.

FLATMAN, THOMAS (c1635-88), was born in London and, after training as a barrister, turned to poetry and the painting of

miniatures and excelled at the latter. His work is often compared with that of Samuel Cooper and he was probably the finest young miniaturist of the day when Cooper was at the height of his power. His portraits were mainly oval, on card or ivory. He frequently painted his sitters against the background of a blue sky. Examples of his work are to be seen in the V & A (self-portrait); W Coll; AM; and Woburn Abbey, Bedfordshire.

FORSTER, THOMAS (b c1677). Little is known about this artist except that he produced what are known as 'plumbago miniatures' drawn with lead pencil on vellum. His work, which was usually signed *T. Forster*, may be seen in the BM; V & A; and the Holburne of Menstrie Museum, Bath.

FRASER, CHARLES (1782-1860), was born in Charleston, S Carolina, and became a prolific artist. An exhibition in Charleston in 1857 included 313 of his miniatures.

GIBSON, WILLIAM (1644-1702), studied under Lely and copied many of his works. These included miniature portraits.

GRIMALDI, WILLIAM, 8th MARQUIS (1751-1830), was born in Middlesex into a family with origins in Genoa. From 1768 until 1777 he worked in London and then went to Paris, where he lived until 1783, when he returned to England and married in Maidstone. Possibly he worked there for a while and also in other provincial centres, though he also worked in London : he was living in Chelsea when he died. Grimaldi painted miniatures for members of the Royal Family. Most of his work, which was in enamel on ivory, was signed. Examples may be seen in the W Coll; and at Woburn Abbey, Bedfordshire.

HAMILTON, GUSTAVUS (1739-75), was a Dublin miniaturist, a pupil of Robert West. His work is signed *G.H.*, *Ham*, or sometimes *Gus. Hamilton*.

HARGREAVES, THOMAS (1775-1846), was born in Liverpool. In 1793 he moved to London and worked as an assistant to Sir Thomas Lawrence, the portrait painter, but returned to Liverpool because of ill-health in 1795. He worked as a miniaturist in this city, exhibited at the Liverpool Academy, and died there in 1846. His work shows the influence of Lawrence. His miniatures, which were mainly rectangular, were signed, usually on the back.

HAUGHTON, MOSES (c1772-1848), was a miniaturist whose work can be seen in the AM.

HAZLEHURST, THOMAS (w1760-1818), was a Liverpool miniaturist who exhibited at the Liverpool Academy from 1810 to 1812. His portraits show a halo of light round the head and the hair is painted in strong clear lines. He signed his work *T.H.* Hazlehurst died in 1821.

HILLIARD, LAURENCE (c1581-1640), was the son of Nicholas Hilliard, the only one of his eight children to follow his father's profession. When his father died in 1619 Laurence became Limner to James I. Although he clearly learnt much from his father's techniques, his work never reached the same standard of artistry.

HILLIARD, NICHOLAS (1547-1619), was born in Exeter, the son of a goldsmith. He started painting miniatures at an early age, usually on vellum backed by card. By 1570 he was working in London and in 1576 he married the daughter of the Chamberlain of the City of London and had a large family. In 1584 he became Court painter 'in little' to Queen Elizabeth and in 1587 engraved the Great Seal of England. His portraits usually incline slightly to one side, giving a three-quarters view and he was a fine artist in the tradition of Holbein, whom he greatly admired. His work is particularly noted for the skill with which lace on the costumes has been painted. In 1600 he was asked to write a *Treatise Concerning the Art of Limning*, which describes his methods in detail. (There is a copy in the Library of the University of Edinburgh.) By 1610 his work began to deteriorate a little, perhaps because he was worried about money. Examples may be seen in the NPG (Queen Elizabeth in 1572, and Sir Walter Raleigh); V & A (self-portrait, and portrait of his father); National Maritime Museum; FM; Norwich Castle Museum; Berkeley Castle; Windsor Castle; Waddesdon Manor, near Aylesbury; and Woburn Abbey.

A portrait by Hilliard of Mary Queen of Scots in 1581 sold for £860 (A 1904) and one of James I of England and VI of Scotland for £5,500 (A 1969). This was a record price for the work of this artist.

HOLBEIN, HANS (c1498-1543), or Holbein the Younger as he is sometimes called, was born in Augsburg. He moved to Basle in 1514 and when there was political unrest in this city in 1536 he travelled to England, where he stayed in the house of Sir Thomas More in Chelsea. He was the first painter of miniatures to work in England. More introduced him to Henry VIII, who subsequently gave

him many commissions. His portraits are round and the sitters are painted against a blue background. Holbein's work is rare and seldom reaches the salerooms. A single miniature by this artist, however, sold for £21,000 (A1969). Examples may be seen in the V & A (Anne of Cleves) and Windsor Castle.

HOLLIER, JEAN FRANÇOIS (d 1845), was born in Chantilly, France, and was a pupil of Jean Baptiste Isabey.

HOLMES, JAMES (1777-1860), was a miniature and water-colour painter well known to George IV. He helped to found the Society of British Artists in 1829.

HONE, HORACE, ARA (1756-1825), was born in London, the son of Nathaniel Hone, from whom he learnt his craft. He first exhibited at the Royal Academy in 1772. In 1795 he became miniature painter to the Prince of Wales. He was a prolific artist and his portraits show glowing colours. His early work was done in London but he spent many years in Dublin from 1782 to at least 1802. There is a miniature self-portrait of Horace Hone in the NPG and his work may be seen in the FM (see plate, p 89).

HONE, NATHANIEL (1718-84), was born in Dublin and became Ireland's most noted miniaturist. For some years he moved from town to town in England and then, in 1742, he married and settled in London. He was a foundation member of the Royal Academy in 1768. His miniatures are usually small and are signed *N.H.* Examples are to be seen in the NPG (self-portrait) and AM.

HOSKINS, JOHN (c1595-1665). Little is known about this superbly skilful limner except that he had a son also called John, who became a limner, so that it is difficult to distinguish their work with certainty. Alexander Cooper and Samuel Cooper were nephews who worked with him.

Hoskins became Limner to Charles I. He made copies of the masters, especially Van Dyck. His early miniatures have a blue or brown background; later he used landscapes. His work was signed *I.H.* or *H.* John Hoskins died in London. Examples of his miniatures may be seen in the AM and at the Vyne, Hampshire.

A miniature of Charles II as a boy sold for £1,080 (A 1961); one of John Gauden, signed and dated 1655, for £1,000 (A1968); and a portrait of Henrietta Maria, Queen to Charles I for £52 (1925) and again for £7,500 (A 1968), which, at the time, was a record price for a miniature.

HOYER, CORNELIUS (1741-1804), was born near Copenhagen and became Miniaturist to the Danish Court. In 1777 he became secretary of the Copenhagen Academy. From 1780 to 1797 he worked in St Petersburg.

HUMPHREY, OZIAS, RA (1742-1810), was born at Honiton in Devon. He studied in London but returned to Honiton on the death of his father. Later he worked under Samuel Collins in Bath and eventually took over his practice. However, Sir Joshua Reynolds, for whom he had always had a great admiration, urged him to move to London, which he did in 1763. His work was much admired and he was asked to paint miniatures of members of the Royal Family, including the Queen. In 1772 a fall from a horse shook him badly and affected his work. It took several years spent at home and in India before he could regain his reputation for miniature painting. In 1791 he became an RA but failing sight made it impossible for him to continue. Examples of his work may be seen in the AM and in Woburn Abbey, Bedfordshire.

INMAN, HENRY (c1801-46), was born in Utica, New York. He learnt his craft as a painter from J. W. Jarvis in New York from 1831 to 1834, and established himself in Philadelphia. He painted many portraits of Indians. The year before his death he visited Europe where he had commissions to paint the portraits of a number of famous people.

ISABEY, JEAN BAPTISTE (1767-1833), was a French miniaturist who had a successful career leading to an appointment under Napoleon I in 1805 as first painter to the Empress Josephine. In 1814 he was commissioned by Talleyrand to paint plenipotentiaries at the Congress of Vienna.

JARVIS, JOHN WESLEY (1780-1834), was born at South Shields in England. He was brought up by his uncle, John Wesley, until he was five years old. Then he went with his father to Philadelphia and later became one of the best portrait painters of his time, working mainly in New York.

JEAN, PHILIP (1755-1802), was born in Jersey, and after a short youthful career in the Navy under Admiral Rodney, became a miniaturist. He lived in London from 1784, first at 50 Margaret Street, Cavendish Square, and later at 10 Hanover Street, Hanover Square. He exhibited at the Royal Academy from 1787 to 1802 and painted portraits of the Duke and Duchess of Gloucester and

their children. He signed his work *P.J.* or sometimes *P. Jean*. NPG and V & A.

JOHNSON, CORNELIUS (c1593-c1661), was brought up in London though his parents came from Antwerp where the name was Janssen. He worked as a miniaturist in England until 1643 and then moved to Amsterdam. He painted on card with meticulous care and the influence of Van Dyck, whom he greatly admired, is seen in his work. AM.

LAURENCE, GEORGE, was an Irish miniaturist who learned his craft at Robert West's Drawing School in Dublin where he worked (c1771). Later he moved to Kilkenny (c1774). He is noted for his use of pale colours.

LENS, BERNARD (1682-1740), was born in London, the son of a mezzotint engraver who also taught drawing. With this background it is not surprising to find that he became a skilful miniaturist and a teacher of art at Christ's Hospital. He also taught a number of well known people privately. He was the first English miniaturist to paint on ivory and often used rectangular frames made of pinewood as well as the traditional round and oval frames. Although much of his work was from life he also copied, especially from Kneller, an artist who had a considerable influence on his style.

Bernard Lens had two sons who also became successful miniaturists—Andrew Benjamin Lens (b 1713) and Peter Paul Lens (c1714-c1750).

LINNELL, JOHN (1792-1882), was born in London. He was a pupil of John Varley and went to the Royal Academy School in 1805. For over twenty years he produced many miniatures, though he was not so prolific as some of his contemporaries since his preference was for landscape painting. His work may be seen in the BM (John Rennie) and in the NPG.

MALBONE, EDWARD GREENE (1777-1807), was born at Newport. He studied painting and in 1796 went to Boston and later to New York, Philadelphia and Charleston working as a miniaturist. Many of his miniatures were painted in Charleston after 1801. He suffered at this period from ill-health and in 1807 died in Savannah.

MEE, Mrs JOSEPH, née ANNE FOLDSTONE (c1770-1851), was the daughter of John Foldstone, a portrait painter. The death

of her father forced her to try to earn a living by painting. In this she succeeded and by 1804 she was exhibiting miniatures at the Royal Academy. For a time (1790-91) she worked at Windsor. Some critics suggest that her sitters look as though they have been in tears, since she used a red colour round the eyes.

MEYER, JEREMIAH, RA (1735-89), was born in Germany but came to England in 1749 at the age of fourteen. He studied under C. F. Zincke and in 1726 was naturalised. From this date he had Royal patrons and was a founder member of the Royal Academy, the only miniaturist to be selected. His portraits show the influence of Reynolds, whose work he had carefully studied. He was a prolific worker, noted for the way in which he touched up the embellishments on the clothes of his sitters with white, bringing out the delicacy of lace and silks. Unfortunately, he rarely signed his work. Examples in the NPG; V & A; AM; Norwich Castle Museum; Windsor Castle; and Woburn Abbey, Bedfordshire.

MILES, EDWARD (1752-1828), was born at Yarmouth in Norfolk. In 1771, encouraged by a local surgeon, he moved to London. By 1775 he was exhibiting at the Royal Academy and continued to do so when he returned to Norwich in 1779. He became Miniature Painter to the Duchess of York and Queen Charlotte. In 1797, Miles went to Russia and became Court Painter to Czar Paul I. Ten years later he crossed to America to live in Philadelphia, where, though he continued to paint and to teach, his output declined; he had made enough money to take more leisure. Examples of his work are in the AM; and Windsor Castle.

NEWTON, SIR WILLIAM JOHN (1785-1869), was born in London. He painted large portraits on ivory and joined several pieces together in order to provide a large area to work on. He did a number of miniatures for the Royal Family and was knighted by Queen Victoria in 1837. His work is signed and dated on the back.

NIXON, JAMES, ARA (c1741-1812); was born at Tiverton in Devon, but worked mainly in London, though he was in Edinburgh for a brief period between 1795 and 1798. He first exhibited miniatures at the Royal Academy in 1772, became an ARA in 1778, and continued to exhibit until 1807. In 1798 he became Miniaturist to the Prince Regent. Among his sitters were many actresses dressed for the parts they played. Nixon returned to Tiverton before his death in 1812.

NORGATE, EDWARD (c1581-1650), was the son of the Master of Corpus Christi College, Cambridge. He was primarily an illuminator but did paint a number of miniature portraits; one may be seen in the V & A. He wrote *Miniatura, or the Art of Limning*.

OLIVER, ISAAC (c1556-1617), was born in Rouen, the son of a Huguenot who fled to England when Isaac was a boy. He spent some time in Italy in the 1590s where he studied painting. Oliver was considerably influenced by Nicholas Hilliard in the style of his early work. He painted on vellum or parchment, backed by card. Many of his portraits have a landscape background. They are seldom signed or dated though occasionally the initials *I.O.* may be found. His work may be seen in the V & A (Salting Bequest).

A portrait of Queen Anne of Denmark, wife of James I, by Oliver sold for £650 (A 1968).

OLIVER, PETER (c1594-1647), was the son of Isaac Oliver by his first wife, who was taught to paint by his father, and in the view of many experts became a greater miniaturist. He did a great many copies of larger portraits : a copy of Van Dyck's *Sir Kenelm Digby with his wife and two sons* is a superb example of its genre. Most of his work, which was on vellum or parchment on card, was signed *P.O.* Examples may be seen in the V & A; Waddesdon Manor, near Aylesbury; and at Windsor Castle. A portrait of Charles I as a youth sold for £1,800 (A 1968).

PAILLOU, PETER (w c1763-1800), was a London miniaturist who seems to have spent some time in Scotland, though little is known about him. He exhibited at the Royal Academy between 1786 and 1800. His work shows considerable variation but is usually signed with an initial and full surname.

PALMER, SIR JAMES (1584-1657), was well regarded by Charles I and held many important appointments. He was a Governor of the Royal Tapestry Works at Mortlake and Chancellor of the Order of the Garter. Painting miniatures was a sideline and some are merely copies of portraits in the Royal Collection. An oval miniature of a gentleman by Sir James Palmer, signed and dated 1623, sold for £4,400 (A 1969).

PEALE, CHARLES WILLSON (1741-1827), was born at Chesterton in Pennsylvania, was apprenticed to a saddler and also worked for some time as a watchmaker and woodcarver. He studied painting under Copley in Boston in 1767 and spent two years (1771-2) in

London with Benjamin West where he painted some miniatures as well as engraving. He then settled in Philadelphia and worked as a portrait painter and miniaturist. He was responsible for the establishment of the Pennsylvania Academy of Fine Arts.

PEALE, JAMES (1749-1831), brother and pupil of Charles Willson Peale, was a miniaturist from the 1770s.

PETITOT, JEAN (1607-91), was born in Geneva. He first became an enameller in the jewellery trade and then turned to painting miniatures. He worked closely for many years with a friend, Jacques Bordier (1616-84). In 1633 they moved together to Paris and they remained close friends throughout Petitot's life. Bordier is said to have painted the draperies and background, and sometimes the hair, and Petitot did the faces of their sitters. By 1637, Petitot was painting in London for Charles I and he was the first painter in England to use enamels. Later, Charles II came to know him and introduced him to Louis XIV, for whom he painted Royal portraits. He also copied many portraits, working in enamel, in the Louvre. As a Protestant convert he was imprisoned and when released found it necessary to leave France and return to Geneva, his birthplace. To avoid the publicity which came with fame, he moved to Vevey, where he was able to live and work in relative peace until his death at the age of 84. Petitot's work in enamel was superb, better than anything that had previously been achieved in that medium. Examples may be seen in the V & A (Jones Collection) and in the Louvre, Paris.

PLACE, GEORGE (w 1775-1805), was born in Dublin and studied at the Dublin Society's School. Between 1791 and 1797 he worked in London and exhibited at the Royal Academy. After a brief spell in York he went to Lucknow in India where he died. He did not sign his work so it is sometimes difficult to decide whether miniatures attributed to him are genuine.

PLIMER, ANDREW (1763-1837), was born in Shropshire into a family of clockmakers. Reacting against this trade, Andrew and his brother Nathaniel left home and for some time lived and moved around with a group of gypsies, painting caravans, theatrical scenery, etc. When their travels brought them near London they set out for the capital, where they took jobs in service. Andrew succeeded in securing a position with Richard Cosway, who soon realised that the young man had an artistic flair and helped to arrange for

him to receive some training. Andrew Plimer started in Golden Square, London, as a miniaturist in 1785. From 1815 to 1818 he was in Exeter. Then he returned to London, though he did a good deal of travelling not only in the West of England but as far north as Scotland. Finally, in 1835, he settled with his family in Brighton and died there two years later. He exhibited at the Royal Academy from 1786 to 1819. His portraits were painted in oil and in water-colour on vellum, card, or ivory. Many experts regard his minia-tures of men as superior to those of his lady sitters, who seem to lack character. He had a tendency to exaggerate the length of the nose. His early work was signed *A.P.* and dated. Later work was unsigned. Examples in the AM. An Andrew Plimer miniature sold for £650 (A 1968).

PLIMER, NATHANIEL (1751-87), was the elder brother of Andrew Plimer (see above) but his work is rarer and the quality inferior, though he exhibited at the Royal Academy from 1787 to 1815. Only his early work is signed. Examples in the V & A and FM.

PREWETT, WILLIAM (w 1735-50), was a good miniaturist about whom very little is known. All examples of his work fall be-tween 1735 and 1750 : some may be seen in the V & A.

REILY, JAMES (c1730-c1788), was an Irish miniaturist who trained at Robert West's Drawing School in Dublin. There is an example of his work in the V & A.

RICHMOND, THOMAS (1771-1837), was a pupil of George Engleheart. He exhibited at the Royal Academy between 1795 and 1825. His work may be seen at the AM.

ROBERTSON, ANDREW (1777-1845), was born and brought up in Aberdeen, where he took a university degree in 1794. How-ever, the family was not well-to-do and in 1801 he decided to walk to London. Here he became a protégé of Benjamin West and trained as an artist at the Royal Academy Schools. He quickly achieved a reputation and painted miniatures for the Royal Family. He ex-hibited at the Royal Academy from 1802 to 1842. Robertson's miniatures are usually rectangular and with their rich colours look more like small versions of larger oil paintings. They are usually signed *A.R.* Examples in the NPG and AM.

ROBERTSON, CHARLES (1760-1821), was born in Dublin and started painting miniatures in 1775. Ten years later he went to work

in London, and stayed for seven years. He exhibited at the Royal Academy from 1790 to 1810. When he returned to Ireland he helped to found the Royal Hibernian Academy. His work may be recognised by the greyish look he gave to the faces of his sitters.

ROCHARD, FRANÇOIS THÉODORE (1798-1858), was born in France and moved to England in 1820 to help his brother Simon. He exhibited at the Royal Academy in 1820 and 1823. His work was signed *Rochard*. He married in 1850 and retired; in 1858 he died at Notting Hill, London.

ROCHARD, SIMON JACQUES (1788-1872), was born in Paris. He started by drawing crayon portraits for sale to help the family income. In 1815 he moved to England and established contacts with distinguished clients : he painted Princess Charlotte. In 1846 he moved again, this time to Brussels. Like his brother he signed his work *Rochard*, so it is sometimes difficult to know whether to attribute a miniature to François or to Simon.

ROCHE, SAMSON TOWGOOD (1759-1847), was born and studied in Dublin. He worked in Dublin and Cork and, after 1792, in Pierrepont Street, Bath, returning to Ireland towards the end of his life when he retired. He exhibited at the Royal Academy in 1817. He is noted for smiling portraits in semi-profile. His work is signed *Roch or Roche*.

ROSS, SIR WILLIAM CHARLES, RA (1794-1860), was born in London. He was a natural artist and went to the Royal Academy Schools in 1808, exhibiting at the Royal Academy in 1809 at the age of fifteen : he continued to exhibit for fifty years. In 1814 he became an assistant to Andrew Robertson but soon branched out on his own and became the most noted miniaturist of the century. He became Miniature Painter to the Queen in 1837 and was knighted in the following year. He was a prodigious worker and is said to have painted over 20,000 miniatures, finely drawn and with rich colouring. His work was usually signed in full.

SCOULER, JAMES (1741-1812), was born in London. He exhibited at the Royal Academy from 1787. His work was nearly always signed, with initials, initial and surname, or in full, and with the date.

SHELLEY, SAMUEL (c1750-1808), was born in London and was largely self-taught : he owed much to his study of the work of Reynolds. He painted miniature portraits but also nymphs, cupids,

Psyche, and other mythological subjects, and they were shown when the Old Water Colour Society which he helped to form held its opening exhibition in 1805. He exhibited at the Royal Academy from 1774 to 1804. His work is sometimes signed *S.S.* on the front; at other times *Sam Shelley* on the back. Examples may be seen in the AM.

A miniature of a gentleman by Shelley sold for £85 (A 1969) and one of Captain Edward Riou as a post captain painted soon after 1795 for £450 (A 1968).

SHIRREFF, CHARLES (b c1750), a Scot, was born deaf and dumb. In 1768, after some training in Edinburgh, he moved to London to study at the Royal Academy Schools. He exhibited at the Royal Academy between 1771 and 1831, though not every year. His movements are uncertain : he was certainly in London in the 1770s, later in Brighton and Cambridge, and in the early 1790s in Bath. In 1800 he went to India, and probably lived both in Madras and Calcutta before returning to England in 1809. Some of his miniatures were signed on the back.

SMART, JOHN (c1742-1811), was one of England's finest miniaturists. He was born in Norwich and was already painting extremely well at the age of eleven. For many years he worked in London and established a reputation as one of the best miniaturists of the day. In 1785 he left for India, where he worked until 1795, then returned to England. The miniatures painted during this period carry the letter *I* with the date, for Smart always signed and dated his work. The portraits were usually painted on ivory against a plain or sky background, and the ivory left unpainted where a high light was needed. He never flattered his sitters : if their faces were lined he would show them as lined. All detail was painted meticulously. His work may be seen in the V & A, and the AM. A book by Daphne Foskett—*John Smart: the Man and his Miniatures* (1964)—contains over 100 illustrations of his work, some in colour. His miniatures appear frequently in salerooms and prices in 1968-9 varied from £850 to £2,400.

SMIADECKI, FRANCISZEK, was a Swedish miniaturist who worked in the late seventeenth century. A signed example of his work sold for £1,000 (A 1969).

SPENCER, GERVASE (d 1763). Little is known about this artist, who appears to have been self-taught. Most of his miniatures were

small and were signed. Examples may be seen in the Usher Gallery, Lincoln and in the AM.

SPICER, HENRY (1743-1804), was born in Norfolk and moved to London in the 1760s. In the late 1770s he went to Dublin, returning to London in 1782. He worked mainly in enamel and in 1790 became Portrait Painter in Enamel to the Prince of Wales. His work may be seen in the AM.

STEWART, ANTHONY (1773-1846), was born at Crieff in Perthshire. He learnt to paint under Alexander Nasmyth in Edinburgh and started to paint miniatures, later working in London. He exhibited at the Royal Academy from 1807 to 1820. He painted Queen Victoria and was particularly successful in his portraits of children. His work may be seen in the National Galleries of Scotland and in the Royal Collection, Windsor.

TIDEY, ALFRED (1808-92), was born in Worthing. In 1834 he went to the Royal Academy Schools in London and acquired a distinguished clientele. For a short period he worked in Jersey and he travelled a good deal. His work may be seen in the NPG and V & A.

TROTT, BENJAMIN (c1790-c1841), was one of a distinguished group of New York miniaturists which included Edward Malbone and Joseph Wood.

TRUMBULL, JOHN (1756-1843), was born at Lebanon in Connecticut. He served in the War of Independence, retiring from the army in 1776. In 1784 he visited London to study under Benjamin West. On his return he painted some of the heroes of the war and for these portraits he did miniature portrait studies. He later became President of the Academy of Arts in New York, but his arrogance, which arose from a sensitive pride, nearly wrecked the organisation.

TURMEAU, JOHN (1777-1846), was a Liverpool miniaturist.

VESTIER, ANTOINE (1740-1824), a French miniaturist and oil painter, exhibited in Paris between 1782 and 1806. His work may be seen in the Louvre.

VIEN, THÉRÈSE, née REBONE (1728-1805), was born in Paris. She was a pupil of the painter and engraver Joseph Marie Vien (1716-1809) and married him. She exhibited at the Salon between 1757 and 1767.

WEYLER, JEAN BAPTISTE (1749-91), was born in Strasbourg, and worked in Paris, exhibiting at the Salon between 1775 and 1790. He married one of his pupils, Louise Kingler, who also exhibited at the Salon but much later—from 1802 to 1812.

WOOD, JOSEPH (c1778-1830), of New York, was at one time a partner of John Wesley Jarvis. He painted miniatures and particularly cabinet-sized portraits.

ZINCKE, CHRISTIAN FRIEDRICH (1684-1767), was born in Dresden. He was an enameller who came to England in 1706 and studied painting under Charles Boit. By 1726 he had built up a large clientele and it has been said that for some years he had more persons of distinction daily sitting to him than any living painter. He probably employed a number of assistants, which may account for variations in style. Since he was willing to try to please his sitters, and frequently made them look younger than they were, many of his portraits of women look somewhat alike. In 1746 he gave up painting miniatures because of poor eyesight. His work may be seen in the NPG; the National Army Museum; the AM (Queen Caroline); and the Vyne, Hampshire.

BOOKS TO CONSULT

Bolton, T. *Early American Portrait Painters in Miniature*. New York, 1921

Bradley, J. W. *A Dictionary of Miniaturists, Illuminators, Calligraphers and Copyists*. 3 vols. London and New York, 1958

Foskett, D. *British Portrait Miniatures*. London and New York, 1963 (1968)

Foster, J. J. *Miniature Painters*. 2 vols. London, 1903

Lister, R. *The British Miniature*. London and New York, 1951

Long, B. S. *British Miniaturists, 1520-1800*. London, 1929. London and West Orange, NJ, 1967

Porcher, J. *Medieval French Miniatures*. London and New York, 1960

Reynolds, G. *English Portrait Miniatures*. New York, 1952. London, 1953

Williamson, G. C. *The Miniature Collector*. New York, 1921

11

MUSICAL INSTRUMENTS

MUSICAL instruments are a fascinating study not only for the professional musician but for all who delight in social history and admire fine craftsmanship. They range from humble instruments made by primitive people to the superb examples of craftsmanship created by Italian makers in the seventeenth and eighteenth centuries, and they also include some of the strange mechanical contrivances produced by the Victorians. Few can make large collections of early instruments but there are many places where they may be seen. The new Musical Gallery in the Victoria & Albert Museum, opened in 1969, and the collection at Yale University in America are outstanding. There are also fine collections in the Horniman Museum, and the Donaldson Museum in the Royal College of Music, London; the Pitt Rivers Museum and the Ashmolean Museum, Oxford; and the Albert Spencer Collection housed in the Art Gallery & Museum, Brighton. The field, of course, is enormous. Exhibits include strange instruments such as the baryton, ravanastron, and musette; pianos, violins, and guitars, and even self-playing devices—which may be seen in the British Piano Museum in London.

Musical instruments sometimes appear in auctions, and many a saleroom optimist has been convinced for a while that he has purchased a violin made by one of the early Cremona masters, only to be disillusioned when expert advice has been called in. A violin bearing the name of a great maker was not necessarily made by him : many copies and fakes have been produced and only a real expert can decide whether a musical instrument is genuine or not. Auctioneers, in any case, normally cover themselves by using descriptions such as 'Italian violin labelled Andreas Guarnerius' rather than 'Italian violin by Andreas Guarnerius'. Note also that names are often anglicised in auction catalogues and even on museum labels; 'Joseph' will often replace 'Giuseppe' for example.

The following list is highly selective since it covers the whole field of musical instruments. More detailed information can be obtained in some of the specialist books listed on p 178.

ADAMS, W. F. (1787-1859), of Montpelier, Vermont, was an American violin-maker who used pine and maple for his instruments. He was in business c1810-50.

ADDISON, WILLIAM, was a seventeenth-century viol and violin maker of Moorfields, London.

AIRETON, EDMUND, was a London violin-maker of the eighteenth century, noted for the copies he made of Amati and Stradivarius models.

ALBANI, MATTHIAS (1621-73), worked in the Tyrol and made copies of Stainer violins. His son, also Matthias Albani, went to Cremona to study the craft and when he returned to the Tyrol modelled his instruments on those of Amati. He was working until about 1706.

AMATI, ANDREAS (1520-c1577), founded a school of violin-makers at Cremona in Italy. The family became famous for their fine instruments.

AMATI, ANTONIO (w 1587-1627), was one of Andreas Amati's sons.

AMATI, GERONYMO (w 1570-1635), brother of Antonio Amati, is assumed to have worked with him.

AMATI, NICOLAS (1596-1684), was the son of Geronymo Amati and the finest craftsman of the family.

BACHMANN, CARL LUDWIG (1716-1800), of Berlin, had a high reputation as a maker of violins.

BAFFO, GIOVANNI, was a seventeenth-century maker of harpsichords.

BAKER, JOHN, of Oxford, made viols in the second half of the seventeenth century.

BANKS, BENJAMIN (1727-95), was a maker of violins and cellos at Catherine Street, Salisbury. He had learnt the craft from Peter Wamsley. He copied Amati's violin pattern, one of the first English makers to do so, but he also made a Stainer-type model for the London firm of Longman & Broderip, a name sometimes seen on violins. Benjamin Banks had three sons, all violin-makers.

BANKS, BENJAMIN, Jr (1754-1820), moved to London (c1770) and later to Liverpool.

BANKS, HENRY (1770-1830), the youngest son of Benjamin Banks, Sr, stayed in Salisbury with his brother James to carry on the violin business until 1811 and then moved to Liverpool.

BANKS, JAMES (1756-1831), worked with his brother Henry Banks in Salisbury and Liverpool.

BARRETT, JOHN, London violin-maker of Piccadilly, made instruments of Stainer type in the early eighteenth century.

BERGONZI, CARLO (w 1718-47), a violin-maker of Cremona, was regarded as the best pupil of Stradivarius.

BERGONZI, MICHAEL ANGELO (w 1720-60), son of Carlo Bergonzi, was not such a fine craftsman as his father. His sons, Nicolaus and Zosimo, were also violin-makers between 1737 and 1765.

BETTS, JOHN (1755-1823), was born at Stamford. He moved to London and became a violin-maker with premises near the Royal Exchange.

BROADWOOD, JOHN (1732-1812), was the founder, with the Swiss Burkhardt Tschudi, of the pianoforte firm which bears his name. He came from Berwickshire and started in London as a cabinetmaker. His workshop was at Great Pulteney Street, Golden Square. In 1807 the business became John Broadwood & Son.

BUCHSTETTER, GABRIEL DAVID, was an eighteenth-century violin-maker of Ratisbon who copied Cremona models. He was not a first-class craftsman, using wood of insufficiently high quality. His son Josephus followed the same calling.

CAPPA, GIOFREDO (w c1590-1640), is best known for his violon-cellos. He learned his craft from members of the Amati family at Cremona, where he lived.

CROSS, NATHANIEL (w c1700-51), was a maker of violins.

DAVIS, JOHN, made pianofortes and other musical instruments at 11 Catherine Street, London, in the early nineteenth century.

DICKINSON, EDWARD, of London, was a maker of guitars in the mid-eighteenth century.

DUKE, RICHARD (w c1750-80), worked as a violin-maker in London and achieved a considerable reputation, following the models of Amati and Stainer.

EBERLE, ULRIC, was a noted German violin-maker of Prague in the mid-eighteenth century.

EVANS, DAVID A., of London, made harps in the mid-eighteenth century and became 'Harpist to George III'.

FENDT, BERNHARD (1756-1832), was born in Innsbruck. He learnt his craft as violin-maker in Paris and then moved to London. He worked with Thomas Dodd but never produced the finished article.

FLEMING, JOSEPH ADAM (w c1770-90), of 27 Crown Street, New York, was a maker of harpsichords.

FORSTER, WILLIAM (1739-1808), was born at Brampton in Cumberland. He moved to London in 1759 and after some difficult times he started making violins for a Mr Beck of Tower Hill. In 1762 he started up on his own, first in Duke's Court and later in St Martin's Lane, where he also undertook music publishing. His reputation grew rapidly. In 1784 he moved to the Strand and made violon-cellos for many eminent musicians. No one in England has ever made better instruments. His son William (1764-1824) was also a violin-maker but was not in the same class as his father.

FRITZ, BARTHOLD, made clavichords in Brunswick in the mid-eighteenth century. Example in the V & A.

GAGLIANO, ALLESSANDRO (1640-1725), was a Neapolitan violin-maker who probably worked under Stradivarius at Cremona. His sons were also violin-makers—Gennaro (1695-1750) and Nicolas (1665-1740): both produced finer violins than Allessandro, their father. Then followed other members of the family—Ferninando (1706-1781), Giuseppe (d 1793), Giovanni (d 1806), Raffael, and Antonio (d 1860). A violin made in 1780 and signed by Giuseppe Gagliano sold for £1,628 (A 1968).

GIBSON, WILLIAM, was a Dublin maker of guitars in the mid-eighteenth century. Example in the V & A.

GOLDT, J. H., of Hamburg, was a mid-seventeenth century maker of theorboes. See plate, p 90.

GRANCINO, PAOLO (w 1665-90), worked as a violin-maker under Nicolas Amati. Some of his descendants worked in Milan—Giovanni, Battista, Grancino, for example. A Giovanni Grancino violin of c1690 sold for £2,500 (A 1969).

GUADAGNINI, GIOVANNI BATTISTA & LORENZO, of Placentia, Italy, brothers, were founders of another family of violin-makers, including Giambattista and Giuseppe, the former's sons.

GUARNERIUS, ANDREAS (c1626-98), who learnt his craft from Nicolas Amati, was the first of another family of violin-makers at Cremona which included his sons, Pietro (b 1655), who later worked in Mantua, and Giuseppe (1666-c1739) and his brother's son Joseph Anthony (1683-1745), one of the finest of all violin-makers for a short period in the middle of his career (c1730-40), though his early and late work does not reach the same standard. Paganini used one of his violins. A Pietro Guarnerius violin made in Mantua and dated 1715 sold for £6,800 (A 1969).

HATLEY, ROBERT, was a maker of virginals. There is an example in Fenton House, London, dated 1664.

HELMER, CHARLES, was a pupil of Ulric Eberle of Prague in the late eighteenth century.

HINTZ, FREDERICK, of Leicester Fields, London, made bass viols and guitars in the second half of the eighteenth century. He became 'Guitar maker to Her Majesty and the Royal Family' in 1763. There is a bass viol by Hintz in the V & A.

HITCHCOCK, THOMAS (w c1690-1730), was a London maker of harpsichords and spinets. A spinet (no 1243) in oak case sold for £1,925 (A 1969).

HOFFMAN, MARTIN, of Leipzig was a late seventeenth-century maker of lutes and violins.

JAIS, JOANNE, was a Tyrolean violin-maker in the second half of the eighteenth century.

JAY, HENRY, was a London maker of viols in the seventeenth century. There is an example in the V & A.

KENNEDY, ALEXANDER (1695-1785), was a Scot who settled in London early in the eighteenth century and made violins and cellos. There were two other members of his family in the business, John and Thomas Kennedy.

KIRCKMAN, JACOB (1710-92), a harpsichord maker, for some time worked with a relative, Abraham. Examples of their work may be seen in Fenton House, London, and in the AM.

KLOTZ, EGIDIUS, was born in Mittenwald, Germany, and went to learn violin-making from Stainer in the mid-seventeenth century. He returned and started a business, making some very fine instruments.

KLOTZ, MATHIAS (1653-1745), after an unpromising start at Mittenwald, went to Italy to gain experience and when he returned ran a thriving business as a violin-maker.

KLOTZ, SEBASTIAN (1700-60), was the son of Mathias Klotz. There were a number of other violin-makers in the family working in the second half of the eighteenth century.

LANDOLPHUS, CARLO (w 1750-75), was a violin-maker of Milan, Italy.

LIESSEN, R., was a London maker of guitars in the mid-eighteenth century.

LIGHT, EDWARD, made harps and lutes in London early in the nineteenth century.

LONGMAN & BRODERIP were London makers of harpsichords and square pianos in the second half of the eighteenth century. Examples of their work can be seen in Fenton House, London, and the V & A

LOOSEMORE, JOHN, of Exeter was a maker of virginals in the mid-seventeenth century.

LUPOT, NICHOLAS (1758-1824), was born at Stuttgart in Germany. In 1770 his family moved to Orléans, where Nicholas studied violins and started making instruments on the model of Stradivarius. In 1798 he moved to Paris, where he became violin-maker to the Conservatoire. His best work was done after 1805. His brother François was a maker of bows.

MAGGINI, GIOVANNI PAOLO (1580-1640), violin-maker of Brescia, was the first maker to concern himself with the inside of the instrument.

MERLIN, JOSEPHUS, was a London piano-maker in the 1780s. Two examples are illustrated in John Gloag's *Short Dictionary of Furniture* (1969 ed), pp 512-13.

MONTAGANA, DOMINIC (w 1700-40), was a violin-maker of Cremona and Venice, who also made violon-cellos. His finest work was done in Venice towards the end of his working life.

MOTT, J. C., & CO, were makers of the grand piano in the Music Room at the Royal Pavilion, Brighton, which is dated 1817.

NORMAN, BARAK (1688-1740), was a London maker of viols, violas, and violon-cellos. Between 1715 and 1720 he was in partner-

ship with Nathaniel Cross at 'The Bass Viol', St Paul's Church-yard.

PERRY, THOMAS, of Dublin made guitars in the second half of the eighteenth century.

PLAYER, JOHN, of London made spinets in the second half of the seventeenth century.

RACKWITZ, G. A., was a Swedish maker of clavichords at the end of the eighteenth century and the beginning of the nineteenth. An example with a compass of five-and-a-half octaves, made in 1796, is to be seen in Fenton House, London.

RAUCH, MICHAEL, was a London maker of theorboes in the second half of the eighteenth century. There is an example in the V & A (see plate, p 90).

RAUCH, THOMAS, was a violin-maker of Breslau in the early part of the eighteenth century.

RUCKERS, HANS, was the founder of a famous and respected Antwerp family that made harpsichords and virginals. He worked at the end of the sixteenth century, and his son, Hans the Younger, or Jean Ruckers as he is often called, was thought of so highly that in 1623 he was exempted from civic-guard duty with Rubens and Jan Breughel the elder. One of Jean Ruckers' harpsichords in a fine decorated case sold for £9,600 (A 1969).

RUDMAN, JOSEPH, of Aberdeen, made guitars in the late eighteenth century.

RUGERI, FRANCESCO (w 1670-1720), of Cremona, Italy, was a noted violin-maker, a pupil of Nicolas Amati.

RUGERI, GIOVANNI BATTISTA (b 1660), of Cremona, went to Brescia about 1670. A violin dated 1706 (with a bow by R. Weishold of Dresden) sold for £2,100 (A 1968).

SALO, GASPARO DA (1542-1612), of Brescia, is regarded as the earliest maker of violins as we know them today.

SCHEINLEIN, MATTHIAS FREDERICK (w 1730-71), of Langenfeld, Germany, made violins, few of which have survived intact.

SERAPHIN, SANCTUS (w 1710-48), was a violin-maker of Venice. His instruments are noted for their beautiful finish.

SHUDI, BURKAT, was one of the best-known harpsichord makers of the second half of the eighteenth century. His partner was his son-in-law, John Broadwood. An example may be seen at Fenton House, London.

STAINER, JACOBUS (1621-83), was born at Absam and he became the most famous of all German violin-makers. He learnt organ building at Innsbruck, then went to Cremona, where he learnt to make violins under Nicolas Amati, and later worked in Venice under Vermacati. He then started a violin-making business in Absam and in 1658 became Maker to Archduke Leopold. However, his skill at the craft brought him little reward, and money troubles eventually caused a complete mental breakdown.

STORIONI, LORENZO (w 1780-98), was the last of the great violin-makers of Cremona.

STRADIVARIUS, ANTONIO (1644-1737), was the greatest of all violin-makers, starting as so many other violin-makers have done, in the workshop of Nicolas Amati in Cremona, his birthplace. He started to make violins of his own in 1670. This began a period of experiment which culminated in about 1700 with the production of as perfect a violin as anyone has ever made. For some twenty-five years he made these superb instruments. Then there was a falling off, not surprisingly, for he was over eighty and beginning to hand over to his son—Francesco (1671-1743) and Omobono (1679-1742).

An early Stradivarius violin dated 1684 sold for £9,500 (A 1968).

TECHLER, DAVID (1680-1740), an Italian violin-maker, worked in turn at Salzburg, Venice, and Rome.

TESTORE, CARLO GIUSEPPE (w 1690-1720), was a violin-maker of Cremona who modelled his work on that of Guarnerius. His sons, Carlo Antonio and Paolo Antonio, were violin-makers in Milan.

TIELKE, JOACHIM, was a Hamburg maker of guitars and bass viols towards the end of the seventeenth century, noted for the fine marquetry decoration on his instruments (see plate, p 90). Examples may be seen in the V & A, including a baryton, the only one known to have survived.

TSCHUDI, BURKHARDT. See Broadwood, John.

L

VOIGT, MARTIN, a pupil of Joachim Tielke in Hamburg, made bass viols early in the eighteenth century.

VUILLAUME, JOHN BAPTISTE (1798-1875), was born at Mirecourt. He started to make viols and bows in 1828. As he found difficulty in selling these he concentrated for a time on repairing and copying Italian instruments. With the experience gained in this way he then produced a finer type of his own. A Vuillaume viola of about 1855 to 1860 sold for £1,900 (1968).

WAMSLEY, PETER (w1727-60), London maker of violas, violon-cellos, and double basses, had his workshop in Piccadilly. His instruments tend to lack strength : a number have been subsequently improved by skilled craftsmen.

WHITE, THOMAS, was a London maker of virginals in the mid-seventeenth century.

ZUMPE, JOHANN, of London, made square pianos in the second half of the eighteenth century.

BOOKS TO CONSULT

Boalch, D. *Makers of the Harpsichord and Clavichord, 1440-1840.* London, 1955

Galpin, F. W. *Old English Instruments of Music.* London, 1932. 4th Edition. New York, 1965; *A Textbook of European Instruments.* London and New York, 1937

Harding, R. *The Pianoforte, its History to 1851.* London and New York, 1933

Jalovec, K. *Italian Violin Makers.* London and New York, 1957. (1964); *German and Austrian Violin Makers.* London and New York, 1967; *Encyclopaedia of Violin Makers.* 2 vols. London and New York, 1968

James, P. *Early Keyboard Instruments.* London and Chester Springs, Pa. 1930

12

NETSUKE

IN the eighteenth and early nineteenth centuries Japanese dress had no pockets and small objects for personal use were kept in a little box or pouch known as an *inro*. This was suspended from the belt by a cord, and a little toggle, known as a *netsuke*, was used to hold the cord and prevent it from slipping. Enormous ingenuity was used in decorating inro and carving netsuke. The carvers represented scenes from Japanese history and mythology. They fashioned netsuke in the shape of rats, dogs, horses, birds, flowers, mushrooms, and other models from nature. These came to be regarded as miniature works of art and are avidly collected, especially the animal figures. In recent years prices have risen steadily. In 1969 the previous record price was nearly doubled when a single netsuke sold for £2,800.

In the eighteenth century there were some fifty well known carvers, or netsukehi, in Japan, working in Akakusa, Iwami, Kyoto, Nagoya, Osaka, and Tokyo, where they founded schools. Pupils of the early masters would often use part of their teacher's name in their own. Tadatoshi, for example, had pupils who became Tadayiki and Tukitada. The earliest netsuke, which were made of ivory, were often unsigned. Later, especially in the early nineteenth century when the art flourished and carvers proliferated, many were signed. By about 1870, with the advent of European dress, the art began to decline. All kinds of materials were used—ivory, hardwoods, lacquered softwoods, amber, coral, jet, bone, and stagshorn.

The collector who has no knowledge of the Japanese language must rely on the expert to identify signatures and to discriminate between genuine and forged specimens. Many signatures have been forged, including those of artists such as Hidemasa, Okatomo, and Tomotada. Well known auctioneers who have experts at their disposal normally give detailed and accurate descriptions of netsuke lots. Indeed, such an auction catalogue can be useful for reference.

The following list of names in anglicised form gives the type of subject and material particularly favoured by each artist.

BAZAN (1833-97), made netsuke designed as rotting pears being eaten by insects; using ivory. He signed his work in relief.

CHOKEI (late eighteenth/early nineteenth centuries), inlaid his netsuke with insects, using lacquer.

CHOKOSAI (late nineteenth century), worked in ivory, often stained.

DORAKU (early nineteenth century), carved animal forms and shells in ivory.

DOSHO (mid-nineteenth century), was a pupil of Doraku and worked in the same style.

GAMBUN (late eighteenth/early nineteenth centuries), made mushroom-shaped netsuke covered with insects of metal.

GECHU (eighteenth century), favoured mythical creatures in ivory. A netsuke in the form of an animal known as a shishi with her cub, both coats richly covered in stylised curls and eyes inlaid with gold, sold for £2,500 (A 1969).

GENKOSAI (mid-nineteenth century), carved shells in ivory.

GOHO (early nineteenth century), carved shells in ivory.

GYOKKSAI (late eighteenth/early nineteenth centuries), carved figure-groups in ivory.

GYOKUHOSAI, RYUCHIN (mid-nineteenth century), carved fish in ivory.

GYOKUYOSAI (late eighteenth/early nineteenth centuries), carved in ivory.

GYOKUZAN, ASAHI (1842-1943), carved human skulls in ivory.

HAKURYO (mid-nineteenth century), carved tigers in ivory.

HARUMITSU (mid-nineteenth century), favoured animals carved in wood.

HIDEMARU (early nineteenth century), carved in wood.

HIDEMASA (early nineteenth century), carved figures in ivory.

HIKAKU (early nineteenth century), carved in ivory.

HIRONOBU, KAKUYASAI (early nineteenth century), often inlaid his netsuke.

HOJITSU (early nineteenth century) carved in wood.

HOKEI (late nineteenth century), was a professor at the Tokyo School of Art. He used red lacquer over wood.

HORAKU (early nineteenth century), carved in wood.

HOSAI, OISHI (1829-1900), carved mainly in wood.

HOSHIN (eighteenth century), worked in wood and ivory. A tightly coiled dragon with brilliantly worked scales sold for £2,300 (A 1969).

HOSHU (late nineteenth century), worked in wood with inlay.

HOZAN (mid-nineteenth century), often carved Buddhist figures in wood.

IKKAN (early nineteenth century?); a netsuke of a rat holding a bean sold for £336 (A 1969).

IKKO (early nineteenth century), made animals in ivory. Several artists bore the same name and it is difficult to differentiate between their work.

IKKOSAI (mid-nineteenth century), of Osaka, made groups in ivory. Several different artists bear this name.

IKKWAN (mid-nineteenth century), worked in both wood and ivory and is well known for his carving of rats. A reclining stallion carved in ivory sold for £700 (A 1968).

IPPO (early nineteenth century), carved shell groups in ivory.

ISSAN (early nineteenth century), carved animals in wood.

ITSUMIN, HOKYUDO (mid-nineteenth century), carved animals in wood.

ITTAN (mid-nineteenth century), carved animals in wood.

JOBUN (eighteenth century), carved figures in wood.

JORYU, SHOWNSAI (late eighteenth/early nineteenth centuries), illustrated legends in ivory.

JOSO, MIYASAKI (late nineteenth century), of Tokyo, carved in wood.

JUGYOKU, RUIKOSAI (eighteenth century), used many different materials. A sleeping cat netsuke by this artist sold for £1,700 (A 1969).

KAGETOSHI (eighteenth century), carved scenes with figures and animals hollowed out in ivory.

KISUI (eighteenth century), carved mainly legendary figures in ivory.

KIYOKATSU (mid-nineteenth century), carved vegetables and fruit in ivory.

KWAIGYOKUSAI, MASATSUGU (1812-92), of Osaka, is considered in Japan to have been the finest netsukehi of all time. He was noted for reclining horses in ivory and other creatures with eyes inlaid. An ivory netsuke showing an eagle with its prey sold for £440 (A 1968), and a reclining cat in ivory, its slit eyes inlaid in translucent horn with dark pupils, sold for £2,800 (A 1969).

KOHOSAI, UEDA (eighteenth century), carved flowers and plants in ivory.

KOKEI (early nineteenth century), carved animals, especially tigers, in wood.

KOKUSAI (mid-nineteenth century), of Tokyo, used stagshorn.

KOSEKI, WAITO (late nineteenth century), was a carver in wood.

KOUN (late nineteenth century), carved in ivory.

KWANMAN (early nineteenth century), was an artist whose carvings all differ : he never carved the same model twice.

MASACHIKA (early nineteenth century), carved monkeys in wood.

MASAKA (late nineteenth century), carved rats in ivory.

MASAKATSU (1839-99), was the son of Masanao of Tamada and followed in his father's footsteps.

MASAKATU was a name used by many netsukehi.

MASANAO ((eighteenth century), of Kyoto, founded a school of carvers. He worked in ivory.

MASANAO (1815-90), of Tamada, carved animals in wood. He had two pupils of the same name who repeated his models.

MASANOBU, ADACHI (mid-nineteenth century), a pupil of Masayoshi, carved tiny landscapes in ivory.

MASAYOSHI (1819-65), carved animals in wood, characterised by tapering paws.

MASAYUKI, HOSHUNSAI (late eighteenth/early nineteenth centuries), was the first carver to use stagshorn.

MINKO (1735-1816), carved animals in wood. A tiger sold for £120 (A 1969).

MINSUAKI (early nineteenth century), of Tokyo, carved in ivory and wood.

MITSUHIRO, OHARA (1810-75), of Osaka, carved naturalistic netsuke, especially plants and fruit. A fly on a large biwo fruit sold for £210 (A 1968).

MIWA (eighteenth century), carved figures in wood.

NATSUKI (late eighteenth/early nineteenth centuries), carved in wood and ivory.

NATSUO (1829-98), used metal.

OKATOMO (late eighteenth century?), of Kyoto, carved animals and buds in ivory. A rabbit sold for £320 (A 1968).

OTOMAN (eighteenth century), carved animals in ivory, especially tigers.

RANTEI (mid-nineteenth century), carved animals and birds in ivory. A pigeon with young sold for £210 (A 1968).

RITSUO (1663-1747), was one of the earliest netsukehi. He worked in lacquer. A netsuke of a dried salmon executed in natural fish skin, lacquered wood, and inlay, attributed to Ritsuo, sold for £1,400 (A 1969).

RYUKEI (early nineteenth century), of Tokyo, used wood with ivory inlay. Several other carvers had the same name.

SARI (eighteenth century), carved animals in wood.

SEIYODO (eighteenth century), of Iwami, was a family name used by the descendants of Tomiharu, the founder.

SEKISHU (late eighteenth century), carved tortoises in wood.

SESSAI (mid-nineteenth century), carved in wood.

SHOKO (mid-nineteenth century), carved frogs in wood.

SHUZAN, YOSHIMURA (eighteenth century), carved figures in lacquered wood. His work has frequently been copied.

SUKENAGA (early nineteenth century), carved reptiles in hardwoods. He had many pupils who included 'SUKE' in their names.

TADAKAZU (eighteenth century), carved tortoises in wood. His work has often been copied.

TADATOSHI (eighteenth century), carved animals in wood. He had many pupils with 'TADA' in their names.

TADOYOSHI (mid-nineteenth century), was the most famous of Tadatoshi's pupils.

TAMEKAZU (late eighteenth century?). A signed figure of Tengu by this artist with outspread wings, sitting on a clam, sold for £357 (A 1969).

TOMIHARU, SEIYODO (early nineteenth century?), made netsuke of whale teeth.

TOMOKAZU (early nineteenth century), made monkeys and tortoises in wood. A netsuke of Shoki, the demon-queller, in which a demon has trapped him under a basket, carved in boxwood, sold for £200 (A 1969).

TOMOTADA (eighteenth century), of Kyoto, was a master carver in ivory and wood, particularly noted for his oxen. A model of an ox sold for £1,650 (A 1969), and a netsuke of a mythical creature known as kirin for £1,800 (A 1969).

TOUN, TAKAMURA (1846-1910), made ivory figures with inlay.

TOYOMASA (1773-1856), carved animals in wood with eyes of yellow horn.

YOSHINAGA (eighteenth century), of Kyoto, carved figures and animals in ivory.

ZESHIN, SHIBATA (late nineteenth century), worked in lacquer.

BOOKS TO CONSULT

Brockhaus, A. *Netsuke*. Leipzig, 1905. Translation from German. New York, 1969

Jonas, F. M. *Netsuke*. London, 1928. Rutland, Vermont, 1960 (1969)

Reitichi, U. *The Netsuke Handbook*. English translation from the Japanese, London, 1964

Ryerson, E. *The Netsuke of Japan*. New York, 1968

13

POTTERY AND PORCELAIN

THE number of people who have contributed to the growth of the pottery and porcelain industry in Europe, Britain and America in the last 200 years has been enormous. Inventive makers have developed new bodies and glazes; clayworkers, throwers and modellers have moulded the wares. These have been decorated by painters and gilders, or by transfer-printing the patterns produced by designers and engravers. Every degree of practical and artistic skill was called for and many fine painters were employed to produce work of the highest quality. To produce a fine piece of china was a co-operative task even down to its decoration. An account of the industry written about 1840 emphasises this fact. 'There is a sort of sub-division in the labours of the painting room, according to the variations in talent : one person takes flowers, another foliage, another animals, a fourth landscape, a fifth figures, a sixth heraldic bearings and so on.' No wonder attributions are difficult unless work is signed or has some unmistakable characteristic.

The china painters and the copperplate engravers of the eighteenth and early nineteenth centuries worked much as journalists do today. Some were employed full-time by a single firm, others were freelance professionals (hausmaler) who worked for several firms or perhaps had a short-term contract with one particular china works. Some grouped themselves together to form what we might call an agency and worked under a well known craftsman such as James Giles. Many moved from place to place, presumably attracted by higher remuneration or better working conditions, or to find the freedom to do the kind of artistic work which would give them the greatest satisfaction. The facts about many of the artists and modellers are obscure, but detailed information about some of them has been preserved and this section traces their careers in outline. Relatively few makers are included : their names can readily be traced in encyclopaedias of marks. Those that are mentioned are the men whose names find their way most frequently into saleroom catalogues.

ABBEY, RICHARD (1720-1807), was an engraver apprenticed to John Sadler in Liverpool. He engraved the plates for transfer-printing jugs with the arms of some of the guilds—the weavers', joiners', bakers', etc—but by 1773 had a business of his own. He is said to have spent some time, after about 1780, in Glasgow and in France, before starting a Merseyside pottery in 1793 or 1794 which became known as the Herculaneum Pottery. In 1796 he retired and the factory was taken over by Worthington, Humble & Holland.

ABRAHAM, R. F. (d 1896), was a figure-painter at the Coalport works between about 1850 and 1860. He had been a pupil of the painters Etty and Mulready, and had studied abroad. Some of his pieces are signed. He later moved to Staffordshire and by 1870 had become Art Director of Copelands, a post he held for over twenty-five years.

ABSOLON, WILLIAM (1751-1815), started a glass, china, and earthenware business at 4 Market Row, Great Yarmouth (c1784), moving to 25 Market Row a few years later. His trade card states that he had 'a manufactory for Enamelling and Gilding his goods with Coats of Arms, Crests, Cyphers, Borders or any other Devise'. He bought earthenware and stoneware in the white from Turner, Wedgwood, Shorthose and Davenport in Staffordshire, and also from Leeds, Liverpool, and Welsh potters. Most of the pieces he decorated bear his name, in red, *Absolon Yarm*, sometimes with an arrow and *25*, the number of his premises in Market Row. His subjects included local views, fishing and farming scenes, naval scenes, and flowers. Examples in the V & A and Norwich Castle Museum.

ACIER, MICHEL VICTOR, was a modeller of porcelain who worked at the Meissen factory from 1764 to 1781 where he shared the post of *Modellmeister* with Kändler until 1775 when Kändler died. His work was not so fine as that of his colleague but he was able to meet more readily the demands of fashion.

ADAMS, WILLIAM (1746-1805), of Greengates, Tunstall, Staffordshire, was a friend of Josiah Wedgwood and established his Greengates pottery (c1787) where he made jasper wares, stone-wares, creamwares, black basalts, and blue transfer-printed wares. It is also said that he was the first potter to make Mocha ware in the eighteenth century. The most notable of a family of potters, he is often confused with relatives, some bearing the same name, e.g.

William Adams (1748-1831), a cousin; William Adams (1772-1829), a cousin; and William Adams (1798-1865), a son of the preceding William. The firm has continued to the present time. There have been a number of studies of the family including: Turner, W. *William Adams, an old English Potter.* 1904; Adams, P. W. L. *The Adams Family.* 1914; Peel, D. *A Pride of Potters.* 1959.

AINMILLER, MAX EMMANUEL (1807-70), was for a time designer at the Royal Porcelain Factory at Nymphenburg in Bavaria.

ALCOCK, SAMUEL, studied at the Royal Academy Schools and became a painter at Copelands, Stoke-on-Trent, in the 1880s. He specialised in figures in period costume and in decorated 'jewelled porcelain'.

ALLEN, ROBERT, was a decorator at the Lowestoft factory around 1790.

ALLEN, THOMAS, was a painter of figures employed by the Minton factory from 1845. In 1872 he became art director of Josiah Wedgwood & Sons Ltd.

ALONCLE, FRANÇOIS, was a bird-painter at the Sèvres factory in the 1760s. His work may be seen at Waddesdon Manor, near Aylesbury, Buckinghamshire.

ARNHOLD, JOHANN SAMUEL (1766-1827), became a professor in the Art School of the Meissen porcelain factory. He was noted for landscapes and for fine fruit and flower paintings.

ASKEW, RICHARD, was a decorator at Chelsea and in 1772 moved to Derby. He was noted as a painter of cupids and other figures.

ASTBURY, JOHN (1688-1743), is said to have worked for the brothers Elers at Bradwell Wood and to have learned their secrets. He later set up on his own in the 1730s and made red-glazed ware with applied decoration of white Devon clay, and is said to have been the first potter to add calcined flint to the clay when he made white salt-glazed wares. He also made small figures in which the use of different clays gave variety and contrast. His set of fourteen figures making up *Nebuchadnezzar's Band* are to be seen in the Willett Collection in Brighton Museum.

ASTBURY, THOMAS (w c1723-?), is credited with developing a creamware body which was later improved by Wedgwood.

AUFENWERTH, JOHANN (d 1728), was a goldsmith who worked as an outside decorator for the Meissen and Vienna porcelain factories. His work for Meissen started about 1720. He particularly favoured iron-red used with lilac or black. He was assisted in his work by his daughter, Sabina.

AULICZEK, DOMINICUS (b 1734), was born in Bohemia. He studied in Vienna and later in Paris (1754), London (1755), and Rome (1756-8) where he took a course in anatomy. In 1762 he succeeded Bustelli as *Modellmeister* at the Nymphenburg factory. He was, however, temperamentally difficult and his work shows an almost sadistic delight in ferocious combat between animals. Most of his modelling is in the rococo style though neo-classical influences reveal themselves later in his career. In 1773 he became the factory inspector and after stormy years in management he was retired in 1797.

AUSTIN, JESSIE (1806-79), was born at Longton in Staffordshire. He showed a keen interest in drawing and painting while still at Longton Grammar School. He became an apprentice at Davenport's China Works (Burslem) where he learnt engraving. For some time he worked on his own but in the 1840s found this kind of life precarious and accepted an invitation from F. & R. Pratt & Co of Fenton to join them as chief decorator (c1846). With Felix Pratt he developed the art of underglaze colour-printing on earthenware, using several different colours. Skilled as a watercolour painter and engraver, he designed many of the pictures himself. The output of colour-printed pomade pots, fish and potted meat jars, and dessert services, was considerable. Many of the pictures were after well known artists such as Gainsborough, Landseer, and Mulready. Some of the pieces bear Austin's signature—*J. Austin, Sculp., J. Austin Sc.,* or *J. A., Sc.*

AYNSLEY, JOHN (w 1802-26), of Lane End, Staffordshire, was a designer and engraver who catered for the market created by the potteries making transfer-printed earthenware. Some of his engravings were signed.

BACHELIER, JEAN JACQUES (d 1791), joined the Sèvres porcelain factory at Vincennes in 1748 and became the art director in 1751. It is thought that he was responsible for the introduction of biscuit figures.

BACON, JOHN, RA (1740-99), the sculptor, modelled for the Derby porcelain factory (c1769). He is believed to have been responsible for the figures of Milton and Shakespeare. He also worked for Wedgwood and possibly for the Bow and Bristol factories, though this is not certain.

BANFORD, JAMES (1758-c1798), was born at Berkeley in Gloucestershire. He was a painter and first worked as an apprentice under Champion at Bristol, and later in London and at Derby. At Bristol he formed a friendship with Henry Bone (qv) and in 1778, when the Bristol factory closed, they both moved to London, where for some years Banford worked as a porcelain decorator in the Wedgwood establishment. He specialised in garlands of flowers and putti. In 1783 he married Bernice Glisson, also a decorator in the Wedgwood London workshop. By 1790, or perhaps a little earlier, he had moved to the Derby factory. He was versatile and added classical themes and landscapes to his repertoire, though the latter were painted in the style of Boreman. In 1795, when Michael Kean became general manager at Derby, he left and it is thought that he spent the last three years of his life painting on enamel at Bilston. See Foden, M. 'James Banford, Ceramic Artist', *Collectors' Guide*. November 1968, pp 64-7.

BARLOW, ARTHUR B., was a ceramic artist at the Doulton factory, Lambeth, from 1872 until he died in 1878. He did some incised work on pottery and modelled floral patterns, mainly using blues and browns. He also favoured bead decoration. His pieces are signed *A.B.B.*

BARLOW, FLORENCE (d 1909), worked as an artist at the Doulton factory from 1873, specialising in leaves, animals, and birds. Her early work was incised : later, she applied coloured slips to the main body of the article she was decorating, to create a design in relief. Her work is signed *F.E.B.* or *F.B.*

BARLOW, HANNAH B. (1851-1916), was the first woman trained at the Lambeth School of Art to be employed at the Doulton factory at Lambeth, which she joined in 1871. In the late 1870s she became their leading ceramic artist. Her characteristic work was *sgraffito*, usually of animals—dogs, sheep, or horses. The design was scratched on the moist clay and the incised marks were sometimes filled with colour to emphasise the outlines. After some years she suffered from paralysis in the right hand but managed to work

with the left. She retired in 1906. Her pieces are signed *H.B.B.* and her early work is much sought after. See Barber, E. A. *Salt-glazed Stoneware*. New York, 1907.

BARNES, ZACHARIAH, was the owner of a pottery at Old Haymarket, Liverpool, which made delft tiles to be printed by Sadler & Green. Some porcelain may also have been made.

BARR, MARTIN, joined the Worcester factory as a partner in 1793. Members of the Barr family were associated with the firm until 1840. The periods were—Flight & Barr (1793-1807); Barr, Flight & Barr (1807-13); and Flight, Barr & Barr (1813-40). See also Flight, Thomas, pp 203-4.

BAXTER, THOMAS, was a London china decorator who had workshops at 1 Goldsmith Street, Gough Square. A watercolour drawing in the V & A shows him decorating Coalport wares.

BAXTER, THOMAS, JR (1782-1821), son of the above, worked intermittently as a decorator at Worcester between 1815 and 1821 in the Flight, Barr & Barr period. He established a school of art in the city. He is best known for his painting of shells and feathers. He also painted figures for Chamberlain. In 1816 he moved to Swansea and worked as a decorator for Dillwyn & Co, painting plants and flowers, figures and landscapes. In 1819 he returned to Worcester, where he worked as a freelance until his death in 1821. A desk set of five pieces of Worcester porcelain decorated by Baxter sold for £2,350 (A 1969).

BAYER, JOHANN CHRISTOPHER, was a painter of porcelain at the Copenhagen factory c1789.

BELL FAMILY. Peter Bell of Hagerstown, Maryland, Samuel Bell of Strasbourg, Virginia, and Solomon Bell of Waynesboro, Pennsylvania, made redwares and stonewares in the period between 1820 and 1880. These wares are known as Shenandoah Pottery. See Rice, A. H. and Stoudt, J. B. *The Shenandoah Pottery*. 1929.

BELL, JOHN (1812-95), the sculptor, designed and modelled the Parian figure of Miranda for Mintons in 1850. It was included in the Great Exhibition of 1851.

BENCKGRAFF, JOHANNES (1708-1753), was a skilled maker of porcelain. About 1749 he became director of the Höchst factory and succeeded in producing a good-quality product but he showed little loyalty and took no trouble to guard the secrets of manu-

facture, which were soon acquired by the factories at Berlin and Fürstenberg.

BENNETT, EDWIN (b 1818), moved from England to America in 1841 and worked in his brother James' pottery in East Liverpool, Ohio. In 1846 he started a pottery of his own at Baltimore, Maryland, which became the Edwin Bennett Pottery Company in 1890.

BENNETT, JAMES, emigrated from England to America in 1834 and after working in Jersey City and in Troy, Indiana, started a pottery at East Liverpool, Ohio.

BENTLEY, THOMAS (1730-80), was born in Derbyshire, and became a businessman in Liverpool, where he acted as agent for Josiah Wedgwood. He later formed a partnership with Wedgwood from c1768 to 1780, taking a particular interest in the London side of the business. The two partners carried on a voluminous correspondence (see Wedgwood's *Letters to Bentley*. 3 vols. 1902) which throws much light on the pottery industry in the second half of the eighteenth century. See Bentley, R. *Thomas Bentley of Liverpool, Etruria and London*. 1927.

BILLINGSLEY, WILLIAM (c1758-1828), a decorator and maker of porcelain, was one of the most colourful characters the ceramics industry ever produced. He was apprenticed in the Derby factory in 1774 and set a new style in flower-painting with sprays branching out from a central cluster. He skilfully obtained the highlights by removing paint from the surface instead of leaving the body unpainted. When Zachariah Boreman came to Derby from Chelsea in 1783 they worked together and became great friends. It is probable that they conducted experiments in the making of soft paste porcelain; at all events, Billingsley left Derby in 1796 for Pinxton in the same county, where some unmarked porcelain was produced until he left in 1799, when John Coke continued the factory. Billingsley then moved to Mansfield in Nottinghamshire, where he worked for some time as a freelance decorator. In 1803 he went to Yorksey in Lincolnshire but there is no record of how he employed himself. It is known, however, that he worked for the Worcester factory from 1808 with his son-in-law, Samuel Walker. He was employed as a decorator but he almost certainly contributed in other ways to the success of the firm. However, Billingsley apparently broke his contract. It is certainly known that in 1813, with Samuel Walker, he established a small factory at Nantgarw—the Nantgarw China

Works—and a certain William Weston Young helped to finance the venture. Here they made translucent porcelain of the finest quality, though kiln wastage was high and the firm soon ran into financial trouble. It was rescued by Lewis Dillwyn, who owned the Cambrian Pottery at Swansea, and Billingsley moved there with his friends in 1814.

Further experiments were made but wastage remained high, differences of opinion were frequent and in 1817 when the Cambrian Pottery was sublet to John and Timothy Bevington, Billingsley and Walker returned to Nantgarw, where they battled on for two more years with Young's financial help, producing some superb porcelain. But failure again forced a move. Billingsley and Walker accepted an offer by John Rose to work at Coalport. Here Billingsley spent the last years of his life. A pair of Pinxton yellow-ground pot-pourri vases and covers of campana shape thought to have been decorated by Billingsley sold for £540 (A 1968). See John, W. D. and Simcox, A. and J. *William Billingsley, 1758-1828*. 1967.

BIRBECK, J., was a painter of flowers, especially roses, on early Coalport porcelain.

BIRKS, ALBION (1860-1940), was born and educated in Fenton and joined the Minton factory, where he worked under M. L. Solon. He made pâte-sur-pâte pieces for over half a century and many people consider his work equal to that of his master.

BLOOR, ROBERT (d 1846), was a clerk and salesman at the Derby factory. In 1811, though short of capital, he took over the factory as a tenant. He tried to revive the fortunes of the firm by taking large stocks of white ware which had been regarded by the previous management as sub-standard and decorating them quickly for sale. This action injured Derby's reputation for reliability, though much fine work was still done by first-class decorators. Unfortunately, probably as a result of financial worries, Bloor's health suffered and mental trouble in 1828 made it necessary for him to hand over most of the responsibility to a manager. In 1846 Bloor died and two years later the Derby factory closed down.

BÖHME, KARL WILHELM, was a painter at the Meissen factory from 1736 to 1761 and then became the chief decorator at Berlin. He was noted for his landscapes.

BONE, HENRY, RA (1755-1834), was a Cornishman, the son of a Truro woodcarver. He painted landscapes and flowers on

porcelain, first at Plymouth and from 1772 as an apprentice to Richard Champion at Bristol. In 1779 he moved to London and worked as a miniature painter (see p 150). He became an RA in 1811.

BORMANN, ZACHARIAH (1738-1810), was a ceramic decorator who started to work at Chelsea during the gold-anchor period. From 1779 until 1785 he was at Derby in charge of the painters, and it was at this time that he greatly helped William Billingsley. He often went into the countryside to sketch the landscapes for which he was noted; his river scenes frequently have two figures on or near the bank. In 1795 Boreman moved back to London to work, mainly for the decorating establishment of an ex-Derby employee called Sims.

BORMANN, JOHANN BALTHASAR (1725-84), was a painter at the Meissen factory. He did some fine harbour scenes on porcelain early in the 1760s but was dismissed c1765 because he also did outside work for other factories. He then moved to Berlin.

BOTT, THOMAS (1829-70), was a decorator with the Worcester Royal Porcelain Company from about 1855 to 1870. He specialised in painting on an underglaze blue ground after the style of Limoges enamel. Examples in the V & A.

BOTTENGRUBER, IGNAZ (w 1720-30), of Breslau was one of the finest outside decorators of his time. He favoured purple but used a great range of colours and is noted for battle and hunting scenes, for fabulous animals, and classical subjects with putti. His early work was for the Meissen factory but when the supply of white porcelain to outside decorators ceased, he started to work for the Vienna factory.

BÖTTGER, JOHANN FRIEDRICH (1682-1719), was born at Schleiz in Thuringia. He studied chemistry and tried to transmute lead into gold, financed by Frederick I, King of Prussia. When he failed he was disgraced and imprisoned. However, fortunately, his talents were used by his patron to carry out experiments in the making of porcelain. The successful outcome in 1710 led to the founding of the Royal Saxon Porcelain Manufactory at Meissen which produced the first hard-paste porcelain in Europe. Böttger worked to improve the quality of the product until his death in 1719.

BOULLEMIER, ANTON (1840-1900), was born at Sèvres, where he learnt his craft as a painter. Later he moved to Paris, and in

M

1870 to England, where he took a post at the Minton factory. He painted mythological subjects with consummate skill.

BOULLEMIER, LUCIEN (1869-1949), Anton's son, was also a painter at Minton's.

BOURNE, SAMUEL, was designer-in-chief at Minton's from 1810 to 1860. In 1847 he became Professor of Ceramic Design at Marlborough House.

BRAMELD, JOHN WAGER (w 1806-42), was the chief traveller for the Rockingham China Works, Swinton, and a good artist. He decorated many of the finer pieces. The Rhinoceros' Vase in the Clifton Park Museum, Rotherham, shows scenes he painted from *Don Quixote* in 1826.

BRAMELD, THOMAS (w 1806-42), was general manager of the Rockingham China Works. In 1830 he designed a Royal Dessert Service for William IV.

BREWER, JOHN (d 1816), was a painter at Derby, particularly of flowers. He worked there from 1793 but, like his brother, later became a drawing master in the town.

BREWER, ROBERT (d 1857), was a decorator at Derby with his elder brother John from about 1793 to 1815, when he became a drawing master. He was a pupil of Paul Sandby, the watercolour artist. He painted landscapes, camp scenes, ships at sea, and scenes after Angelica Kauffman. See Tapp, W. H. *The Brothers Brewer, 1764-1820*. 1932.

BROAD, JOHN, modelled figures for the Doulton factory from about 1873 until the First World War. He signed his pieces *J.B.*

BRODEL, GIOVANNI VITTORIO, started the Vinovo Porcelain Factory at Turin in Italy in 1776.

BRONGNIART, ALEXANDRE (d 1847), was director of the Sèvres factory at Vincennes in France from 1800 until his death in 1847. It was during this period that the manufacture of soft-paste porcelain ceased.

BROOKES, WILLIAM, was an engraver of Tunstall who provided the firm of Adams with many of its best-known patterns.

BRÜHL, COUNT HEINRICH GRAF von (1700-1763), became the director of the Meissen porcelain factory in 1733 although he had shown much interest in its output prior to this date. During

his term of office modelling was developed with great success and the rococo style became current.

BUSTELLI, FRANZ ANTON (1723-63), was born at Locarno in Italy, and from 1754 to 1763 was at the Nymphenburg factory in Bavaria. He became one of the finest porcelain modellers in Europe; his work is considered by many to surpass that of Johann Kändler, and is light and elegant in the rococo style. The range of his models was considerable—oriental figures, putti, singers, and musicians—but he is particularly noted for those derived from the Italian comedy. A Bustelli figure of an egg-seller sold for £5,800 (A 1969) and one of a fisherman for £5,400 (A 1969).

BUTLER, FRANK A., was a ceramic artist at the Doulton factory from 1873 to 1911. He was deaf and dumb and devoted his life to his work, which was of high quality. His pieces are signed *F.A.B.*

CARRIER-BELLEUZE, ALBERT-ERNEST (1824-87), the French sculptor (see under Bronzes) was chief modeller for the Minton factory in Stoke-on-Trent for a period in the 1850s and in later life did similar work for the Sèvres factory in France.

CHAMBERLAIN, HUMPHREY, was the son of Robert Chamberlain, who founded the factory which bore his name (see below). Humphrey Chamberlain was a painter in the factory, noted for his fine meticulous brushwork. He was a partner in the firm from some time in the 1790s until he died in 1827.

CHAMBERLAIN, ROBERT, was apprenticed as a painter at Dr Wall's Worcester factory where he worked for some years. When William Davis, the manager, died in 1783, he left to start his own enamelling workshop in King Street. In 1792 a new factory was established (where the present Worcester factory stands) to make and decorate porcelain. Some wares for decoration were obtained from Thomas Turner of Caughley. There were many changes of partnership until, in 1840, the factory merged with Flight, Barr & Barr.

CHAMPION, RICHARD (1743-91), opened a factory at Castle Green, Bristol, in 1770. He obtained a licence from Cookworthy of Plymouth to make hard-paste porcelain and in 1774 acquired the patent rights. In 1775 he successfully petitioned Parliament for an extension of these rights for a further fourteen years, though there was strong opposition from Josiah Wedgwood. However, he found

it difficult to finance his projects and in 1781 sold the patent to a syndicate of Staffordshire potters which founded the hard-paste porcelain works at New Hall. It is said that Champion moved to New Hall but this is by no means certain. In 1784 he emigrated to America and died on a farm in South Carolina in 1791. See Mackenna, F. S. *Champion's Bristol Porcelain*. 1947.

CHAPLET, ERNEST. See under Art Nouveau. p 14.

CHAPPUIS, the elder, was a bird painter at the Sèvres factory in the 1760s. His work may be seen at Waddesdon Manor, near Aylesbury, Bucks.

CLARK, HENRY, was a skilful painter of flowers and landscapes who was employed by the Water Lane Pottery, Bristol, in the early years of the nineteenth century.

COFFEE, WILLIAM, was a modeller of porcelain figures. He is noted for his work at the Derby factory between 1794 and 1810. There is a fine Derby biscuit figure in the V & A, showing a young shepherd with his dog and sheep. For a time Coffee was in partnership with a relative of William Duesbury and later ran a pottery on his own, making terra-cotta. He may well have done some modelling for the Derbyshire stoneware firms. There is a Bampton stoneware Toby jug in Salisbury Museum, attributed to Coffee.

COLEMAN, WILLIAM STEPHEN (1829-1904), was an illustrator and watercolour artist who started ceramic decoration in 1869. For a short period he did work for Copelands and later joined Mintons, decorating earthenware plaques and tile slabs for framing. In 1871 an Art Pottery Studio was established by Mintons in South Kensington and Coleman became the first principal. It was mainly for 'educated women, of good social position employed without loss of dignity, and in an agreeable and profitable manner'. The Minton factory at Stoke provided the biscuit ware but there was a local kiln which used the engine-house chimney of the Royal Albert Hall as a smoke vent. Coleman ceased to work on pottery decoration in 1873 and the London studio was burned down in 1875. Coleman's best work was signed *W. S. Coleman*.

COMPLIN, GEORGE, was a decorator at Derby from 1791 to c1795, though he may have worked in the town as an outside decorator after that date. He is noted for his landscapes and for his skill in depicting birds, especially bullfinches, goldfinches, fieldfares, and tits.

COOKWORTHY, WILLIAM (1705-80), was born at Kingsbridge, Devon. He was a Quaker and worked as an apothecary in Plymouth. When he was forty years of age he became interested in the manufacture of porcelain after an American friend had shown him specimens of kaolin and petuntze. He found similar materials in Cornwall and near Plymouth, and after a period of experiment at a factory at Coxside, Plymouth, took out a patent in 1768 for the manufacture of hard-paste porcelain. The venture, however, was not a financial success, and from 1770 the work was carried on in Bristol under Richard Champion, who eventually acquired the rights of the process in 1774

COOPER, WILLIAM, was a gilder at the Derby factory in the 1790s.

COPELAND, WILLIAM TAYLOR, was the son of William Copeland, a traveller for the firm of Josiah Spode. When the third Josiah Spode died in 1829, William Taylor Copeland, who had been in charge of the London salerooms, continued the business under the same name until, in 1883, Thomas Garrett was taken into partnership. This continued until 1847. W. T. Copeland then ran the firm until 1867, when his four sons became partners and the firm became W. T. Copeland & Sons Ltd.

CORDON, WILLIAM, was a ceramic decorator who worked for the Derby factory in the early nineteenth century, painting figures. He also painted for the Rockingham China Works.

COTTON, WILLIAM, was a figure painter who probably worked at the Chelsea factory after it had been taken over by Duesbury, and later at the Derby factory. A porcelain service at Breamore House, Hampshire, dated 1795-1800, has figure painting attributed to Cotton.

COWEN, WILLIAM (w c1826-42), was a decorator at the Rockingham China Works.

COZZI, GEMINIANO, founded a soft-paste factory in Venice which was in production between 1765 and 1812. Much of the ware imitated Meissen designs and the mark was a red anchor, but usually larger than that of the Chelsea factory.

CURTIS, THOMAS, was a painter at the Lowestoft porcelain factory in the 1770s.

CUTTS, JOHN, painted landscapes for the Pinxton porcelain factory, near Mansfield between 1796 and 1812.

CYFFLÉ, PAUL-LOUIS, was a modeller at the Ottweiler factory in the Rhineland c1765 and shortly afterwards at Niderviller.

DALMAZZONI, ANGELO, was an Italian who was employed by Wedgwood to model copies of Italian work from 1787.

DANIEL, HENRY (d 1841), was for some time the chief enameller in the Spode factory but in 1820 started to make good-quality porcelain with his relative, Richard, at London Road, Stoke.

DANNHÖFFER, JOSEPH PHILIPP (b 1712), was a painter who decorated for porcelain factories at Vienna (until 1737), Höchst and Ludwigsburg (from 1762). For some periods he was an outside decorator.

DAVENPORT, JOHN (d 1848), had some early experience in the ceramic industry with Thomas Wolfe of Stoke. He went to France in 1789 to study the methods used in that country. In 1793, or possibly 1794, he started manufacturing at Longport, and paid particular attention to the quality of body and glaze, varying them for specific purposes. George IV showed much interest in the factory and gave Davenport several important commissions.

DEAN, J. E., was employed by the Minton factory in the 1880s primarily as a painter of dogs, fish and game, though he also painted landscapes of historical interest. He made a number of copies of Landseer's subjects for ceramic decoration.

DE MORGAN, WILLIAM FREND (1839-1917), was the son of Augustus De Morgan, a London professor of mathematics. He went to the Royal Academy Schools, and, when in his twenties, came to know William Morris, Edward Burne-Jones, and Dante Gabriel Rossetti, and was much influenced by them. He started as a maker of stained glass and this led to experiments with coloured glazes on pottery. In 1872 he rented 36 Cheyne Row, Chelsea, and started a small business as a decorator of tiles and pottery. In 1882 De Morgan established a workshop at Merton Abbey close to those of William Morris; but he found the journey from Chelsea, and the responsibility involved, too exacting and in 1888 formed a partnership with a well known architect, Halsey Ricardo. Together they started the Sands End Pottery at Fulham. De Morgan's health, however, continued to deteriorate and he had to winter in Florence, trying to direct the pottery from Italy. In 1898 the partnership ended, though with the help of Fred and Charles Passenger, Frank

Iles, and Reginald Blunt (who was for some years the manager), the firm survived until 1907. While De Morgan was in Florence he formed a friendship with Signor Cantagalli, head of a firm which copied early maiolica, and the company decorated some pieces to his designs. De Morgan's decoration falls into two main types—lustred wares and those which show Persian influence and colouring. See Blount, R. *The Wonderful Village*. 1918; Stirling, A. M. W. *William De Morgan and his Wife*. 1922; Wakefield, R. *Victorian Pottery*. 1962, Chapter 8.

DILLWYN, LEWIS WESTON, had a controlling interest in the Cambrian Pottery at Swansea from 1802 until 1831. In 1814 William Billingsley's Nantgarw enterprise was moved to Swansea and came under Dillwyn's control for about three years when some excellent porcelain was made.

DIXON, THOMAS, was a painter of flowers on Coalport porcelain early in the nineteenth century; he particularly favoured passion flowers and pansies.

DIXON, WILLIAM, was a painter at Derby during the Bloor period. He based some of his scenes on engravings by John Collier. A painted mug with fighting men is to be seen in the museum of the Crown Derby Porcelain Works.

DODD, JOSEPH, was a gilder in the Derby factory in the 1790s.

DODSON, RICHARD, decorated porcelain at Derby between 1815 and 1825. He is noted particularly for bird-painting. The birds are usually in a landscape setting, often with water. A thirty-piece turquoise-ground ornithological dessert service painted by Dodson sold for £3,150 (A 1968).

DONALDSON, JOHN (1737-1801), was born in Edinburgh. He moved to London to work as a miniaturist but by 1760 was working as an outside porcelain decorator for Chelsea, Worcester, and Derby. He may even have visited Worcester and Derby to execute special commissions. His work for Worcester in the 1770s included the painting of vases with flowers or classical scenes. His work is sometimes signed *J.D.* See Hobson, R. L. *Worcester Porcelain*. 1910; Marshall, H. R. *Coloured Worcester Porcelain of the First Period*. 1954; Sandow, H. *Worcester Porcelain*. 1970.

DONOVAN (w 1770-1829). This name of a Dublin agent is found on the wares of a number of Staffordshire potteries. In Dublin he

was known as 'The Emperor of China' and he ran a workshop to decorate imported pieces—mostly from the Minton factory in Staffordshire.

DOULTON, JOHN (1793-1873), established a stoneware pottery with John Watts at Lambeth, London, in 1818 to make bottles. Salt-glazed stoneware 'Reform bottles' which represented Lords Brougham, Grey, Russell, and others, were made in 1832 and proved to be popular.

DOULTON, SIR HENRY (1820-97), succeeded his father, John Doulton as head of the stoneware factory of that name in 1846. In the 1860s he was very friendly with John Sparkes of the Lambeth School of Art and between them they worked out a plan for pupils of the school to decorate stoneware. The pupils were given a great deal of freedom to express their own ideas and when these wares were exhibited in 1871 and 1872 they proved to be a commercial as well as an artistic success. Many fine artists worked in the factory during the last quarter of the century, among them Hannah Barlow, Arthur Barlow, Frank Butler, Mary Capes, and George Tinworth. A number of new bodies were produced at the factory, the names of which appear on the wares. Silicon ware is a smooth hard unglazed stoneware. Carrara ware is a semi-glazed white stoneware which looks like marble (as the name suggests). Impasto was ware decorated before firing with thick paint that caused the pattern, after firing, to stand out in relief. Henry Doulton was knighted in 1878.

DRESSER, DR CHRISTOPHER, was an architect who became chief designer of the Linthorpe Pottery (1879-89). The wares are noted for their brilliant glazing.

DUCHÉ, ANDREW (1710-78), was the son of Antoine Duché who made redware and stoneware in Philadelphia in the 1690s. Andrew settled in Savannah and discovered a fine clay which he shipped to England for use in the Bow factory. He is also said to have been the first man to make porcelain in America, though not commercially.

DUESBURY, WILLIAM (1725-86), was born at Longton in Staffordshire but moved to London and from c1750-53 ran a business as a porcelain decorator, painting white porcelain for the Bow, Chelsea, and Derby factories. As the factories established their own painters, his work grew less and he decided to start manufacturing

porcelain himself. He soon acquired a controlling interest in the Derby factory (1756), bought the Chelsea factory (1770) and probably took over the equipment and stock of the Bow factory when it closed (c1778). After his death his son William took charge of the Derby factory. The firm presumably had a London address. William Duesbury II died in 1796 leaving his partner, Michael Kean, to continue the business. William Duesbury III joined the firm in 1808. A Derby wine-cooler made for the Duke of Hamilton in 1790 and bearing his arms and the rare mark of 'Duesbury London' (see plate, p 107) made £310 (A 1969) although repaired.

DUNDERDALE, DAVID, established a pottery at Castleford near Leeds in 1790, making unglazed white stoneware with relief decoration in panels. The firm continued until 1820.

DUPLESSIS, CLAUDE-THOMAS, the royal goldsmith, joined the Sèvres porcelain factory at Vincennes c1746. He was also a sculptor and was particularly interested in the outlines of the wares, many of which derive from silver shapes.

DU PAQUIER, CLAUDIUS INNOCENTIUS, started a porcelain factory in Vienna in 1719 with the help of Samuel Stölzel and Christoph Hunger who had brought some of the technical 'secrets' from Meissen. The factory was taken over by the State in 1744 but he continued as manager until his death in 1751.

DUVIVIER, FIDÈLE, was an apprentice at Tournai in Belgium and moved to London (c1763) to work as an outside decorator for Chelsea, Derby, New Hall, and Worcester. From 1769 he worked at Derby: the agreement with Duesbury was for four years. His work is not easily identified though some pieces are signed—a Worcester teapot in the AM, for example. See Foden, M. 'Fidèle Duvivier: Ceramic Artist,' in Collectors' Guide. July 1968. pp 56-9.

DUVIVIER, HENRI-JOSEPH (b 1740), Fidèle's cousin and son of William Duvivier, learned the decorator's craft at Chelsea. In 1763 he went to Tournai, where he worked for the rest of his life.

DUVIVIER, WILLIAM (d 1755), moved to London from Tournai about 1743 and worked as a painter at Chelsea during the red-anchor period.

DWIGHT, JOHN (c1640-1703), was educated at Oxford and soon began to experiment with the making of pottery, possibly at Wigan in Lancashire, where he worked as scribe to the Rector, Dr

Hall. In 1671 he was in London at Fulham running his own pottery and in that year he claimed to have discovered 'the Mistery of Transparent Earthenware' and applied for a patent. No evidence has been found to prove his claim was well founded. However, he did build up a fine reputation for making stoneware jugs, tankards, bellarmines (ale-house bottles), and bowls. The factory output is also known to have included figures.

EBERLEIN, JOHANN FRIEDRICH, became an assistant to Johann Kändler at Meissen in 1735 as a modeller. An Eberlein figure of a blackamoor, 7½ in high, sold for £290 (A 1965). A finely coloured group of Tirolean dancers sold for £1,470 (A 1968).

EDKINS, MICHAEL (1734-1811), was a painter of delft wares in Bristol at a pottery at Redcliffe Backs. In 1755 he married Elizabeth James, the daughter of a glass-maker. By 1761 he had started to work on his own, painting coaches and scenery. A year later he began decorating glass (see p 128). Signed examples of his decorated delft pieces are known : they bear the initials *M.E.B.* (the *B* is for Betty, his wife).

EDWARDS, EMILY J., was a ceramic artist at the Doulton works at Lambeth from 1872 to 1879. She favoured incised decoration of leaves against a ground of incised vertical lines. Many designs included acanthus leaves.

EDWARDS, LOUISA E., was a ceramic artist at the Doulton works from 1873 to 1890. Many of her floral designs suggest an Indian or Persian influence.

ELERS, DAVID (1656-1742) and ELERS, PHILLIP (1664-1738), almost invariably linked together as 'the Elers Brothers', were silversmiths who came to England from Amsterdam. David had learned about making pottery in Cologne. They appear to have made 'browne muggs and red theapotts' in Fulham, London, from about 1690, for they were sued by Dwight for infringing his patent in 1693. Their main work, however, was done at Bradwell in Staffordshire, where they used a vein of red clay, obtained between Burslem and Wolstanton, to make a fine unglazed compact red stoneware ornamented with stamped-out reliefs applied to the body and subsequently modelled. They also made salt-glazed stoneware. Some of their work probably carried a pseudo-Chinese seal mark but such marks are not easy to attribute to a particular potter. The Elers left Staffordshire in 1710.

ESCALLIER, ELÉONORE, was a painter on faience who worked for Theodore Deck of Paris in the 1860s. She used a Japanese style and her work was exhibited at the Paris Exhibition of 1867. Examples in Musée des Arts Decoratifs, Paris.

EVANS, ETIENNE, was a bird-painter at the Sèvres porcelain factory in the 1760s. His work may be seen at Waddesdon Manor, near Aylesbury, Buckinghamshire.

FEILNER, SIMON, who had been a modeller at the Fursten-berg and Höchst porcelain factories, became the director at Franken-thal from 1775 until 1797.

FENTON, CHRISTOPHER WEBBER (1806-1865), was born in East Dorset, Vermont. He was a keen businessman and was closely associated with the growth of the Bennington Pottery between 1846 and 1858, where porcelain, Parian ware, American 'Rockingham' ware and brilliant flint enamel pottery were made.

FERNER, J. F., was an outside decorator of defective porcelain from the Berlin, Meissen and Vienna factories, which he painted or gilded heavily in red and gold. His paint work is undistinguished.

FIFIELD, WILLIAM (c1777-c1857), worked at Bristol Pottery as an enamel painter from 1807 for over forty years. His work was signed *W.F.* This pottery was owned by Joseph Ring when Fifield joined the firm : he continued under Pountney & Allies (1816-35) and Pountney & Goldney (1836-49).

FLAXMAN, JOHN, RA (1755-1826), was born at York, the son of a moulder of plaster figures. As a child he was an invalid and showed an early interest in art. He went to the Royal Academy Schools in 1770 and won their silver medal the next year. In 1775 he started to model vases, plaques, and medallions for Messrs Wedgwood. Helped by Wedgwood, he went to Italy in 1787, where he studied Italian art and supervised the work of some Italian artists designing for the Wedgwood pottery. Later, after his return, he specialised in monumental work, became an RA in 1800, and a Professor of Sculpture to the Royal Academy in 1810. The Wedg-wood Room at the Lady Lever Art Gallery at Port Sunlight has the modelling tools used by Flaxman at Etruria. See Constable, W. G. *John Flaxman.* 1927.

FLIGHT, THOMAS, was the London agent for the Worcester factory when William Davis, the manager, died in 1783. He bought

the property for £3,000 and installed his son John to manage it. In 1791 John Flight died and Joseph Flight, the younger son, continued in partnership with Martin Barr until 1807 when the younger Martin Barr joined the firm and it became Barr, Flight & Barr. The Flight interest continued until 1840. See also under Barr, Martin.

FOSTER, H. W., joined Mintons in 1879 as an artist. He was noted for plaques on which he painted the heads of distinguished persons such as Sarah Bernhardt and the Prince and Princess of Wales.

FRYE, THOMAS (1710-62), was born in Ireland and moved to London in 1729 to work as a painter. He began to study the technique of making porcelain and in 1744, with Edward Heylin, a merchant of Bow, registered a patent for the manufacture of porcelain from unaker, a clay found in North America, though there is no evidence that the formula was ever used. In 1749 he took out another patent, this time in his own name, which described a method in which bone ash was to be included in the porcelain body. With financial help from local merchants Frye established a porcelain factory at Bow, which he managed until 1759 when he retired because of ill-health.

GELY, LEONARD, was a ceramic decorator who used the pâte-sur-pâte technique at the Sèvres factory, France. His work was shown at the Paris Exhibition of 1855. Example in the V & A.

GILES, JAMES (1718-80), ran a decorating business in Berwick Street, Soho, London, from some time in the 1750s and, as 'Chinaman and Enameller' employed many artists and did a great deal of painting himself. He is sometimes known as the 'cut-fruit' painter, since he included apples and other fruit, cut to show the cross-section, in his designs. He is best known for his work for the Worcester factory between 1767 and 1776, the year he went bankrupt. He also worked for Bow, Chelsea, Derby, Liverpool (from 1771), Longton Hall, and Plymouth. It is difficult to attribute decoration with confidence. Henry Sandon discusses some of the problems involved in his book, *The Illustrated Guide to Worcester Porcelain* (1970), pp 48-50.

GRAINGER, THOMAS (d 1839), was an outside decorator in Worcester until he started a factory in 1801 for making porcelain in St Martin's Street. It was known as Grainger, Wood & Co and

in 1812 became Grainger, Lee & Co. In 1839, when Grainger died, his son George Grainger succeeded him and the firm became George Grainger & Co. In 1899 it was taken over by the Worcester Royal Porcelain Company.

GRICCI, GIUSEPPE, was the chief modeller in the Capodimonte Porcelain Works, just north of Naples, between 1743 and 1759. A pair of lovers, modelled by Gricci, sold for £9,450 (A 1969).

HADLEY, JAMES (1837-1903), was a modeller for the Royal Worcester Porcelain Company c1870-1890. He specialised in vases in the Japanese style in which metal mounts were used on the porcelain base. Examples in V & A.

HANCOCK, JOHN (1757-1847), was noted not only as a painter but also as a gilder, for he succeeded in devising a process costing a great deal less than the gold leaf and honey that had previously been used. His material for gilding combined gold with mercury and turpentine. He worked at the Derby, Spode, and Wedgwood factories. His son and his grandson were also called John. The former was mainly a flower painter at Derby, but the latter was more versatile.

HANCOCK, ROBERT (c1730-1817), was born in Burslem, Staffordshire. In 1746 he was apprenticed to George Anderton, an engraver, in Birmingham, but by 1753 was in London. He is known to have worked for the Battersea enamel works under Simon François Ravenet, the French engraver, and later for Thomas Frye, at the Bow porcelain works. He had been involved in London with simple transfer-printing, for when he moved to Worcester in 1756 he took some experience with him. He did some fine work for overglaze printing, using French subjects (after Watteau and Lancret), later some English ones (after such artists as Gainsborough and Reynolds), and also some popular chinoiseries. Much of his work was signed.

In 1772 he became a partner in the firm but as the result of some disagreements he sold out his share in 1774 for £6,000, some of which he unfortunately lost when the bank in which it was deposited failed. In 1775 he joined Thomas Turner (at Caughley), now very experienced in the technique of transfer-printing. Five years later he left and little is known about his subsequent career. He is known to have been in the Oldbury and Dudley districts of Worcestershire for some time in the 1780s and in Birmingham and Bristol

in the 1790s. In 1808 he was in London, but apparently returned to Bristol later, for he died at Brislington, Bristol, in October 1816. A First Period Worcester yellow-ground mask jug decorated by Robert Hancock sold for £1,900 (A 1969). See Ballantyne, A. R. *Robert Hancock and his Work*. 1885; Cook, C. *Robert Hancock. His Life and Work*. 1948, and Supplement to the *Life and Work of Robert Hancock*. 1955.

HANNONG, PAUL-ANTOINE, was given control of his father's faience factory in Strasbourg in 1732. He was inventive and tried many new formulae. With help from J. J. Ringler he succeeded in making porcelain, but the granting of a virtual monopoly to the Sèvres factory which was under royal patronage stopped further developments. Hannong moved into Germany and in 1755 established a factory at Frankenthal which was then managed by his son, Charles-François Paul Hannong.

HARRISON, JOHN, established the Linthorpe Pottery in 1879 at Middlesbrough-on-Tees. The business lasted for ten years.

HASLEM, JOHN (1808-84), was an enamel painter whose career was closely linked with the Derby factory, for which he worked from a very early age. He was the nephew of James Thomason, who managed the works from 1828 to 1845. Haslem, a skilled miniature painter, executed a number of small plaques on porcelain. He was also noted for figure subjects after Watteau and he painted some birds in the Sèvres style. Much of our knowledge about the history of Derby porcelain is due to a book he wrote in 1876, *The Old Derby China Factory*.

HEINTZE, JOHANN GEORG, was for some years in the laboratories of the Meissen factory. Between 1720 and 1749 he worked as a landscape painter there, and for a time was imprisoned for working outside its walls. He is said to have worked later at Berlin and Vienna, but little is known about this period of his life.

HEMPHILL, JOSEPH (1770-1842), was in partnership with William Ellis Tucker in Philadelphia when porcelain was first produced in America. From 1832 to 1836 he owned the works which became the American China Manufactory.

HENDERSON, D. & J., were owners of the New Jersey Porcelain & Earthenware Company. They were noted for making pitchers decorated in relief.

HENK, CHRISTOPHER (c1821-1905), was a modeller and figure painter at Mintons from about 1848 and his son John also worked at the factory from 1860.

HEROLD, CHRISTIAN FRIEDRICH (1700-79), was a decorator at the Meissen porcelain factory from 1726. His favourite subjects were chinoiserie harbour scenes. Example in BM.

HILL, THOMAS, sometimes known as 'Jockey Hill', was a landscape painter at Derby from 1795 to 1800. He is said to have preferred to work against a yellow ground. A born countryman his work has an air of authenticity.

HIRSTWOOD, HAIG (c1826-42), was a decorator at Rockingham.

HOLDSHIP, JOSIAH, was a signatory of the first partnership deed bringing the Worcester factory into existence in 1751, and he played a major part during its first twenty years.

HOLDSHIP, RICHARD, was also a founder-partner at Worcester, but he sold his interest in 1759 and later went to Derby, where he passed on his knowledge of underglaze transfer-printing to Duesbury and Heath.

HORÖLDT, JOHANN GREGOR (1696-1776), was a colour chemist at the Meissen porcelain factory from c1720. He became the *Obermaler*, supervising all the painting and the work of the apprentices. In 1731 he became director of the factory, a post he held until 1756 and again from 1763 to 1765. A pair of Meissen blue-ground chinoiserie vases painted by Horöldt c1725, only slightly restored and bearing the Augustus Rex mark, sold for £10,000 (A 1969).

HUNGER, CHRISTOPH KONRAD, was one of the men responsible for spreading the knowledge of how to make porcelain, having gained his technical experience at Meissen. In 1719 he took the secret to Vienna and in 1720 to Venice.

HURTEN, C. F. (1818-1901), was a flower painter for Copelands in the 1860s, probably the finest of his time.

IFIELD, HENRY, was a maker of slipware at Wrotham about 1660. A jug of this date sold for £1,200 (A 1969).

JACKSON, T., is a name that occasionally appears as a signature on pot lids made by F. & R. Pratt & Co in the 1850s. He was presumably an artist and/or engraver.

JEANNERT, ÉMILE (1813-57), was a French sculptor who became an instructor at the Potteries Schools of Design between 1848 and 1852. He designed for Mintons.

JONES, CECIL, was a painter of flowers and fruit on early nineteenth-century Coalport porcelain.

KÄNDLER, JOHANN JOACHIM, joined the porcelain factory at Meissen as chief modeller in 1731, a post he held until 1775. He was versatile and lively and his influence on the porcelain industry in Europe was enormous. He created an astonishingly large number of models; at first they were large, several feet in height, but he was soon making the delightful small figures in the baroque manner for which he is famous—ladies in crinolines, musicians, Italian Comedy figures, and symbolic groups representing the seasons, the arts, the elements, etc. He also modelled many birds from nature, particularly the swan. Some of his work may be seen at Waddesdon Manor, near Aylesbury, Buckinghamshire. A dancing group of Columbine and Harlequin modelled by Kändler in 1744 sold for £10,000 (A 1969).

KAUFFMAN, ANGELICA (1741-1807), was born in Switzerland. She was a painter and worked in London from c1766 to 1782, doing a good deal of decorative work for Robert Adam on interiors, as did her husband, Antonio Zucchi. She did not paint on porcelain, but so much ceramic decoration is 'after Angelica Kauffman' that it is important for the student to be able to recognise her style.

KEAN, MICHAEL, became a partner with William Duesbury II in the Derby factory after William's father died, and general manager of the works in 1795. He was hot-headed and unpopular and many of the better craftsmen left the firm. His term of office ended in 1811.

KEYS, EDWARD, started his career as a modeller at the Derby factory, where he worked until 1826. He made Dr Syntax figures, all manner of animals (including a monkey band), and some small figures of London characters. He then moved to Staffordshire and by 1831 was working for Mintons as a modeller of figures and flowers. In 1842 he set up his own workshop, but it failed and in 1843 he took employment at Wedgwoods.

KEYS, SAMUEL, SR, father of Edwards Keys, started work at Derby at an early age in 1785. He was an extremely competent gilder, decorating china figures in the style of Dresden. From about

1831 until 1850 he was at Mintons, where he continued to do gilding of fine quality.

KEYS, SAMUEL, JR, also started his career at Derby and was, like his brother Edward, a modeller, but of theatrical figures. He left Derby in 1830 and by 1833 had joined his brother at Mintons. In 1850 he joined John Mountford, who is said to have invented parian ware, and the partnership exhibited parian at the 1851 Great Exhibition, London.

KIRBY, THOMAS (1824-90), was employed by Mintons as a flower and figure painter from 1841. He made an effort to break away from the style 'after Watteau' and started to paint cupids : these paintings were highly praised. After 1850 he painted and signed some fine pieces of maiolica ware. He retired in 1887.

KIRCHNER, JOHANN GOTTLOB, was the chief modeller at the Meissen porcelain factory for a short period from 1727. He modelled animals and birds from life, and large figures and groups.

KIRK, W. B., was a modeller at the Worcester porcelain factory in the Kerr and Binns period (1851-61). Examples in Dyson Perrins Museum, Worcester.

KLINGER, JOHANN GOTTFRIED (1711-1781), was a painter at the Meissen porcelain factory from 1731 to 1746, and then went to Vienna where he lived for the rest of his life.

LATHAM, JOHN, who started as a painter at Nantgarw, set up an enamelling kiln at Ironbridge early in the nineteenth century and did work for the Coalport factory.

LAWTON, CUTHBERT, was a Derby painter early in the nineteenth century, noted for his flowers drawn in gold. His work is rare.

LEE, FRANCIS E., was a ceramic artist at the Doulton factory from 1875 to 1890; he was known for formal patterns, incised or impressed with the signature *F.E.L.*

LEROI, DESIRÉ (d 1908), was a Frenchman; employed at Sèvres from the age of eleven, he quickly established a reputation as a painter. In 1874 he moved to Mintons in Staffordshire : flowers and birds were a speciality. In 1890 he went to the Royal Crown Derby Porcelain Co Ltd as art director and designer, and he personally executed a number of important commissions. One example was an eighteen-piece dessert service, which Derby Corporation gave

N

as a wedding present to the Duke of York and Princess Victoria May of Teck.

LESSORE, ÉMILE (1805-76), was a French artist who worked at Sèvres, where he decorated a pair of vases which were bought by the Emperor of Russia for 1,000 guineas. In 1858 he came to England and, after a few months at Minton's, spent some years with Wedgwood's, where he experimented with colours and was noted for his paintings on tablets. His work varied in quality but his best pieces, which were decorated plaques, are outstanding; most of them are signed *Émile Lessore, E. Lessore* or simply with initials *E.L.* In 1867 he returned to France but continued to work for Wedgwood's. A Wedgwood plaque painted by Lessore after Boucher sold for £651 (A 1970). See Mankowitz, W. *Wedgwood.* 1953 (1967), Chapter 7.

LEYLAND, WILLIAM (c1825-42), was a decorator at the Rockingham Works.

LLANDEG (c1825-42), was a painter of fruit and flowers at the Rockingham Works. He created an attractive 'blackberry border'.

LONGDEN, WILLIAM, was a painter and gilder at the Derby factory in the 1790s. He specialised in landscape.

LÖWENFINCK, ADAM FRIEDRICH VON (1714-54), who was apprenticed in the Meissen factory, decorated porcelain with flowers and chinoiseries. He became restive in his early twenties and started to move from place to place. He first went to Bayreuth, then to Chantilly, Ansbach, Fulda and Höchst, ending at Haguenau in Alsace. His brothers, Carl Heinrich and Christian, who were also apprentice flower painters at Meissen, were similarly given to moving about.

LUCAS, DANIEL (d 1867), was a painter at Derby during the Bloor period, though it is not certain when he joined the firm— some sources say 1815, others 1830. He had three sons, who all worked at the factory before 1848, which adds to the confusion. Much painted porcelain attributed to Lucas was probably painted by others. He specialised in landscapes.

LUPTON, EDITH D., was a ceramic artist at the Doulton factory from 1876 to 1889. She specialised in floral patterns and signed her work *E.D.L.*

McLAUGHLIN, MARY LOUISE, of Cincinnati, Ohio, USA, was noted for painted decoration with coloured slips in the

1870s and 1880s. Her work may be seen in the Cincinnati Art Museum.

MARCOLINI, COUNT CAMILLO (1739-1814), became director of the Meissen porcelain factory in 1774 and held the post until 1813. During this period there was a striking change in the style of output. Rococo designs were replaced by the neo-classical, and the quality of the porcelain declined owing to the fact that the deposits of finer clay were worked out.

MARSHALL, MARK V., was a ceramic artist at the Doulton factory from 1876 to 1912. He had previously worked with the Martin Brothers. He designed and modelled : his individual pieces are often large and are signed *M.V.M.*

MARTIN BROTHERS. A small organisation established by four brothers first at Fulham in 1873 and then at Southall in Middlesex in 1877. By steady application and much laborious experiment they succeded in producing a salt-glazed stoneware of fine quality. Their work included bowls, jugs, vases, and grotesque figures of animals, birds, and fish. Each piece is different. 'We make it a matter of pride never to repeat a single specimen of our work,' said Charles Martin in 1897 when asked to describe their policy. Pieces are invariably signed in a recognisable form; the name *R. W. Martin* usually appears. Martinware is much sought after by collectors. Specimens may be seen in the public library in Osterley Park Road, Southall, Middlesex, and in the V & A.

MELCHIOR, JOHANN PETER (1742-c1810), was chief modeller at the Höchst factory from 1767 and at the Frankenthal factory from 1779 to 1793. After a period of poverty and distress he was made *Modellmeister* of the Nymphenburg factory in 1797. His work, which tends to be sentimental, includes many pastoral scenes and small children, and often uses a light rose-pink colour, which he greatly favoured. A Melchior figure of a child gardener standing on a grassy mound beside a pedestal marbled in puce, and holding a tub with a flowering plant, sold for £350 (A 1969).

MINTON, THOMAS (1765-1836), was born at Shrewsbury and apprenticed as an engraver to Thomas Turner at the Caughley porcelain factory, where he engraved plates for blue-printed transfer wares. He then moved to London, where he was employed in the warehouse of Josiah Spode at Lincoln's Inn Fields, and in 1788 he

set up on his own in Stoke as an engraver, still doing work for Spode. In 1793 he took into partnership Joseph Poulson, a practical potter, and together they established the firm that still bears the Minton name. A general survey of the early days of Mintons Ltd is given in G. A. Godden's *Minton Pottery and Porcelain of the First Period, 1793-1850*. 1968. Chapter I.

MIST, JAMES UNDERHILL, was an agent whose name sometimes appears on pottery with the address of the warehouse, 82 Fleet Street, London. Mist was in partnership with Andrew Abbott from 1802 to 1811, after which he continued to operate from the same premises. A full account of the partnership and agency is given in Bevis Hillier's *The Turners of Lane End*. 1965. Chapter 8.

MITCHELL, MARY, was a ceramic artist at the Doulton factory from 1876 to 1887. She is known for incised work, which includes children and other figures. She signed her work *M.M.*

MORRIS, HENRY, was a decorator at the Swansea factory from 1815, where he worked under the direction of William Billingsley. He was a fine painter of fruit and flowers and decorated the famous Lysaght service (see *Collectors' Guide*, October 1967, pp 50-52).

MORTLOCK, JOHN, is a name which is sometimes seen impressed or painted on pottery and porcelain. He was an Oxford Street dealer in London from the middle of the eighteenth century and also did some decorating.

MUSSILL, W., was a painter who came from Bohemia to join Mintons in 1872. He is noted for flowers, birds, and marine subjects.

NIEDERMAYER, JOHANN JOSEPH, was *Modellmeister* at the Vienna porcelain factory from 1747 to his death in 1784.

NORTON, CAPTAIN JOHN, established the Norton Pottery at Bennington, Vermont, in 1793.

O'NEALE, JEFFRYES HAMET (c1734-1801), was an Irish artist who went to London around 1752 and became an outside decorator for the Chelsea factory during the red and gold anchor periods. He was elected to membership of the Society of Artists in 1765. It is thought that he may have lived in Worcester from 1768 to 1770, working for the Worcester porcelain factory. He was a figure and landscape painter, and is sometimes referred to as the 'Fable painter' because of the splendid paintings he did that were

based on Francis Barlow's *Aesop's Fables* (1687 edition). He was also a skilful animal-painter, especially of horses. The panels on which he painted, set in coloured grounds, were often heart-shaped. A hexagonal Chelsea teapot painted by O'Neale sold for £2,400 (A 1963) and two Worcester vases for £3,900 (A 1963). See Marshall, H. R. *Coloured Worcester Porcelain of the First Period*. 1954.

PAQUIER. See DU PAQUIER.

PARDOE, THOMAS, was born in Derby in 1770 and apprenticed to the Derby factory in 1785. In 1795 he was in Swansea and by 1809 he had established himself in Bristol as an outside decorator, painting birds, fruit, and flowers, mainly on Staffordshire wares. For some time in the 1820s he was at Nantgarw with Billingsley and Weston Young, and it was here he died in 1823.

PEGG, WILLIAM (b 1775), was the son of a Staffordshire gardener. He loved flowers from an early age and soon learned to paint them. He joined the Society of Friends and when he started to work as a flower-painter at the Derby porcelain factory in 1796 he became known as 'Quaker Pegg'. His single flower sprays were beautifully painted, usually life-size. Some of them were from nature, others were adapted from illustrations in William Curtis's *Botanical Magazine*. Religious scruples made him leave the factory in 1801, but he returned in 1813 and spent seven more years painting flowers on porcelain. He signed his more important pieces *W. Pegg*. On his earlier pieces a blue mark appears; on later pieces a red mark.

PENNINGTON, JAMES, was a figure-painter at Worcester during the Flight period. In 1792 he painted an important service for the Duke of Clarence, and it had a figure of Hope with an anchor on each piece.

PETIT, JACOB, took over a factory at Fontainebleau near Paris about 1830 to produce decorative porcelain, including imitations of other factories.

PILLEMONT, JEAN, was an engraver who worked at the Worcester factory with Robert Hancock in the 1770s.

POWLES, RICHARD, was a decorator at the Lowestoft factory from about 1774 to 1790.

PRATT, FELIX EDWARDS (1813-94), ran the pottery of F. & R. Pratt at Fenton, Staffordshire, with his brother Robert where they maintained a very high standard of output. With the help of

Jessie Austin, a friend who accepted an invitation to join the firm, they produced the first colour-printed earthenware (c1847).

PRATT, HENRY LARK (1805-73), became a landscape artist at the Derby Porcelain Factory. At the age of twenty-five he moved to Minton's for a short period.

PREISSLER, DANIEL (1636-1733) and his son IGNAZ (b c1676) of Breslau, were outside decorators for the Meissen Factory (c1730-40). They favoured a palette of iron red and black. They also decorated glass and Chinese porcelain. A cream pot and cover with pan top and scroll handle, on three paw feet, painted by 'Preissler' with a scene of Abraham about to sacrifice Isaac in a setting of continuous river landscape sold for £2,625 (A 1968).

PUGIN, AUGUSTUS WELBY (1812-52), was a friend of Herbert Minton, for whom he designed tiles during the last three years of his life.

RANDALL, JOHN (d 1910), was a painter at the Coalport factory from about 1835. He specialised in making copies of the decoration on Sèvres porcelain.

RANDALL, THOMAS MARTIN, had a factory at Madeley in Shropshire (c1825-40) where he made a soft-paste porcelain in imitation of Sèvres. He also had an interest in a decorating workshop in London.

REYNOLDS, ALFRED, was a pupil of the colour printer George Baxter (c1836). By 1846 he was a member of the partnership of Gregory, Collins & Reynolds, who started colour printing, varying the process from that employed by Baxter in order to avoid copyright difficulties. In 1849 he was with Mintons. It is said that his friendship with Jessie Austin led to the colour printing on pottery started by F. & R. Pratt.

RICHARDSON, GEORGE, was a Wrotham maker and decorator of slipware in the seventeenth century. A Richardson tyg dated 1654 sold for £1,600 (A 1969).

RILEY, JOHN & RICHARD, established a pottery at Nile Street, Burslem, in 1802 and moved to new premises, the Hill Works, Burslem, in 1814, continuing there until 1828. Much of their output consisted of fine-quality blue transfer-printed earthenware. They had a considerable export to America, mainly of English scenes. (See plate, p 108).

RINGLER, JOSEF JAKOB (1730-1799), was born in Vienna and worked in the porcelain factory from 1744 to 1748. He succeeded in probing the secrets of porcelain manufacture and from 1750 to 1752 was at Höchst. He then went to Strasbourg and did some work for minor factories before becoming the director at the Ludwigsburg factory in 1759, a post he held until c1799.

ROBERTSON, GEORGE, was a ceramic decorator at the Derby factory between 1796 and 1820, noted for his landscapes and seascapes.

ROBINS, JOHN, was a gilder in the Minton factory from about 1839 to 1860.

ROGERS, GEORGE, was a nineteenth-century Worcester painter who became an outside decorator.

ROGERS, JAMES, was a decorator for Chelsea during the red-anchor period. He also painted designs of flowers and insects on First Period Worcester (c1755-65).

ROGERS, JOHN & GEORGE, owned a pottery at Dale Hall, Longport, from 1784 to 1814, and during the period 1814-36 it became John Rogers & Son. The firm was one of the largest manufacturers of good quality underglaze blue transfer-printed earthenware of the period, supplying large quantities to the home and American markets (see plate, p 108).

ROSE, JOHN (c1760-1841), was apprenticed to Thomas Turner at Caughley and about 1793 started a pottery at Jackfield. In 1796, in partnership with Edward Blakeney and Richard Rose, he established the Coalport Porcelain Works. Three years later the partnership bought the Caughley factory a few miles away, and continued to operate it until 1814, making hard-paste porcelain tea wares. It was then closed and the Coalport factory was extended. See *Collectors' Guide*. February 1968, pp 44-7.

SADLER, JOHN, was born in Liverpool in 1720. He invented a process in the 1750s for transfer-printing pottery with designs first engraved on copper plates. He formed a partnership with Guy Green to exploit the invention and they decorated much earthenware from Staffordshire, including Wedgwood creamware, using black or red prints. Sadler retired in 1770 and Green continued the business alone.

SALT, RALPH (d 1846), made Staffordshire chimney ornaments at a small pottery at Miles Bank, Hanley, from 1812 to 1834.

Some of his pieces have tree backgrounds. A number are marked SALT, impressed or on a raised scroll.

SAMSON, EDMÉ, ET CIE, of the Rue Béranger, Paris, have specialised since 1845 in making copies of early porcelain—Bow, Chelsea, Chinese armorial, Meissen, Sèvres, and Worcester. The copies are all made of hard paste, and many bear an 'S' mark, which unscrupulous dealers are known to have removed from some pieces with hydrofluoric acid in order to pass them off as originals.

SEUTER, BARTHOLOMÄUS (1678-1754), was an outside decorator of Augsburg who bought porcelain from the Meissen factory (c1728).

SHERRATT, OBADIAH, was an ale-house keeper and part-time potter, who modelled groups from 1822 to 1855—his *Bull-baiting* and *Wombell's Travelling Managerie* are good examples. He also made earthenware cow creamers.

SIMMANCE, ELIZA (or ELISE), decorated stoneware at the Doulton factory between 1873 and 1928. She used many techniques but favoured floral patterns. She signed her work *E.S.*

SIMPSON, JOHN (1811-84), was born in Derby and trained at the Derby works as a figure and landscape painter. He moved to Staffordshire and was at Mintons from 1837 to 1847, then went to London to work as a painter of miniatures.

SIMPSON, RALPH, was a Burslem maker of slipware towards the end of the seventeenth century. A squat Simpson jug decorated with a bold tulip design in brown, signed *W.S.* and dated 1691, sold for £1,700 (A 1968).

SLATER, WILLIAM (1794-1867), was apprenticed as a painter at Pinxton, but moved to Derby in 1813, where he worked until 1848, when he moved again to Staffordshire and worked at Daven-ports until his death. At Derby he is known to have painted moths and other insects in natural colours.

SMITH, JESSE, was born at Stoke (c1819) and is noted as a painter of roses for Mintons (c1840-c1865) and subsequently for Copelands.

SMITH, JOSEPH, was born at Worcester (c1802). He worked for Minton's in Staffordshire from 1834 for some twenty-five years, mainly as a bird-painter.

SOAR, THOMAS (w 1785-1800), was foreman of the gilders at Derby in the 1790s, and his work shows superb artistry.

SOLON, MARC LOUIS (1835-1912), was born at Mantaubon in France and spent some years at the Sèvres factory. He came to England in 1870, joined Mintons, and later married the daughter of his countryman Leon Arnoux, who was art director of the firm. He brought with him the *pâte-sur-pâte* (clay on clay) technique, in which a light-coloured slip was painted on a darker-stained parian base. The material had to be kept in the clay state while the work was done. The slip was built up layer by layer and was then modelled with delicate tools. Solon's designs were of classical figures and he never duplicated his handiwork. Solon's son Leon was for a time the art director of Mintons, succeeding his grandfather Leon Arnoux. Examples of Solon's work are to be seen in the V & A.

SPÄNGLER, JEAN JACQUES, was the son of a director of the porcelain factory at Zurich in Switzerland. He came to England in the 1770s and was a temperamental modeller of bisque figures at Derby, where he caused many disturbances. He did work for Vulliamy, the London clockmaker, to use on his clocks.

SPODE, JOSIAH (1733-97), worked for Thomas Whieldon from the age of twelve and was apprenticed to him at sixteen. In 1754 he is thought to have had a small pottery of his own. In 1762, however, he was working as manager for Turner & Banks in Stoke. In 1770 he established the Spode factory, in which he perfected the process of transfer-printing in underglaze blue. In 1779 William Copeland (qv) became a partner in the firm and later managed the London shop and warehouse. By the turn of the century the firm had perfected a hard-paste porcelain which contained considerable quantities of bone ash and came to be known as bone china. Josiah Spode I died in 1797 and his son, Josiah Spode II (1754-1827) took over the management of the business until his death in 1827. Josiah Spode III succeeded him but died two years later.

SPRIMONT, NICHOLAS (1716-71), a Huguenot silversmith, came to England and registered his mark at Goldsmith's Hall in 1742. He made silver ware for a short period and in 1745 became manager of the Chelsea porcelain factory, where his work as a silversmith influenced the porcelain designs. He had several illnesses and in 1759 the Chelsea equipment was sold. See 'Silver Shapes in Chelsea Porcelain', *Country Life*, 1 February, 1968, pp 224-6.

STEEL, EDWIN (1805-71), was the son of Thomas Steel (qv). He trained at the Derby porcelain factory and then went to the Rockingham China Works. Later he moved to Staffordshire and worked at Minton's.

STEEL, THOMAS (c1771-1850), was a noted painter of insects, flowers, and particularly fruit. He was born and brought up in Staffordshire, where he trained. He worked at Derby from 1815 to c1830 and then spent a short time at Rockingham before moving to Minton's about 1832, where he worked until 1849. A number of his pieces were signed. It is worth noting that many earlier writers have incorrectly spelt his name with a final 'e'.

STEEL, THOMAS, JR, was a painter of landscapes for the Coalport Porcelain Works (c1820).

STEPHAN, PIERRE, was a prolific modeller of bisque figures at the Derby porcelain factory between 1770 and 1774 and continued work for Derby, probably as a freelance, until 1795. Many of his models were 'after Angelica Kauffman'. He also worked for Wedgwood.

STORER, MARIA LONGWORTH, was an art potter who, after a period of experiment, founded the Rookwood Pottery in Cincinatti in 1880. For twenty years all the work was hand produced and each piece was signed by the decorator. Much of the decoration shows Japanese influence.

TATLER, THOMAS, was a flower-painter at Minton's from c1831 to c1842.

TAYLOR, WILLIAM, was a gilder at the Derby factory in the late eighteenth century.

TEBO was a ceramic modeller : his name was possibly from the French Thibault. Little is known about this craftsman except that he probably worked at the Bow factory from about 1750. Figures with a T^{o} mark are presumed to have been modelled (or repaired) by him. There is also evidence that he worked at Plymouth, and probably at Worcester (in the 1770s). See Fisher, S. W. 'The Legendary Tebo and Bristol Porcelain', *Collectors' Guide*, July 1966. pp 48-9.

TINWORTH, GEORGE, was a ceramic modeller and decorator at Doultons from 1867 to 1917. He made terra-cotta plaques for churches and amusing animal groups, but he also decorated vases.

He was an excellent craftsman and is recognised as the finest stone-ware artist to be employed by the Doulton firm.

TOFT, THOMAS, was a Staffordshire maker of slipware, one of the few who signed and dated his pieces between 1671 and 1689, the year of his death.

TUCKER, WILLIAM ELLIS, of Philadelphia, Pennsylvania, produced the first porcelain to be made for the home market in the United States—a hard-paste product. The factory was in operation from 1825-38. In 1828 Tucker formed a short partnership with Thomas Hulme, and in 1832 a partnership with Joseph Hemphill which lasted until the factory closed down in 1838. Examples may be seen in the Newark Museum, Newark, New Jersey. See McClinton, K. M. *A Handbook of Popular Antiques*. New York, 1945, Chapter 4 on 'Tucker China'.

TURNER, JOHN (1738-87), the son of a Staffordshire lawyer, was apprenticed in 1753 to a small potter at Pentehull. By 1756 he was running his own pottery with a partner, William Banks. In 1762 he had established a factory of his own at Lane End which was continued by his sons, John and William, until 1806 when the firm went bankrupt. The factory continued, however, until 1829 making fine creamware, stoneware, and jaspers. It also had a considerable output of blue transfer-printed wares. See Hillier, B. *The Turners of Lane End*. 1965.

TURNER, THOMAS, who had been an apprentice at Worcester, married the daughter of Ambrose Gallimore, who owned a pottery at Caughley in Shropshire. In 1772 Turner took over the works and started making porcelain. In 1772 he was joined by Robert Hancock from Worcester, after which the output of pottery and porcelain with underglaze blue-printed patterns was considerable, much of it 'in the Chinese taste'. In 1799 the Caughley works was sold to John Rose (qv).

VEZZI, FRANCESCO, was a goldsmith who founded the Vezzi porcelain factory in Venice in 1720, using secrets brought from Meissen. Production lasted only seven years. A damaged teapot of Vezzi porcelain sold for £3,045 (A 1968).

VOYEZ, JEAN (1735-1800), or JOHN VOYEZ as he is often called, came to England from France and worked for some time in London as a silversmith, woodcarver, and modeller. In 1768 he

joined Wedgwood's as a modeller. He appears to have had a serious quarrel with Wedgwood within a year and then tried to undermine the business by selling forged seals. In 1788 he was responsible for modelling the *Fair Hebe* jug for Astbury and he almost certainly modelled for Ralph Wood (signed examples are in the V & A). See Charleston, R. J. 'Transactions of the English Ceramic Circle', Vol 5, Part 1.

WALL, JOHN, MD (1708-76), was a doctor and amateur painter who lived in Worcester. In 1751, with fourteen associates, he founded the Worcester Tonquin factory at Warmstry House on the Severn for the manufacture of porcelain. 'Wall period' Worcester, or 'First Period Worcester' as it is now generally known, covers the years from 1752 to 1783.

WALTON, JOHN, of Burslem was a maker of pottery figures and toby jugs from c1806 to 1835. He used trees as a background (bocage) and crude bright enamels. Many of his figures bear the name WALTON on a raised scroll.

WAREHAM, JOSEPH (b 1783), was a notable painter of birds, flowers, and fruit, who spent much of his working life at Mintons (c1838-c1861).

WEBSTER, MOSES (d 1870), was apprenticed as a painter at the Derby factory, worked for a period at Worcester and in London, and returned to Derby to work there from c1820-26. His flower painting was good.

WEDGWOOD, JOSIAH (1730-95), was born at Burslem, the youngest of thirteen children. He was apprenticed to his brother and in 1752 formed a partnership with John Harrison to work a small pottery at Cliff Bank, Stoke. By 1754 he formed a new partnership with Thomas Whieldon for five years. It was a period of experiment in the making of 'marbled' and 'tortoise-shell'' wares, using coloured glazes. In 1759, Wedgwood started on his own at Ivy House Works, Burslem, and within three years he had perfected a creamware. In 1765 he became 'Potter to the Queen' and his creamware became 'Queen's Ware'. In 1762 he became friendly with Thomas Bentley, his agent in Liverpool, and (c1768) they formed a partnership.

By this time a new works and residence was ready at Etruria and a period of great activity began with new and fine ceramics pouring from the factory. It was during this period that jasperware

and black basalts were perfected. Bentley died in 1780 and Wedgwood in 1795. Unfortunately, the finest period of Wedgwood production had ended. His son Josiah Wedgwood II, who succeeded him, lacked the enthusiasm and drive of his father and the Napoleonic Wars injured the export trade. In 1828 the London showrooms were closed. They were not opened again until 1875.

WHIELDON, THOMAS (1719-95), started a factory at Fenton Low, Staffordshire, in 1740, making small objects such as agate snuff boxes to be mounted in metal in Birmingham. He then branched out and by 1749 had a thriving business, with Josiah Spode as an apprentice. Then came his partnership with Josiah Wedgwood in 1754. His 'tortoise-shell' ware with coloured glazes, and figures, animals, and birds, with similar glazes, are now much sought after. Many of his wares were shaped as cauliflowers, pineapples, or melons. Beware of imitations.

WHITAKER, JOHN (1807-74), started to work in the Derby Porcelain Works in 1818. By 1820 he was foreman of the figure-making department and did a good deal of modelling himself. (A list of the models he made between 1830 and 1847 is given in F. Brayshaw Gilhespy's *Derby Porcelain*. 1961 (1965), pp 138-9.) By 1848 he had moved to Minton's in Staffordshire.

WILLEMS, JOSEPH (d 1766), of Tournai in Belgium, was a modeller at the Tournai porcelain factory. He did some modelling for the Chelsea factory but returned to Tournai in 1766 before his death.

WOOD, ENOCH (1759-1840), was the son of Aaron Wood, a noted modeller. He was apprenticed to Josiah Wedgwood and showed great skill as a modeller himself at an early age. In 1781 he modelled a bust of John Wesley. By 1784 he was in partnership with his cousin, Ralph Wood (Enoch Wood & Co) and in 1790 with James Caldwell (Wood & Caldwell). In 1818 the firm became Enoch Wood & Sons. Wood produced many figures with a religious theme and many copies of porcelain figures; and was a keen collector of figures of all kinds.

WOOD, RALPH (1715-72), was a famous maker of figures, and decorated them with coloured glazes. Some notable examples include an equestrian figure of Hudibras, a figure of Diogenes with his lamp, the Vicar and Moses, and the well-known Toby Philpot

Jug. He also made table wares. A Ralph Wood elephant teapot without its lid sold for £1,300 (A 1969) and an equestrian figure of Hudibras for £1,943 (A 1969). Many pieces were signed *R. Wood.*

WOOD, RALPH, JR (1748-95), the son of Ralph Wood (above), carried on the tradition of his father though his work is not so distinguished. He used enamel to colour his figures, which, it is said, could be distinguished from his father's by the signature of *Ra. Wood,* though these differing signatures are not a certain guide.

WRIGHT, ALBERT, was a painter of fish and game who worked for Minton's from 1871.

WYSE, WILLIAM, was an etcher and painter employed by Minton's from 1877. He worked particularly on the decoration of tiles and plaques.

YOUNG, WILLIAM WESTON, was a painter at the Swansea Pottery, where he was a pupil of Lewis Weston Dillwyn (c1801-13). He was skilled at painting butterflies, plants, and other natural subjects. In 1813 he joined Billingsley at Nantgarw. When Billingsley left for Coalport in 1819, Young continued to operate the Nantgarw works with Thomas Pardoe, mainly as a decorating establishment, until its closure in 1822.

BOOKS TO CONSULT

There are many books on pottery and porcelain which can be useful to the collector and it is impossible to list them all here. A comprehensive bibliography is given in *The Buying Antiques Reference Book* published annually (Newton Abbot, Devon). The following general books will help with the identification of marks, materials and styles.

Barber, E. A. *Pottery and Porcelain of the United States.* New York, 1901

Barret, R. *How to Identify Bennington Pottery.* Brattleboro, Vt., 1964

Charleston, R. J. (Ed.) *World Ceramics.* London and New York, 1968

Cushion, J. P. *A Pocket Book of English Ceramic Marks.* London, 1959 (1965); *A Pocket Book of German Ceramic Marks.* London, 1961; *A Pocket Book of French and Italian Ceramic Marks.* London, 1965

Godden G. A. *Encyclopaedia of British Pottery and Porcelain Marks*, London and New York, 1964; *Illustrated Encyclopaedia of British Pottery and Porcelain*, London, 1966; *Handbook of British Pottery and Porcelain Marks*. London and New York, 1968; *British Pottery and Porcelain, 1780-1850*. London, 1964; *Victorian Porcelain*. London, 1961. New York, 1962

Mankowitz, W. and Haggar, R. G. *The Concise Encyclopaedia of English Pottery and Porcelain*. London 1957. New York, 1968

Mudge, J. M. *Chinese Export Porcelain for American Trade 1785-1835*. New York, 1962

Ramsey, J. *American Potters and Pottery*. New York, 1939

Wakefield, H. *Victorian Pottery*. London, 1962

Watkins, L. W. *Early New England Potters and Their Wares*. Cambridge, Mass, 1950. Hamden, Conn., 1968

14

SHEFFIELD PLATE

SHEFFIELD plate resulted from a discovery made by Thomas Bolsover, a cutler, in 1743. It is said that he touched some copper with heated silver while repairing the handle of a knife and the two metals fused together. Further experiment revealed the fact that these fused metals could be rolled or hammered as though they were one. Articles made of this material, in which a thick layer of copper was covered with a thin layer of silver, could be made to appear like solid silver, and within a relatively short time small items such as snuff boxes were being turned out.

From 1750 to 1840 Sheffield plate was used in considerable quantities and, as it was relatively cheap compared with pure silver, found a new market. After 1840, when electro-plating became possible, the manufacture of articles from Sheffield plate declined rapidly, though there was a small output throughout the Victorian period mainly of municipal plate.

In the early days of Sheffield plate, makers usually marked their pieces with their initials, similar to those on silver but without any official hallmark. There was no official registration of marks so it is not easy to compile a comprehensive list of early makers. From 1784, however, makers of Sheffield plate registered their names and marks at the Sheffield Assay Office. The usual practice was to use a surname associated with a simple symbol or device such as a fish, a bell, an anchor, or crossed keys. After about 1800 this device was sometimes used alone. Many makers added a crown to their mark as a symbol of high quality, but after 1896 this was discontinued.

The following notes on prominent makers give the name of the firm, the date of registration, a description of the mark, and the locality of manufacture, since much Sheffield plate was made in Birmingham. In the nineteenth century the registered Birmingham makers outnumbered the Sheffield firms. It should be noted that 'close-plating', which involves coating iron or steel with a layer of silver, was done by a number of Sheffield and Birmingham firms. These are not included in the list unless the fact is stated.

ASHFORTH, ELLIS & CO (c1770). Early Sheffield-plate makers.

ASHLEY (c1816, fish). Birmingham.

ASHWORTH, G., & CO (c1784, scales). Sheffield. Some pieces bear the name of Thomas of New Bond Street, London, the retailer who sold the firm's products.

BELDON, GEORGE (c1809, figure 8). Sheffield.

BELDON, HOYLAND & CO (c1785, fish-hook). Sheffield.

BEST & WASTIDGE (c1816, stirrup). Sheffield.

BINGLEY, WILLIAM (c1787, arrow). Birmingham.

BOLSOVER, THOMAS (w 1740-1785), was born in 1704. In about 1743 he made the discovery that copper and silver could be fused together so that they could be rolled and worked as one metal. He started making buttons and small boxes of this 'Sheffield plate'.

BOULTON, MATTHEW (1728-1809), started making Sheffield plate at his Soho factory in Birmingham in 1764, and became the largest maker. In 1784 he registered his mark—a sun—which is most frequently seen on articles made after 1805. Examples of Boulton's work can be seen in the Greenberg Collection in the City Museum & Art Gallery, Birmingham.

BRADBURY, THOMAS & SONS. An important Sheffield firm in the 1830s.

BRITTAIN, WILKINSON & BROWNHILL (c1785, circle). Sheffield.

CAUSER, JOHN FLETCHER (c1824, two triangles interlocked to form a star). Birmingham.

CHESTON, THOMAS (c1809, leaf). Birmingham.

COLDWELL, WILLIAM (c1806, ram's head). Sheffield.

COPE, CHARLES GRETTER (c1817, watch key). Birmingham.

CRACKNALL, JOHN (c1814, dog's head). Birmingham.

CRESWICK, THOMAS & JAMES (c1811, eight arrows arranged to form a grid). Sheffield. Makers of entrée dishes.

DAVIS, JOHN (c1816, candlestick). Birmingham.

DEAKIN, JOHN. Maker of uniform buttons in the 1820s.

DEAKIN, SMITH & CO (c1785, two overlapping triangles, one vertically over the other). Sheffield.

o

DIXON & CO (c1784, star). Birmingham.

DIXON, CHARLES (1776-1852), was a Sheffield candlestick maker.

DIXON, JAMES & SON (c1835, Tudor rose). One of the larger Sheffield makers.

DRABBLE, JAMES & CO (c1805, pipe with upright bowl and curved stem). Sheffield.

ELLIS, RICHARD. A goldsmith of George Street, Foster Lane, London, who patented a process of close-plating in 1779.

EVANS, SAMUEL (c1816, spoon). Birmingham.

FENTON, MATTHEW & CO (c1773). Sheffield silversmith who made Sheffield plate. A candlestick dated 1780 can be seen in the Sheffield City Museum.

FOX, PROCTOR, PASMORE & CO (c1784, Maltese cross surmounted by a heart). Sheffield.

FREETH, HENRY (c1816, rectangle surmounted by a semi-circle). Birmingham.

FROGGATT, COLDWELL & LEAN (c1797, ram's head placed to the left of maker's name; used after 1806 by William Coldwell,

GAINSFORD, ROBERT (c1808, two elephant's heads). Sheffield maker of church plate.

GARNETT, WILLIAM (c1803, beehive above clover leaf). Sheffield.

GIBBS, JOSEPH (c1808, Staffordshire knot). Birmingham.

GILBERT, JOHN (c1812, cross above triangle). Birmingham.

GOODMAN, ALEXANDER & CO (c1800, trumpet). Sheffield.

GOODWIN, EDWARD (c1794, squirrel). Sheffield.

GREEN, JOHN, & CO (c1799, crossed keys). Sheffield. John Green had previously been a partner of J. Parsons & Co.

GREEN, JOSEPH (c1807, mark with wavy edge embracing formalised leaf). Birmingham.

GREEN, W. & CO (c1784, pistol). Sheffield.

HANCOCK, JOSEPH, was born in 1711. He worked in the same building in Sheffield as Thomas Boulsover and in the mid-1750s established himself as the first maker of larger plated ware; until

this time production had consisted of buttons, buckles, and boxes. He made plated cutlery, trays, coffee-pots and tea-urns, cups and tankards, and rococo candlesticks. In 1758 he introduced the single lapped edge. In the years 1762-5 he owned his own rolling mill and was the first to use water power for rolling. He became Master Cutler in 1763. Some of his early pieces carry dummy hallmarks. Examples of his work are in the Sheffield City Museum.

HANSON, MATTHIAS (c1810, jackboot). Birmingham.

HATFIELD, AARON (c1808, small fleur-de-lys, within mark; c1810, larger fleur-de-lys, as separate mark). Sheffield.

HILL, DANIEL & CO (c1806, cannon). Birmingham.

HINKS, JOSEPH (c1812, hand with index finger pointing left). Birmingham.

HOLLAND, H. & CO (c1784, unicorn's head). Birmingham.

HOLY (Daniel Holy), PARKER & CO (c1804, pineapple). Sheffield.

HOLY (Daniel Holy), WILKINSON & CO (c1784, pipe with straighter stem than that used by James Drabble & Co. The bowl inclines slightly to the right). Sheffield makers who favoured the Adam style. They produced a most elaborate tea and coffee machine.

HORTON, DAVID (c1808, cross). Birmingham.

HOWARD, STANLEY & THOMAS (c1809, chain links). Worked at St Paul's Churchyard, London, the only London maker to register a mark. The firm also engaged in close-plating.

HOYLAND, JOHN, & CO. An early Sheffield maker in business from c1764 to c1790, making tankards, candlesticks, dish-crosses, etc.

JERVIS, WILLIAM (c1789, bow and arrow). Sheffield.

JOHNSON, JAMES (c1812, gothic cross). Birmingham.

KIRKBY for USE (c1812, troy weight—not unlike a chess pawn). Sheffield. The name was used by Samuel Kirkby.

LAW, JOHN, & SON (c1807, crescent with tips pointing down). Sheffield.

LAW, THOMAS, & CO (c1784, bowl and cover). Sheffield silversmiths who were early makers of Sheffield plate (c1758), making it for mounting pottery.

LEES, GEORGE (c1811, conical drinking glass. There are two versions of this mark, one with Lees spelt in capitals, the other in script). Birmingham.

LILLY, JOSEPH (c1816, two parallel wavy lines). Birmingham.

LINWOOD, JOHN (c1807, tree). Birmingham.

LINWOOD, WILLIAM (c1807, feather). Birmingham.

LOVE, JOHN, & CO (c1785, bird with twig), Sheffield.

MADIN, P. & CO (c1788, diamond). Sheffield.

MARKLAND, WILLIAM (c1818, thistle). Birmingham.

MITCHELL, WILLIAM, of Glasgow, invented a mechanical process which he patented in 1822 for producing on flat surfaces the same kind of effect as handworked flat chasing.

MOORE, FREDERICK (c1820, gun). Birmingham.

MORTON, RICHARD, & CO (c1785). The mark simply gives 'Morton and Co.' with a cockerel. Sheffield silversmith. Maker of coffee-pots, urns, and water jugs, in the Adam style.

NEWBOULD, WILLIAM, & SONS (c1804. The maker's name is printed as part of a circle which includes the head of a dog). Sheffield.

NICHOLDS, JAMES (c1808, tower). Birmingham.

PADLEY, PARKIN & CO (c1849, open hand). Nineteenth-century Sheffield makers.

PARSONS, JOHN, & CO (c1784, crossed keys). Sheffield.

PEARSON, RICHARD (c1811, a form of anchor). Birmingham.

PEMBERTON & MITCHELL (c1817, only the name of Pemberton with a coronet shows in the mark). Birmingham.

PIMLEY, SAMUEL (c1810, cross-hatched square). Birmingham.

RAWLE, VALENTINE, patented drawn silver wire edges in 1785, which he licensed to other makers.

ROBERTS, JACOB & SAMUEL (c1786, orb). Sheffield.

ROBERTS, SAMUEL, a Sheffield silversmith, was apprenticed to Thomas Law prior to 1785 in which year he took George Cadman as a partner. (Their mark was a bell.) He was a versatile inventor, designer, and businessman, and was the most influential figure in the industry between 1785 and 1810.

ROBOTHAM, JOHN, & CO. An early Sheffield maker, especially of candlesticks in the 1750-60 period.

RODGERS, JOSEPH, & SONS (c1822, battleaxe). Sheffield. Wholesalers of plate with a Royal Warrant.

ROGERS, JOHN (c1819, hand holding horn or trumpet). Birmingham.

RYLAND, WILLIAM, & SONS (c1807, an eye). Birmingham.

SANSOM, THOMAS, & SONS (c1821, barrel). Sheffield.

SHEPHARD, JOSEPH (c1817, ear). Birmingham.

SILK, ROBERT (c1809, scallop shell). Birmingham.

SMALL, THOMAS (c1812, fleur-de-lys). Birmingham.

SMITH, NATHANIEL, & CO (1784, open hand). Birmingham. Makers of tankards, and of spoons and forks in which the two parts were soldered together.

SMITH, WILLIAM (c1812, semiquaver). Birmingham.

STANIFORTH, PARKIN & CO (c1784, dagger). Sheffield.

STOT, BENJAMIN (c1811, inverted trident with circle). Sheffield.

SYKES & CO (c1784, Maltese cross). Sheffield.

THOMASON, EDWARD, & DOWLER (c1807, the mark mentions the one name—Thomason, with a shuttlecock). Birmingham.

TONKS, SAMUEL (c1807, square). Birmingham.

TUDOR & CO (c1784, crescent with tips pointing upwards). Sheffield.

TUDOR, HENRY, & LEADER, THOMAS, was one of the early partnerships in the Sheffield plate business. They were certainly active in 1760 and the mark was *H.T. and Co.* (in script). A later mark (c1784) shows a crescent. Thomas Leader, an Essex man, had been apprenticed to a London silversmith. Henry Tudor of Welshpool had also been trained as a silversmith. They were the first to use horse-power for rolling the plate which they used for all kinds of domestic ware, especially tankards, candlesticks, and pear-shaped coffee-pots.

TURLEY, SAMUEL (c1816, wheel). Birmingham.

TURTON, JOHN (c1820, an inclined shaded eclipse with a single dot on each side). Birmingham.

WALKER, KNOWLES & CO (c1840). Makers of tea-urns and wine-waggons.

WATERHOUSE & CO (1807, acorn). Birmingham.

WATERHOUSE, J., & CO (1833, fleur-de-lys). Sheffield.

WATSON, FENTON & BRADBURY (c1795, the mark simply says Watson and Co and shows a three-masted ship in full sail). Sheffield partnership which lasted from 1795 to about 1818. It was a very large business with an export trade to Ireland, Europe, and America. They offered over 1,000 different patterns for candle-sticks alone. Examples of their work may be seen in the Sheffield City Museum.

WHATELEY, GEORGE, of Birmingham, patented a process in 1768 for the use of a double-lapped copper edge. A thin wire or ribbon of plated copper was soldered to the edge and lapped over so that all the copper was hidden and even the join, when burnished, could scarcely be seen.

WHITE, JOHN (1811, bird's head). Birmingham.

WILKINSON, HENRY, & CO (1836, crossed keys in shield). Sheffield.

WILLMORE, JOSEPH (1807, triangle). Birmingham.

WRIGHT, JOHN, & FAIRBAIRN, GEORGE (1809, trumpet). Sheffield.

YOUNGE, S. C., & CO (1813, bishop's mitre). Sheffield.

BOOKS TO CONSULT

Bradbury, F. *History of Old Sheffield Plate*. Sheffield, 1912. (1968)
Watson, B. W. *Old Silver Platers and Their Marks*. London, 1908
Wenham, E. *Old Sheffield Plate*, London, 1955
Wyler, S. B. *The Book of Sheffield Plate*. New York, 1949

15

SILHOUETTES OR PROFILES

THE days of the family album of posed photographs are gone; today people can carry a neat pack of colour transparencies to remind them of friends and relatives. Before the advent of photography, those who wanted a likeness of somebody and could not afford to have a portrait painted, had to be content with a profile— a likeness cut in black placed against a white background. These were often hung in oval frames in a sitting-room or bedroom. Early examples were usually painted on plaster, glass or card, though many were cut by hand or machine, especially by American profilists.

Some cut-out profiles were touched up with grey paint to emphasise the folds of clothing or the texture of hair. Early artists, however, who painted the profile directly on white card or plaster, sometimes used colours for embellishment. Bronze paint was often used to suggest hair. Some used a brown paint for the whole profile; others decided on a tinted background. A few painted on glass. The variations in technique are considerable and the finest artists had a highly individual style.

It is, however, impossible to identify an artist with absolute certainty unless the name can be found. A few painted their initials on the actual profile, but the common practice was to back the profile with a trade card. Unfortunately, many of these have disappeared or been defaced. Where they are present, they greatly add to the value of the work; they not only give the name and address of the artist but often much fascinating information about methods used and prices charged. It is also desirable that a profile should be in its original frame, or at least a contemporary one, and it is worth remembering that the finest profiles were produced in the fifty years between 1775 and 1825.

Beware of faked profiles: a number of examples which purport to be by 'Mrs Beetham' or 'Mr Charles of the Strand' appear on the market from time to time. It is also wise to remember that silhouette prints were sometimes used to illustrate books and that these can be mistaken for the genuine profile.

ADOLPHE, MONSIEUR (w c1830-46) of 113 St James Street and 4 East Street, Brighton, a Frenchman, was profilist to King Louis Philippe. His profiles were painted on card, often in a dark greenish-black, and he touched up the decorative parts of the dress with bluish-white and the hair with bronze.

ANDRÉ, MAJOR JOHN (1751-80), was born in Switzerland, joined the British army and was sent to America. He cut silhouettes for a hobby and there are a number of examples of his work showing the likenesses of eminent people such as Benjamin Franklin and George Washington.

ATKINSON, FREDERICK of 40 Old Steine, Brighton, and also Windsor, cut his profiles from black paper, mounted them on card, and touched them up with bronze. He made likenesses of George III and his family, and worked for the Prince Regent.

ATKINSON, GEORGE, son of Frederick Atkinson, appears to have been an itinerant profilist with a base at Gravesend. He is recorded as having worked at a number of seaside resorts—Dawlish, Margate, Ramsgate, and Teignmouth. He painted in black on card, touching up lace or other white embroidery with pale grey and blue.

BACHE, WILLIAM (w c1795-1820), was an English artist who settled in Philadelphia and cut or painted profiles of a number of famous Americans. He often touched them up with bluish-white paint. Some of his profiles carry the words 'Bache Patent'. He is also known to have worked in Wellsborough, Pennsylvania; New Haven, Connecticut; in Louisiana; and in the West Indies.

BATENHAM, G., of Chester, painted his profiles on glass. He was first recorded by John Woodiwiss in *British Silhouettes*. 1965, pp 37-8.

BEAUMONT, W. H. (w c1840-45), of Cheltenham, painted his profiles in dark brown touched here and there with grey. Those of his lady sitters are most attractive : the decorative elements in their clothing were painted in colour and they often hold a book painted in red. Some are signed and dated—but not all.

BEETHAM, MRS ISABELLA (w c1765-1809), of London, was born in Lancashire in 1744. At the age of 20 she married Edward Beetham, a London actor. It was difficult for them to live on his money and Mrs Beetham decided to try to augment their income

by making profiles. Her first silhouettes were made at Clerkenwell and consisted of simple cut-out profiles of black paper on card. She soon learnt to paint and produced fine profiles on card and also on convex glass by painting the underside. Much of the dress and hair of her sitters was painted so delicately that in places the background of card or plaster shows through to give a diaphanous effect. The oval profiles were framed in pearwood. As her practice flourished she moved (in 1784) to a studio on an upper floor of 27 Fleet Street, above a saleroom for a washing machine invented by her husband. Her work may be seen in the V & A and the Worthing Museum.

BROWN, WILLIAM HENRY (1808-83), of Charleston, South Carolina, cut full-length profiles, often of eminent men or well-known families, which were then touched up with bronze or gold paint. They were often backed by lithographs. Brown travelled a great deal and published a *Portrait Gallery of Distinguished American Citizens* (1846). He also delighted in profiles of steamships and railway engines.

BRUCE, G., was an Edinburgh profilist of the late eighteenth century who used backgrounds of plaster.

BULLOCK, W., was a Liverpool profilist who set up a museum to attract his clients. He usually painted in a dark brown touched with bronze.

BUNCOMBE, JOHN, worked at the end of the eighteenth century and possibly into the nineteenth at 114 High Street, Newport, Isle of Wight. He specialised almost exclusively in profiles on card of soldiers in full military uniform. The flesh is in black, the rest in colour, and the uniforms are completely accurate. His work may be seen in the V & A (Coke Collection).

BURT, ELVIN, worked in the 1820s and 1830s and was profile artist to Queen Caroline.

BUTTERWORTH, JOHN, of Leeds. There were two profilists of this name working in a studio 'opposite the Vicarage, Kirkgate'— father and son—during the eighteenth century. John Woodiwiss illustrates a profile by the son, dated 1793 and painted on card, and also his trade label, in *British Silhouettes*. 1965, plates 33 and 34.

CHAPMAN, MOSES (w c1783-1820) of Salem, Massachusetts, cut profiles by hand and machine.

CHARLES, A., of 130 The Strand, London, worked as a profilist from about 1780 to 1800 and painted 'in a masterly manner'. His profiles cost a guinea and were 'finished in one day'. His prices rose rapidly as he made a name for himself and was appointed 'Profilist to HRH The Prince of Wales' in 1793. Almost all his profiles were on card, though one or two have been recorded on glass. Sometimes he signed his profiles below the bust—*Charles,* or *Charles, R.A.,* for he claimed to be an Academician, almost certainly correctly. His work may be seen in the V & A and the Royal Collection, Windsor.

COLLINS, MRS, of Bath, was an assistant to Mrs Sarah Harrington in Bath and later took over the business. A profile of Jane Austen (c1801) may be seen in the NPG.

CROWHURST, GEORGE, of Brighton, succeeded Frederick Atkinson at 40 Old Steine about 1830. He produced full-length profiles in brown, blue, grey, and black, touched here and there with white to produce the highlights, and with gold. A profile of George IV and his brother the Duke of York is in the NPG.

CURTIS, ELEANOR PARK (1779-1852), was an American profilist.

DEMPSEY, JOHN, of Liverpool was an itinerant profilist who sometimes cut and sometimes painted his likenesses. He did much work in Liverpool, but also moved round the towns and villages. He normally signed his work *'J.D.',* occasionally *'John Dempsey'.*

DILLON, of Devonport. Only one specimen has been recorded— a profile of a naval officer correctly painted in colour and dated 1813.

DIXON, JOHN, of Bath, worked at Northumberland Place with his wife Mrs M. Dixon, who was also a profilist in the 1820s. They often used papier-mâché frames.

DOYLE, WILLIAM (1756-1828), was an American profilist who advertised his work as 'in the manner of the celebrated Miers of London'. He worked in Massachusetts and was the son of a British officer.

EDOUART, AUGUSTIN AMANT CONSTANT FIDÈLE (1783-1861), was probably the finest of Victorian profilists and was certainly the most adept at cutting. He was born in Dunkirk, became a soldier in Napoleon's army, and later decided to emigrate to England in 1814 during the post-war reaction. He found it hard

to make a living but started to make portraits, using hair and wax, which attracted a good deal of attention. It was not until 1826, after the death of his wife, that he began to cut profiles. He started in Cheltenham and later moved to Bath, from which he travelled widely and built up a thriving connection. He was orderly and efficient. His profiles were nearly always full-length and were cut in duplicate from black paper so that he was able to keep a complete record of his work.

He later worked for periods in studios in London (155 Cheapside), Edinburgh (72 Princes Street), and Dublin (27 Westmoreland Street), and travelled from each of these centres. His final English tour was in 1837-8 and included several Midland towns and Liverpool. He sailed from this port to America, where he worked for ten years touring the Eastern and Southern states and making profiles of many leading citizens. He then returned to France, where he spent the rest of his days. Unfortunately, many of his records were destroyed in a shipwreck off Guernsey but some were saved and form the basis of a valuable book on this artist—Jackson, E. N. *Ancestors in Silhouette*. 1920. Edouart himself wrote a book on profiles called *A Treatise on Silhouettes*. 1835.

FIDLER, J. W., was a travelling profilist who is known to have been working about 1840. He surrounded his profiles with a border of leaves snipped from brown paper. His work is seldom seen.

FIELD, JOHN (1771-1841), of London, was apprenticed to John Miers and was his chief assistant for thirty years. In 1821, when Miers died, Field formed a partnership with his son, William Miers, and they carried on the business together until 1830. Field then moved to 11 The Strand and later to No 2, and worked on his own until his death. He became Profilist to Queen Adelaide and to HRH Princess Augusta. It is probable that most of the profiles attributed to John Miers in the later years of his life were, in fact, done by Field, who was an accomplished artist and he is credited with having been the first to use bronze paint on profiles. He painted on card, plaster, and ivory. Examples of his work may be seen in the V & A.

FOLWELL, SAMUEL (1765-1813) was an American profilist.

FOSTER, EDWARD (1762-1866), was born in Derby. He joined the Derbyshire militia and later became a regular soldier and it was not until 1805, at the age of 43, that he left the army. He then

decided on a second career as an artist and spent some time painting miniatures at Windsor Castle, where he seems to have been very much *persona grata*. By 1811 he was travelling a good deal, painting silhouettes, and he eventually settled in his home town at Friar Gate, Derby. His profiles were on card and were signed. He was adventurous and experimental, so that many of his portraits show a free use of colour, especially red, and he sometimes decorated the dresses of his lady sitters with a pattern of dots. He married five times and died at the age of 104.

FRIEND, ROBERT, of Tunbridge Wells, was a profilist who appears to have worked in the 1780s, though little is known about him. His likenesses were done on paper in Indian ink and touched up with grey to indicate hair, clothing, etc.

FRITH, FREDERICK (w c1809-48), of Dover, was an early nineteenth-century artist who cut profiles often full or three-quarter length, set against a coloured hand-painted background appropriately drawn for the subject—an army officer against a camp scene, a girl in a garden of flowers. He is noted also for profiles of children playing with hoops, toys or donkey carts or with their pets. These are often touched up with bronze. Although he is always referred to as 'Frith of Dover', he travelled a great deal in England and Ireland. His profiles are usually framed in maple wood.

GAPP, JOHN, was the first profilist to work in a booth on the Chain Pier at Brighton. He set up his business when the pier opened in 1823. His outlines were snipped from black paper and these were placed against grey watercolour backgrounds. He usually showed gentlemen with coat tails projecting, one knee bent, and with one hand holding a pair of gloves.

HAINES, E., of Brighton, succeeded John Gapp on the pier, where he worked until about 1850, producing good profiles often mounted on cards of pale colour.

HAMLET, WILLIAM, of Bath. This name alone is confusing since there were two profilists answering to it. They may well have been related, though there is no direct evidence to prove this. Calling them I and II, the known facts are :

Hamlet I (w 1780-1818) was profile painter to the Queen and the Royal Family. He worked at 17 Union Passage, Bath and later at 12 Union Street, Bath. He was particularly successful with full-length portraits on glass.

Hamlet II (w 1779-1815) worked first at 17 Union Passage and later at 2 Old Bond Street, Bath. His profiles were inferior to those of Hamlet I. Both Hamlets appear to have worked for short periods in Salisbury and Weymouth.

HARRADEN, R., of Cambridge, was an engraver who published views of the university cities and books on their academic dress. He was a member of the British Society of Artists from 1824 to 1849. His profiles are painted in dark brown touched with Indian ink to emphasise the shadows.

HARRINGTON, MRS SARAH, was a distinguished practitioner of the 1770s and 1780s. She worked at 131 New Bond Street, London, and patented a machine for copying profiles on a larger or smaller scale. She spent periods away from London at Leeds (in 1780) and at Bath (in 1782). Many of her portraits are 'hollow'— that is to say they were cut from the centre of a piece of white paper which was then placed against black paper to give the profile. However, she also cut out black profiles and painted on silk.

HERVÉ, A., of London, worked from about 1828 to 1840. He is noted for his skill at touching up his work with bronze and grey paint in a manner which gives depth to his profiles. He had a studio at 143 The Strand and also used other premises.

HERVÉ, CHARLES, of London, worked over roughly the same period as A. Hervé, on card and on plaster. When his work is in the original frame the name HERVÉ will normally be seen embossed on the brass hanger.

HERVÉ, HENRY, of London, was a prolific profilist who cut full-length likenesses by machine. He also worked on plaster, ivory, and glass, and painted miniatures. His work was done a little earlier than that of the other family profilists, probably from about 1800 to 1820.

HOLLAND, W. L., of Dublin, had a studio at 46 Capel Street.

HOUGHTON, SAMUEL, was apprenticed to John Miers and later had his own business in Edinburgh, where he took G. Bruce, a pupil, into partnership.

HUBARD, WILLIAM JAMES, showed the ability to cut profiles at a very early age and this was exploited by a certain Mr Smith who arranged a contract with the parents which enabled him to plan a public career for the boy. In 1822 when William was about 12

(his actual date of birth is in doubt), Smith began to tour the young profilist—'Master Hubard' as he was called. He started at Ramsgate, went to Cambridge and Oxford, and then to Manchester, Liverpool, Edinburgh, and Glasgow. The 'Hubard Gallery', as the exhibition was called, then went to Ireland and finally, in 1824, to America. Here Hubard eventually reacted against his sponsor and the cheap publicity, and started on a serious professional career as a portrait painter. He became a United States citizen and married an American girl.

Hubard profiles frequently appear in England. They sometimes carry an embossed seal with the words 'Taken at the Hubard Gallery', and sometimes carry a label with Master Hubard's name, and they show some artistry. In 1825 his *Gallery of Silhouettes* was published in New York.

JOLIFFE, of London, appears to have been the son of a bookseller, though little is known about him except that he worked as a profilist from about 1758 to 1780. He started by cutting likenesses from paper but later painted directly on the flat glass. His sitters are usually shown three-quarter length beneath draped curtains. The glass is painted black to provide a surround so that, but for the fact that gold dots are used to break the surface, it would look like a mourning card. The glass is normally backed with silk.

KING, WILLIAM (w 1785-1805), of Salem, Massachusetts, was an early nineteenth-century profilist : his shades of women are regarded as particularly attractive. His work is usually impressed on the card.

LAVATAR, JOHANN CASPER (1741-1801), was born at Zurich and became a Protestant priest. He became intensely interested in the art of judging character from the features of face or form and tried to elevate physiognomy into a science. He wrote the earliest book on profiles—*Essays on Physiognomy: Calculated to extend The Knowledge and Love of Mankind*—which was published when he was in his late thirties. It did much to encourage the art because it stressed the need for accuracy.

LEA (1768-1828), of Portsmouth, lived at Great Charlotte Street, Blackfriars Road. He was a fine profile painter on glass, and some go so far as to say that he was a miniaturist rather than a profilist. He had a studio at the Parade, Southsea, c1795-1805. His work

may be seen in the BM and the V & A. See article by Peggy Hick-man in *Country Life*. 16 January 1969.

LIGHTFOOT, MRS M., of Liverpool, painted on plaster in the 1780s and made a number of tours to other parts as far afield as Scotland.

LOVELL, THOMAS, worked in the 1780s as an apprentice of John Miers. He then set up his own business.

McGAURAN, EDWARD, of Dublin, worked at 16 Aungier Street. He was a hairdresser who became a profilist in 1793. His work, which is on plaster, is not common : an interesting example is shown in Peggy Hickman's *Silhouettes* 1968, p 22.

MIERS, JOHN (1756-1821), is generally regarded as the greatest of all profilists. He was born in Leeds and started an oil and paint business in Lowerhead Road in about 1781, selling profiles as a side-line. These were simply cut from black paper, but he soon gave up this method and started to paint in black on plaster. As his skill increased and his reputation grew he decided to make a career as a profilist. He first spent periods in a number of northern cities—Newcastle (1783), Manchester (1784), Liverpool (1785), and Edinburgh (1786), and paid a visit to Kilmarnock (1787), where he made profiles of Robert Burns. In 1788 he set up in London at 162 The Strand, and in 1791 moved to 11 The Strand. His standards, despite the fact that his framing and presentation became more elaborate, began to decline. The finest profiles, with the characteristic 'muslin' quality around the neckline and hair, which fades off into a smoky grey, belong mainly to his provincial period. Perhaps his business grew too large, for he had to take on a number of assistants—Field, Houghton, and Lovell—and in the early part of the nineteenth century they were almost certainly responsible for the major part of the output. Many of Miers' framed profiles carry a trade card but he personally signed the very small ones he painted on ivory.

MITCHELL, J. S., of Bath, had a studio at 17 Union Street, probably between 1820 and 1830. He cut his profiles from brown paper and touched them up with bronze. It is also possible that he worked in London.

NEVILLE, J., of Brighton, was a seasonal artist who normally lived in London. He worked at 4 Pool Lane, and used a very pale blue to touch in costume details.

O'DRISCOLL, STEPHEN, of Cork, Ireland, learnt to cut pro-
files from Augustin Edouart when he visited the city in the 1830s.
O'Driscoll depicted local events and celebrities and hand-painted
his backgrounds. The profiles were sometimes reproduced as litho-
graphs so that a number of copies could be sold. A typical example
of an O'Driscoll profile is shown on p 125.

PEALE, CHARLES WILLSON (1741-1827), of Philadelphia,
was a sculptor and painter who also cut profiles by machine which
he often touched up with Indian ink. They often carry impressed
marks—*Peale, Peale's Museum* or simply *Museum*.

PHELPS, W., of Drury Lane, London, painted in the late 1780s
and early 1790s, mainly on card or paper, but occasionally on plaster.
He is noted for his use of colour, especially on the profiles of the
ladies who sat for him. He also copied profiles for clients, at the
same time improving their appearance by adding his own charac-
teristic touches.

POLK, CHARLES PEALE (1767-1822), of Maryland, was one
of the few American profilists to paint on glass. His profiles are
normally in black against a gold background.

READ, MRS JANE, of London, the eldest daughter of Mrs Isa-
bella Beetham, learnt to paint from John Opie. She worked on con-
vex glass, using colour, and her profiles are usually set against a
background of pink wax.

REDHEAD, H., of Upper Norton Street, Fitzroy Square, London,
used a stippling technique in brown for the clothing of his sitters,
leaving the face in plain black. He appears to have started as a
profilist early in the 1790s and to have continued into the nine-
teenth century.

ROSENBERG, CHARLES (c1745-1844), was a distinguished
artist who became Profile Painter to the Prince and Princess of
Wales and the Duke and Duchess of York in 1818. Carl Rosenberg
came to England from Germany at the age of fourteen as a pageboy
in the Royal Family. The boy had already some experience of pro-
ducing profiles and he was encouraged by George III and Queen
Charlotte. He first spent a season at Ramsgate and in 1787 he settled
in Bath, where he set up a studio in St James Street. In 1790 he
moved to North Parade and in 1793 to 14 The Grove. For some
years he did well but by the end of the century competition had

become keen and his commissions declined. In 1816 he went to Windsor as King's Messenger, a post which he held, with one small break, until 1834, when he retired on a pension. Most of Rosenberg's profiles are painted in black on flat glass backed by pink paper or red enamel.

ROUGHT, W., of Oxford, had a studio in the Corn Market, where he painted plain black profiles of good quality. These were mounted in oval frames.

SAINT-MÉMIN, CHARLES B. J. F. du (1770-1852), came to New York from France in 1793 and started to draw portraits in crayon using a physiognotrace. He developed into a fine profilist and also painted miniatures in aquatint. He returned to France in 1814 and became director of the museum in Dijon.

SEVILLE, F. N., of Manchester, worked in Market Street as a cutter of profiles. Domestic animals often appear with his sitters. He used bronze paint to touch up his portraits but he had little skill with the brush.

SILHOUETTE, ETIENNE DE (1709-67) was a spare-time profilist. He was made the Controller General of Finances in France in 1759 with the task of bringing financial security to his country when it was nearly insolvent. He made all-round cuts in spending and, as a result, became extremely unpopular. Those who scorned profiles because they were cheap (the poor man's miniature) called them profiles 'à la Silhouette', a mean economy. The name is now more widely used than profile.

THOMASON, I., cannot be pinned down to a single locality. He is known to have worked in London, Nottingham, Leicester, Dublin, Liverpool, and Newcastle, and there is no doubt that he took in other places on his tours. It is certain, however, that he was in Dublin from 1790 to 1792. His profiles are painted on plaster, though in the 1800s he appears to have started to paint on glass. His work is of high quality : the hair is painted in thin black lines and there are often touches of colour on the clothing. He particularly liked to paint a coloured ribbon below the head and shoulder portraits of ladies. Thomason favoured oval frames of hammered brass. There is a Thomason profile of George Washington at Sulgrave Manor, Northants.

'TODD' was an early nineteenth-century American profilist whose work may be recognised by the fact that the hair usually hangs over

P

the forehead and the bust ends in a simple curve. A large number of his profiles are in the Boston Athenaeum.

TOROND, FRANCIS (1742-1812), was a French painter who came to England as an exile and started as a profilist, specialising in family groups, or 'conversation pieces', which often included domestic animals. He also did head and shoulder portraits. All his work was painted with a brush in Indian ink. He first visited Bath, but later worked in London, first in Berwick Street, Soho, then near Leicester Square, and finally in Oxford Street.

WELLINGS, WILLIAM, of London, is described by John Woodiwiss as 'among the masters of his age'. He was particularly skilful at shadow pictures with several figures in a furnished setting. He worked at 3 Tavistock Row from 1778 to 1792 and then removed to 26 Henrietta Street, Covent Garden, perhaps a more convenient address since he also worked as a designer of costumes and scenery for the playhouses. His work may be seen in the V & A.

WOODHOUSE, JOHN, of Newcastle, was a profile painter who produced mainly full-length likenesses on glass.

BOOKS TO CONSULT

Bolton, E. S. *Wax Portraits and Silhouettes*. 1914

Coke, D. *The Art of Silhouette*. 1913 (1928)

Edouart, A. *A Treatise on Silhouette Likenesses*. 1835

Hickman, P. *Silhouettes*. London, 1968

Jackson, E. N. *Ancestors in Silhouette cut by Augustin Edouart*. New York, 1920; *The History of Silhouettes*. 1911. New York, 1970; *Silhouette: Notes and Dictionary*. New York and London, 1938

Van Leer Carrick, A. *Shades of our Ancestors*. Boston, 1928; *History of American Silhouettes: A Collectors' Guide. 1790-1840*. Rutland, Vt., 1968

Woodiwiss, J. *British Silhouettes*. 1965

16

SILK PICTURES, PORTRAITS, AND BOOKMARKS

THE name of Thomas Stevens is so closely associated with woven-silk pictures that many people are unaware that there were other makers. The first silk portrait was produced in Lyons in 1839 as a tribute to Joseph Marie Jacquard, the inventor of the loom which bears his name. The Jacquard loom was perfected in 1805 and five were operating in Coventry by 1823, though not for weaving silk pictures. A special ribbon was designed and woven for the Great Exhibition of 1851 as the result of the initiative shown by a committee of Coventry manufacturers and the costs of production were borne by a town subscription. (Examples may be seen in the V & A and in the Herbert Art Gallery & Museum, Coventry.) It was some years, however, before the pictures, portraits and bookmarks which are now so widely collected were first introduced. The urge to find a way of injecting new life into the ribbon industry came in 1860 when silk goods from France and elsewhere were allowed into England without restriction.

The inventiveness of Thomas Stevens, a young weaver, led to a partial revival of the industry. In 1854, at the age of 26, he had established his own business and was soon trying to adapt the Jacquard loom to weave designs in colour, using a series of perforated cards to control the manipulation of the warp threads. The draughtsman who prepared a picture for weaving needed to understand the weaving process and men such as Robert Barton who draughted the Coventry Ribbon became key technicians. Thomas Stevens first offered coloured woven bookmarks for sale in 1863. In 1879 he introduced the first of his famous mounted silk pictures or Stevengraphs at the York Exhibition. These now fetch high prices. But other firms both in England and on the continent also made woven silk bookmarks and commemorative portraits of high quality. The following list gives notes on some of the people and firms associated with their production.

ANDREWS, WILLIAM, was manager of the silk-weaving firm of Dalton & Barton in the 1860s.

BARTON, ROBERT, was a key figure in the development of the woven-silk picture industry in Coventry between about 1850 and 1865. He was a skilled draughtsman and was able to adapt a design to the needs of the weaver without destroying the intention of the artist. He draughted the pattern for the Coventry Ribbon of 1851 from a design by Thomas Clack. There is no doubt that he did work for a number of Coventry firms but his name is particularly associated with John Caldicott, the manufacturer. Their names both appear on a silk portrait of the Hon Edward Ellice, MP, who ardently supported the Coventry weavers in their fight to keep the import duties on foreign ribbons. It also appears on a silk picture of Queen Victoria, after a painting by Winterhalter, which appeared in 1861.

BAUMAN, J., was a designer of ribbons for the firm of Wahl & Socin of Basle in the 1860s.

BOLLANS, EDWARD, & CO, of Ranelagh Works, Leamington, were manufacturers of fancy stationery and their name appears on silk bookmarks. They were in business from c1863 to c1893 and probably started to sell bookmarks in the 1870s. It is not known whether they were actually responsible for weaving their own bookmarks or whether they bought them from another manufacturer.

BROUGH, NICHOLSON & HALL, of Leek in Staffordshire are known to have woven silk pictures.

CALDICOTT, JOHN, was one of the most important ribbon manufacturers in Coventry in mid-Victorian times and may well have been the first to weave silk pictures. Many of these were of fine quality and were wider than those of other manufacturers, indicating that he had a particularly fine loom. He produced a large ribbon with a view of Coventry in 1858 and about the same time issued a portrait, based on an oil painting which is now in the Coventry Museum, of the Hon Edward Ellice who was for many years Member of Parliament for the city. The firm also made bookmarks.

CARQUILLAT, FRANÇOIS (1803-84), of Lyons, was considered to be one of the best artist-weavers in France. He was chosen by Didier Petit et Cie to produce the first known woven-silk picture,

a portrait of J. M. Jacquard, the inventor of the loom which made such pictures possible. This was based on an oil painting by C. Bonnefond, now in the Musée Historique des Tissues in Lyons. The picture shows Jacquard seated in his workshop with the tools of his trade on the wall and a roll of cloth on the table. An example may be seen in the V & A which bears the woven title *A La Mémoire de J. M. Jacquard*, and is dated 1839, the year in which it was exhibited at the Paris Exhibition. A smaller version, woven about the same time, is illustrated on p 126. Carquillat was also responsible for a woven-silk picture of Baron Alexander von Humboldt, the German traveller and naturalist who died in 1859.

CASH, JOHN & JOSEPH, were partners in the firm of J. & J. Cash Ltd of 70 Hertford Street, Coventry. The firm operated early in the nineteenth century and the Kingsfield Works were established in 1856. In 1862 they issued a portrait of *Albert the Good* and in 1863 made a rosette for the wedding-day of Prince Edward, the centre formed of a button covered with a woven piece of silk ribbon showing the plume of the Prince. This was widely sold and worn 'to help the weavers of Coventry'. The firm also made bookmarks.

In 1961 Cash's took over the firm of W. H. Grant of Livingstone Mills, Lockhurst Lane, Foleshill. As late as 1967 they produced a silk picture to commemorate the 900th Godiva Anniversary.

CLACK, THOMAS, was the designer of the Coventry Ribbon commissioned by a committee of manufacturers for the Great Exhibition of 1851. He was a pupil of the city's School of Design. He also designed a silk picture of Prince Albert for J. & J. Cash Ltd which appeared in 1862.

COX, R. S. & CO of King Street, Coventry, owned a small factory where the Coventry Ribbon was made for the Great Exhibition of 1851. They won a prize medal at the Exhibition for an assortment of silk ribbons which included two sashes with woven designs taken from Paxton's *Flower Garden*. One was seven inches wide with 'the glittering gland-bearing trumpet flower'; the other was five inches wide with 'the oval and the pallid Hoyas'.

DALTON, BARTON & CO LTD, was founded in 1848 by Robert Arnold Dalton (b 1825) at Grey Friars Lane, Coventry. He took his friend George Samuel Barton into partnership and in 1860 the firm moved to Earl Street. In 1862, at a time of severe depres-

sion in the silk industry, the firm was described as 'the most progressive in Coventry', and in 1866 they were certainly the largest manufacturers of silk ribbons. In 1872 Barton became the first chairman of the limited company and in 1875 premises were acquired in King Street.

Dalton & Barton were noted for their woven-silk portraits and bookmarks of members of the Royal Family. A silk of 'England's Royal Sailor, Highness Prince Alfred Ernest Albert' was exhibited at the Draper's Hall in Coventry in 1861. Other portraits included those of Princess Alice (1861), HRH the late Prince Consort (1862), Her Majesty Queen Victoria (c1862) and Albert the Good (1863).

DARLINSON, G., were Coventry ribbon manufacturers known to have woven bookmarks in the 1860s.

FRANKLIN, G. CASEY, of 19-21 Earl Street, Coventry, established a firm of that name in 1883 but did not weave silk pictures or bookmarks until after 1920.

GRANT, WILLIAM HENRY, JP (1858-1932), of Foleshill, Coventry, established his business in 1882 weaving silk ribbon bands for the Royal Navy and the Salvation Army, and also club badges. The company of W. H. Grant operated Livingstone Mill in Lockhurst Lane. William Grant was a remarkable figure—a keen geologist and an enthusiastic Liberal who was Parliamentary candidate for the Nuneaton Division but did not win the seat. In 1920 he was Mayor of Coventry. Grant was the chief competitor of Thomas Stevens in the 1880s and 1890s. He had warehouses at 33 Cheapside in London and representatives in Glasgow (5 National Buildings, Queen Street), Luton (Guildford Street), and Manchester (69 Piccadilly). In 1893 the firm exhibited at the World Fair in Chicago.

W. H. Grant's silk pictures are mainly portraits in black and white, occasionally with a single colour to pick out a necktie or some other item of clothing. These portraits were mounted : those of Gladstone and Queen Victoria are best known. The firm also produced a series of silk pictures under the title *Views of Olde London*.

JACQUARD, JOSEPH MARIE (1752-1834), was a silk weaver of Lyons who, perfecting earlier processes, invented a silk-weaving loom which first came into operation in 1805. It controlled the number and order of warp threads raised for a single pass of the

weft, and so dispensed with the need for a draw-boy. Its introduction was violently opposed by the weavers who feared they might lose their employment. In 1805 Napoleon gave Jacquard a small pension. Six years after his death in 1834 a statue was erected to his memory in Lyons and a few years later a silk portrait was woven to his memory (see page 126). See also under Carquillat.

KOECHLIN & SONS of Basle produced silk pictures including a portrait of Prince Albert, using a design by J. Bauman, for the English market.

MATTHEWS. A London firm of this name appears to have produced some bookmarks in 1862.

NEWSOME, CHARLES, of Coventry, produced a number of bookmarks in 1862 including an Ode by Alfred Tennyson on the opening of the 1862 Exhibition.

OAKDEN & CO of Bedworth produced a silk woven ribbon for the Warwickshire Miners Association, probably in the 1880s.

ODELL & FRENCH were weaving silk pictures early in the 1860s.

OWEN BROTHERS were designers and draughtsmen who worked for a number of Coventry firms including John Caldicott and Charles Newsome.

RATLIFF, J. & SON were Coventry ribbon manufacturers whose managing director was John Cleoptas Ratliff. They were well equipped to weave wide ribbons and although few were produced, they appear to have received commissions to weave prestige specimens. In 1862 the firm exhibited a Lady Godiva Ribbon in colour which is certainly one of the finest woven ribbons ever produced. It was draughted by the firm of Welch and Lenton. The upper part shows the arms of Coventry, the crest of the Ratliff family and the crest of the designer. The main part is a passage from Tennyson's poem 'Godiva', the lettering in black, illuminated in rich crimson with enrichments of yellow, blue, green and orange-red. Over 17,000 cards were required to weave this ribbon of which there is a black-and-white illustration in the *Illustrated London News* for 5 July 1862.

Another ribbon with a group of cacti in yellow, crimson, purple and orange-red was also exhibited: 22,000 cards were used and twenty-one colour tints.

In 1863 Ratliff's were chosen as the only firm with a loom which could weave a wide enough coloured ribbon to carry an address to Her Royal Highness the Princess of Wales from the Mayor, Aldermen and Citizens of Coventry.

SLINGSBY. Little is known about this manufacturer or designer, but the *Coventry Standard* for 12 July 1861 states that 'at the celebration by the Americans in London on the 85th Anniversary of the Declaration of Independence, most of the Americans and many of the English present, wore a very elegant badge, bearing the Arms of the United States, very beautifully interwoven on a ribbon of superior quality by Mr Slingsby of Coventry'.

STEVENS, THOMAS (1828-1888), was born at Foleshill, then a village on the outskirts of Coventry. He was trained as a ribbon weaver in the factory of Messrs Pears & Franklin in Upper Well Street, Coventry, and by working hard and saving his money was able to establish his own business in 1854 in Queen Street where he made fancy ribbons. However, the possibility of weaving something more elaborate with the Jacquard loom caught his imagination, and after several years of experiment he started to produce woven silk bookmarks in 1863 with elaborate floral designs, portraits, words of greeting, poems, and texts. He claimed to have produced 900 but fewer than 450 have so far been identified. In 1875 he opened a new factory, the Stevengraph Works, which continued until 1914.

In 1879 he produced the first coloured silk pictures in cardboard mounts with a trade label on the back. Over 200 different subjects have been recorded. These 'Stevengraphs' are avidly collected on both sides of the Atlantic and individual rare examples have sold for over £400 at auction although they only cost a shilling or so when they first appeared on the market. The trade label is important because it is some guide in determining the date of production. See Baker, W. S. Le Van. *The Silk Pictures of Thomas Stevens*. New York, 1957. Sprake, A. and Darby, M. *Stevengraphs*. Guernsey, 1968. This was published in a limited first edition of 1,000 copies. It lists the mounted silk woven pictures and portraits, and also the bookmarks produced by Thomas Stevens and gives some indication of which silk pictures are common and which are scarce. See also Sprake, A. 'The Silk Pictures Stevens Wove' in *Collectors' Guide*, February 1968. pp 58-61.

TUTILL, G. of London. A woven-silk ribbon bearing this name with a registration number of 1894 has been noted.

WAHL & SOCIN of Basle produced silk pictures including a portrait of Queen Victoria (1862).

WELCH & LENTON were Coventry makers of silk bookmarks. Their work was of high quality. They were the first to introduce black grounds (1877) and they exhibited at the Yorkshire Fine Art and Industrial Exhibition in York in 1879 where Thomas Stevens first introduced his mounted silk pictures.

BOOKS TO CONSULT

Baker, W. S. Le Van. *The Silk Pictures of Thomas Stevens.* New York, 1957

Sprake, A. and Darby, M. *Stevengraphs.* Guernsey, 1968

17

SILVER

THE silversmiths listed in this section are those working between about 1660 and 1860. They fall roughly within the following periods :

1. *Restoration Silver, 1660-97*
Towards the end of this period, in 1685, Louis XIV revoked the Edict of Nantes (1598) which allowed Huguenots to exercise their own religion. This forced Protestants into exile and many Huguenot silversmiths settled in England or America. In the American Colonies silver was being made in Boston and New York.

2. *Britannia Silver, 1697-1719*
Between these dates it became a legal obligation under the New Silver Standard Act for British silversmiths to use silver of a higher quality than sterling. Marks had to include the Lion's Head erased (the head and mane only), and the figure of Britannia.

3. *Rococo Silver, 1719-60*
French fashion in this period led to a style with curves, scrolls, and shellwork, in profusion.

4. *Adam Silver, 1760-1800*
In this period simpler styles prevailed and by 1770 neo-classical designs were the vogue.

5. *Regency Silver, 1800-30*
Regency styles developed from the Adam style but Greek, Roman, Egyptian, and Chinese, influences were at work.

6. *Romantic and Early Victorian Silver, 1830-60*
Many of the designs of this period are very ornate and hark back to 'antique' models of the rococo period.

The list of silversmiths gives the working life, usually from the date of registration of the first mark with the Guild of Goldsmiths, or the earliest mention, to the hallmark date of the latest known piece : in many cases, no doubt, the date of retirement was later.

It is seldom possible to date early American silver since there were no official assay centres, even in Boston, Newport, New York and Philadelphia, where most silversmiths worked.

ABDY, WILLIAM (w 1767-91), was a London maker of candlesticks, wine strainers, etc.

ABERCROMBY, ROBERT (w 1731-44), was a London maker of muffineers, alms plates, and especially waiters and salvers with shaped, moulded rims. A circular salver, later monogrammed, 1743, diam 11 in, 25 oz 2 dwt, sold for £480 (A 1969).

ADAMS, PYGAN (1712-1776), was a noted silversmith of Connecticut.

ALDRIDGE, CHARLES (w 1786-c1790), was a London maker noted for Adam-style pieces with bright-cut engraving. He specialised in warmers and dish-crosses.

ALLEINE, JONATHAN (w c1769-78), was a London maker of candlesticks, ladles, etc.

ANDREWS, WILLIAM (w 1697-1707), was a London maker of porringers.

ANGELL, GEORGE (w c1855-65), was a London maker of claret jugs and dishes.

ANGELL, JOHN (w 1815-40), London.

ARCHAMBO, PETER (w 1720-49), was a Huguenot silversmith working in London when rococo decoration was at its height. He made a variety of pieces—candlesticks casters, ladles, salt-cellars, salvers, etc, but is particularly noted for his fine pierced baskets. His work is often decorated with scrolls and shells, and chased with flower designs. An octagonal teapot, 1721, sold for £6,800 (A 1969). In 1749 Peter Archambo formed a partnership with Peter Meure.

AVERIE, JOHN (w 1569-1621), of Exeter, is sometimes spelt Avery.

BACHE, JOHN (w 1700-13), was a London maker of chargers, kettles, etc. A silver-gilt charger, 1713, 180 oz, sold for £10,000 (A 1969).

BAMFORD, THOMAS (w 1719-31), was a London maker of casters, etc.

BANCKER, ADRIAN (1703-72) of New York, made tableware and tankards.

BARNARD, E. See Emes, Rebecca.

BARNARD, E., E., J., & W. (w 1829-40). This was a London partnership of four relatives—two Edwards, John, and William.

They made candelabra, tea and coffee services, salvers, etc. A 10 in circular salver, 22 oz, sold for £124 (A 1969).

BATEMAN, HESTER (w 1761-89) of London, is a name to conjure with among silver dealers, especially in the USA. She was married to John Bateman of Bunhill Low and had three sons, John, Peter, and Jonathan. When her husband died in 1760 she became head of the family business, helped by her children. She showed determination and persistence and had a good business sense, but appears to have worked mainly for other silversmiths until about 1774. Between 1771 and 1787 she entered nine marks. In 1778 her son John died. In 1790 Hester Bateman died at the age of 81.

Hester Bateman silver is mainly domestic—spoons, teapots, cruets, salts, cream jugs, tea caddies, salvers, etc. The workmanship is always sound and reliable but shows no outstanding skill in design. This is always restrained and decoration consists mainly of beading, fluting and piercing. Oval shapes were favoured and her late work shows Adam influence and bright-cut engraving. The business was so successful that extensions were made at the Bunhill Low premises in 1786. Hester Bateman silver may be seen in the V & A, Bristol Museum, and the Museum of Fine Arts, Boston, USA.

Prices for her silver are well above the general average. A gravy spoon, 1776, length 12 in, 4 oz, sold for £75 (A 1968); an oval tea caddy having engraved armorials with a delicate design of tied ribbons, bright-cut husk swags, floral festoons and pendants, 1782, 11 oz, sold for £2,000 (A 1969). See Shure, D. S. *Hester Bateman.* London and New York, 1959; Smith, E. J. G. 'Woman Silversmiths; Hester Bateman', *Collectors' Guide*, September 1969, pp 81-7.

BATEMAN, PETER, was the son of John and Hester Bateman. When his mother died in 1790 he formed several London partnerships, first with his brother Jonathan, who died in 1791, then with his wife Anne, and finally with his son, William. They ran as follows :

Peter & Jonathan Bateman, w 1790-1
Peter & Anne Bateman, w 1791-1805
Peter & William Bateman, w 1805-15.

BATEMAN, WILLIAM (w 1815-40), of London, continued the business he previously ran in partnership with Peter Bateman, his father.

BAXTER, JOHN (w c1770-c1773), was a London maker of porringers.

BAYLEY, RICHARD (w 1708-31), was a London maker of tankards, coffee-pots, etc. A coffee-pot, 15 oz 2 dwt, sold for £1,100 (A 1969).

BEALE, RICHARD (w 1731-40), was a London maker of coffee-pots, tea caddies, etc.

BELL, DAVID (w 1756-73), was a London maker of candlesticks, salvers, etc. A sugar basket dated 1773 is in the City Art Gallery, Manchester.

BOELEN, JACOB (1654-1729) was born in Amsterdam and moved to New York in 1659. He was one of the earliest of the silversmiths to work in the city and his work shows the characteristic Dutch influence. He made Dutch communion beakers, for example, beautifully engraved with scrolls and medallions. Examples in MMANY. His son Hendrick (1684-1755) worked with him making ale tankards.

BOLTON, THOMAS (w 1686-1702), of Dublin, is regarded by many as the finest Irish silversmith of his day. A finely moulded ewer, engraved with the royal arms of the lion and the unicorn, 1702, sold for £7,000 (1969).

BOULTON, MATTHEW (1728-1809), of Birmingham, was the son of a silver stamper who expanded his father's business by building a new works at Soho, near Birmingham, which was opened in 1762. The output was varied and included silver and Sheffield-plate pieces, ormolu, coining machinery, and many other lines. In the 1770s Boulton formed a partnership with John Fothergill to produce much fine silver and they persuaded the authorities to establish assay offices in Sheffield and Birmingham. Previously their silver had been assayed in Chester. When the partnership ceased in 1790 Boulton entered his own silver mark.

BOULTON, MATTHEW, & FOTHERGILL, JOHN (w 1773-90), of Birmingham. See Boulton above.

BRIDGE, JOHN (w 1823-33), was a London maker of coffee-jugs, tea-kettles, etc. He favoured classical styles : his decoration is naturalistic and he sometimes embossed his silver with classical scenes after Flaxman. See also Rundell, Bridge and Rundell.

BRIGDEN, ZACHARIAH (1734-1787), was a silversmith of Cornhill, Boston.

BROOKE, ROBERT (w 1673-98), was a Glasgow maker of trifid and rat-rail spoons.

BURT, JOHN (1691-1745), of Boston, was a maker of engraved hollow-ware pieces such as punch bowls. His sons continued the business after his death : they were Samuel (1724-54), William (1726-52) and Benjamin (1729-1805).

BURWASH, WILLIAM, & SIBLEY, RICHARD (w 1805-11), were London makers who produced fine quality work, especially large pieces for the table—meat dishes, epergnes, etc.

BUSFIELD, WILLIAM (w 1679-1705), was a York maker of church silver cups and plates.

BUTEAUX, ABRAHAM (w 1721-31), of Norris Street, St James's, London, made candlesticks, porringers, teapots and tea caddies, salvers, etc. A hexagonal salver, 1727, 19 oz 3 dwt, sold for £1,550 (1968). When Buteaux died in 1731 his wife Elizabeth entered her mark and continued the business until 1734. She then married Benjamin Godfrey (qv).

BUTTY, FRANCIS, & DUMEE, NICHOLAS (w 1759-68), were London makers of meat-dishes, etc.

BYRNE, GUSTAVUS (w 1791-1813), of Dublin, made two-handled cups, etc.

CACHART, ELIAS (w 1742-55). London maker of waiters, etc.

CADMAN, GEORGE. See Roberts, Samuel, Jr.

CAFE, JOHN (w 1740-65). Several members of the Cafe family worked in London in the middle of the eighteenth century, all primarily candlestick-makers. Four table candlesticks by John Cafe, 1751, 69 oz 10 dwt, sold for £2,800 (A 1968).

CAFE, WILLIAM (w 1757-72), of London, ended his business life in bankruptcy. A pair of his table candlesticks, 1762, 27 oz 6 dwt, sold for £1,250 (A 1969).

CALDECOTT, WILLIAM (w 1756-66), was a London maker of table ware. A baluster coffee-pot, later engraved with inscriptions on one side and crest on the other, 10 in high, 1760, 21 oz 4 dwt, sold for £820 (A 1969).

CALDERWOOD, ROBERT (w 1764-94), was a Dublin maker of salts, etc.

CARTER, JOHN (w c1768-89), was a London maker of candelabra, trays, sauceboats, salvers, etc. Some of his candelabra designs were taken directly from the drawings of Robert Adam. Some of his silver was decorated in the Chinese taste. Examples may be seen in the V & A and Temple Newsam House, Leeds.

CARTWRIGHT, BENJAMIN, (w 1739-54), of London, made tankards and was the inventor of the mechanical candle snuffer (1749) in which a coiled spring controlled the movement of the flat press into the snuffer box, a method which prevented hot wax from spluttering. A tankard and cover, 8½ in high, 1754, 23 oz 5 dwt, sold for £270 (A 1969).

CASEY, SAMUEL (c1724-1773), was a silversmith of Newport, Rhode Island.

CHAWNER, HENRY (w 1786-96), was a London maker whose work appears frequently in salerooms—cream jugs, mustard pots, cake baskets, teapots and tea caddies, jugs and tureens. In 1796 he formed a partnership with John Emes.

CHAWNER, WILLIAM. See Heming, George.

CLARE, JOSEPH (w 1713-19), was a London maker of tankards : an example dated 1714 sold for £1,050 (A 1968).

COKER, EBENEZER (w 1763-70), was a London maker who favoured the classical style : his work is plain and neat, often with bright-cut engraving. He made salvers and waiters, some with cast and pierced applied borders, and also candlesticks.

COLLIER, JOSEPH (w 1713-33), was a Plymouth maker who made coffee- and chocolate-pots. He entered his mark at Exeter and his work was assayed there.

CONEY, JOHN (1655-1722), was born in Boston, Massachusetts, and became one of the finest of all Colonial silversmiths, breaking away from the Puritan tradition of simplicity and making pieces with a great deal of ornamentation, including many for prominent citizens. He made an inkstand, for example, for the Governor of Massachusetts. He was also a fine engraver and made the plates in 1690 from which the first paper money was printed for use in the Colonies. His work may be seen in MMANY and BMFA.

COOKE, THOMAS. See Gurney, Richard.

COOKSON, ISAAC (w 1728-57), was a Newcastle maker of muffineers, tea- and coffee-pots, etc. A coffee-pot made in 1732 sold for £1,380 (A 1969).

COOPER, MATTHEW (w c1699-1715), was a London maker of salvers and candlesticks during the period of high standard silver. A pair of octagonal table candlesticks with baluster stems sold for £5,000 (A 1969).

COOPER, ROBERT (w 1697-1708), was a London maker of jugs and tankards.

CORNOCK, EDWARD (w 1707-24), was a London maker of tobacco boxes, salvers, and waiters.

COURTAULD, AUGUSTINE (w 1708-43), of London was a Huguenot silversmith who made elaborate baskets with piercing, engraving, and chasing—both flat and applied. He favoured rococo decoration. See Courtauld, S. L. *The Huguenot Family of Courtauld*. 1957; Jones, E. A. *Silver wrought by the Courtauld Family*. 1940.

COURTAULD, SAMUEL (w 1746-65), was the son of Augustin Courtauld. He worked in London and had a son, also called Samuel, who eventually worked with his father. When Samuel Courtauld Sr died in 1765, his wife Louisa carried on the business for three years and then formed a partnership with George Cowles which lasted until 1777. This partnership adopted the Adam style: previously the Courtauld silver had been rococo. In 1777 Louisa formed a formal partnership with her son.

COWELL, WILLIAM (1682-1736), was a noted Boston silversmith.

CRADDOCK, JOSEPH, & REED, WILLIAM (w 1812-26), were London makers of coffee-pots, tea urns, etc. A coffee-pot 9 in high, 1818, 29 oz, sold for £425 (A 1968).

CRESPIN, PAUL (w 1720-57), was a Huguenot silversmith who made spoons. He had a workshop in London next door to Nicholas Sprimont, from whom he took the idea of decorating his work with sea shells. Examples may be seen in the AM.

CRIPPS, WILLIAM (w 1743-64), was a London maker of inkstands, coffee-pots, sauceboats, epergnes, etc. He favoured rococo marine motifs and decorated some pieces with dolphins. His son William entered his mark in 1767.

CROUCH, JOHN, & HANNAM, THOMAS (w 1760-1802), of Giltspur Street, London, were spoon makers in addition to their production as general silversmiths. They made dinner plates with beaded edges and salvers and trays with shell and scroll borders. A silver two-handled tray, 1793, 68 oz, sold for £450 (A 1969).

CRUMP, FRANCIS (w 1756-69), was a London maker. A coffee-pot dated 1768, 20 oz, sold for £750 (A 1969).

DAVENPORT, BURRAGE (w c1772-83), was a London maker of sugar-tongs, pierced baskets, muffineers and dish-crosses, etc. A pierced and festooned sugar basket on round pierced and beaded feet, with swing handle and blue glass lining, 1776, 5 oz 7 dwt, sold for £140 (A 1968).

DENZILOW, JOHN (w 1774-90), was a London maker of tea caddies, tureens, etc. Two soup tureens, on oval bases, with reed and shell borders, 1779, 235 oz, sold for £5,800 (A 1968) and two oval sauce tureens and covers, 1782, 23 oz, for £850 (A 1969).

DIXWELL, JOHN (1680-c1723), was born in New Haven and moved to Boston in 1698 to become a silversmith. He was a keen churchman and made many two-handled cups for ecclesiastical use.

DU BOIS, ABRAHAM (w 1777-1802), of Philadelphia, made silver in the classical style with ovoid shapes and pierced galleries.

DUMEE, NICHOLAS (w 1776-1783), was a Huguenot silversmith who worked in London, at first in partnership with William Holmes for three years. His pieces followed the Adam style and usually had gadrooned edges. See Butty, Francis, and also Holmes, William.

DUMMER, JEREMIAH (1645-1718), was born in Newbury, Massachusetts, and moved to Boston where he was apprenticed to John Hull. In 1666 he started on his own, and was a prolific and notable silversmith making tankards, beakers, porringers, caudle cups and candlesticks. His work often has fluted bands on a plain surface. Examples may be seen in the BMFA.

DWIGHT, TIMOTHY (1654-91), was a Boston silversmith, probably an apprentice of John Hull. He made pieces engraved with chinoiserie decoration. Examples in BMFA.

EAMES. See Emes.

Q

EBBS, JOHN, combined his work as a silversmith with watchmaking. His workshops were in Dublin and he is known to have made wine labels from 1766.

EDWARDS, EDWARD (w 1818-49), was a London maker of snuffboxes.

EDWARDS, JOHN (1670-1746), was born in England and learnt his craft in London. He then emigrated to New England and formed a partnership with John Allan (1671-1760). His son Thomas (1701-55) was a silversmith.

ELLIOTT, WILLIAM (w 1810-44), was a London maker of saltcellars, inkstands, snuffboxes, etc.

ELSTON, JOHN (w c1701-48), was an Exeter maker of casters, tankards, mugs, salvers, coffee-pots, and flagons, both simple and highly decorated. He had a son, also called John, who is known to have been working in 1734.

EMES, JOHN (w 1798-1808), of London, is sometimes spelt 'Eames'. He made a wide range of pieces—butter dishes, coasters, coffee-pots, inkstands, teapots, trays, tankards, tureens, etc. Two oval sauce tureens with covers, 1800, 26 oz, sold for £950 (A 1969). When he died in 1808 his widow Rebecca went into partnership with Edward Barnard.

EMES, REBECCA, & BARNARD, EDWARD (w 1808-28), were London makers, especially of coffee-pots and tea services. The latter show half-fluting : birds were sometimes used as finials to coffee-pots and teapots. A pair of heavy and ornate wine coolers sold for £4,500 (A 1969).

FELINE, EDWARD (w 1720-53), was a Huguenot silversmith who worked in London making bread baskets, coffee-pots, salvers, etc, with rococo decoration. He sometimes applied strapwork to his pieces. When he died in 1753 his widow Magdalene continued the business until 1762.

FOGELBURG, ANDREW (w c1770-90), of Church Street, London, was a Swedish silversmith, born about 1732, who came to England in his thirties and was well established by 1772. Soon after, he was working in Church Street, Soho with Stephen Gilbert. Much of Fogelburg's work is in the simple outlines of the Adam style. In his later work he effectively used beading with fluting. Paul Storr

was apprenticed to him in 1785 at the age of 14. Examples of his work can be seen in the V & A; the Museum & Art Gallery, Birmingham; and the National Museum of Wales. An oval tureen engraved with contemporary armorials, 1785, 85 oz 15 dwt, sold for £1,400 (A 1969).

FOSSY, JOHN (w 1733-9), was a London maker of coffee-pots, etc.

FOTHERGILL, JOHN. See Boulton, Matthew.

FOUNTAIN, WILLIAM (w 1794-1816), was a London maker of spoons, salts, and ornate coffee-pots.

FOWLER, MICHAEL (w 1751-60). A Dublin goldsmith who made silver candlesticks

FOX, CHARLES (w 1822-42), was a London maker. An embossed silver teapot, 1825, 18½ oz, sold for £165 (A 1969).

FRISBEE, WILLIAM (w 1792-1801), of London, partnered Paul Storr for some time before entering his own mark in 1792.

FROMENT-MEURICE, FRANÇOIS DESIRÉ (1802-55), was goldsmith to the City of Paris and is noted for the superb quality of his chased work.

FULLER, CRISPIN (c1778-1827), was a London maker of casters, mugs, teapots, etc.

GAINSFORD, ROBERT (w 1808-31), was a Sheffield maker of candlesticks.

GAIRDNER, ALEXANDER (w 1754-84), was an Edinburgh maker of tea services, etc.

GAMBLE, WILLIAM (w 1689-1701), was a London maker. A silver-gilt monteith, 1701, 85 oz, sold for £4,800 (A 1969).

GARDEN, PHILLIPS (w c1751-5), of London, was a maker of ornate rococo beer jugs decorated with barley, hops, and barrels. He bought tools from Paul de Lamerie in 1751. A pair of his beer jugs, 1754, sold for £17,000 (A 1969).

GARRARD, ROBERT (w 1801-42), of Panton Street, London, became the Royal Silversmith and was the most influential silversmith in London in the 1830s. He made a wide range of silver pieces —teapots, with the lower half fluted, gadrooned meat and entrée

dishes, candelabra, etc. A pair of nine-light candelabra, 1836 and 1842, 1,574 oz, sold for £5,600 (A 1969).

GHISELIN, CESAR (d 1733), was a French silversmith who worked in Philadelphia from c1693-1715 and then moved to Annapolis.

GILLOW, PIERRE or PETER (w 1754-64), was a London maker who produced fine tea canisters, etc.

GODFREY, BENJAMIN (w 1732-49), was a London maker. When he died in 1749 his widow Eliza Godfrey (formerly Elizabeth Buteaux) entered her mark and ran the business until 1758, making cake baskets, soup tureens, etc, in the rococo style.

GOULD, JAMES (w 1722-47), was a London maker of candlesticks, taper holders, snuffer trays, etc. A pair of candlesticks, 8 in high, 1738, sold for £2,100 (A 1968).

GOULD, WILLIAM (w 1734-57), was a London maker of candlesticks, spoons, etc. Four table candlesticks, 1745, 97 oz 12 dwt, sold for £3,600 (A 1969).

GRAY, ROBERT, & SON (w 1819-25), were Glasgow makers of sugar casters, strainers, etc.

GREENE, HENRY (w 1700-20), was a London maker of porringers, spoons, casters, etc. A set of three casters with baluster bodies and bayonet covers applied with moulded girdles, 1704, 26 oz 10 dwt, sold for £2,200 (A 1969).

GREEN, JOHN, & CO (w 1792-1801), were Sheffield makers of coasters and candlesticks.

GREENWAY, HENRY (w 1775-90), was a London maker of Adam-style pieces. A chocolate-pot may be seen in the V & A.

GRIBELIN, SIMON, was a noted Huguenot engraver of silver who came to England from Blois (c1680). He signed much of his work, including pieces he engraved for Pierre Harache. His book of designs may be seen in the British Museum.

GRIERSON, PHILIP (w 1810-21), was a Glasgow maker of tea-sets, etc.

GROVES, THOMAS. See Kentenber, John.

GRUNDY, WILLIAM (w 1748-68), was a London maker of rococo sauceboats, coffee-pots, candlesticks, etc.

GURNEY, RICHARD, & COOKE, THOMAS (w 1721-38), were London makers of mugs and tankards.

HALFORD, THOMAS (w 1807-19), was a London maker of mugs, wine labels, etc.

HALL, WILLIAM E. (w 1795-1828), was a London maker of inkstands, milk jugs, melon-shaped teapots, etc, who favoured reeding, beading, and lion masks with ring handles.

HANNAM, THOMAS. See Crouch, John.

HARACHE, PIERRE (w 1685-1705), was the first Huguenot silversmith to come to England when the Edict of Nantes was revoked in 1685. He started working in London and entered his mark in 1697.

HARACHE, PIERRE, JR, entered his London mark in 1698. A silver-gilt bowl and cover, 5 in high, decorated with cutcard acanthus leaves and inscribed, c1698, 16 oz 2 dwt, sold for £11,800 (A 1968).

HAYNES, JONATHAN. See Wallis, Thomas, & Haynes, Jonathan.

HEASLEWOOD, ARTHUR (w 1625-d1671), was the first of a family of silversmiths working in Norwich. His son, Arthur, worked from 1661 to 1684, when his wife Elizabeth took over the business until her son—another Arthur—qualified in 1702. This third Heaslewood died in 1740.

HEMING, GEORGE, & CHAWNER, WILLIAM (w 1774-81), of New Bond Street, London, made spoons, coffee-pots, soup tureens, etc.

HEMING, THOMAS (w 1744-88), a noted London maker, became chief silversmith to the Crown around 1760-2. He made cups with covers, candelabra, tea-urns, sauceboats, and tureens. His early style was rococo and he also decorated with chinoiserie; in the 1760s he began to discard early designs and to work with convex fluting, nearer to the Adam style. Examples may be seen in the V & A. A set of four cast candlesticks, 1776, 116 oz, sold for £1,400 (A 1969).

HENNELL, DAVID (w 1736-60), was a London maker of spoons, ladles, casters, and salts.

HENNELL, ROBERT (w 1753-94), was a London maker of spoons, cruets, sugar baskets, urns, inkstands, tureens, etc. Eight

oval boat-shaped gilt-lined salt cellars with handles, engraved with bands of foliage, 1789, 24 oz, sold for £620 (A 1969).

HENNELL, ROBERT & DAVID (w 1795-1801), was a London partnership which continued Robert Hennell's business.

HENNELL, ROBERT & SAMUEL (w 1802-c1818), took over the Robert & David Hennell business.

HERBERT, SAMUEL, (w 1747-60), started a company in Foster Lane, London, in 1750, which lasted for ten years. He made cake baskets, dish-crosses, epergnes, teapots, and coffee-pots.

HERIOT, JOSEPH (w 1769-93), was a London maker of wine labels.

HOGARTH, WILLIAM (1697-1764), was apprenticed to Ellis Gamble (mark entered 1712) and became an engraver on silver. It is probable that he engraved the Walpole Salver by de Lamerie, now in the V & A. In 1719, Hogarth decided to give up engraving and to start painting. In *The Complete Works of Hogarth* there is an illustration of an engraving he made on a large silver dish and also a design he engraved for a silver tankard which belonged to an artists' club of which he was a member.

HOLMES, WILLIAM, & DUMEE, NICHOLAS (w 1773-6), was a London partnership which made cups, butter-boats, etc.

HOWLAND, SAMUEL (w 1760-79), was a London maker of table ware. A pair of sauceboats, 1779, sold for £210 (A 1969).

HOYLAND, THOMAS (w 1776-8), was a Sheffield maker of tea and coffee urns.

HUGHES, WILLIAM (w 1767-81), was a Dublin maker of two-handled cups, dish rings, etc.

HULL, JOHN (1624-83), was born in Leicestershire, England, and emigrated to settle in Boston in 1635. He became Mint-master in 1652 and coined the first Massachusetts shillings. In the same year he formed a partnership with Robert Sanderson and together they produced some fine silver pieces including caudle and communion cups. Examples in BMFA.

HUNTER, GEORGE (w 1748-55), was a London maker of tankards, salt cellars, etc.

HUNTER, WILLIAM (w 1739-55), was a London maker of coffee-pots, snuffer trays, salvers, etc.

HURD, JACOB (1702-58), was a prolific Boston silversmith. After his death his son Nathaniel (1729-1777) carried on the business.

HYATT, JOHN, & SEMORE, CHARLES (w 1750-58), were London makers of tapersticks, waiters, etc.

INNES, ROBERT (w 1742-59), was a London maker of sauceboats, etc.

JACKSON, THOMAS (w 1736-69), was a London maker of ladles, gravy argyles, etc.

JACOB, JOHN (w 1734-68), was a London maker of spoons, cake baskets, etc. An oval cake basket, 1737, sold for £3,600 (A 1969).

JOHNS, JOSEPH (w 1731-74), of Limerick, Ireland, made spoons and general domestic silver. He was a notable citizen and was for a time the Sheriff and also Mayor. His mark was a lion rampant with a letter I on either side.

JONES, GEORGE (w 1724-42), was a London maker of cream jugs, dredgers, punch ladles, and strainers.

KANDLER, FREDERICK (w 1735-75), of London, was one of the earliest silversmiths to develop the rococo style in England, though in later life he favoured Adam designs. He was prolific and his pieces cover a wide range—candelabra, casters, pierced cake baskets, jardinières, tankards, salvers, tureens, wine coolers, etc. Much of his work has reed-and-ribbon or gadrooned borders and his wine coolers carry ram's-head masks with ring handles. His work may be seen in the V & A; the Museum and Art Gallery, Birmingham; the AM; and at Ickworth, Suffolk. A set of four second-course dishes, 1736, 151 oz, sold for £3,200 (A 1969).

KEMPSON, PETER. See Wardell, William.

KENTENBER, JOHN, & GROVES, THOMAS (w 1757-67), were London makers who supplied gunsmiths with silver mounts for pistols.

KERSILL, WILLIAM (w 1749-66), was a London maker of gravy spoons, cream jugs, etc.

KIDNEY, WILLIAM (w 1734-7), was a London maker of candlesticks, etc.

KIERSTEDE, CORNELIUS (1675-1757), of New York, moved

to New Haven, Connecticut, in 1722. He was a maker of tankards and of highly ornamental silver punch bowls with repoussé and chased decoration. His pieces show Dutch influence. Examples in MMANY.

KINCAID, ALEXANDER (w 1692-1718), was an Edinburgh maker of mugs and spoons.

KING, DAVID (w 1703-33), was a Dublin maker of candelabra and sugar casters.

KIP, JESSE (1660-1722), worked as a silversmith in New York City from 1682 to 1710 making lidded tankards and drinking bowls with engraved ornamentation. Examples in MMANY.

KIRKUP, JAMES (w 1713-41), was a Newcastle maker of tankards and flagons. He may have worked longer because he did not die until 1753.

LAMERIE, PAUL DE (1688-1757), was born in the Netherlands in 1688 into an aristocratic family. His father was a Huguenot refugee who moved to Berwick Street in London with Paul in 1691. In 1705, Paul started an apprenticeship with Pierre Platel, also a Huguenot, who had come to England about twenty years earlier. His workshop was in Pall Mall. Lamerie entered his mark in 1712. Although there was no legal obligation for him to do so, he continued to use Britannia standard silver from 1720-1732. This was only possible because most of his customers were wealthy. His work cleverly combined elegance with function, and although he did not hesitate to draw on the ideas of others, he developed a highly individual style. He favoured the rococo style and used gadrooning, engraving and flat-chasing, and strapwork scrolls to enrich many of his pieces. His work may be studied in the V & A (note particularly the Walpole Salver); the AM, which has a fine collection (note particularly the punch bowl of 1726 with pictorial engraving); Birmingham Museum; and Woburn Abbey, Bedfordshire. One of his most famous pieces is the great silver wine cistern, made in 1719, now in the Minneapolis Institute of Art, USA. It weighs over 700 oz and sold for £27,000 in 1961. A pair of square salvers made in 1749 for Admiral Hawke were sold for £20,500 (A 1968), and with them was the original account: the Admiral had paid £23 7s 1d for the salvers and £4 4s 0d for the engraving of the border and arms. A two-handled silver-gilt cup and cover, 1737, 56 oz, sold for

£3,500 (A 1968). See illustration on p 144. An account of this eminent silversmith has been written by Phillips, P.A.S. *Paul de Lamerie, Silversmith of London, 1688-1757.* 1935 (1968).

LANGFORD, JOHN, & SEBILLE, JOHN (w 1759-70), were London makers of pierced baskets, tea caddies, inkstands, etc.

LANGLANDS, DOROTHY (1804-1811), was a Newcastle maker of hot-water jugs and teapots. She may have worked longer, for she lived until 1845.

LANGLANDS, JOHN (w 1754-77), was a Newcastle maker of tankards.

LANGLANDS, JOHN, & ROBERTSON, JOHN (w 1778-95), were Newcastle makers of tankards. John Langlands died in 1793. John Langlands Jr may have continued to 1804.

LAW, THOMAS (w 1773-93), was a Sheffield maker of candlesticks in the Adam style.

LAURENCE, JOHN & CO (w c1793-1823), were Birmingham makers of snuffboxes.

LEJEUNE, JOSH (w 1773-82), was a London maker of tankards.

LE ROUX FAMILY. A famous family of New York silversmiths founded by a Huguenot, Bartholomew Le Roux (d 1713). His son, Charles Le Roux (1689-1745), was for some time official silversmith of New York. Bartholomew Le Roux II (1717-1763) was the son of Charles Le Roux.

LE SAGE, AUGUSTUS (w 1722-69), was a Huguenot silversmith who made cake baskets, tea caddies, etc, in London. There may have been two silversmiths of this name, perhaps father and son.

LE SAGE, JOHN (w 1718-40), was a Huguenot silversmith who worked in London. He made tea kettles with scroll-pattern handles and swan-neck spouts, as well as trays, cutlery, etc.

LIGER, ISAAC (w 1704-30), was a Huguenot silversmith in London who made porringers, bowls, bullet teapots, hot water jugs, and salvers.

LINWOOD, MATTHEW (w c1807-22), was a famous Birmingham boxmaker who made nutmeg graters, snuffboxes, wine labels, etc. He was apprenticed to Joseph Hunt (c1767) before the Birmingham Assay Office was opened and was probably registered at

R

Chester. There is a good account of the Linwood family in Eric Delieb's *Silver Boxes*. 1968, pp 114-16.

LLOYD, JOHN (w 1768-77, d 1821), was a Dublin maker of coffee-pots and salvers.

LOCK, NATHANIEL (w 1698-1716), was a London maker of tankards, chocolate-pots, etc.

LOFTHOUSE, MATTHEW E. (w 1705-26), was a London maker of candlesticks, etc. A coffee-pot, 1726, sold for £2,250 (A 1968) and a plain mug, 1726, for £700 (A 1969).

LOFTHOUSE, SETH (w 1697-1716), was a London maker of salvers, etc, who fashioned a warming pan for the Prince of Wales in 1715; it is now in Buckingham Palace.

LUFF, JOHN (w 1739-47), was a London candlestick maker.

LUKIN, WILLIAM (w 1699-1725), was a London maker of punch bowls, coffee-pots, etc. In 1716 he made some wine coolers for Sir Robert Walpole decorated with scrolls and shells, the beginning of the rococo styles which followed.

McKENZIE, COLIN (w 1695-1713), was an Edinburgh maker of tankards, coffee-pots and hot-water jugs. He was one of the earliest makers to produce a bulging tankard with baluster finial. His work was functional with a minimum of decoration : examples may be seen in the National Museum of Antiquities of Scotland in Edinburgh. A monteith, 1698, sold for £5,500 (A 1969).

MANGY FAMILY : CHRISTOPHER (w 1609-d 1645) was the first of a long family of York silversmiths, which included GEORGE (w 1638-d 1672), HENRY (w 1650-d 1672), THOMAS (w 1664-d 1689), and ARTHUR (w 1681-d 1696), who moved to Leeds but later returned to York where he was hanged for forging coinage.

MANSFIELD, JOHN (1601-1674), according to early records, was the first American silversmith. He settled in Boston in 1634.

MEURE, PETER. See Archambo, Peter.

MIDDLETON, WILLIAM (w 1697-9), was a London maker of vinaigrettes, salvers, etc.

MILLS, DOROTHY (w 1752-c1760), was a London maker of vinaigrettes, salvers, etc.

MILLS, NATHANIEL (w c1826-55), was a Birmingham maker of snuffboxes and vinaigrettes with embossed lids, many of them

with views of castles—Windsor, Warwick, etc. These are widely collected and fetch high prices. A full account of the Mills family is given in Eric Delieb's *Silver Boxes*. 1968, pp 116-17.

MILLS, RICHARD (w 1742-86), was a London maker of cake and sugar baskets, etc. Examples in the V & A.

MOORE, THOMAS (w 1750-83), was a London maker of porringers, punch ladles, casters, and sugar nips, etc.

MORLEY, EDWARD (w 1806-14), was a London maker of mugs, caddyspoons, and wine labels.

MORRISON, JAMES (w 1745-80), was a London maker of candlesticks.

MORTON, RICHARD, & CO (w 1773-85), was a Sheffield maker of pieces in the Adam style, including wine labels.

MOULTON, EBENEZER (1768-1824), of Boston and Newburyport, Massachusetts, followed a long line of silversmiths founded by William Moulton (1664-1732). Ebenezer made tableware with bright-cut ornament : examples may be seen in the Minneapolis Institute of Arts.

MUNNS, JOHN (w 1753-65), was a London maker of tableware. A pair of salt cellars, $2\frac{1}{2}$ oz, sold for £56 (A 1968).

MYERS, MYER (1723-95), of New York, was a noted silversmith who worked in the rococo style using cast ornamentation. He was the President of the New York Gold & Silversmiths' Society in 1776.

NELME, ANTHONY (w c1689-1738), was a London maker of porringers, tankards, etc. He worked during the Britannia period and was responsible for a number of important pieces.

NEWTON, JOHN (w 1726-42), was a London maker of tea caddies, etc.

NORTHCOTE, HANNAH (w 1798-1816), was a London maker of sugar baskets, etc.

PANTIN, SIMON (w c1701-33), was a London silversmith of Huguenot descent and of outstanding skill. His coffee-pots and candlesticks have fetched high prices. A pair of table candlesticks, $6\frac{3}{4}$ in high, on moulded octagonal bases, 1711, 30 oz, sold for £4,800 (A 1968), and a plain cylindrical coffee-pot, 1723, 28 oz, for £4,800

(A 1969). When Simon Pantin died in 1733, Mary, his widow, registered her mark and supervised the workshop until her son Lewis Pantin took over in the same year.

PARKER, JOHN, & WAKELIN, EDWARD (w 1759-78), was a London partnership which produced much fine silver and had royal clients. Much was in the baroque or neo-classical styles and some designs from French pattern books were used. Gadrooning is common, as are fruit and bird finials, and lion mask feet. In the 1770s the output was considerable and other silversmiths, such as Thomas Pitts, worked for them. The firm eventually became Garrard & Co, the Crown Jewellers.

PAYNE, HUMPHREY (w 1701-50), was a London maker of cups, tankards, cruets, and spoons.

PAYNE, JOHN (w 1750-74), was a London maker of candlesticks, alms dishes, and coffee-pots, etc.

PEARCE, EDMUND (w 1704-22), was a London maker of bowls, baluster-shaped casters, etc.

PEARSON, WILLIAM (w 1710-20), was a London maker of spoons and straight-sided tankards.

PEASTON, WILLIAM (w 1745-72), was a London maker of salvers and dish-crosses (see plate, p 143).

PEMBERTON, SAMUEL (w 1773-1818), was a Birmingham boxmaker who described himself as a 'Jeweller and Toy Maker' of Edgbaston and Five Ways. He made scoops, nutmeg graters, caddyspoons, patch boxes, snuffboxes, and vinaigrettes. He was one of a large family which is fully described in Eric Delieb's *Silver Boxes*. 1968, pp 113-14.

PETERSON, ABRAHAM (w 1790-1806), was a London maker of salts, sauceboats, tureens, etc. A pair of sauceboats, 1803, sold for £350 (A 1968).

PHIPPS, T. & ROBINSON, E. (w c1784-1814), were London makers of nutmeg graters, snuffboxes, and wine labels.

PITTS, THOMAS (w c1765-80), was a London silversmith who made epergnes for Parker & Wakelin. Example to be seen in the V & A.

PITTS, WILLIAM (w 1781-91), was the son of Thomas Pitts. He made candelabra, entrée dishes, snuffboxes, etc. A pair of candelabra

in the neo-classical manner, 18½ in high, 1805, sold for £2,500 (A 1969). In 1791 he formed a partnership with Joseph Preedy which lasted until about 1799.

PLATEL, PIERRE or Peter (w c1688-1728), was one of the first Huguenot silversmiths to come to England and settle in London. He entered his mark in 1699. His workshop was in Pall Mall and he favoured the baroque style. Paul de Lamerie was apprenticed to him in 1703. His work may be seen in the AM.

PLUMMER, WILLIAM (w 1755-84), was a London maker noted for beautifully hand-pierced cake and dessert baskets. He also specialised in dish-crosses.

POTWINE, JOHN (1698-1792), was born in London and emigrated to Boston, Massachusetts, where he worked from 1721 to 1737. He then moved to Hartford, Connecticut, and after 1754 he lived in Coventry, Connecticut. He was a fine silversmith who produced beautifully finished work.

POWELL, THOMAS (w 1756-73), was a London maker of epergnes, etc. An example dated 1773, 96 oz, sold for £2,300 (A 1968).

PREEDY, JOSEPH. See Pitts, William.

PRIEST, WILLIAM & JAMES (w 1764-73), were London makers of tankards. An example with floral and scroll decoration, 1766, 24 oz, sold for £425 (A 1969).

PROCTOR, LUKE, & CO (w c1785-90), were Sheffield makers of cake baskets.

PUGH, WILLIAM (w c1805-13), was a Birmingham maker of snuffboxes, caddyspoons, etc.

PURSE, GEORGE (w c1802-32), was a London boxmaker.

PYNE, BENJAMIN (w c1694-1727), was a London maker of tankards who worked during the Britannia period and made much important plate and some regalia for corporations—eg The Great Mace for the Borough of Westminster.

QUANTOCK, JOHN (w 1734-53), was a London maker of candlesticks.

REED, WILLIAM. See Craddock, Joseph.

REVERE, PAUL, SR (1702-54), was a French Huguenot named Apollos Rivoire who emigrated to Boston in 1718 and was an appren-

tice of John Coney. In 1722 he changed his name to Paul Revere and started on his own as a silversmith. His work may be seen in the MMANY.

REVERE, PAUL (1735-1818), was born in Boston and trained in his father's workshop. When his father died in 1754 he continued the business to become one of the greatest of American silversmiths. He is well known for his political activities in support of the American Revolution and for the famous ride he made in 1775, the subject of a poem by Longfellow. His silver work, the best of which dates from 1780, is of the finest quality. Examples in the MMANY and BMFA.

RICHARDS, EDWARD (w c1694-1710), was an Exeter maker of spoons, mugs and tankards.

RICHARDSON FAMILY: Francis Richardson (1681-1729), born in New York, was the first American-born silversmith to work in Philadelphia. The business was carried on by his son Joseph (1711-84) and his grandsons Joseph Jr (1752-1831) and Nathaniel (1754-1827). His other son Francis worked separately.

RICHARDSON, RICHARD. There were three Richards in the Richardson family of goldsmiths who played a prominent part in the city life of Chester and whose work may be seen in the Chester Corporation Collection. The first became Sheriff of the city in 1714, the second Mayor in 1751. The last mention of the family is in 1787.

ROBERTS, SAMUEL, & CO (w 1773-89), were Sheffield makers of candlesticks in the Adam style. Examples in the V & A and Sheffield Museum.

ROBERTS, SAMUEL, JR, & CADMAN, GEORGE, & CO (w 1786-1821), were Sheffield makers of candlesticks.

ROBERTSON, JOHN. See Langlands, John, and Robertson, John.

ROBINS, JOHN (w 1774-1817), was a London maker of epergnes, wine labels, nutmeg graters, etc.

ROMER, EMICK W. (1724-99), was born in Christiania, Norway and moved to England late in the 1750s. He worked in London as a silversmith from 1759 to 1794. He specialised in candlesticks and pierced baskets and epergnes with rococo decoration. See Ban-

nister, J. 'Emick W. Romer : A Norwegian Silversmith in Eighteenth Century London.' *Collectors' Guide*. October 1966, pp 61-4.

RUNDELL, BRIDGE & RUNDELL (w 1804-39), were the dominant London silversmiths of the day, employing at one time over 1,000 people. They were the Royal Silversmiths and made a wide range of pieces, including cutlery. Several other notable silversmiths worked for this firm, including Benjamin Smith and Paul Storr. John Bridge (d 1834) was the leading figure and he used the finest designers (John Flaxman, for example) and the finest craftsmen.

RUSSELL, MOODY (1694-1761), of Barnstaple, Massachusetts, made beakers for use as Communion cups.

SALKELD, JOHN (w c1801-10), was a London maker of caddy-spoons.

SAMPEL, WILLIAM (w 1755-62), was a London maker of rococo silver.

SANDERS, JOSEPH (w 1730-35), was a London maker of waiters.

SANDERSON, ROBERT (1608-93), was born in England, trained as a silversmith in London, and settled in Boston in 1640. In 1652 he formed a partnership with John Hull (qv). They made beakers and tankards, caudle cups, communion cups and spoons. Examples in BMFA.

SAVORY, ADEY B. (w 1826-38), was a London maker of cutlery and ornate tea services.

SCHAATS, BARTHOLOMEW (1683-1758), was a noted New York silversmith.

SCHOFIELD, JOHN (w 1778-99), was a London maker who specialised in candelabra and cruets but also made tureens, tea-urns, coffee-pots, hot-water jugs, etc. His output was considerable, much of it in the Adam style, sometimes decorated with medallions. He concerned himself particularly with the reflection of light from the pieces he made. His work may be seen in the V & A. A pair of three-light candelabra, 17 in high, 1799, sold for £4,000 (A 1968).

SCHRUDER, JAMES (w 1737-53), was a London maker who favoured the rococo style with chasing of flowers, leaves, and shells : many borders were gadrooned.

SCHUPPE, JOHN (w 1753-73), is presumed to have come to London from the Netherlands. He specialised in cow creamers. Examples may be seen in the V & A.

SEBILLE, JOHN. See Langford, John.

SHAW, JOHN (w c1795-1818), was a Birmingham boxmaker who made nutmeg graters, snuffboxes and vinaigrettes.

SHAW, WILLIAM, & PRIEST, WILLIAM (w 1749-64), were London makers of coffee-pots, flagons, and tankards. A coffee-pot with flower heads and scroll work, 1753, sold for £500 (A 1969); a pear-shaped coffee-pot, 1760, for £365 (A 1969); and a baluster tankard with reeded waist and domed cover, 1764, 24 oz, for £340 (A 1969).

SIBLEY, RICHARD. See Burwash, William.

SINGLETON, FRANCIS (w 1697-9), was a London maker of porringers.

SLEATH, GABRIEL (w 1706-48), was a London maker of a wide range of silver—casters, coffee-pots, tankards, teapots, salvers, etc. A tankard with cylindrical body and domed cover, 1748, sold for £570 (A 1969).

SMITH, BENJAMIN & JAMES (w c1807-28), were London makers who favoured the Adam style and Regency ornamentation of fluting, leaf motifs, lions, dolphins, and classical figures. They made a wide range of pieces—creamers, pierced bread and cake baskets, ice pails, candelabra, entrée dishes, tea and coffee services, salvers, wine labels, wine coolers, etc. A pair of wine coolers in campana form, 1811, 503 oz, sold for £9,000 (A 1968).

SMITH, DANIEL, & SHARP, ROBERT (w c1761-88), were London makers who first used the rococo style with gadrooned borders, and later the Adam style, sometimes with decorative classical medallions and repoussé work. A coffee-pot, 1767, 28 oz, sold for £680 (A 1969).

SMITH, EDWARD (w 1826-51), was a Birmingham maker of snuffboxes and vinaigrettes.

SMITH, GEORGE, & HAYTER, THOMAS (w 1792-1802), were London makers of spoons, cake baskets, coffee-pots and tureens in the Adam style. A cake basket, 21 oz, sold for £230 (A 1969).

SOUMAIN, SIMEON (1685-1750), was born in London and settled in New York where he made silver bowls and other pieces based on Dutch designs. Examples in Museum of the City of New York and BMFA.

SPACKMAN, WILLIAM (w 1720-25), was a London maker of tea- and coffee-pots. A cylindrical coffee-pot of tapering form, 1725, sold for £1,350 (A 1969).

SPILSBURY, FRANCIS (w 1729-39), was a London maker of salts, sauceboats, sauce ladles, etc.

SPRIMONT, NICHOLAS (w 1742-9), was a London silversmith who learnt his craft in Liége. A pair of his circular second-course dishes, 14¾ in diam, 1743, sold for £3,000 (1968). In 1749 or 1750 he gave up his work as a silversmith to help start the Chelsea porcelain works. Some of his silver may be seen in the AM.

SUTTON, JAMES (w 1780-93), was a London maker of wine labels.

STORR, PAUL (1771-1844), was a pupil of Andrew Fogelburg and became such a technical master of his medium that he was considered the leading silversmith of his day. He registered his mark in 1792 and started business on his own, producing pieces in the Adam style. He also produced work in a beautiful rococo style in the tradition of mid-eighteenth-century decoration. Some of his pieces were simple, others ornate. He loved lion masks, dolphins, and serpents : entwined serpents sometimes form the handles of his teapots. From 1796 to 1807 he worked in Piccadilly. Then he became Storr & Co of Dean Street, working with Rundell, Bridge & Rundell, the Royal Silversmiths, making presentation pieces. In 1819 this association ceased and he had his own workshop in Harrison Street, Clerkenwell. See Bannister, J. 'The Three Phases of Paul Storr', *Collectors' Guide*, June 1968, pp 84-7; Penzer, N. M. *Paul Storr, The Last of the Goldsmiths, 1771-1844.* 1954.

SWIFT, JOHN (w 1739-73), was a London maker of tankards, candlesticks, and squat teapots embossed with acanthus leaves. A plain lidded tankard with domed cover, 1775, 24 oz, sold for £620 (A 1969).

SYMPSON, JAMES (1687-1700), was an Edinburgh maker of mugs and trifid spoons.

SYNG FAMILY. This family of silversmiths was founded by Philip Syng (1676-1739) who was born in Cork, Ireland, and emigrated to Philadelphia in 1714. His two young sons Philip and Daniel came with him and also became silversmiths. Philip Syng (1703-89) made the inkstand used at the signing of the Declaration of Independence.

TAYLOR, JOSEPH (w c1787-d 1827), was a Birmingham maker of caddyspoons, snuffboxes, and wine labels. Eric Delieb, who gives a full account of the Taylor family in *Silver Boxes*, 1968, p 119, describes his boxes as 'quite outstanding'.

TAYLOR, SAMUEL (w 1744-52), was a London maker who specialised in tea caddies, baluster-shaped, with decoration of chased rococo flowers. An example, 1751, $8\frac{1}{4}$ oz, sold for £150 (A 1968).

TAYLOR, WILLIAM. See Wakelin, John.

TEARLE, THOMAS (w 1719-34), was a London maker of porringers, etc.

TOWNSEND, WILLIAM (w c1767-70), was a Dublin maker of beer jugs, etc. An example of plain pear-shaped form sold for £1,150 (A 1969).

TUCKER, W. (w 1810-13), was a Sheffield candlestick maker.

TUDOR, HENRY, & LEADER, THOMAS (w c1760-78), were active in Sheffield from about 1760 and registered their mark when the Sheffield Assay Office was established in 1773. Their pieces are mainly in the Adam style. They were pioneer makers of Sheffield plate (qv).

TUITE, JOHN (w 1721-41), was a London maker of cream jugs, salvers, and waiters, often with shaped and moulded borders.

TURNER, JOHN (w c1800-18), was a Birmingham maker of caddyspoons, boxes, and vinaigrettes.

TWEEDIE, WALTER (w c1772-86), was a London maker of sauceboats with gadrooned borders.

VAN DYCK, PIETER (1684-1750), was a New York silversmith of Dutch descent. He worked in the Queen Anne style making large lidded tankards, sugar casters, and teapots with flaring sides. His son, Richard Van Dyck (1717-70) continued his father's business.

VECHTE, ANTOINE (1800-68), was a Paris silversmith noted for fine repoussé work. He left Paris in 1849 to work in England.

VERNON, SAMUEL (1683-1731), a silversmith of Newport, Rhode Island, and a cousin of Edward Winslow.

VIDEAU, AYMÉ (w 1739-61), was a London maker of coffee-pots, etc. Some of his work is simple in style, some highly decorated.

VINCENT, WILLIAM (w 1773-6), was a London maker of tea caddies with bright-cut engraving.

WAKELIN, EDWARD (w c1742-59), was a London maker of candlesticks, cake baskets, sauceboats, tea caddies, waiters, etc. A pair of table candlesticks on square gadrooned bases, 1759, 66 oz, sold for £2,800 (A 1969). See also Parker, John.

WAKELIN, JOHN, & GARRARD, ROBERT (w 1792-1801), were London makers of cake baskets, salt cellars, jugs, tureens, etc., in the Adam style. A cylindrical hot-water jug and cover with reeded border engraved with a crest, 1800, 18 oz 10 dwt, sold for £200 (A 1969).

WAKELIN, JOHN, & TAYLOR, WILLIAM (w c1774-92), were London makers of baskets, cups, epergnes, tea services, and tureens, in the Adam style. The firm made the Doncaster Race Cup, now in the Birmingham Museum & Art Gallery. They bought from other silversmiths, acting as middlemen; John Carter, for example, made candlesticks for them.

WALLEY, RALPH (w c1682-92), was a Chester maker of tankards and church plate.

WALLIS, THOMAS (w 1792-1810), was a London maker of tea and coffee services, sometimes decorated with a key pattern. He also made caddyspoons.

WALLIS, THOMAS, & HAYNES, JONATHAN (w 1810-13), were London makers of tea services.

WARD, JOSEPH (w 1697-1720), was a London maker of cups and tankards.

WARDELL, WILLIAM, & KEMPSON, PETER (w 1813-17), were Birmingham makers of coasters, etc.

WALTON, JOHN, & SON (1822-5), were Sheffield makers of candlesticks.

WEST, MATTHEW (w 1769-1806), was a Dublin silversmith.

WHIPHAM, THOMAS (w 1737-75), was a London maker who sometimes used dolphins as handles to his sauceboats. He had two

periods with partners. From 1700 to 1746 William Williams joined him at Spread Eagle, Foster Lane, and from 1757 to 1775 Charles White was with him at Ave Maria Lane. See plate, p 143.

WHITE, FULLER (w 1744-63), was a London maker of beer jugs, tankards and coffee-pots.

WHITE, JOHN (w 1719-39), was a London maker of jugs, bowls, and particularly candle-snuffers. He made candle-snuffers for Paul de Lamerie who then made the stand for them. A composite piece of this type, with stand, 7¾ in wide, sold for £2,700 (A 1969), and a plain lidded jug, 1720, sold for £4,600 (A 1967).

WICKES, GEORGE (w 1721-44), was a London maker of candle-sticks, cups, dishes, tea caddies, etc. A cup and cover, 1739, 45½ oz, sold for £460 (1968).

WILKINSON, HENRY, & CO (w 1831-39), were Sheffield makers of tea caddies.

WILLAUME, DAVID, SR (w c1688-1728), was a Huguenot silversmith who came to London in 1687 and entered his mark in 1697. He favoured scroll work, chased or engraved. There is a tea-pot of 1706 in the Assheton Bennett Collection at Heaton Hall, Manchester, with early cut card handles.

WILLAUME, DAVID, JR (w 1720-50), was a London maker of tankards, etc, who is credited with the introduction of the cow creamer (c1750). He is known to have been working with James Manners in 1735. A plain pair of silver jugs, 1730, sold for £16,500 (A 1969).

WILLIAMSON, JOHN (w 1716-34), was a Dublin maker of cake baskets.

WILLIAMSON, THOMAS (w 1726-40), was a Dublin maker who favoured shallow fluting on his pieces.

WILLIAMSON, WILLIAM (1726-60), was a Dublin maker who made both plain and beautifully chased pieces. A small bowl, 7 in diam, 1732, sold for £700 (A 1969).

WILLMORE, JOSEPH (w 1808-51), was a Birmingham maker of vinaigrettes and snuffboxes who also made handles for knives and forks, buckles and buttons, caddy and salt spoons, and wine labels. His craftsmanship was superb. A full account of the Willmore family is given in Eric Delieb's *Silver Boxes*. 1968, p 118. A flexible vinaigrette in the shape of a fish, 1818, sold for £85 (A 1965).

WINSLOW, EDWARD (1669-1753), of Boston, was an outstanding American silversmith of his period, noted for making boxes and caskets. His work is ornate, decorated with gadrooning, fluting, scrolls and acanthus leaves.

WINTER, JOHN, & CO (w c1775-83), was a Sheffield candlestick maker, the most important of the period. He favoured the Adam style; examples may be seen in Sheffield City Museum.

WOOD, SAMUEL (w 1733-74), was a London maker of cruets, sugar casters, and baskets, etc. A Warwick cruet, 1761, sold for £950 (A 1968).

WRIGHT, CHARLES (w c1772-90), was a London maker of cream jugs and coffee-pots.

YOUNG, JAMES (w 1775-87), was a London maker of a wide range of silverware, from tea caddies and dessert bowls to tureens.

YOUNGE, JOHN & CO (w 1778-88), were Sheffield makers of Adam-style cake baskets.

YOUNGE, JOHN & SONS (w 1788-96), were Sheffield makers of candlesticks and baskets.

BOOKS TO CONSULT

Avery, C. L. *Early American Silver*. New York, 1930 (1968)

Buhler, K. C. *American Silver*. New York, 1950

Chaffers, W. *Handbook to Hallmarks in Gold and Silver Plate*. London, Ninth Edition, 1966. Alhambra, Calif, 1967

Heal, A. *The London Goldsmiths: 1200-1800*. London and New York, 1935

Jackson, C. *English Goldsmiths and their Marks*. London, 1921 (1964). 2nd Edition. New York, 1964

Langdon, J. E. *Guide to the Marks on Early Canadian Silver*. 1969

Macdonald-Taylor, M. *A Dictionary of Marks*. London and New York, 1962. Gives lists of American and English (London) silversmiths.

Oman, C. C. *English Domestic Silver*. New York, sixth ed. 1965. London, seventh ed, 1968

Phillips, J. M. *American Silver*. New York and Toronto, 1949

Ramsey, L. G. G. (Ed.) *Antique English Silver and Plate*. London, 1962

Rowe, R. *Adam Silver*. London and New York, 1965

Stone, J. *English Silver of the Eighteenth Century*. London, 1965. New York, 1966

Wardle, J. *Victorian Silver and Plate*. London and Camden, NJ, 1963

Wyler, S. B. *The Book of Old Silver*. New York, 1937